Martha's Vineyard

GARDENS AND HOUSES

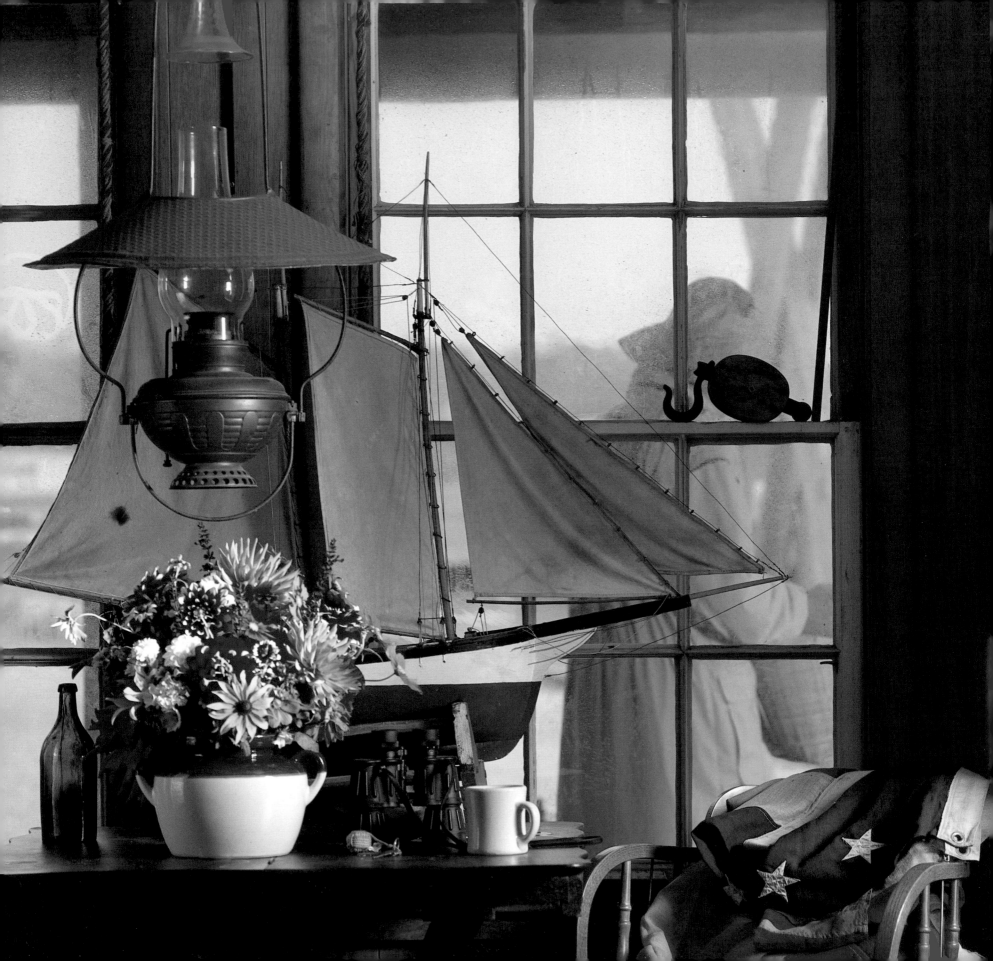

Martha's Vineyard

GARDENS AND HOUSES

PHOTOGRAPHY BY TAYLOR LEWIS

TEXT BY CATHERINE FALLIN AND ELIZABETH TALBOT

Simon and Schuster

NEW YORK LONDON TORONTO SYDNEY TOKYO SINGAPORE

SIMON & SCHUSTER
Simon & Schuster Building
Rockefeller Center
1230 Avenue of the Americas
New York, New York 10020

Designed by Taylor Lewis and Abby Kagan
Printed in Singapore

4 6 8 10 9 7 5 3

Library of Congress Cataloging-in-Publication Data

Lewis, Taylor Biggs.
Martha's Vineyard gardens and houses / photography by Taylor Lewis;
text by Catherine Fallin and Elizabeth Talbot.
p. cm.
ISBN 0-671-88106-x
1. Martha's Vineyard (Mass.)—Description and travel—Views.
2. Dwellings—Massachusetts—Martha's Vineyard—Pictorial works.
3. Gardens—Massachusetts—Martha's Vineyard—Pictorial works.
I. Fallin, Catherine. II. Talbot, Elizabeth (Elizabeth Speakman)
III. Title
F72.M5L49 1992 91-40457
779'.9974494—dc20 CIP

ISBN 0-671-88106-x

Acknowledgments

To the homeowners who so generously opened their homes and gardens and allowed us to share a very private and personal part of their lives in photographing and writing about them. To architect Joe Eldredge for introducing us to special places and people around the Island, and without whose boundless energy and enthusiasm for our project this book would not have been the same. To Anne Hale for her suggestions about wonderful gardens and for her good will and interest in our whole project. To Justine Priestley and Arthur Smadbeck for so good-humoredly fielding our packages and messages. To Joan Wuerth, Jan Cable, Annajean Brown, Margaret R. Steele, John A. Blair, Judith E. Federowicz, Stan Hart, and Ruth Dolby for suggestions of houses to see and recent historical facts. To Josephine Bruno, Dot Howard, and Ellie Kranz for garden suggestions; to Brendan O'Neil for his insights into Island history, historic houses and sites. Also thanks to Anne C. Allen for her help in verification of facts and Island history. To Robert Douglas for letting us board the Shenandoah to photograph and William Marks of VERI for allowing us to photograph the East Chop Light. Special thanks to Sue Pressman for connecting the three of us. To Pat Breinin, our agent, and Patty Leasure, our editor, for their constant support and encouragement as well as thoughtful suggestions.

To Greg Hadley, our photography assistant, who once again never flagged in his photographic work, for taking care of the many details of our work—sorting, filing, checking, recording, checking again, ordering film, and generally keeping track of the detritus of our lives.

To our freelance support staff for all their help and caring well beyond the bounds of duty and to whom enough credit can never be given: designer Abby Kagan for her extra careful preparation of dummy and mechanicals; copy editors Kate Scott and Marion Baker; Pamela Stinson for checking the dummy and mechanicals; Susan Groarke not only for proofreading but also juggling all the last minute corrections; Pauline Piekarz for proofreading; Greg Goebel for filling in as photography assistant.

To an island we fell in love with when we arrived by ferry from Nantucket one summer and decided to try to capture in photographs and words what we saw and felt. After living and working there for half a year, we will never leave for long. It just keeps getting better.

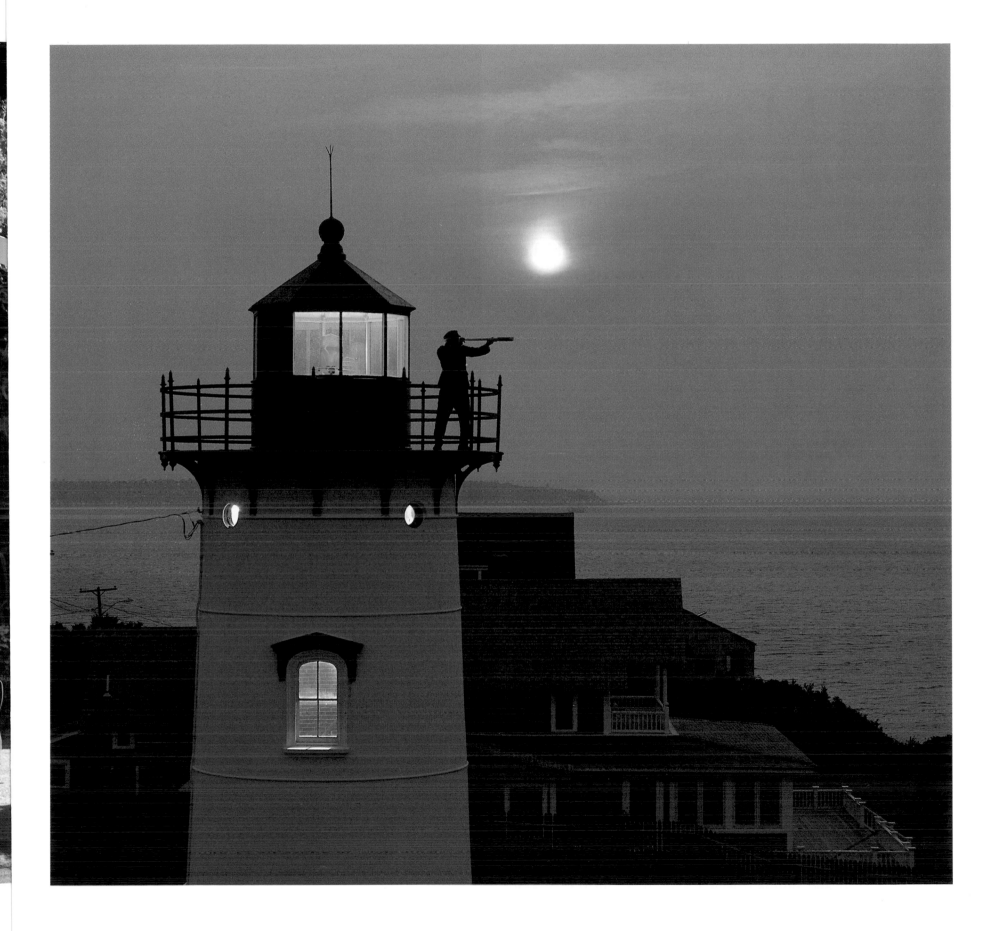

of the extended Algonquin group, were, of course, the true settlers of the Island. A friendly tribe with a well-established culture when the English arrived, they were fishermen and farmers, seamen and hunters, killing whales for meat from dugout canoes. These Native Americans were all but wiped out by the European diseases of smallpox and diphtheria, to which they had no resistance. The town of Gay Head is partially populated by the Wampanoags, who have recently been granted tribal recognition by the federal government and reclamation of some 400 acres of their common land in Gay Head. Portuguese seamen and whalemen were also prominent in the early settlement of the Vineyard well before the American Revolution.

As are all islands and coastline, Martha's Vineyard is a fragile outpost of land that must be protected from erosion and overpopulation. Its wetlands, meadows, and forests are home to a multitude of plant and animal wildlife communities. Conservation and preservation of the Island's resources and history are protected by many active and effective groups on the Island. The Vineyard Conservation Society and the Martha's Vineyard Land Bank actively acquire land. Approximately 12,000 acres, which comprises about 18% of the Island, is now restricted from development and held for public use. The Vineyard Open Land Foundation and the Martha's Vineyard Commission are involved in land planning. Other important groups that preserve and protect the Island are the Martha's Vineyard Garden Club, the Sheriff's Meadow Foundation, the Trustees of Reservations, Felix Neck Wildlife Refuge, Dukes County Historical Society, and Martha's Vineyard Historical Preservation Society, as well as Vineyard Environmental Research Institute, which leases and maintains three of the Island's historic lighthouses.

Most people think of Martha's Vineyard as a summer island, and it is indeed wonderful then, with long summer days and warm nights. Sea breezes gently cool the air; fragrant wild shrubs and trees burst into bloom in spring, which might arrive the first of March or not until well into April. The air smells of pine forests, new-mown hay, honeysuckle, sweet pepper bush, swamp azaleas, and more. Abundant fruit trees, wild berry bushes, beach plums that are native to a very small part of the New England coast, and, of course, wild grapes of a score of varieties—all grow in profusion. Early summer and fall are marked by sparkling clear days. Winter is cold and rainy, and sometimes blizzards and northeasters cover the island in a thick blanket of snow. Though more temperate than much of New England because the climate is moderated by the surrounding sea and sheltered from the cold Labrador currents by Cape Cod, the Island is still very much part of that geographic region with its grand and sometimes bleak winters.

Physically Martha's Vineyard is many places, but its character is best defined by the people who live here, whether year-round or only part of the year. Definitely New England in personality, flavored with Yankee ingenuity, self-reliance, and independence, its residents are from all over the world. There is a very strong sense of community on the Vineyard as well as a great diversity of life-styles and professions. There are six towns on the Island and each one is a devoutly individual community of its own. Vineyard summer residents are just as diverse and dedicated to the Island as any year-rounder, whether their families have been coming here for five generations or one. Each summer visitor discovers a different island, since everyone seeks a different kind of refuge. And it is possible to find seclusion in a cottage down a long, windy lane far away from town but close to the water—for you are never far from water on the Island—or lively and stimulating conversation in the heart of a thriving summer community.

This book is about the Island and its homes and gardens; therefore, it is also about the people of the Vineyard. An individual's home and garden reveal both a private and public expression of self. Whether we have designed them ourselves or have bought a house built for someone else and interpreted

and changed it to suit our needs, our home and garden reflect the way we shelter our family and friends and, most of all, ourselves. Nothing can describe the individualism of Martha's Vineyard more than this markedly diverse sampling of gardens and homes gathered here in photographs and words. A combination of Taylor Lewis's excitement and expertise with the visual charisma of the architecture and gardens, Catherine Fallin's fascination with the why and how of creating the magnetism of the place, and Elizabeth Talbot's long association and deep love of the Island and its most special places, this book is about the allure of this unique outpost at sea.

DOWN-ISLAND

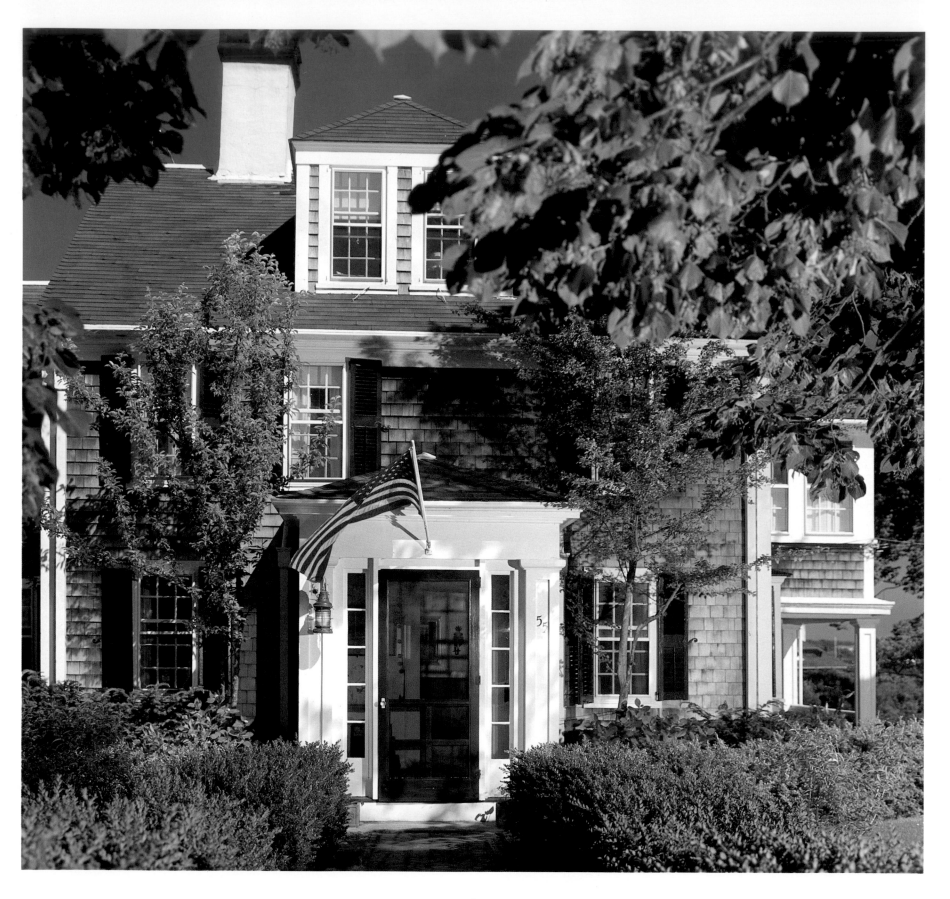

This house known as Pineapple House is one of the oldest in Edgartown. The lot was purchased from Governor Thomas Mayhew in 1679 by John Coffin, son of Tristram Coffin, one of the early settlers of Nantucket. Built soon after 1682, when John Coffin came to Edgartown, the original house was 24 feet wide by 32 feet deep and consisted of two stories plus a basement on the front and one story on the back. The front of the house faced the harbor, as did all the houses at that time, since there was no street behind them until much later. The land slopes down to the water, so the first floor on what is now the street side is the second floor on the water side. John Coffin was a blacksmith by trade, and his shop was in the lower level of the house. Several subsequent owners in the 1700's were also tradesmen. Among them were a cooper, a shoemaker, and a tailor.

The present house is a much expanded version of the original; the dining room and porch wing of the house were added around 1877. The current owners, Paul and Jacquelyn Ronan, have done extensive restorations and have furnished the house with a combination of antiques, some found in it, others purchased elsewhere on the Island.

The Georgian front was probably added around 1786, when South Water Street was laid out. Boxwood hedges line the brick front walk and privet outlines the property edges. Perennial borders and roses are planted selectively throughout the property's extensive lawns.

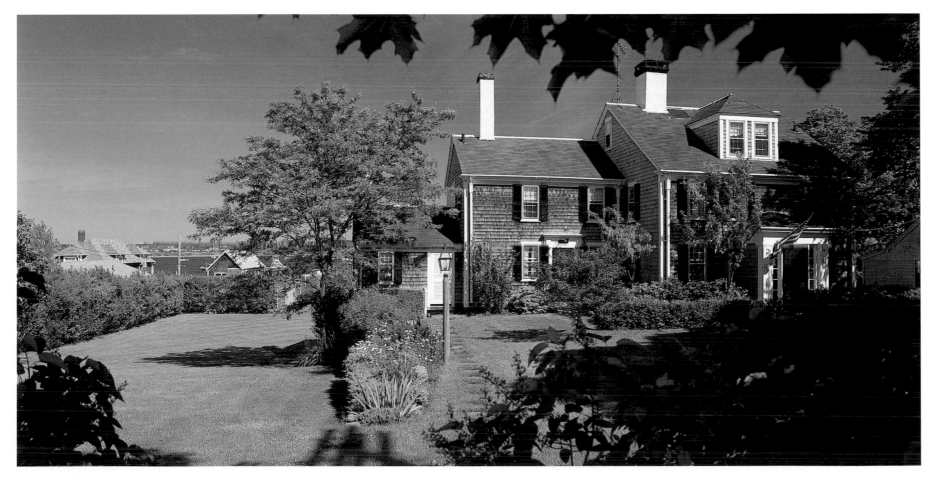

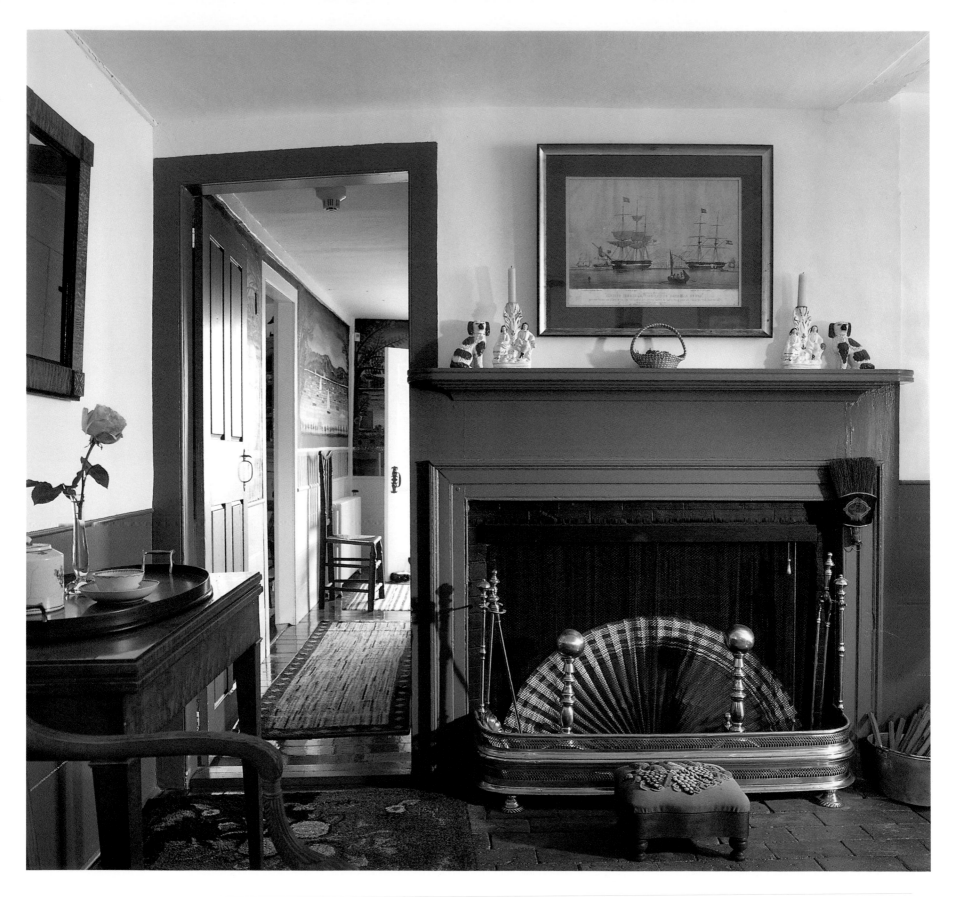

LEFT: *The living room is situated on what is now the front of the house and may have been added later. The lithograph over the fireplace is called* Captain Ingraham, Vindicating American Honor, Smyrna, July 11, 1853. *A New England tole broom holder hangs on the right of the fireplace. To the left of the fireplace is the original entry hall, which is painted with a mural by Margot Datz.*

RIGHT: *A Chinese export teapot and cup and saucer are on an antique Hepplewhite tray. The tiger-maple mirror and table are both original to the house.*

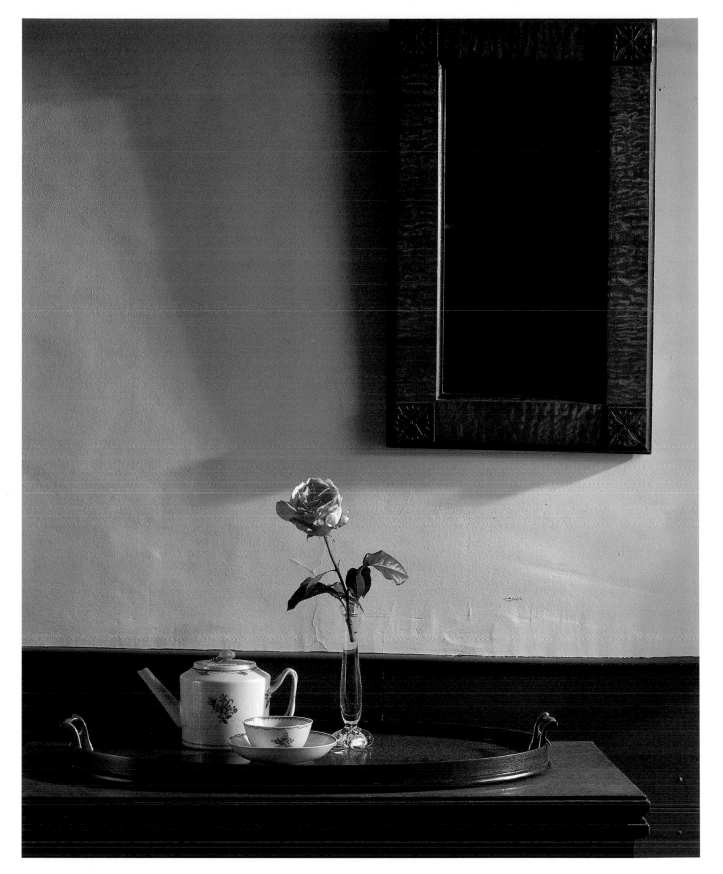

RIGHT: *The cozy den, overlooking the harbor, is furnished with wool-on-cotton crewel-upholstered chairs and sofa and period tables and side chairs. The Windsor chair is next to a period Chippendale tiger-maple drop-leaf table that holds a pair of turned wooden candlestick lamps and an early American pewter pitcher. The lithographs to the right of the window are of eighteenth-century English gentlemen and were found in the house. A tole tea-canister lamp sits on the corner table. In front of the sofa is a camphor tea chest that came around the Horn on a sailing vessel.*

ABOVE: *A ship's inclinometer sits above the doorway leading from the den to the hall. The original entrance to the house on the water side is to the right. The mural painted on the wall above the chair rail is of the Inner Harbor in all seasons, as seen from the Ronans' front porch. The railing along the bottom of the mural is the Ronans' porch railing. The white stair rail on the left belongs to the narrow, steep stairs that lead to the second floor.*

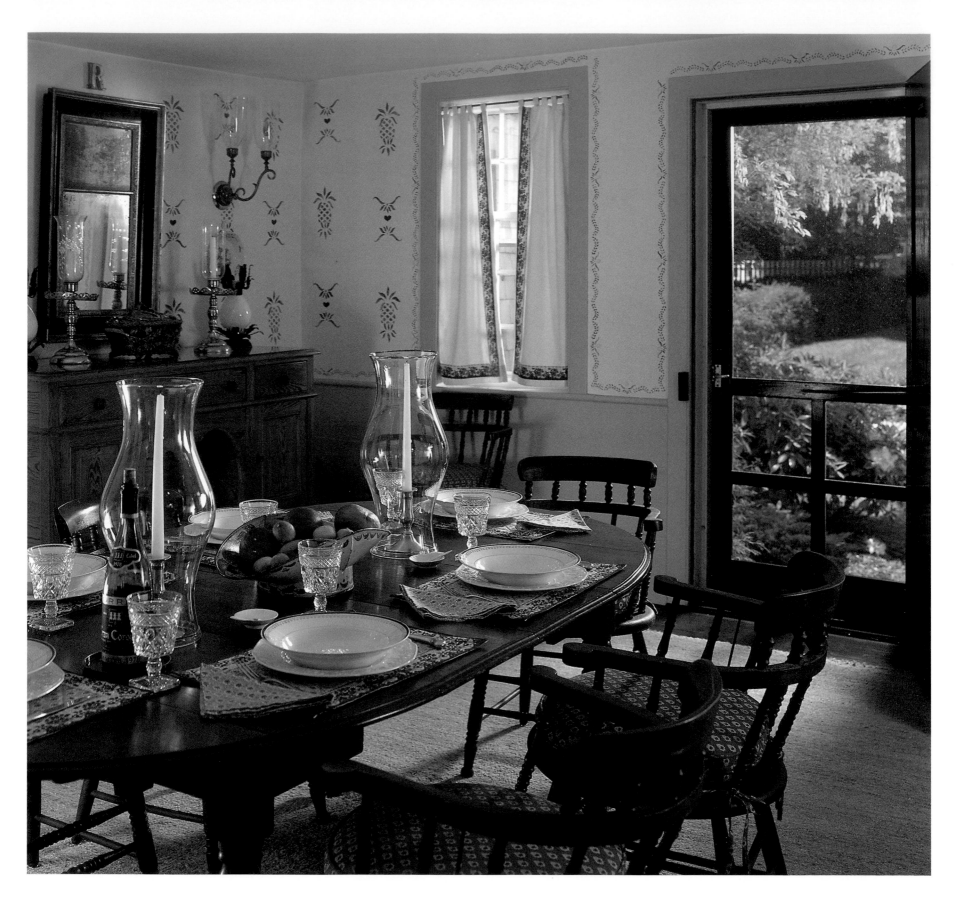

LEFT: *The dining room features the Colonial symbol of hospitality, the pineapple, which gives the house its name. The stenciling on the walls was done by Mary Mayhew, an Island painter. Above the pine sideboard, which was found in a local thrift shop, is a Federal-style mirror, ca. 1850. The pineapple lamp on the top of the sideboard reflects the motif of the stencils on the wall. The Majolica covered dish has a clever design of rabbits and other small game on the top. The door opens out onto delightful gardens and the front lawn.*

RIGHT: *The upstairs morning room opens off the master bedroom through a pair of French doors. Originally a sleeping porch, the room has windows on three sides, with windowseats below for storage. The louvered shutters open to allow both light and cool summer breezes from whichever direction is most desirable. The writing table was in the dining room when the Ronans bought the house. The box on the faux-marble top is a local piece with a whalebone lock.*

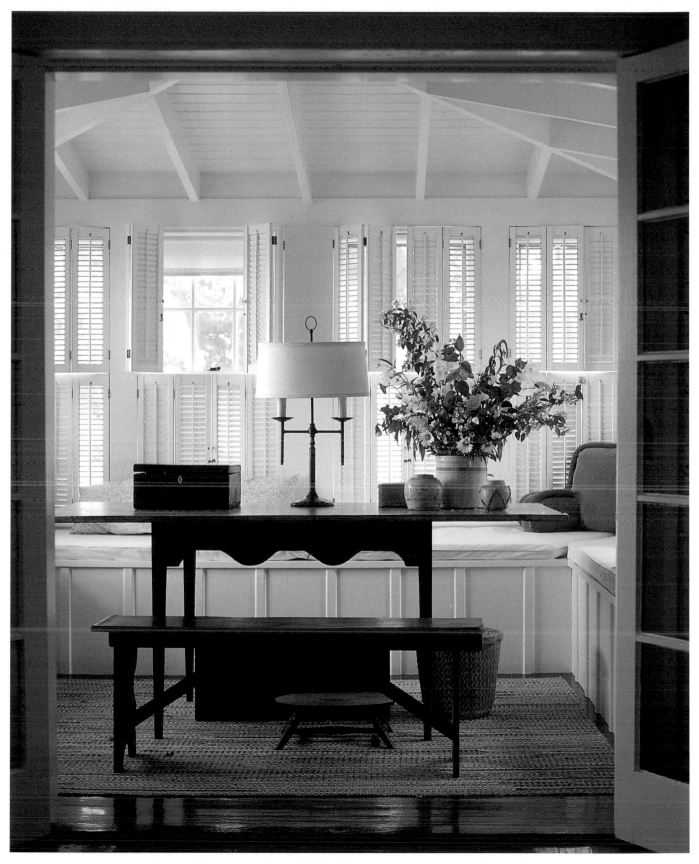

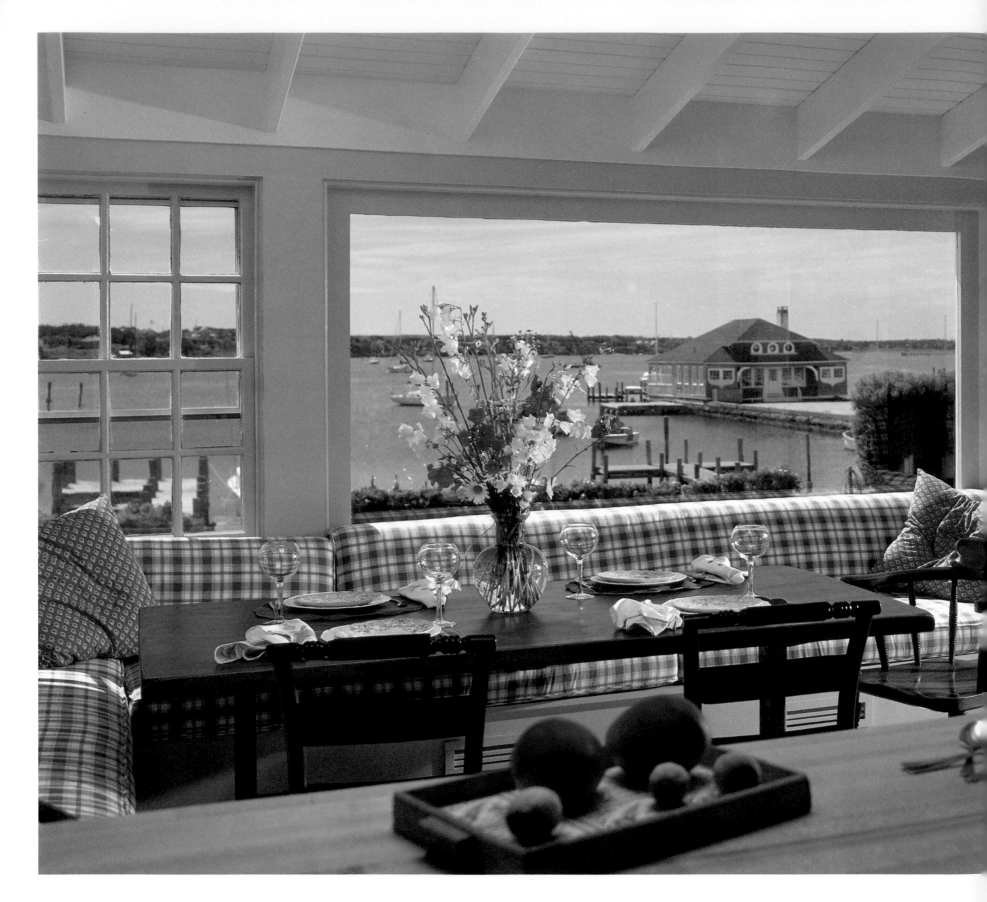

ABOVE: *Beneath the peak of the newly raised kitchen ceiling is a ship's figurehead, ca. 1750, that was inherited with the house. It had originally been on the barn across the street.*

LEFT: *The kitchen—breakfast room extension and sun porch have recently been added on to the old kitchen. The ceiling was taken out to expose the roof beams. The spectacular view of the Inner Harbor through the breakfast-room window includes the Reading Room, a private club, situated on a long pier. Tower Hill can be seen through the windows on the right.*

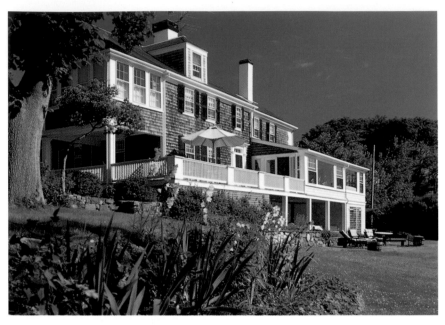

ABOVE: *A view of the rear of the house shows the extensive lawns between it and the water. Even though the original house was modest in size, it occupied a commanding position on the hill above the harbor. This viewpoint shows the morning room above the porch on the left and the new kitchen and sun porch addition on the right. The ground-level patio can be reached from the original basement by going down a few steps. Stone retaining walls across the back of the house hold beds of perennials.*

RIGHT: *Cirrus clouds in the clear blue sky are characteristic of the cool June days that are so enticing on Martha's Vineyard. The stark white chairs, railing, and umbrella lend an almost surrealistic look to the deck, a good vantage point to observe the activity of the Inner Harbor.*

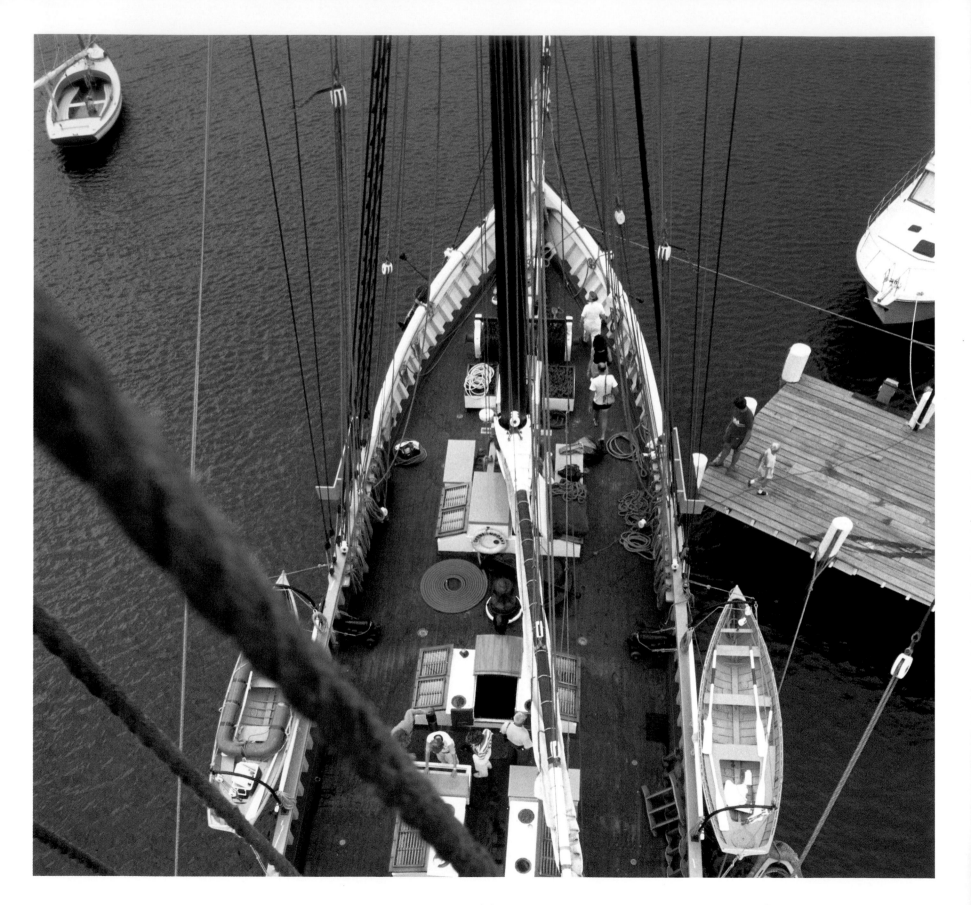

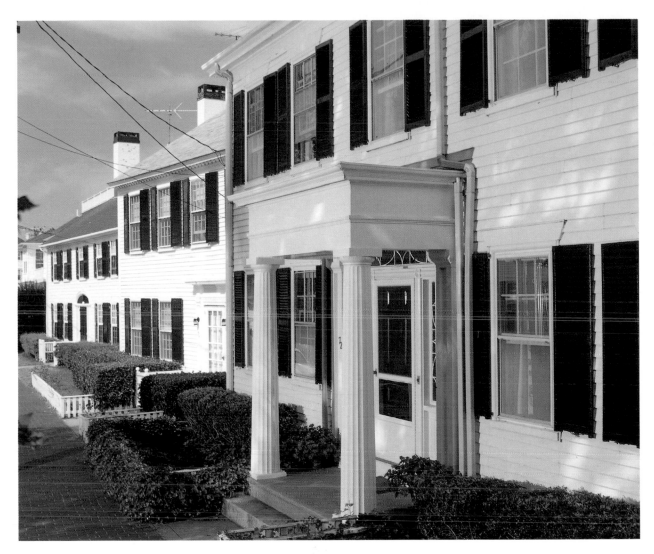

NOAH'S ARK

The house at 72 North Water Street is one in a row of Greek Revival houses typical of those built for the whaling captains of Edgartown in the first half of the nineteenth century, when the whaling ships brought the town to its peak of prosperity. The houses are skewed to the street but parallel to their lot lines. Since they face Cape Pogue, tradition has it that they were positioned toward the direction of the returning ships. Many of these houses that sit so close together have extensive rear gardens, and number 72, owned by Douglas and Lorna

Garron, is no exception. The garden was designed in the late 1920's for Lorna's grandmother by her great-uncle (her grandmother's brother), Arthur Underhill, a professional landscape gardener in New York and New Jersey. He planned a number of gardens in Edgartown during that period.

In the spring the garden is filled with the pinks, blues, whites, and yellows that were common in Colonial gardens. Lorna has chosen the old-fashioned flowers for their colors in the spring. In July the borders are filled with daylilies (*Hemerocallis* hybrids), white phlox (*Phlox paniculata*), and globe thistles (*Echinops ritro*).

ABOVE: *The back of the house as seen from the rear of the garden. In the foreground a bed of hostas is just inside the covered garden gate. The path leads into the inner garden, encircled with perennial beds.* RIGHT: *An overview of the garden from the second-floor porch. The giant boxwood were originally four plants but, since the 1920's, they have grown together into two giant shrubs. In the far right corner are a Chinese dogwood (Cornus kousa) and a late-flowering Viburnum 'Americana.'* BELOW: *In this inviting corner of the garden, lemon-yellow and orange daylilies are backed by vibrant blue globe thistles. Interspersed around the border are white and rose-colored phlox, Nicotiana alata, and coral bells (Heuchera hybrid).*

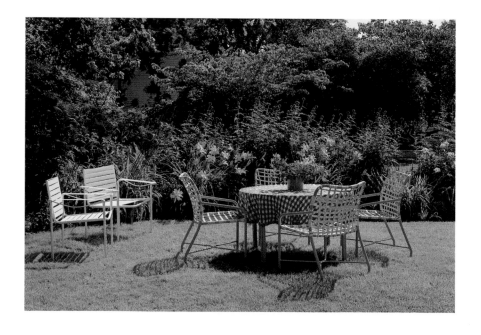

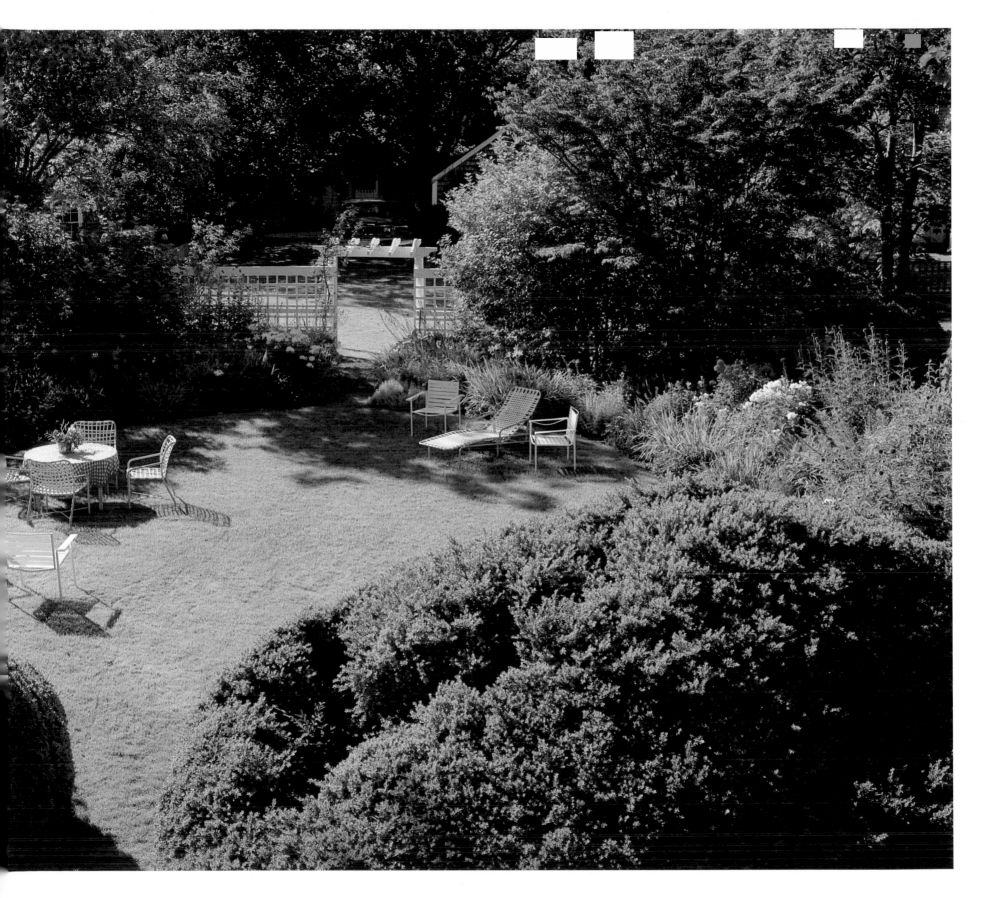

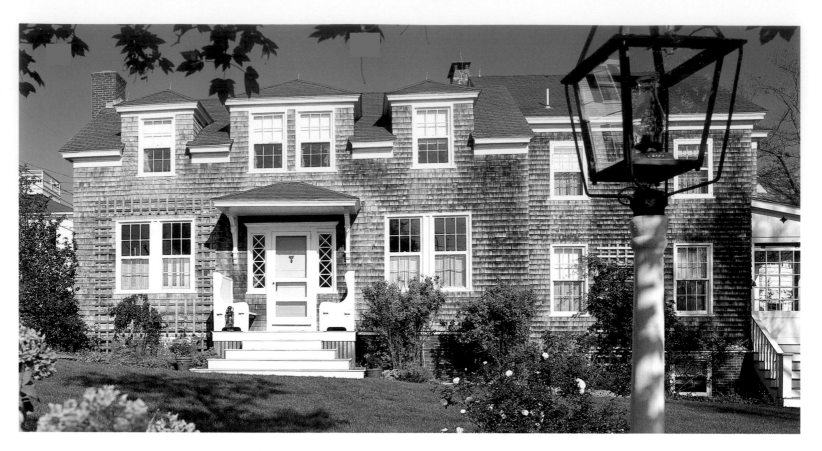

ON THE WATERFRONT

Across the street from grand Greek Revival houses built for the whaling masters of Edgartown is this eccentric gray-shingled house. Located between North Water Street and Edgartown Harbor, it began in 1832 as a general provisions store operated by the Pease brothers. Rumor has it that the lower floor, which is below ground on the street side and on ground level on the water side, was once a tavern. In the early part of the twentieth century there was a coal wharf just below the house.

The onetime entrance to the store on North Water Street now opens into the back of the house near the kitchen. No one knows just how many additions were made or when, but it is apparent from the arrangement of doors, windows, and stairway inside that there have been several. Around the turn of the century, the house was a grand Victorian structure, complete with sweeping lawns and a large formal garden hidden from the street by high privet hedges.

When Jayne and Frank Ikard purchased the house in 1981, they restored and refurbished it, lightening up the dark downstairs rooms by painting all the walls white. They widened doorways and rearranged rooms and walls to open the house to harbor views wherever possible.

RIGHT: *The bright dining room is highlighted with the bold oil paintings of Vineyard artist Michael O'Shaughnessy. The large oak table was in the house when the Ikards purchased it; when all the leaves are added the table can seat twenty comfortably. A few steps down from the dining room is the large living room. The painting on the wall to the left of the doors out to the deck was painted by Island artist Stanley Murphy.*

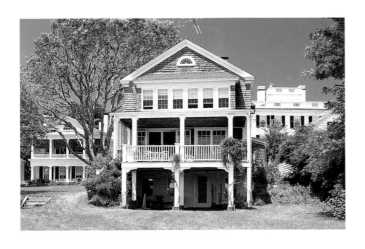

LEFT: *Seen from the harbor's edge, the house shows three full floors, while there are only two on the street side. On either side can be seen the Greek Revival dwellings that line the other side of South Water Street.*

RIGHT: *The deck outside the living room has an impressive view of all the activities of Edgartown Harbor.*

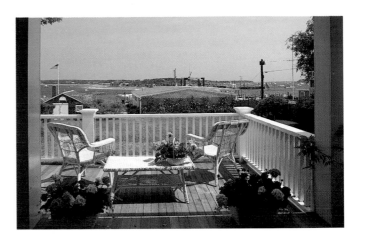

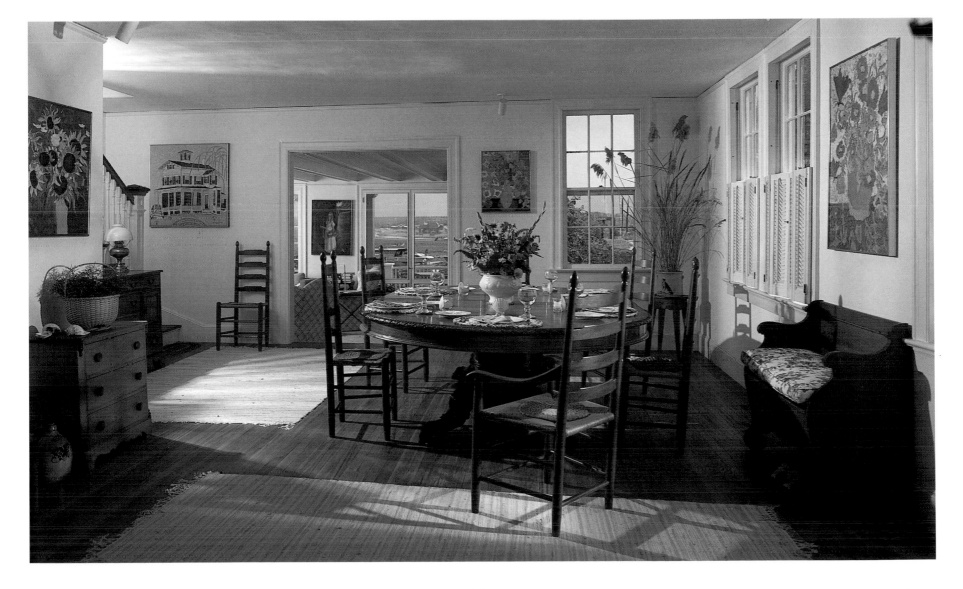

LEFT: *The main entrance to the house is through the dining room.*

RIGHT: *The kitchen underwent the most dramatic changes of any part of the house. When the Ikards bought the house, the kitchen was down a twisting hall all the way at the back of the house. Two little bedrooms were transformed into this large eat-in kitchen with corner cabinets that hold Jayne's collection of cranberry glass. A fireplace was added, and later the owners discovered old photos of the house showing a chimney on this wall long ago. The kitchen opens onto the dining room through a double doorway affording a view of the harbor from the breakfast table on the far side of the room.*

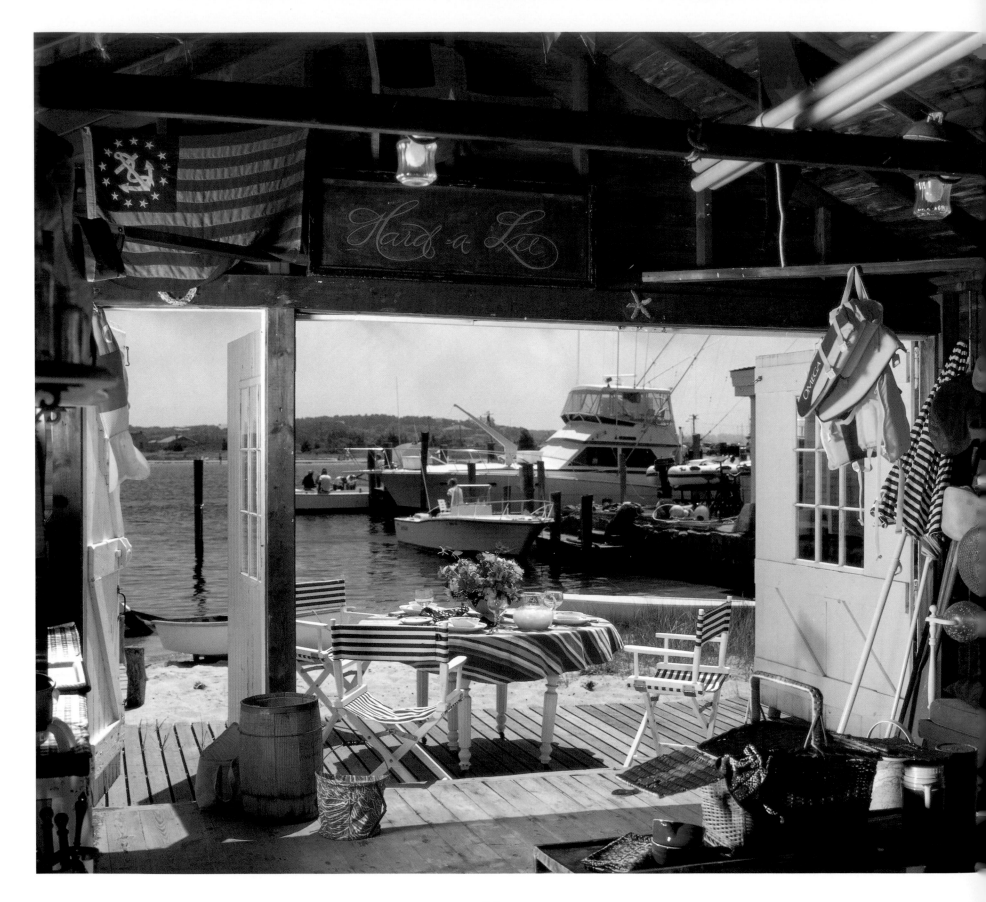

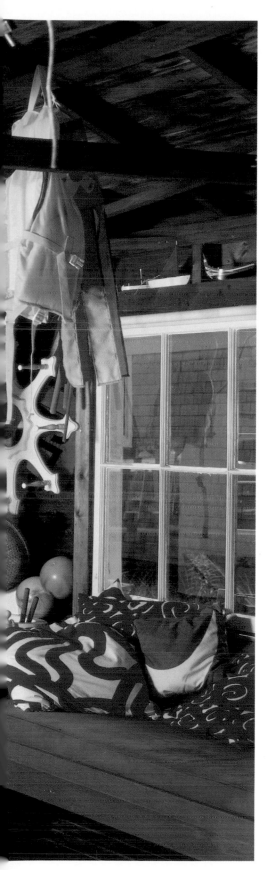

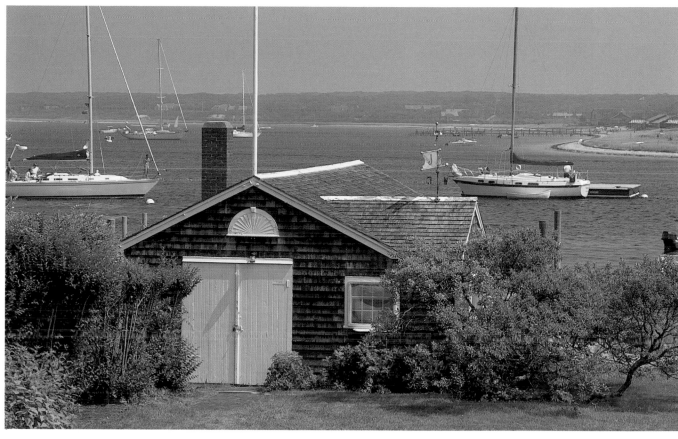

The turn-of-the-century boat house sits right on the beach. It is ideal as a place to entertain and also provides endless hours of fun for grandsons.

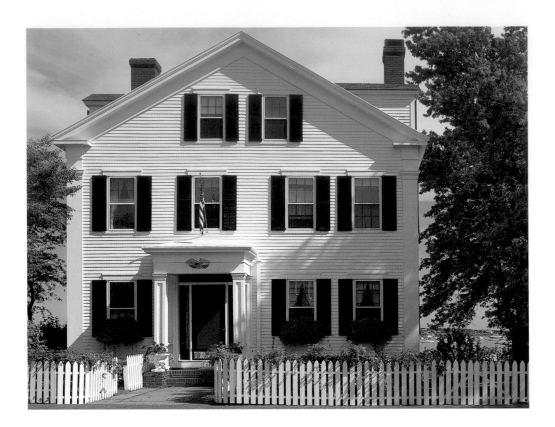

TARA-BY-THE-SEA

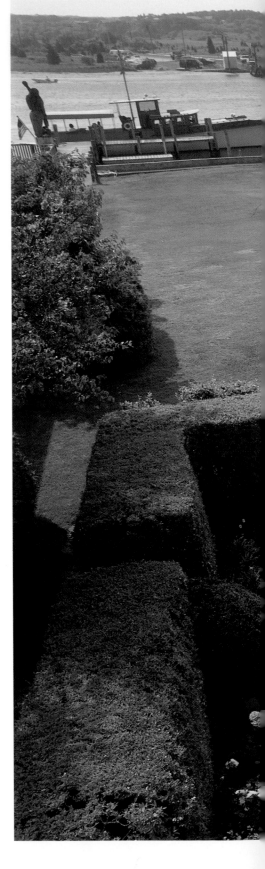

This Federal-style house on North Water Street was built in the 1850's by Joseph Thaxter Pease, a customs collector and the son of Jeremiah Pease, who chose the site for the first camp meeting held in Oak Bluffs. Greg and Gene Sullivan bought the house in 1988 and took it through a total renovation, including the garden. The only things remaining from the old garden are the Belgian-block retaining wall; the hedges; the 'New Dawn' roses, which were overgrown; and grapevines. Gene planned the formal design and chose the plantings—perennials, selected primarily for color and successive seasonal blooms, with some annuals mixed in. Overlooking the ferry to Chappaquiddick, the town dock, and the Inner Harbor, this gracious formal garden with its rose-covered arbor, brick paths, and beds radiating out from a fountain is in its first season at the time of the photograph.

Dwarf boxwood forms a border around each of the four triangular beds, filled with brightly colored dwarf marigolds, petunias, zinnias, and Marguerite daisies. The fountain adds the sound of water to the delicious soft scent of lavender and roses. Privet hedges on two sides of the garden lend an air of grandeur and provide necessary protection from the strong breezes off the harbor. On the right side of the garden is a deep border, filled with a broad variety of perennials, chosen to provide a long season of bloom as well as for color.

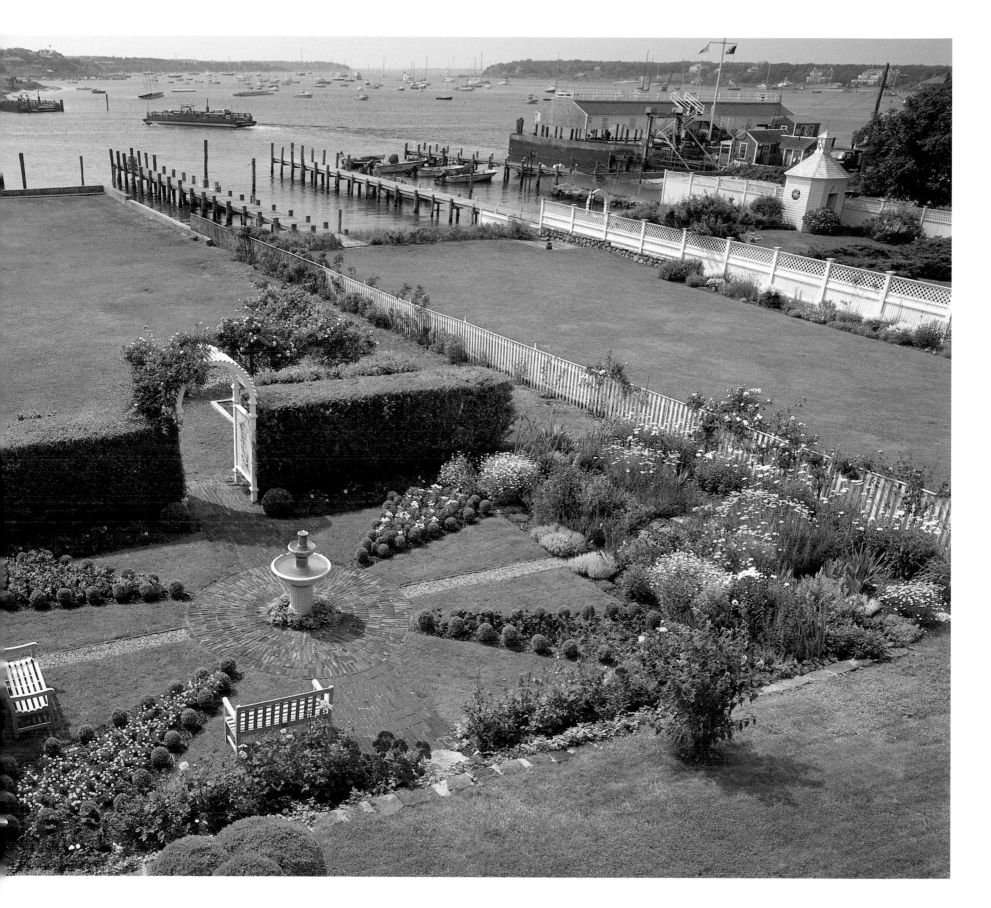

In July, this corner of the border features Marguerite daisies (Chrysanthemum frutescens), yellow yarrow, black-eyed Susans (Rudbeckia fulgida), coreopsis (Coreopsis lanceolata), liatris (Liatris spicata), santolina (Santolina chamaecyparissus), lavender (Lavandula angustifolia), and blanket flowers (Gaillardia grandiflora). Soon, globe thistles (Echinops ritro) and painted daisies (Chrysanthemum coccineum) will add their blues and reds to the garden when they begin to bloom.

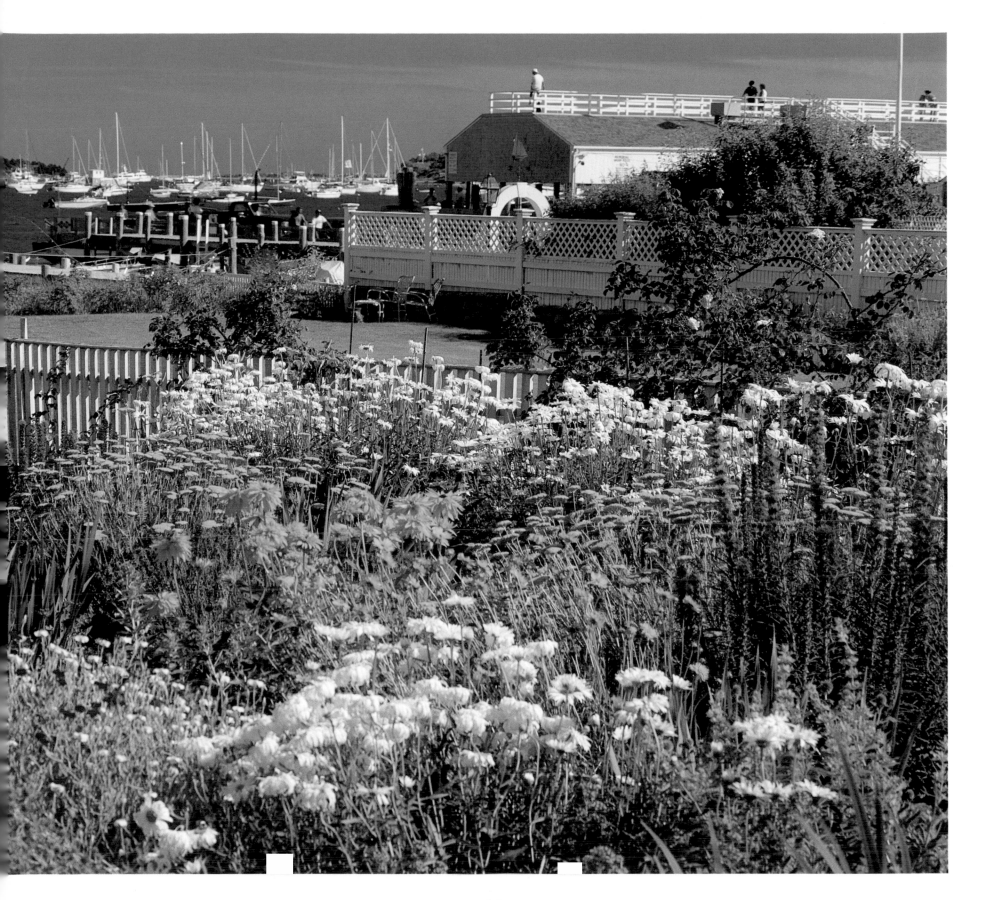

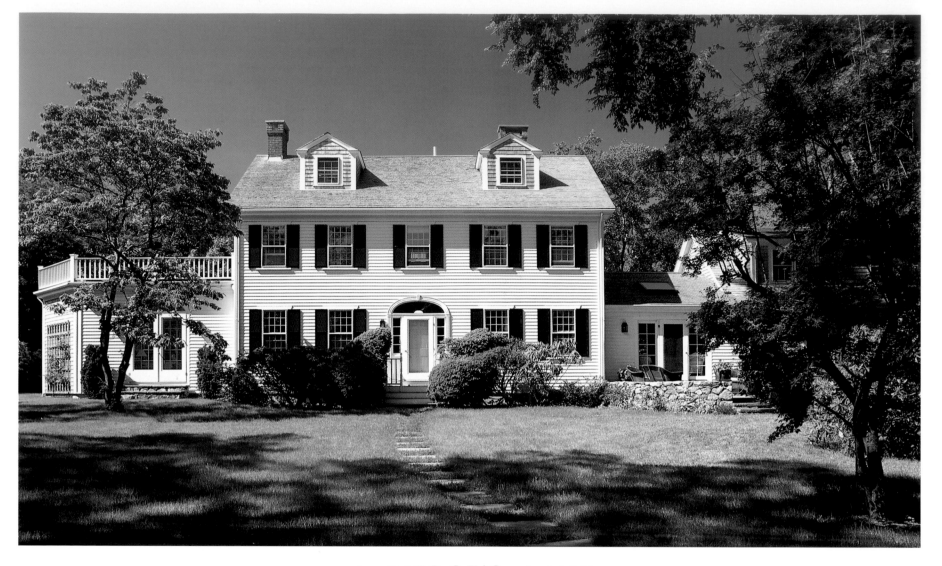

9 PIERCE'S LANE

This Georgian-style house was built in 1929 for Henry Beetle Hough, editor of *The Vineyard Gazette* for sixty-five years. Keith and Nancy Highet bought the house in 1990 and have renovated and expanded it. On the left is an octagonal library addition. The fanlights over the French doors repeat the design of the original window above the front door. New dormers were added on the third floor. The garage was moved to make room for a guest wing and Nancy's studio next to the kitchen.

On the other side of the house is a new and larger kitchen. The interiors are designed to integrate family antiques and collections with the modern life-style of an active family. Color brings it all together.

Nancy has added extensive gardens, while keeping original plantings of spring bulbs and rhododendrons, bringing them back to life with careful pruning.

Henry Beetle Hough was a staunch defender of the Island's past but he also welcomed well-considered change. Friends feel he would be pleased to see his house today.

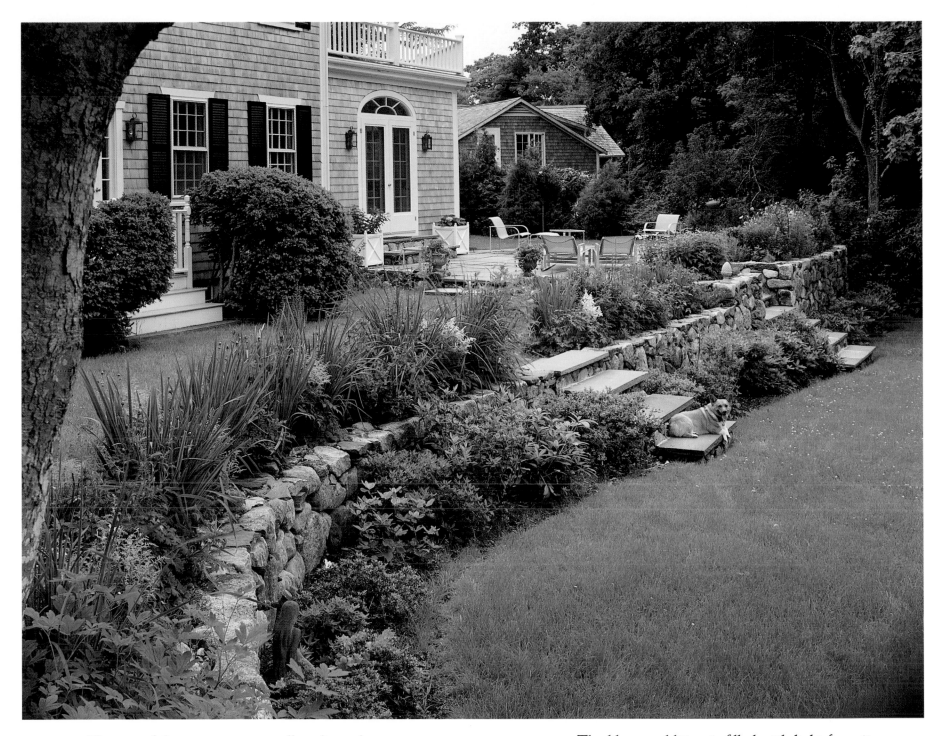

ABOVE: *The graceful, curving stone wall outlines the stone terrace outside the library and divides the lawn across the back of the house into two levels, providing for generous perennial borders on the upper level and at the base of the wall as well. The Highets' Corgi, Hotchkiss, is resting on the garden steps.*

OVERLEAF: *The library addition is filled with light from its skylight and the three sets of double French doors. The rug is an early 1900's Oushak from Russian Georgia and was the focus around which Nancy chose colors and other furnishings for the room. The result is an eclectic mixture of old and colorful things.*

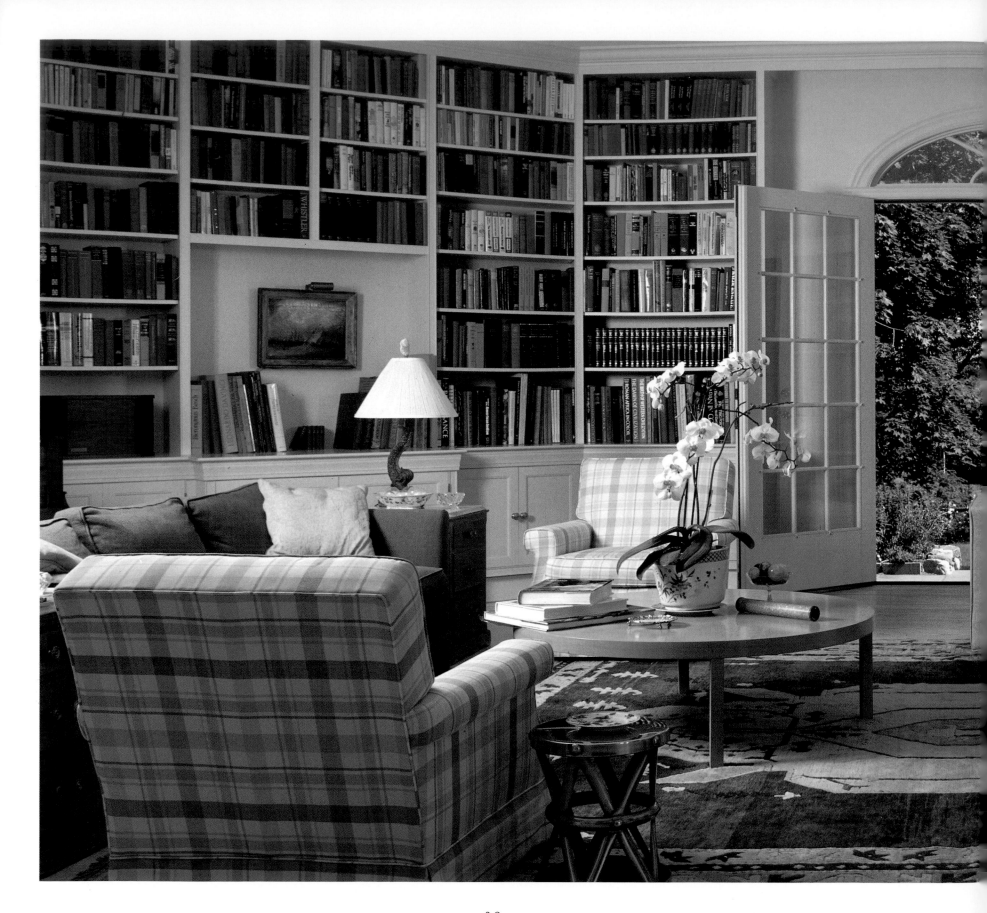

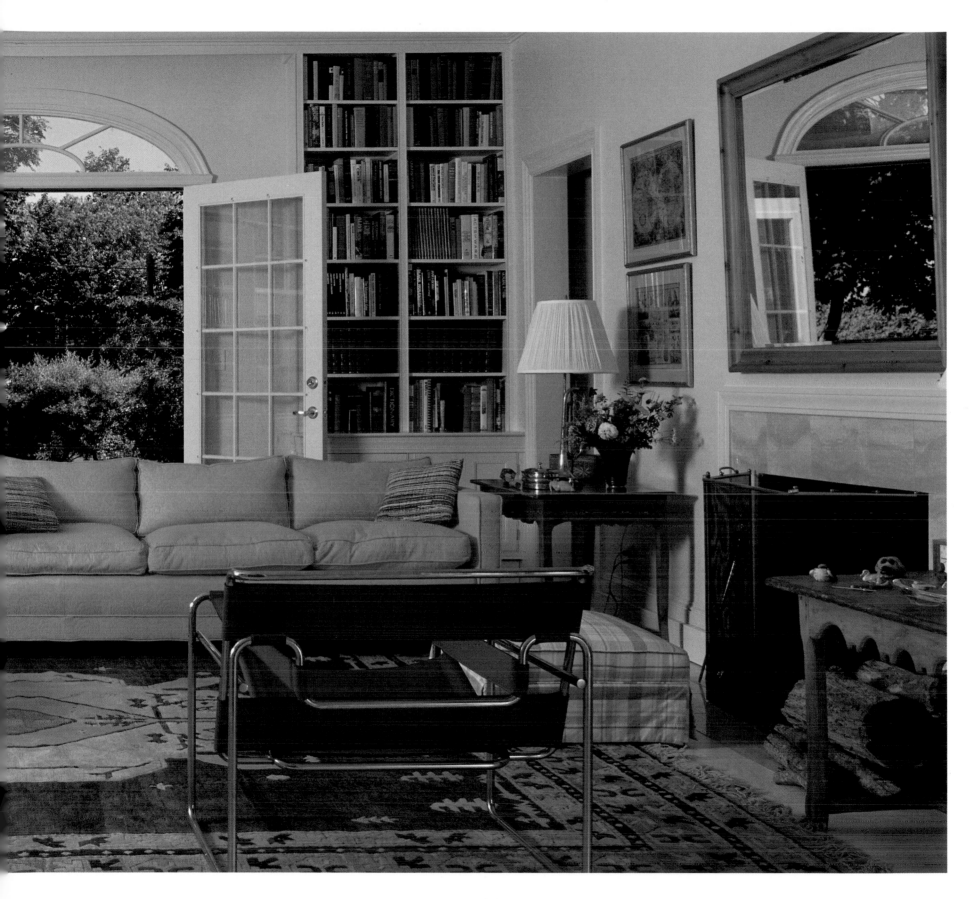

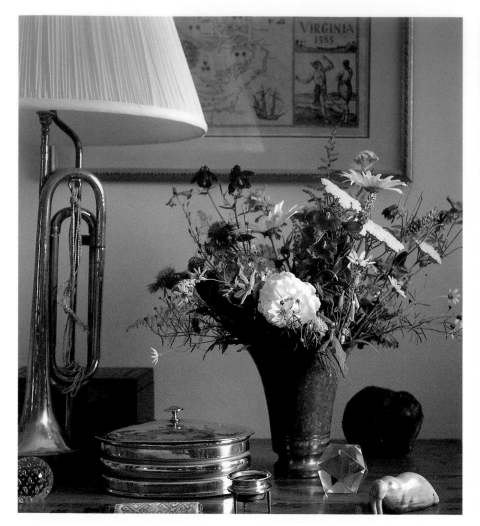

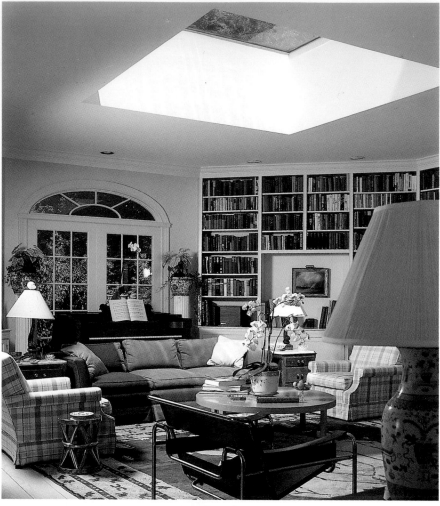

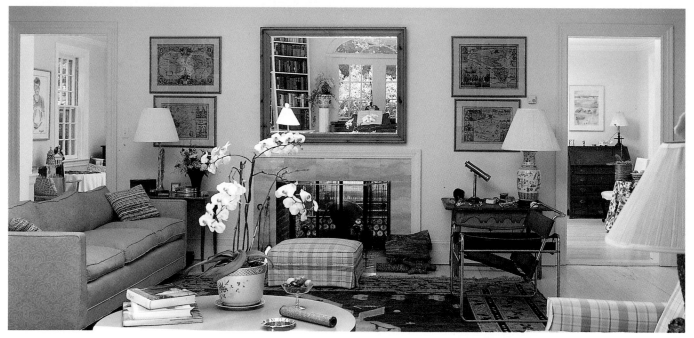

LEFT: *The fireplace side of this truncated octagon connects the library to the living room. The fireplace uses the original chimney. Over it, on either side of the mirror, hang two pairs of hand-painted antique maps. On the round table in the foreground is an orchid phalaenopsis.*

FAR LEFT: *A trumpet lamp and a collection of keepsakes, including a marquetry box, a Regency tea caddy, and a sculpted head of the owner's one-week-old daughter are on the table below a map of Virginia in 1585.*

LEFT: *An antique carved German piano stands on the side of the octagon opposite the fireplace wall, in front of a pair of fixed French doors. The painting in the library niche is Dutch; the lamps on either side of the sofa were made from carved wooden dolphin candlesticks.*

RIGHT: *The center hall has been kept very much as it was originally, with its wide pine floorboards, stair rail, and banister. They are original to the house, as is the first door to the living room, seen on the left. The second doorway down was added to balance the space. The wallpaper is from Clarence House. The backdoor leads to the extensive gardens behind the house. The rugs are Chinese needlepoint. The table in the foreground is a nineteenth-century pine half-round that holds a collection of silver boxes and an arrangement from the garden in an Italian vase.*

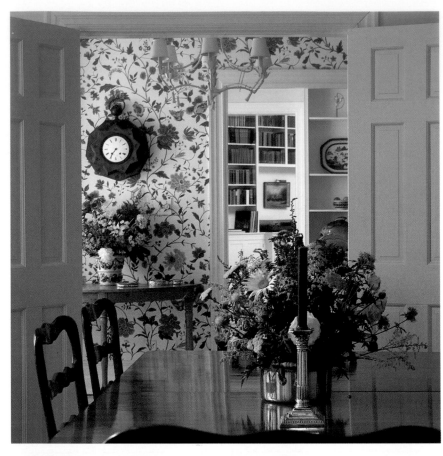

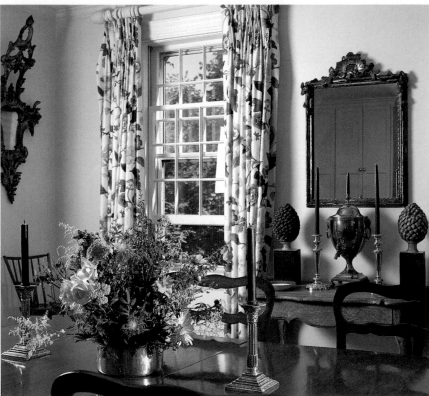

LEFT: *The outside wall of the library can be seen from the dining room with the living room and entry hall in between.*

BELOW LEFT: *On the wall to the left of the window is one of a pair of Venetian sconces, made in the eighteenth century. The provincial fruitwood table holds a pair of Italian ceramic pineapple finials and a pair of Georgian English silver candlesticks on either side of Nancy's grandmother's copper samovar.*

RIGHT: *The dining-room table is set for dinner with Venetian crystal and Spode soup plates on Rosenthal serving plates. The ceramic fish centerpiece is Italian. The candlesticks are of 1920's Georgian design, topped with bobeches, and filled with flowers from the garden. The pine sideboard is a nineteenth-century American piece that belonged to Nancy's grandmother. It holds old Sheffield wine coasters and a large bouquet of flowers from the garden in an Italian ceramic vase.*

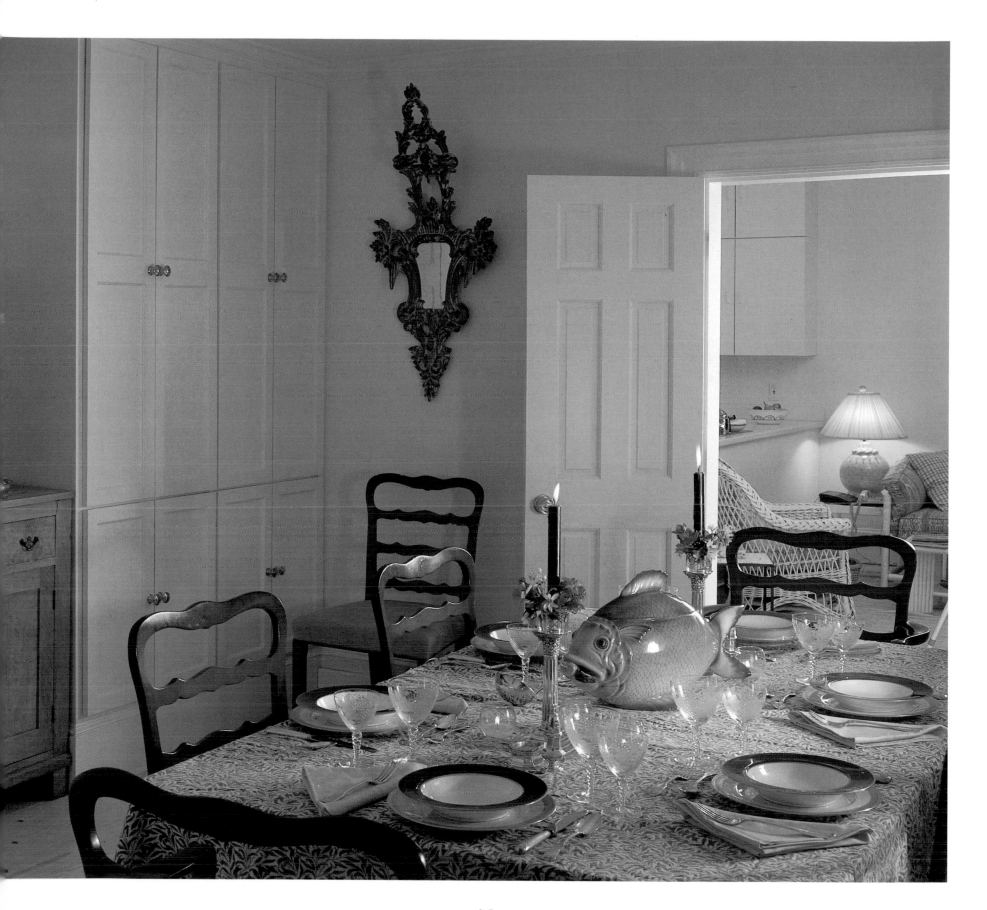

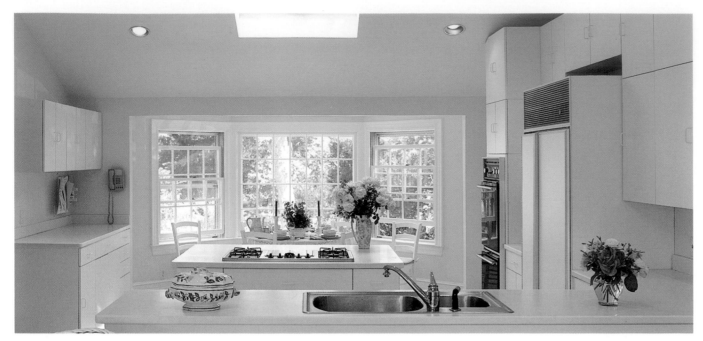

LEFT: *The kitchen has been completely redone with skylights and large bay windows in the breakfast area.*

BELOW LEFT: *At the front end of the kitchen is a comfortable sitting area. The painting above the wicker sofa is by Nancy Highet. The chest next to the chair was painted by illustrator and artist Margot Datz, who is also Nancy's sister-in-law.*

RIGHT: *The breakfast table is set with French pottery. It is an especially cheerful spot overlooking the lush lawn and gardens in back of the house.*

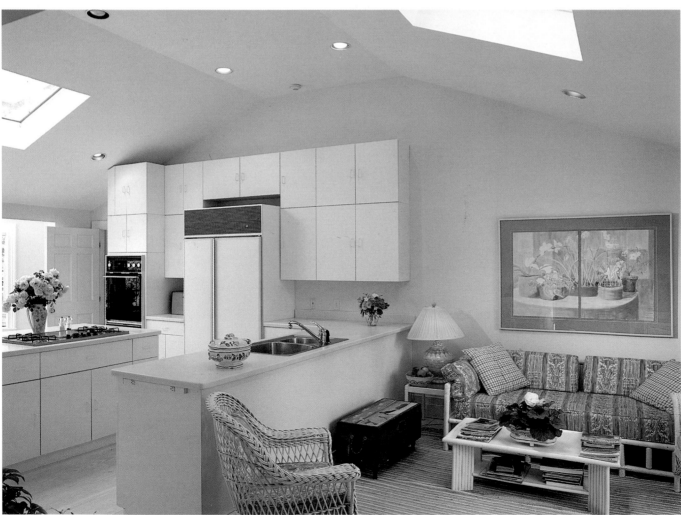

Architecturally, the living room is very much as it was when the Houghs lived here. A doorway has been added at the end of the hall, the floors pickled, and color added to the room. The dhurrie rug was designed by Nancy, and the watercolor on the wall between the windows is a portrait of her son, Ethan. The mantel holds a collection of shells, which decorate the rest of the room as well. Above the mantel is one of several watercolors in the room done by Caribbean artists. To the left of the fireplace wall on the shelves is part of Nancy's collection of blue-and-white Canton china. The fireplace is original to the house and was opened up on the other side to create a fireplace for the library on the same chimney.

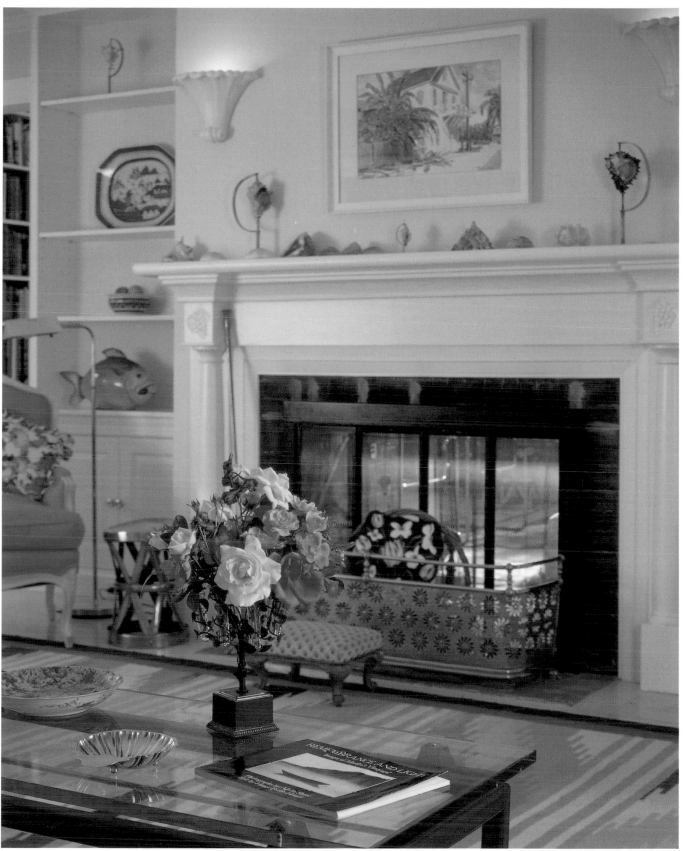

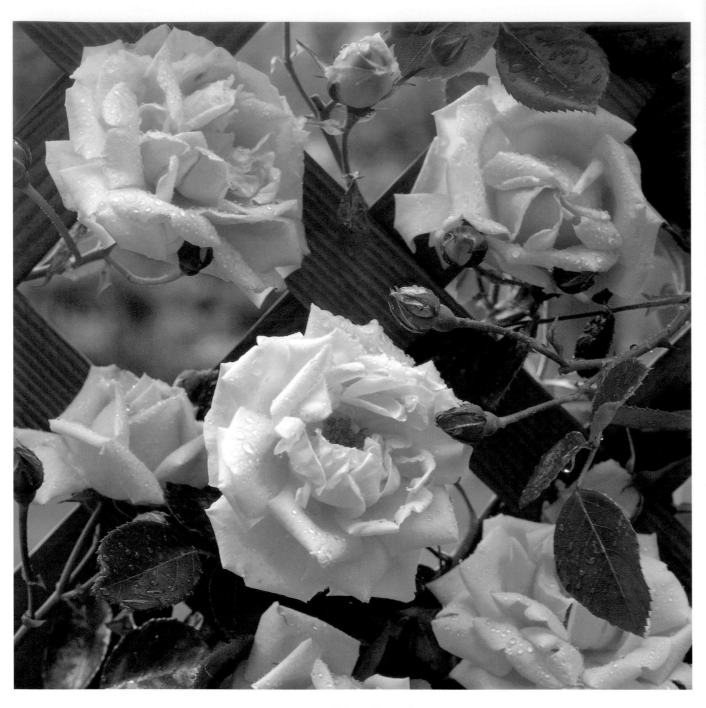

ABOVE: *'New Dawn' roses.* RIGHT: *Along the back fence are several varieties of roses, including both pink and white 'New Dawn' and shrub roses in what Nancy calls her "wild meadow" border of flowering crab apple, dogwood, lilac, and Rosa rugosa. In this rear view of the house are the kitchen and breakfast room on the left; the dormers along the top of the house are Keith's office, and the library is on the right.*

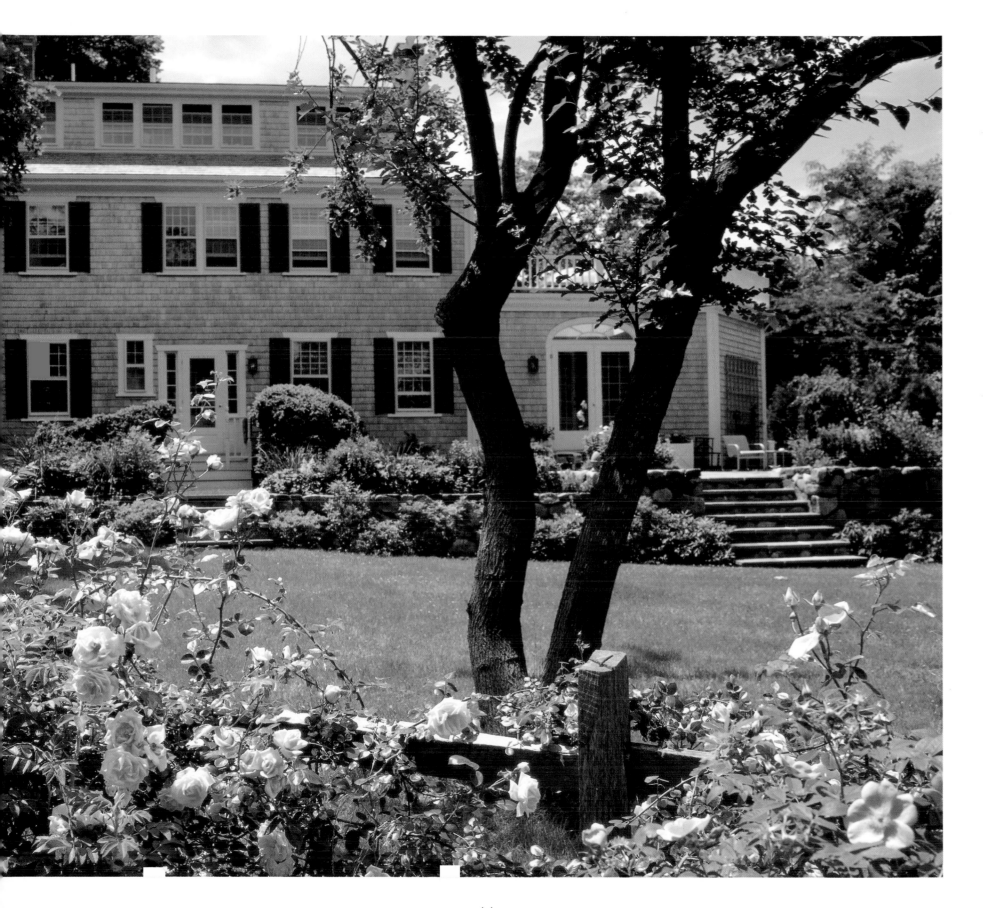

THE BACONS

Bright red trim accents the soft gray shingles on the home of Anne and Nathaniel Bacon. Nat, who is a builder by profession, built the house and later added the studio for Anne, who is a floral designer. She created the gardens and many of the design details of the house.

LEFT: *The curving path leads to the front door. A collection of shade-loving plants provides texture. Their various greens mixed with bright yellow daylilies create a cheery welcome.*

RIGHT: *The little birdhouse was designed and constructed by Anne, who cut each of the shingles by hand. A profusion of 'Jackmanii' and 'Romona' clematis climbs up its post.*

FAR RIGHT: *Anne's studio has south-facing windows for plenty of light and winter warmth. Sliding glass doors lead to a deck and garden on the right, where many shade trees outside help cool the studio in summer.*

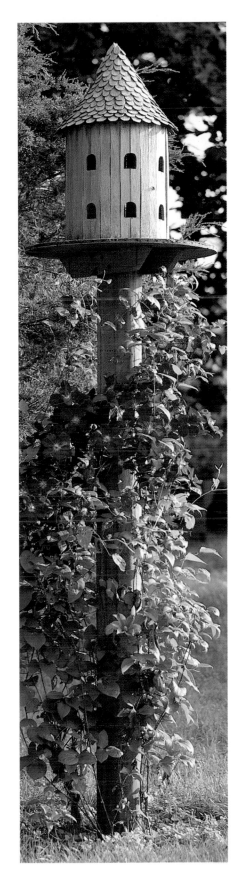

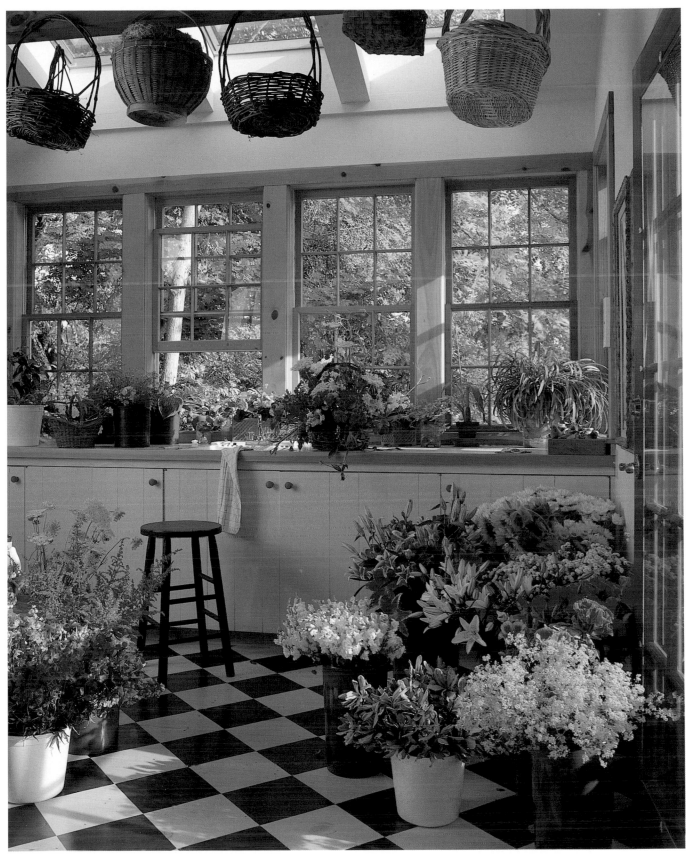

THE DR. PIERCE HOUSE

hen Dr. John Pierce built this house in 1840, it was the only one down the lane, which was later named after him. The two-story Federal house has a cupola on the top that can still be reached by a steep stairway. With windows all around, the cupola is an ideal source of ventilation in the heat of summer, and predictably it provides a view of the sea. Dr. Pierce was in charge of the U.S. Marine Hospital in Holme's Hole, now Vineyard Haven. When James and Alison Cannon bought the house in 1982, they became the fourth family to own it since 1840. It has been lovingly preserved and is filled with collections of maritime art and antiques. The lawns and gardens are extensive and overlook Sheriff's Meadow, an unspoiled wild-life refuge only steps away from the center of Edgartown. This freshwater lake with its bayside marsh was once a source of ice for early settlers and a cranberry bog. It is now protected by a foundation begun by Henry Beetle Hough.

RIGHT, TOP: *The living room holds some splendid marine paintings, such as the* Ship T. F. Oakes *by John Loos, which was probably commissioned by the captain of the ship, ca. 1850. The painting on the right, over the little table with flowers from Alison's garden, is of the yacht* America *off The Needles, painted by William H. Bishop, a contemporary British marine artist, who lives in Bristol, England. A Seth Thomas regulator clock, ca. 1875, sits on one end of the mantel.*

BELOW: *In the foreground of the living room is a clavichord in a solid rosewood case. A replica of a 1794 Scheidmeyer, it was built by Eric Herz of Cambridge, Massachusetts. James Cannon commissioned the model of the Shields class racing sloop, which he sailed for twenty-two years, from Stephen Pinney of Yarmouthport, Massachusetts. On the left is an eighteenth-century Edgartown bookcase, on top of which is a 1930's model of a Baltimore clipper, an 1812 privateer type, which was used for running the British blockade during the War of 1812. To the right of the windows is an 1820 French mirror-doored secretary with a French-made regulator clock of 1873 on top.*

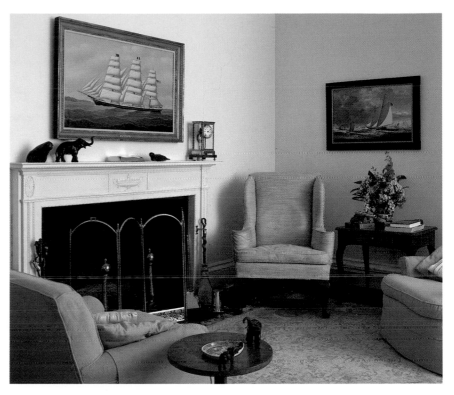

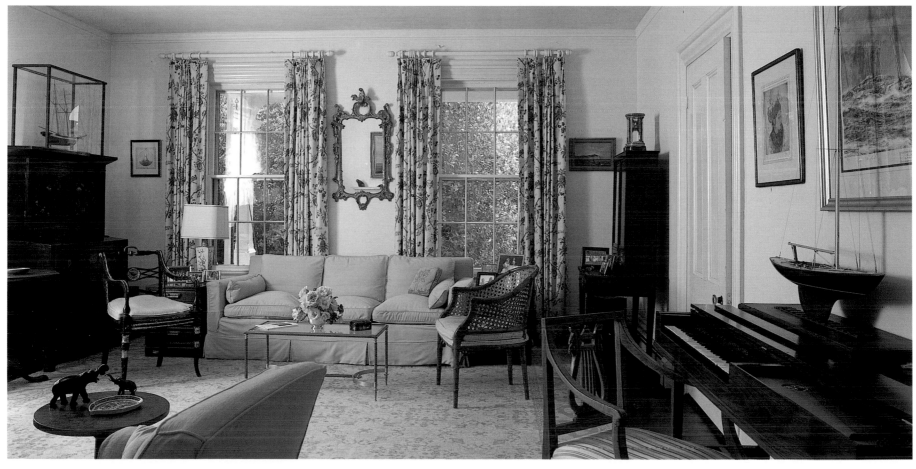

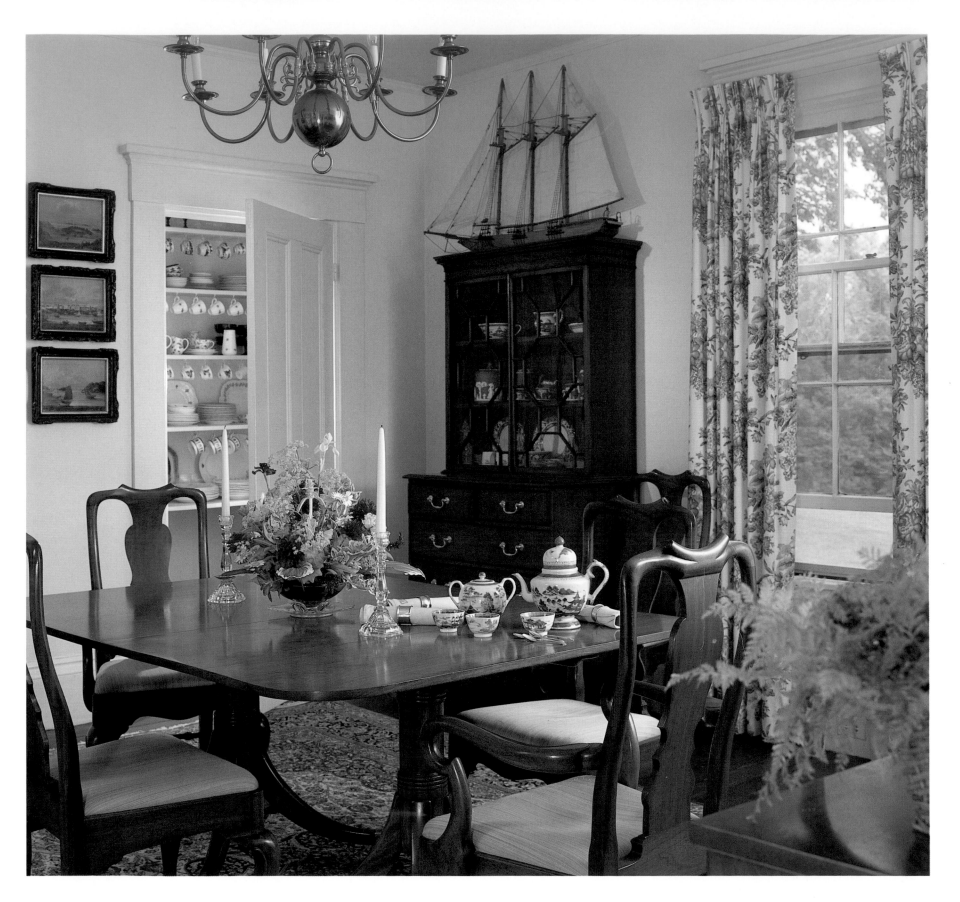

LEFT: *The nautical aura that permeates this house is continued into the elegant Georgian dining room. The eighteenth-century mahogany Sheraton-style table is encircled with antique copies of Queen Anne chairs and holds pieces of blue-and-white Canton. To the left of the china closet are three of a set of five early nineteenth-century oils of Chinese trading ports. On top of the breakfront is a magnificent model of the Sara E. Newcomb, a Maine coastal schooner typical of the mid- to late-nineteenth century.*

RIGHT: *A little English bachelor's chest, ca. 1730, graces the entrance hall just inside the front door. On the wall leading upstairs are two paintings in primitive style by contemporary American artist Charles Wysocki.*

BELOW: *The Queen Anne tall-case clock, made by Thomas Vernon of English walnut burl, ca. 1708, presides over the hall leading into the dining room and to the outside as well. The wonderful broad moldings are original to the house.*

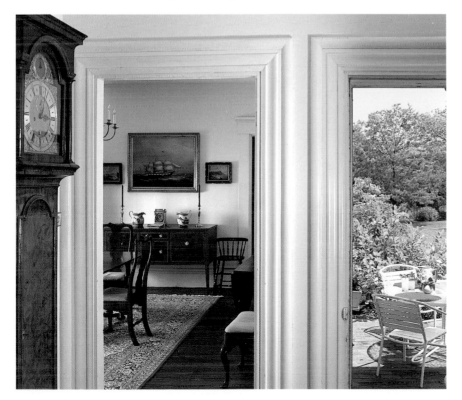

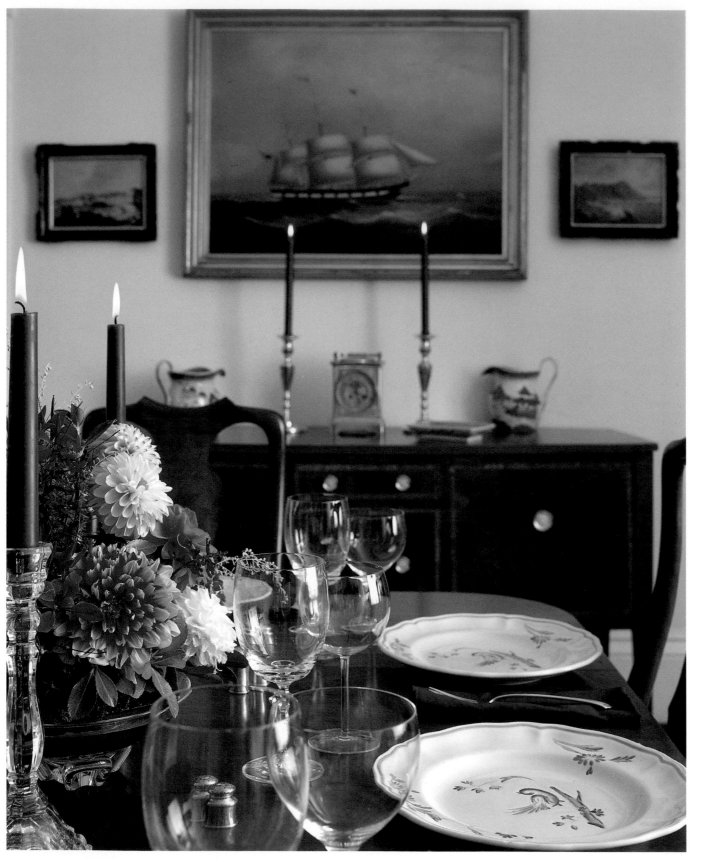

LEFT: *Above the sideboard in the dining room, an oil painting of the eighteenth-century ship* Boston *hangs between paintings of Chinese shipping ports. Blue-and-white Canton pitchers flank an 1870's French carriage clock, so-called because it has a compass on the top and strikes on both the half hour and the hour, and was made for traveling.*

RIGHT: *A harpsichord typical of the 1780's or 1790's made by Eric Herz for James Cannon, who not only plays the harpsichord but is also a designer and maker of steel harpsichords for contemporary uses of the instrument. The ship model in the case is the* America *and the carved wooden statues in the windows are nineteenth-century religious figures.*

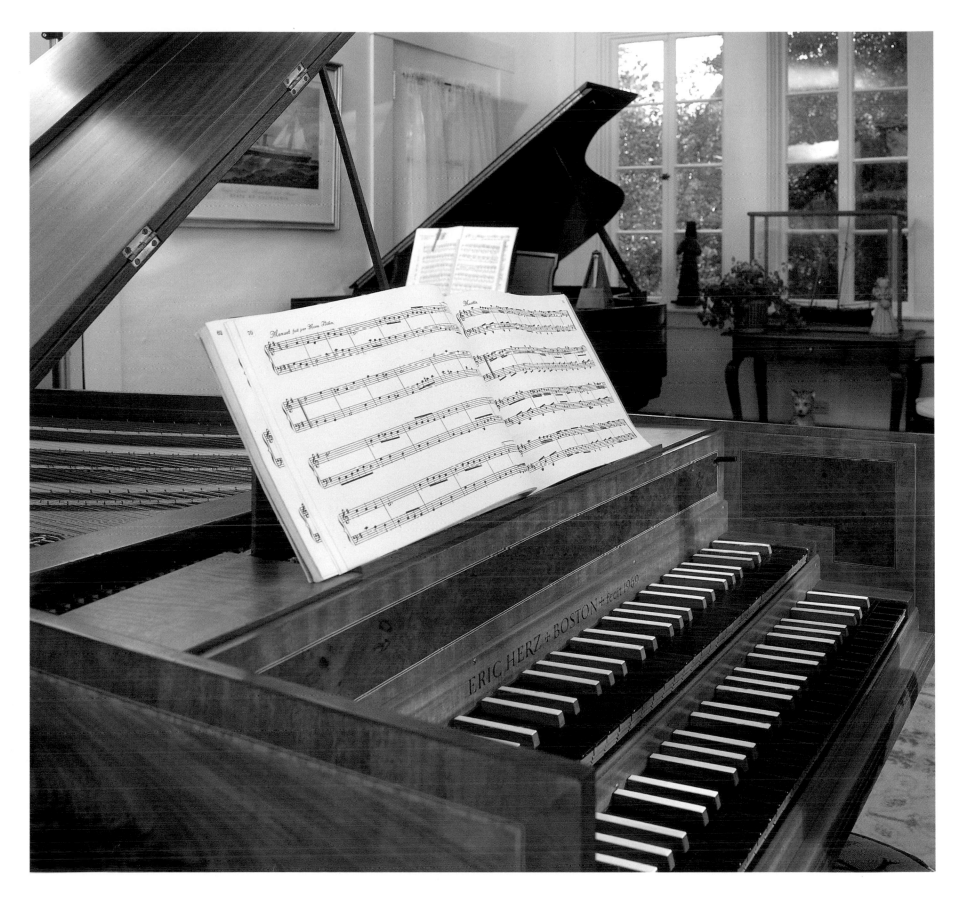

BELOW: *A brick terrace overlooks the spring gardens. A dogwood* (Cornus kousa) *outside the back door is just beginning to bloom.*

RIGHT: *Exuberant lilies in many varieties fill the July garden with luscious colors. Bishop's weed* (Aegopodium podagraria *'Variegatum'*) *surrounds the pool.*

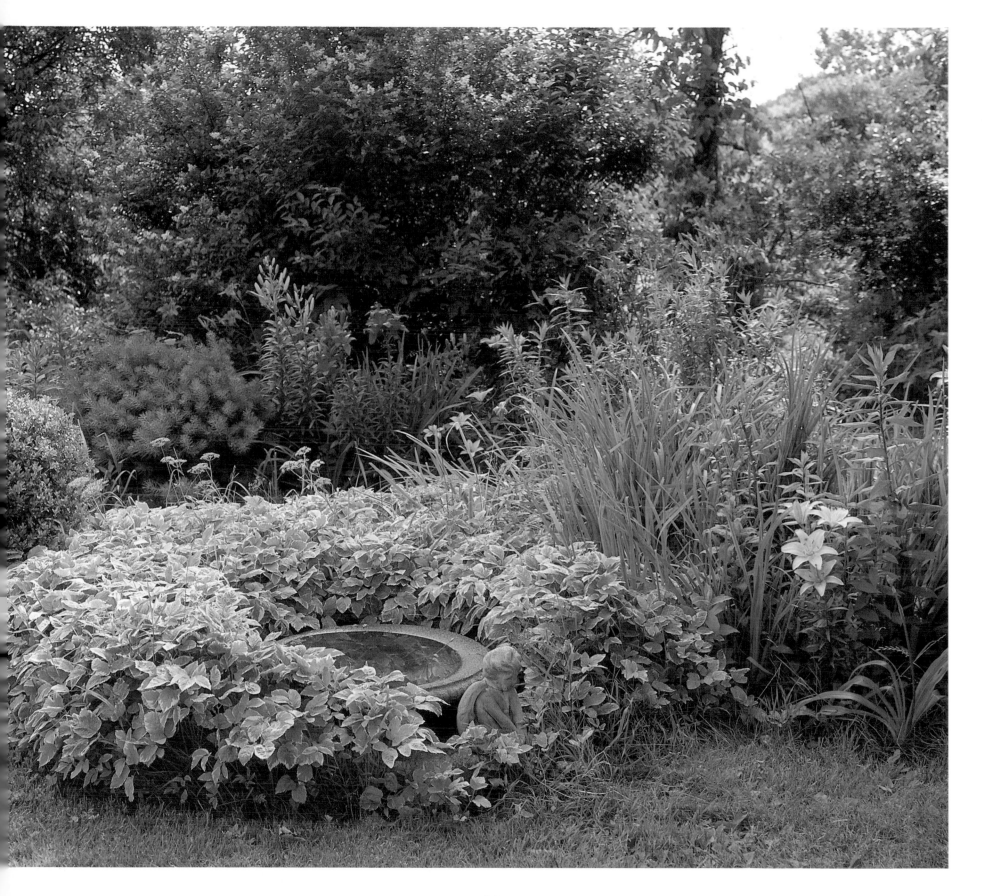

One of the first four houses on the street, this house was built in 1837 by Dennis Courtney. Called a three-quarter house, it has two windows on one side of the front door and one window on the other side. The original structure consisted of three main rooms downstairs and one large room upstairs. The kitchen was added around 1875 and the upstairs dormers around 1925. Niels and Eleanor Olsen bought the house in 1964 and took it through extensive renovation, only to have the pipes burst after it was all finished, necessitating further repairs and more renovation.

The house is filled with antiques and art that the Olsens have collected over the years. Many family pieces came from Denmark with Niels and from Kansas, where Eleanor's family were among the early settlers. The end result is this whimsical mixture of furnishings.

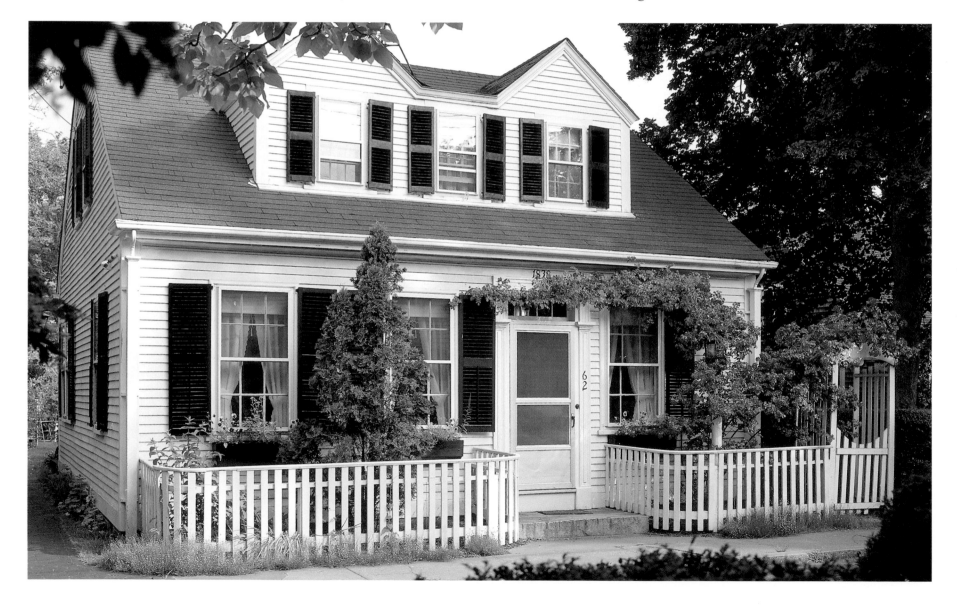

ABOVE: *The perfume of this delicate pink climbing rose, which Eleanor brought from her former home in Pelham, New York, scents the air on a clear June morning.*

RIGHT: *A red geranium is the perfect foil for the beautiful patina of the antique copper hanging lantern outside the sitting-room window.*

BELOW: *An 'American Pioneer' climbing rose envelops the bright white fence and trellis in front of the house. Eleanor estimates the rose to be somewhere between fifty and seventy-five years old.*

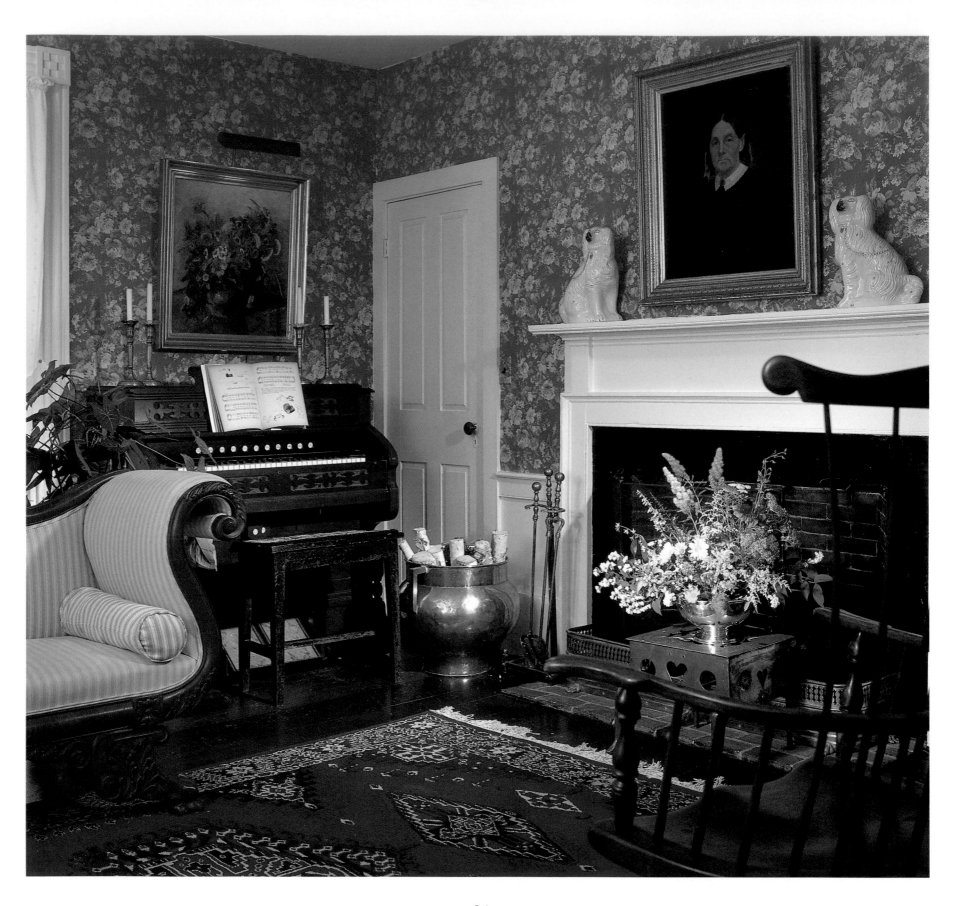

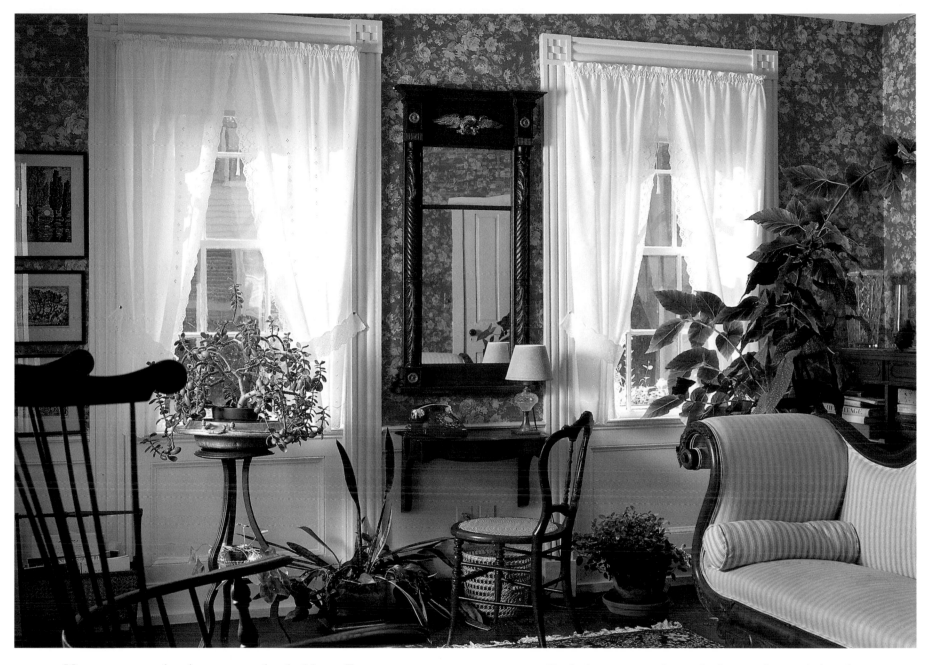

LEFT: *Victorian in style, the cozy parlor holds an Estee organ, which formerly belonged to a local doctor; he acquired it in exchange for his services. A pair of stately Staffordshire dogs graces the mantel and guards the stern-looking woman in the portrait that Eleanor purports to have rescued from a second-hand store in Pelham, New York. One of a pair, the Windsor armchair has a grip end made to hold a candle or lamp.*

ABOVE: *Sunlight streams through the windows of the cheery parlor, which Eleanor believes may originally have been used as a bedroom. A Victorian loveseat sets the tone for the room. To the left of the window is a grouping of woodcuts by Swedish artist Birger Sandzen, who emigrated to Kansas around 1900 and founded the School of Art at Bethany College. The plant stand beneath the window was made on the Island.*

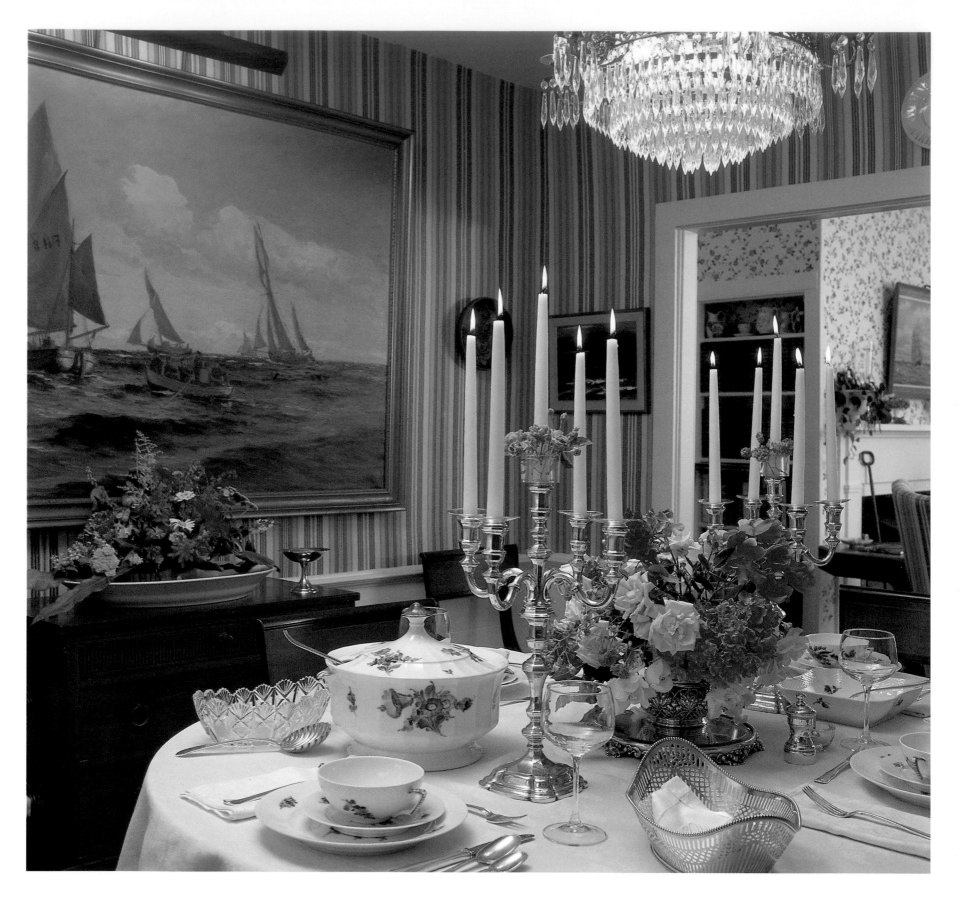

The magnificent seascape in the dining room is by Carl Locker and was painted in 1895. The stunning silver candelabra were made for Niels's uncle when he retired as president of a Danish cement company. Niels brought them here after they had been buried during World War II. The Czechoslovak-made chandelier came from Norway. The table is set with Blue Flower Royal Copenhagen porcelain and an artful arrangement of roses from the garden.

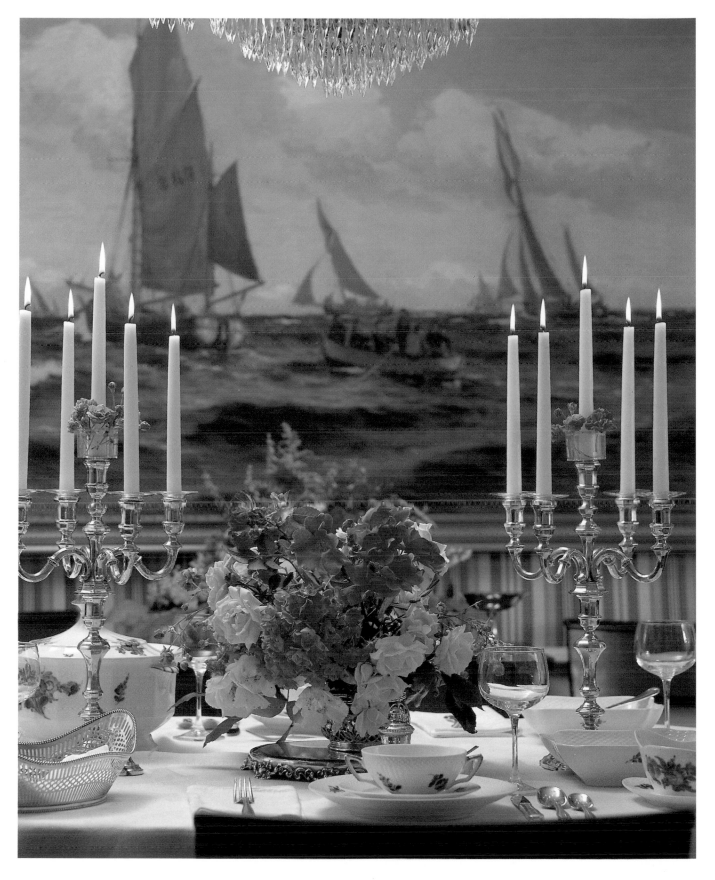

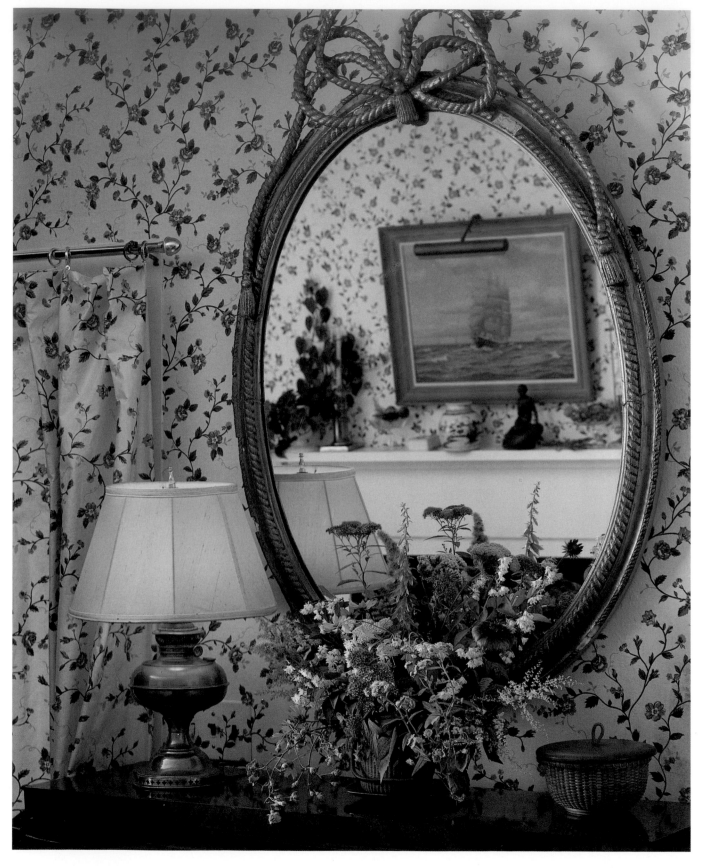

LEFT: *The striking Italian oval mirror is one of a pair that originally hung in Eleanor's New York office and was presented to her as a retirement gift. She bought the ship painting reflected in the mirror because it reminds her of the pictures of* Old Ironsides *that hung in her schoolroom in Kansas. The little brass lamp to the left of the mirror was originally an oil lamp. The Nantucket basket is by José Formosa Reyes, a well-known basket-maker of the thirties and forties.*

RIGHT: *When the Olsens bought the house in 1964, there was a wood cookstove in the fireplace. The exceptional andirons are pre-Revolutionary and come from a house on the Hudson River. On the mantelpiece, which Niels made, are the powderhorn, gun, and clock case that belonged to Eleanor's great-grandparents and traveled to Kansas with them in a covered wagon. The iron fireplace tools are handmade, and the copper funnel, washtub, charcoal pan, and other items have been collected from various places. On the wall are boat plates from a shipping company and Royal Copenhagen Christmas plates.*

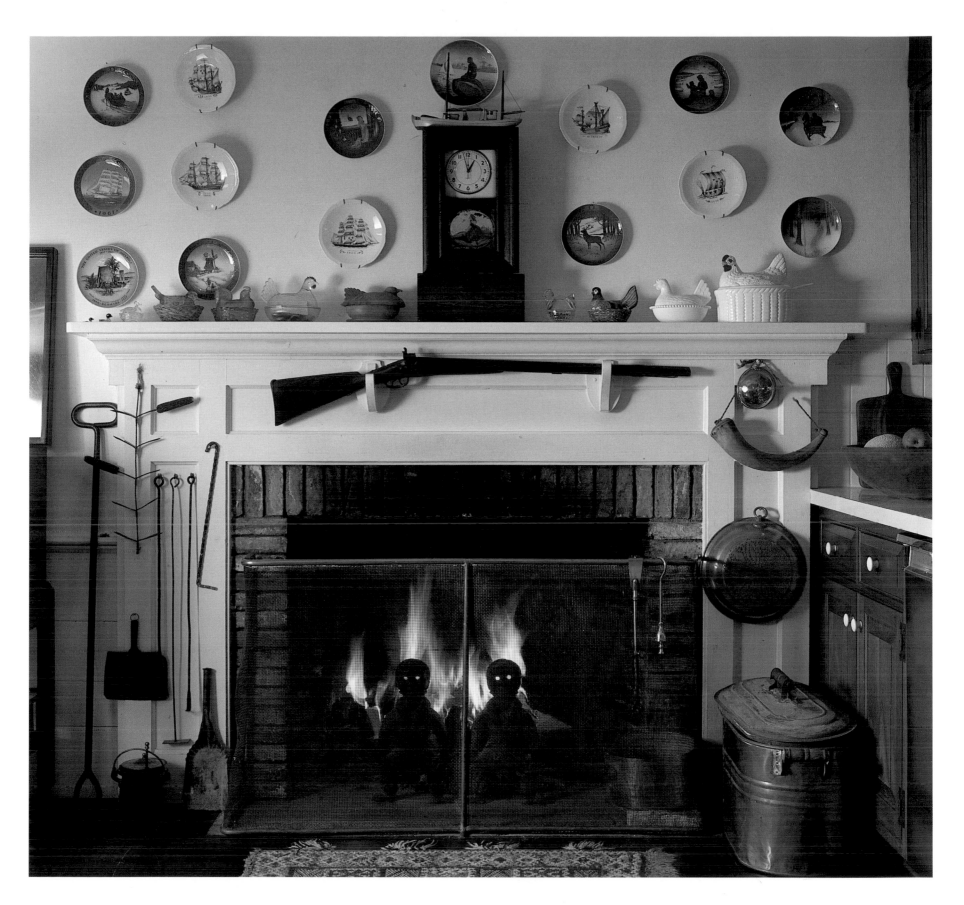

PALETTERRE

Paletterre is a complex of house, studio, and gardens in a new section of Edgartown. Tall trees form a canopy over the drive, evoking a feeling of seclusion and soft shady gardens. This is the home of Ray and Teddie Ellis, who have summered here for many years and have recently moved from Savannah, Georgia, to live on Martha's Vineyard year-round. Although new, the house and grounds nestle into their environment as though they had always been there. Called a bow house because of the shape of the roofline, the house has a shiplike feeling. The Ellises have gradually developed the gardens—including a wildflower field, perennial borders, and a rock-walled lawn—and a studio and pool have been added to the property.

ABOVE: *The old oak tree, surrounded by its rock garden of vinca (Vinca minor) and impatiens, shades the front walk and door of the house. In the entrance hall stands a Bailey, Banks and Biddle tall-case clock, ca. 1910.*

RIGHT: *In June, 'New Dawn' roses cover the trellis and roof of the garden shed.*

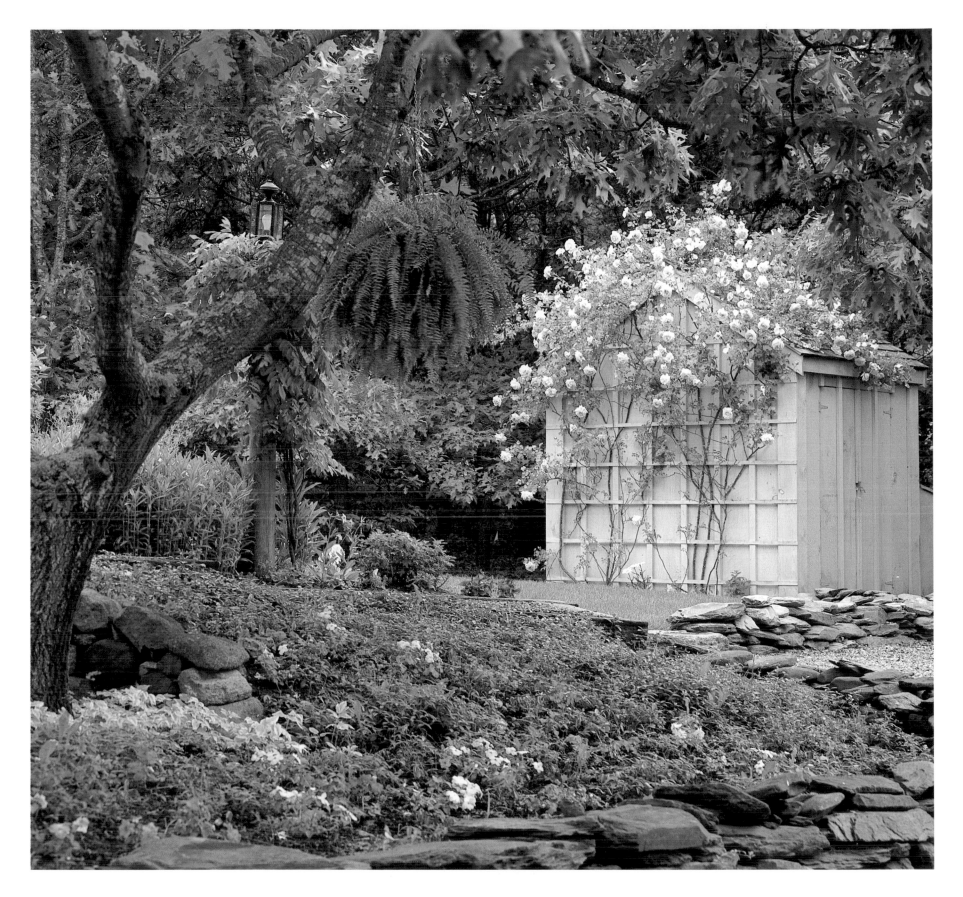

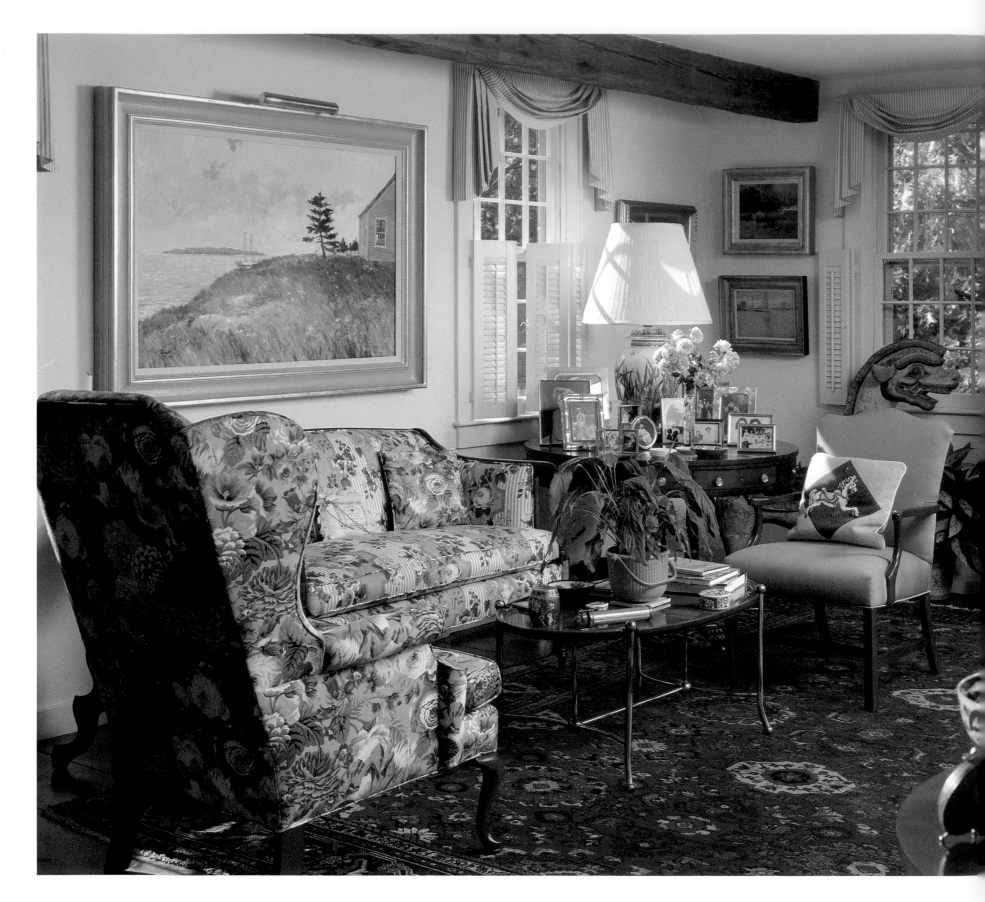

LEFT: *The living room is comfortably furnished with antiques, a Persian rug, and light, bold flower patterns on the chairs and sofa. The oil painting over the sofa is of Monhegan Island, painted by Ray Ellis for his book* North by Northeast. *In the corner between the windows are two oil paintings: The top one is* Haystacks Before the Storm *by Homer Wetson Lewis, painted in the nineteenth century; the lower one is* Sailboats *by Herzog Moore, ca. 1920. To the right of the window is an 1840 linen press.*

RIGHT TOP: *A nineteenth-century painted wooden Balinese wedding horse sits in the corner behind an early-nineteenth-century English mahogany rent table that holds a collection of family photographs.*

RIGHT BOTTOM: *Between the kitchen and master bedroom is a sunny, airy, and cozy den. Over the fireplace is a model of the yacht America, for which the America's Cup was named. Over the bedroom door is a half-model of a catboat, and a half-model of a Maine coastal schooner is mounted above the multipaned bow window. On the window shelves in the case is a model of the first Coast Guard cutter, the Harriet Lane.*

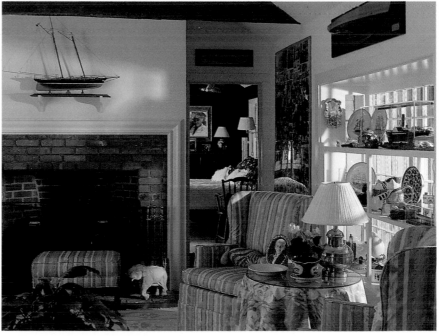

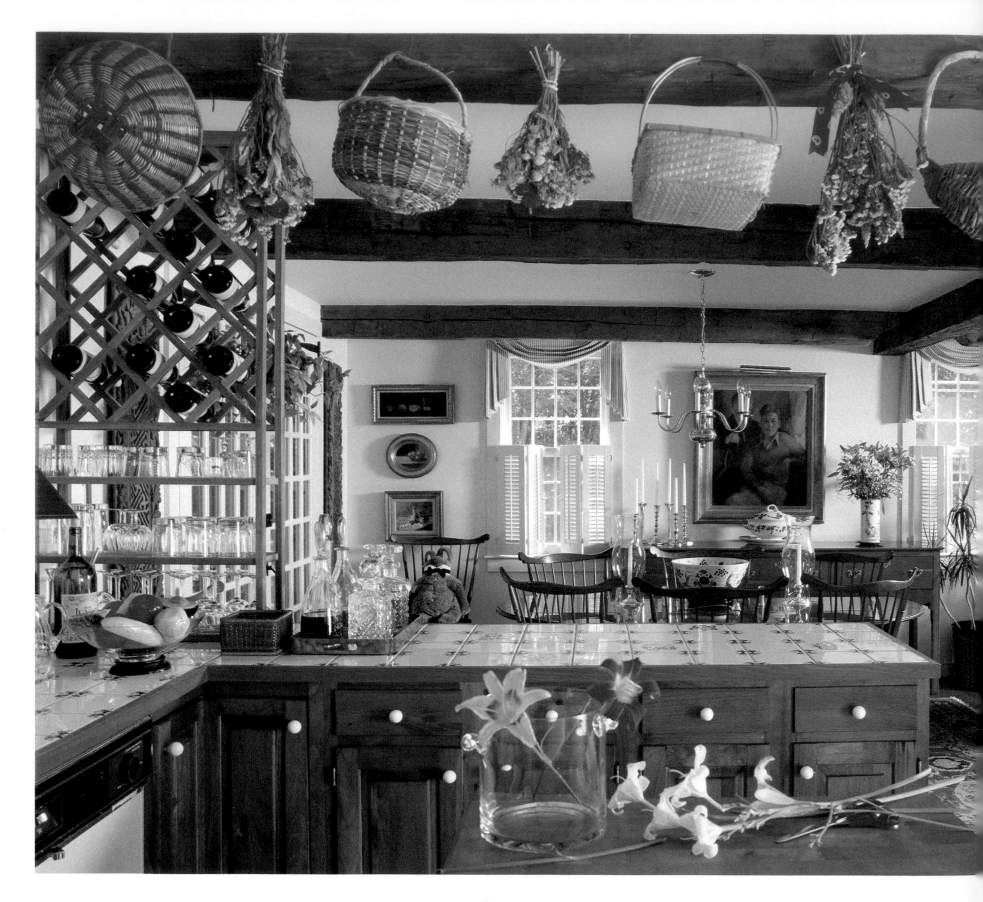

LEFT: *One-hundred-fifty-year-old beams from a Canadian farmhouse enhance the warmth of this country kitchen with its baskets, dried flowers and herbs, and the country tiles on the countertops. Teddie, who loves to cook, designed the kitchen to be open to the dining and living rooms so she can be with her guests while preparing dinner.*

RIGHT TOP: *A portrait of Ray and his brother, Richard, painted by their sister Margaret Dando in 1932, hangs over the cherry hunt board in the dining room. A grouping of brass candlesticks, an antique tureen, and an arrangement of flowers from Teddie's garden decorate the top.*

RIGHT BOTTOM: *A Palladian window in the master bedroom fills the space with light. The trompe l'oeil on the Italian armoire was done by Ray. Joe Bowler painted the portrait of Ray that hangs over the bureau. Above the four-poster bed is another painting by Margaret Dando, Ray's older sister. In the foreground is an American arrow-back Windsor chair, ca. early 1800's.*

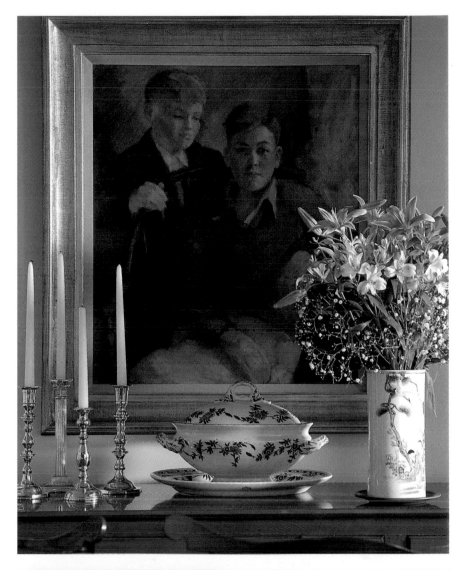

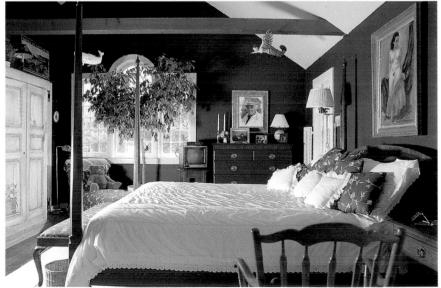

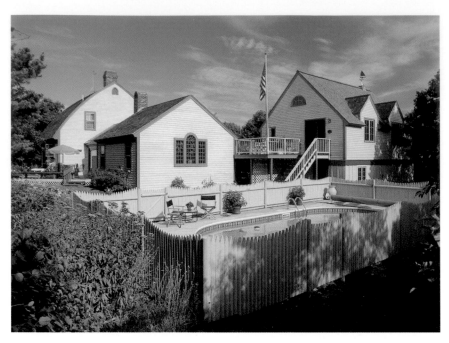

ABOVE: *The Ellis compound as seen from the rear of the property. On the left is the main part of the house with its bow roof. The bedroom, with its Palladian window, and the den wing are connected outside to the main house by a deck running along the back of the house. In the foreground on the left, next to the pool, is a wildflower garden. On the right, Ray's studio, with a garage below, is connected to the main house by a breezeway. The deck at the top of the stairs is ideal for watching sunsets.*

RIGHT: *Ray's studio, which was built in 1987, is spacious and filled with light from the wall of windows across the north-facing end of the building. Bookcases on either side of the large windows hold part of his extensive library of art books and other reference materials. The easel Ray uses for oils is a treasured gift from the late Coby Whitmore, a renowned American illustrator. Surrounding the internationally known artist himself are part of Ray's collection of ship models and other memorabilia. Above the windows on the left is an oil painting by Chauncey Ryder. In the center of the room is the artist's sculpture table and on the far right, his watercolor easel.*

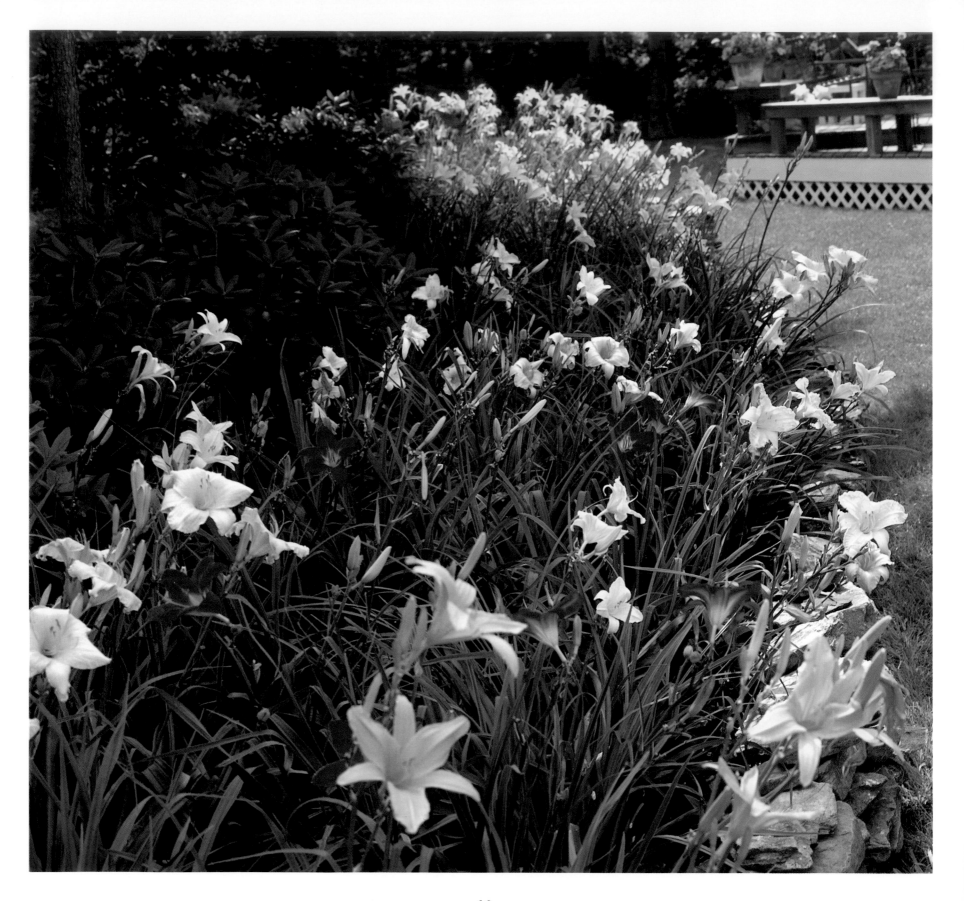

FAR LEFT: *A bed of daylilies* (Hemerocallis *hybrids*) *extends nearly the full length of the house.*

LEFT: *In midsummer, the perennial border along the side of the house is filled with black-eyed Susans* (Rudbeckia fulgida), *white* Physostegia virginiana *'Alba' in front of* Eupatorium fistulosum, *stokesia* (Stokesia laevis), *yarrow* (Achillea *hybrid*), *loosestrife* (Lythrum virgatum), *liatris* (Liatris spicata), *astilbe, and baby's breath* (Gypsophila paniculata). *They are underplanted with brightly colored bedding annuals: ageratum, begonias, pink and white alyssum, marigolds, nicotiana, and zinnias.*

BELOW: *The rear exterior view of the house shows part of the low stone wall that surrounds the back lawn. The double doors on the deck open into the dining room. The den is between the main part of the house and the bedroom wing on the right. A bit of the extensive daylily garden can be seen on the right.*

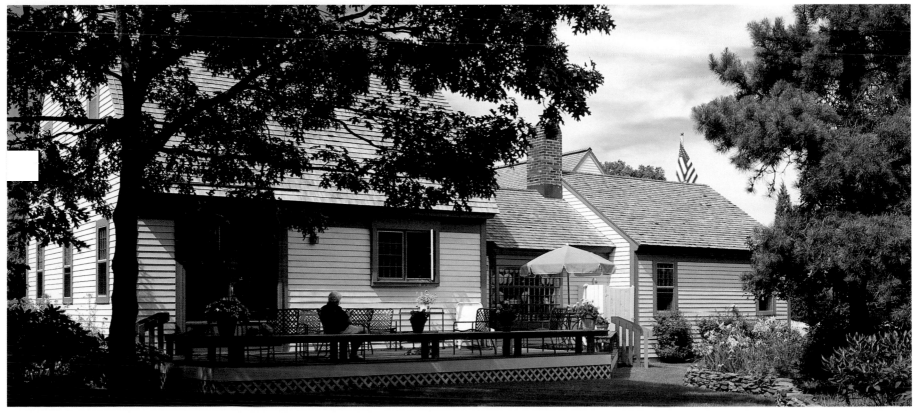

As owners of the renowned Charlotte Inn in Edgartown, Gery and Paula Conover want to provide an environment for their guests that is reminiscent of a gentler time and way of living. In their lovely quarters, an addition to the inn itself, they have created the same elegant and comfortable style. Inveterate collectors of antiques, books, and art, they have filled the rooms with English sporting and hunt paintings, gleaming brass and copper accessories, and an assortment of lovingly restored antiques and art.

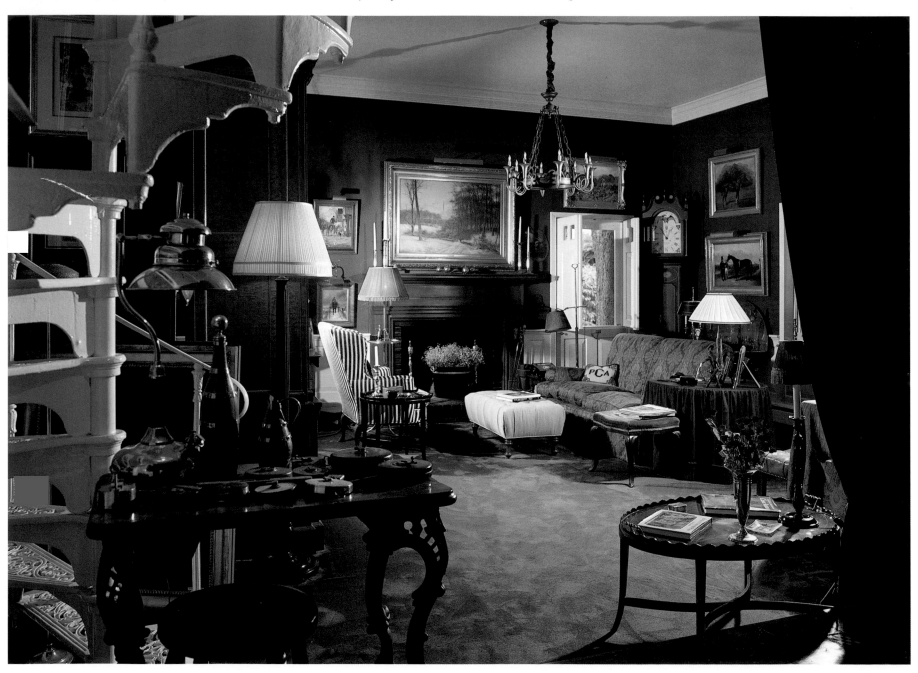

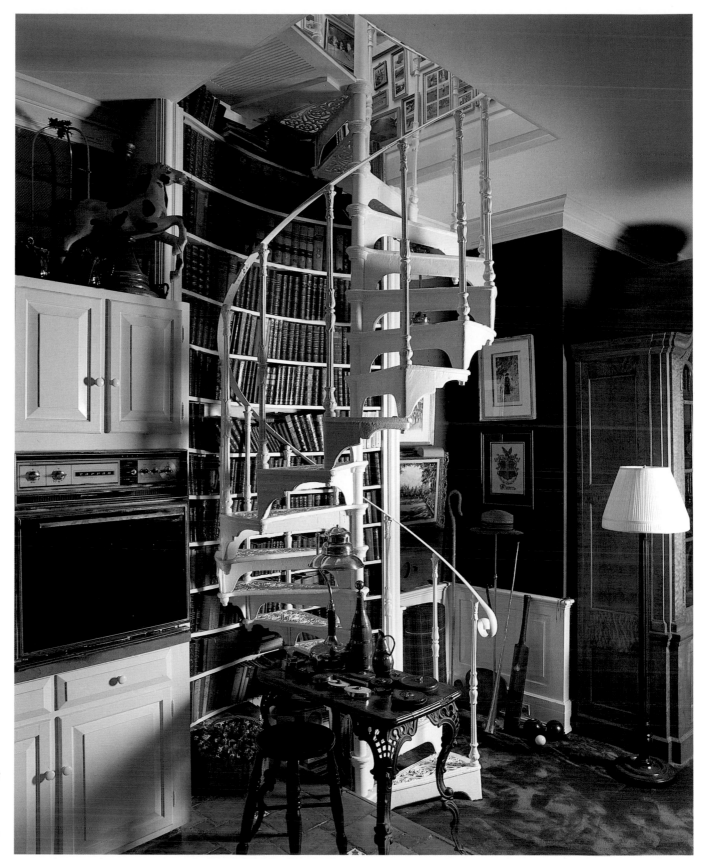

LEFT: *The mantel around the fireplace in the living room is ca. 1800 and comes from another house on Martha's Vineyard. A Dutch oil painting,* Gathering Wood *by Fredrik Rohde, hangs above the fireplace. The furnishings are primarily English antiques from the period of 1850 to 1900. On the table in the foreground is a collection of measuring tapes.*

RIGHT: *The painted iron stairway comes from England and gives access not only to the second-floor rooms but also to the library. Tucked in the corner are a brass hunting horn, canes, cricket bat, and balls.*

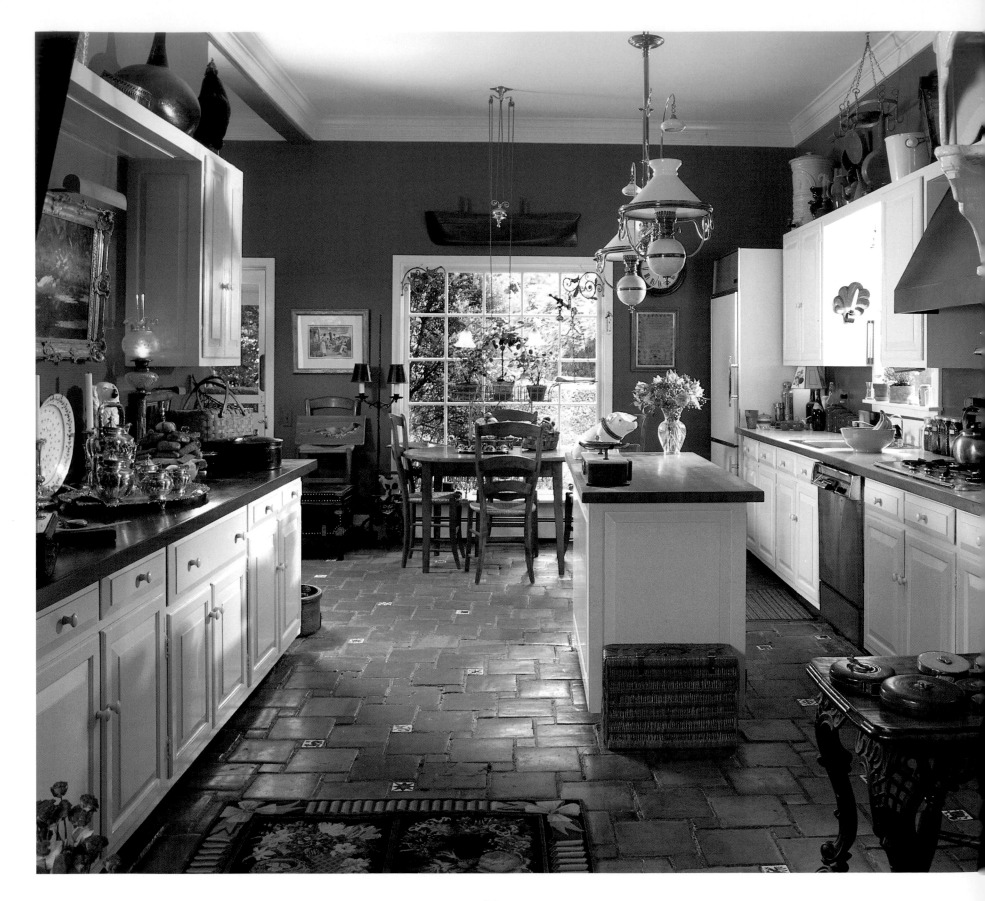

ABOVE: *Another English oil painting, this one of ducks, graces the wall behind the counter, which holds a silver tea service, a pair of Staffordshire dogs, a basket of ceramic rolls, and another converted oil lamp with an etched glass shade.*

Green Hollow, according to the so-called Pease tradition, is the location of a rumored first settlement on the Island of Martha's Vineyard. It is purported that four men landed here in a ship bound for Virginia, and instead of continuing with the ship when it resumed its voyage, they spent the winter in cave dwellings in a place known as Green Hollow. There is evidence that underground dwellings of rooms with walls of stone were uncovered when land was cleared for a farm on the site. Three hollows or indentations still remain today, though the stones discovered there in 1853 were used for other houses. Part of Edgartown, Green Hollow overlooks Katama Bay and Chappaquiddick on the other side. On the shore sits a marvelous old shingled beach house, designed and built in 1924 as a summer home for Tom T. Waller by architect Albert Chapman Fernald, who also designed the Edgartown Yacht Club and Henry Beetle Hough's house on Pierce's Lane. The house is now owned by Waller's grandson and his wife, Jack and Joan Wuerth. There was once a stone wall and garden between the house and the beach, but all was washed away when the 1938 hurricane reclaimed low-lying ground.

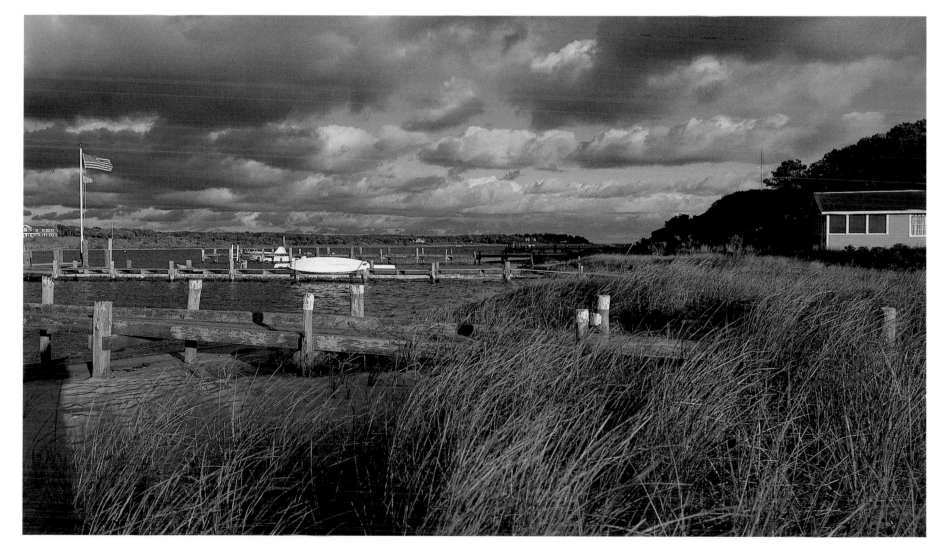

In comfortable beach-house tradition, the dining room and living room are really one big room with a fireplace at one end. The plain wood walls have been painted with a blue-gray wash, which keeps them from darkening further but maintains their original look and feeling. The furniture in the dining room is mission oak, signed by Stickley. With all its leaves installed, the dining-room table seats twelve comfortably. On the far side of the long room, windowseats hold storage space for firewood. Between the windows, a fold-down desk, made to look like a cupboard when closed, holds old-fashioned games and puzzles and other rainy-day entertainments. The first signal of summer is the family's little bright red Lawley 15, a rare flat-bottomed sailboat that was built in Marblehead and purchased in 1939 from Sherman Hoyt, an America's Cup sailor. Above the pull-down desk is a model of a two-masted schooner—actually a weather vane.

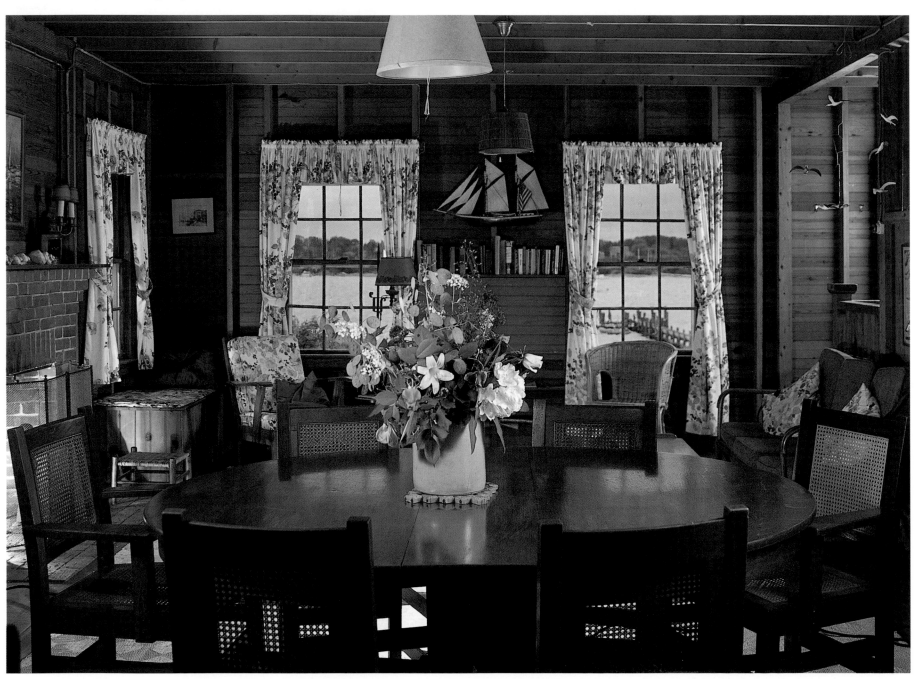

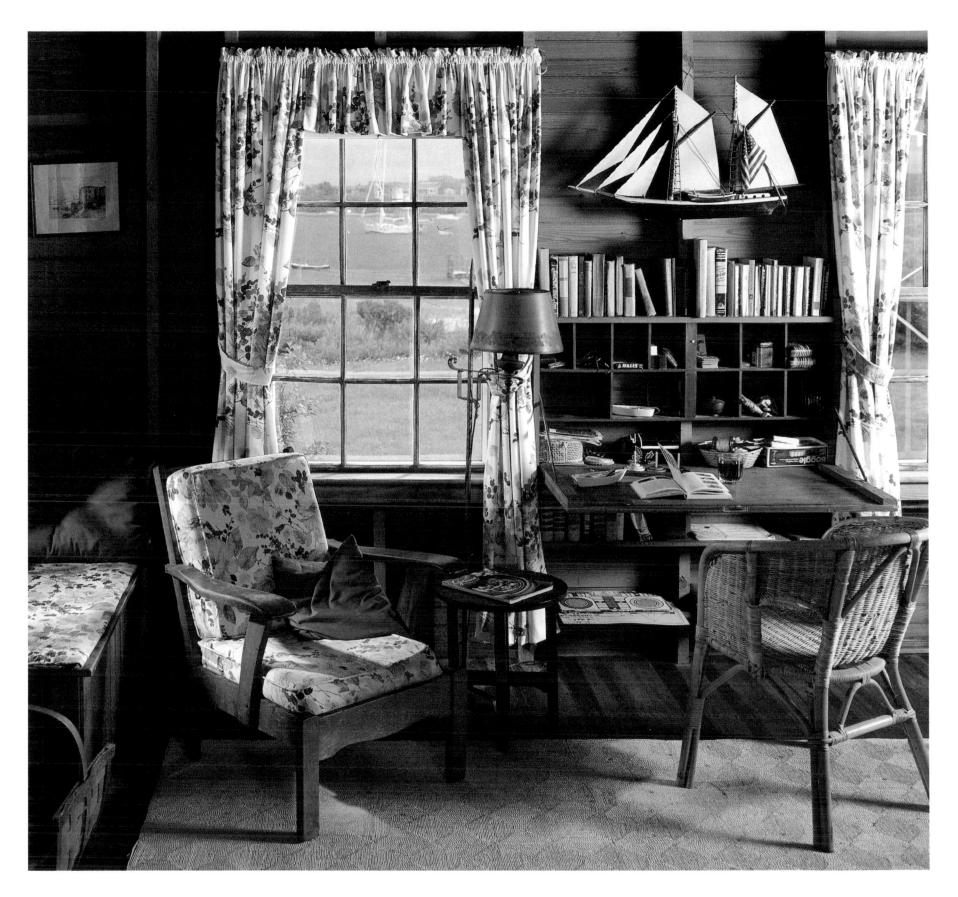

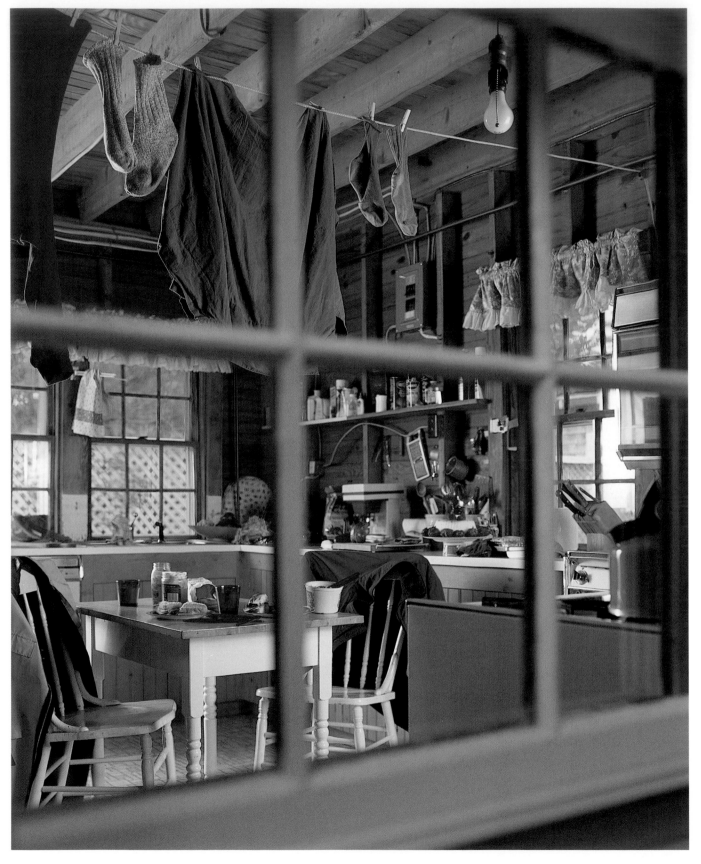

The kitchen is all original except for the counter rebuilt a few years ago to accommodate the dishwasher. Outside the window over the sink is the criss-cross fence that surrounds the outdoor drying yard. On cold or rainy days, the kitchen can be closed off and kept toasty warm with its two stoves, one gas and the other electric. The knotholes in the ceiling have provided great joy to many generations of children, who can drop things down into the kitchen from an attic playroom under the eaves.

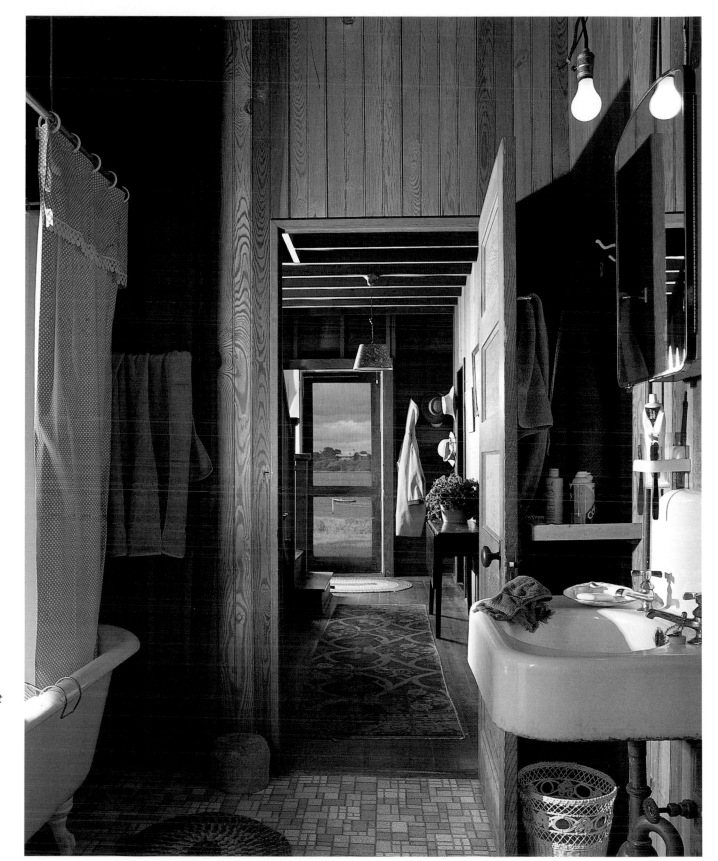

The most convenient entrance to the house is from the back porch through the bathroom. The claw-foot tub dates from 1924, when the house was first built. Since the shower was a later addition, it has been dubbed "the afterthought shower." On the other side of the bathroom, the hall leads to the front door, with Katama Bay and Chappaquiddick beyond.

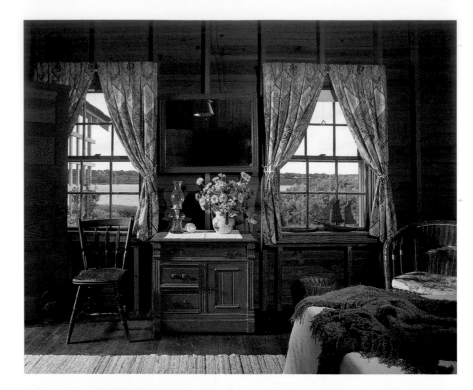

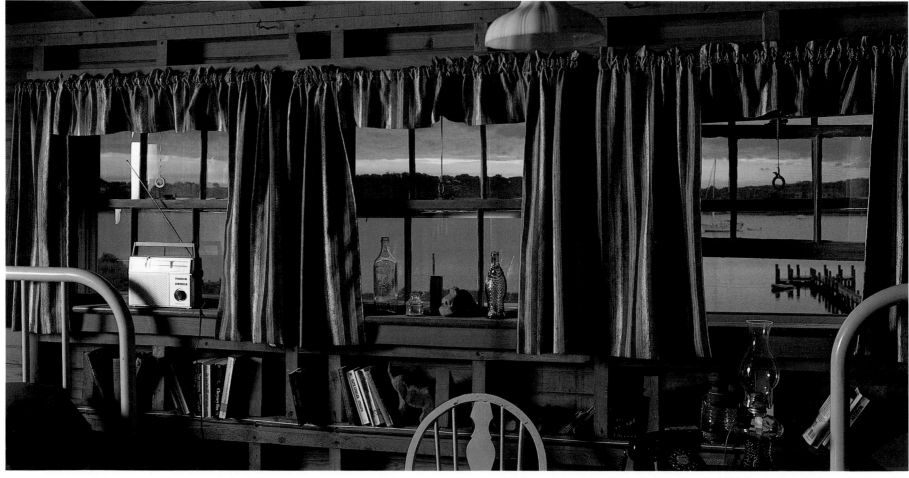

FAR LEFT: *Called the yellow bedroom, even though it is no longer that color, this sunny south room was once a maid's room and, later, Jack's mother's.*

LEFT: *The first-floor bedroom is now the master bedroom and has a wonderful view of the water. Its furnishings have all been in the house since it was built.*

BELOW LEFT AND BELOW: *The east bedroom with its three dormer windows overlooks all the activity of Katama Bay. The red, white, and blue pennants, all named and dated, are sailing prizes of Jack and his brother, Tom. The flag with an anchor is called an Ensign and is traditionally flown from the stern of a sailboat. The origin of the 48-star American flag is not known. The large Japanese flag was picked up by Tom Wuerth from a Japanese submarine beached at Nagasaki after the Armistice in 1945; Tom was task unit commander on a Navy minesweeper that was sent in right after the atomic bomb had been dropped.*

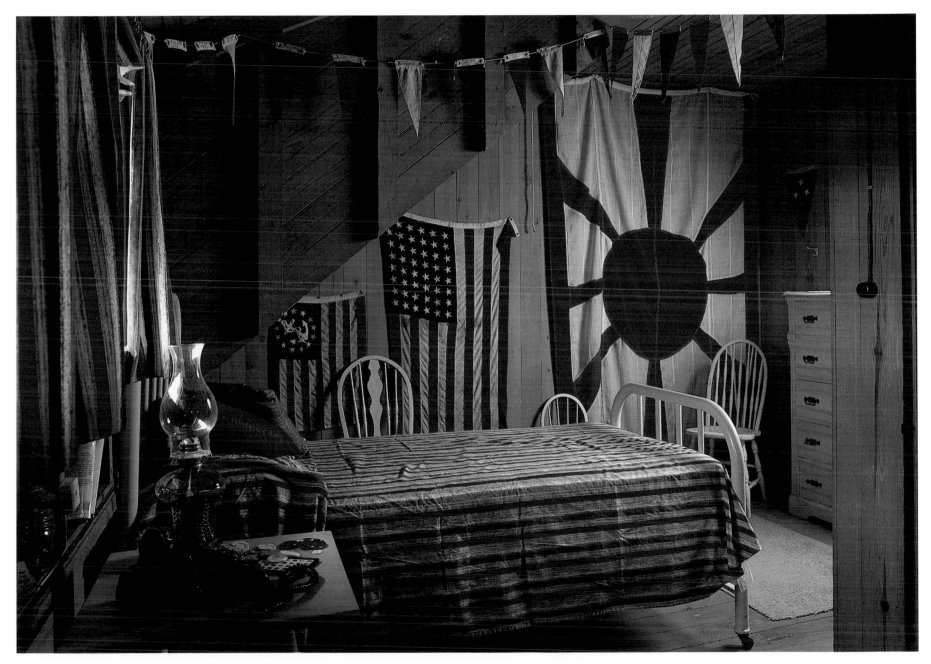

In the heart of the Oak Bluffs Campground, across from Trinity Park, is this lovely little Victorian cottage. The Campground had its beginning in 1835 with the first Methodist camp meeting. Originally it was a true campground with tents, but as the Campground became a permanent fixture, small wooden shelters were built. The cottages themselves began to be built in the 1860's. Oak Bluffs, once known as Cottage City, is one of the first important examples of town planning in the United States. The houses in the Campground are laid out in circular patterns around open park areas. One of these cottages, called Blenheim Minor, belongs to Lucy (Bideau) Hart Abbot, whose great-great-grandfather, Frederick Upham, was the Methodist minister from Edgartown who preached the first camp meeting in Oak Bluffs. After Bideau Abbot bought this cottage and moved in, she discovered that her great-grandfather, also a Methodist preacher, had owned the house next door.

Some three hundred of these Victorian cottages remain out of approximately five hundred that were built. Each one is distinct in its style of Carpenter's Gothic and in its subsequent restorations and renovations. Situated on a corner lot, this cottage was built in 1872 by Joseph Pease, who had had a tent on this location from 1867 to 1872. After Bideau Abbot bought the house in 1986, she made extensive renovations, including winterizing and rewiring. She also enlarged the dining room and music room, and added the solarium, for more light and space. The cottage is furnished with family pieces and memorabilia from Bideau's trips to England.

BELOW: *Blenheim Minor is located on the corner of a row of Victorian cottages, all of which are brightly painted in a variety of colors. Rhododendrons and azaleas decorate the minuscule front yard.*

RIGHT: *The open front door invites visitors into the front parlor, the music room, dining room, and finally the kitchen beyond.*

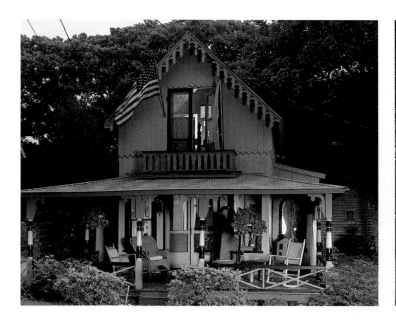

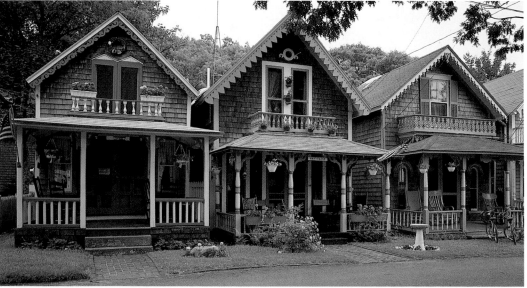

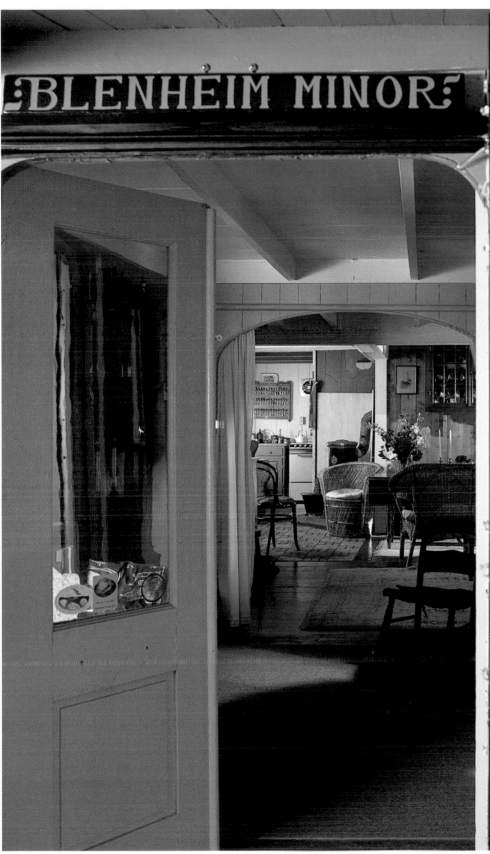

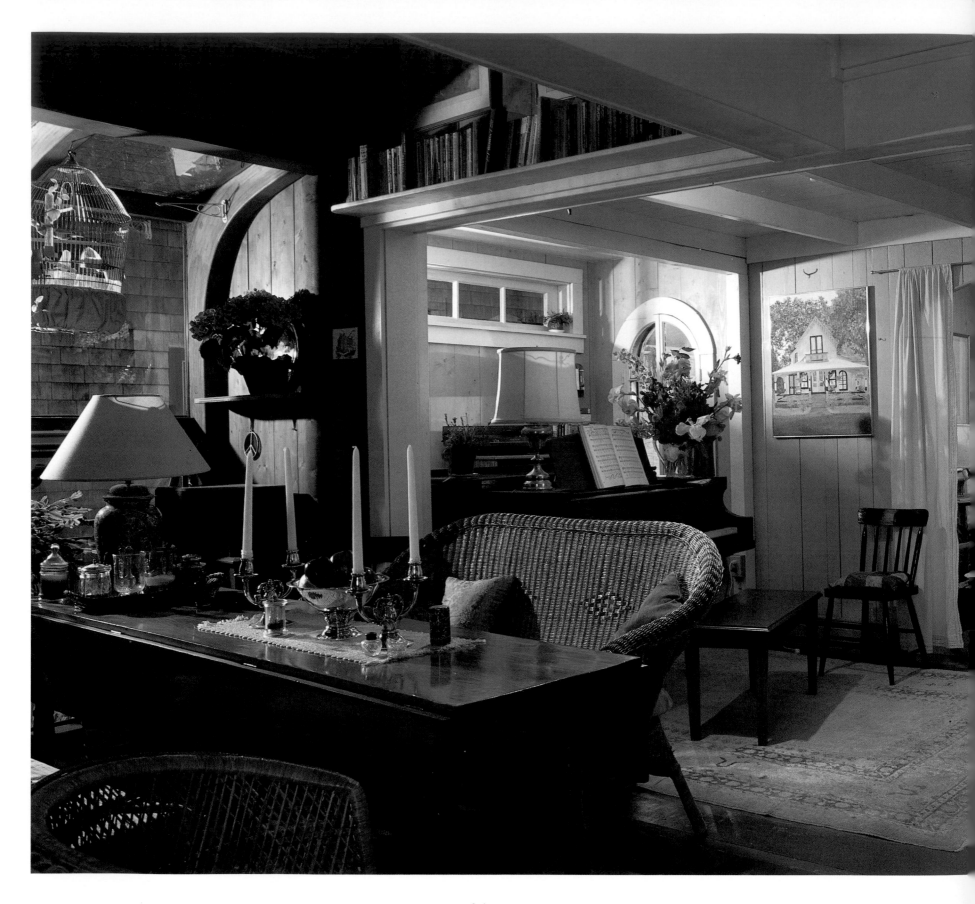

The dining room and music room are much roomier than they appear from the outside, with space for a grand piano on the left beneath the windows that are part of the extension of this room. The painting next to the piano is of this Campground house and was painted by Bideau's grandson Sixten Abbot. Every bit of space is put to good use, such as the shelf above the dining room that holds some of the owner's many books.

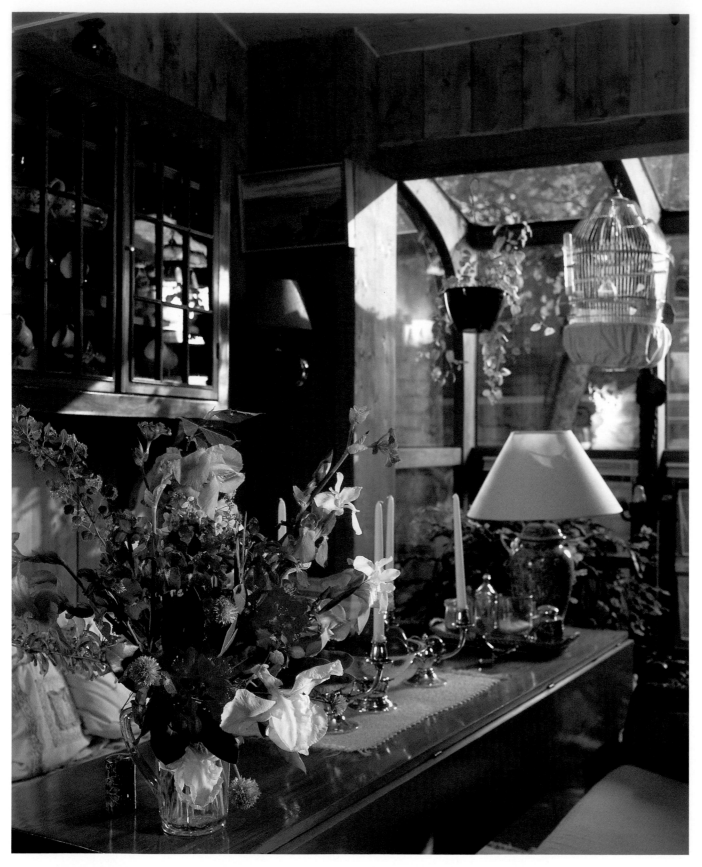

LEFT: *The extra long dining-room table has been in the family for years. Until it was recently refinished, you could see the impressions of Bideau's children's homework in the soft pine finish of the top. The table was originally used for laying out bodies in an undertaker's parlor, or so she was told.*

The pair of finches enjoy the solarium, which was added after Bideau moved in. The cabinet on the wall on the left holds many pieces of family china, which belonged to her grandmother.

RIGHT: *Upstairs under the gabled roof is the cozy front bedroom. A collection of pictures found on trips to Europe, mostly in England, decorates the wall behind the bed.*

LEFT: *A grouping of family photographs lines the hall. At the end of the hallway is the front bedroom with its door that opens out onto the upstairs balcony overlooking Trinity Park and the tabernacle.*

RIGHT: *The upstairs has a series of bedrooms opening from one into the other. The bedroom at the back, with its walls of books, lines up under its gabled roof with the middle bedroom, which opens into the hall. The many angles and twists of the upper floor's rooflines give each of the cozy little bedrooms at least one large window, allowing in plenty of light and air.*

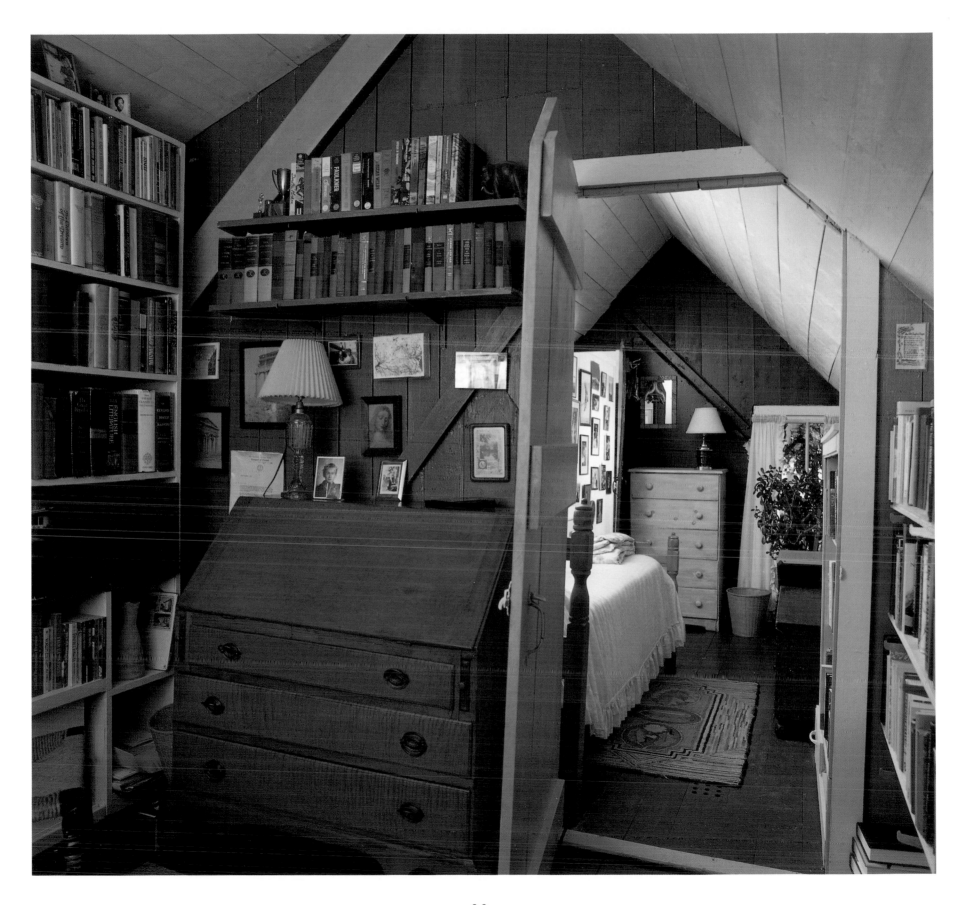

This Victorian house, built in 1871, is right on Ocean Park and has a magnificent view of Nantucket Sound beyond the park. In summer its front porches are ideal spots from which to watch band concerts, kite-flying contests, and the fireworks. This section of Oak Bluffs started in the early 1870's as a community of summer homes and hotels. Much younger than Vineyard Haven and Edgartown, Oak Bluffs began as a religious retreat community. As the Campground grew and became more permanent and as people stayed for longer periods than just the camp meetings, shops sprang up along Circuit Avenue. Then hotels and large Victorian summer houses were built overlooking Nantucket Sound and the harbor. Soon the area became a fashionable seaside resort.

Fleming and Henrietta Norris bought their house in 1969 and were summer residents until 1986, when they became year-round residents. When the Norrises first saw the house, it had their main requirements of a view, garden, fireplace, and year-round porches. Even though the interior was painted in dark colors, it was love at first sight, and after only a few minutes of looking, they bought the house.

RIGHT: *The downstairs porch wraps around the whole front of the house. It faces east and therefore is shady in the afternoon and captures the breezes from the Sound. The windows seen at the top of the porch open from the bottom up and are raised by cords and pulleys secured on latches at the porch supports.*

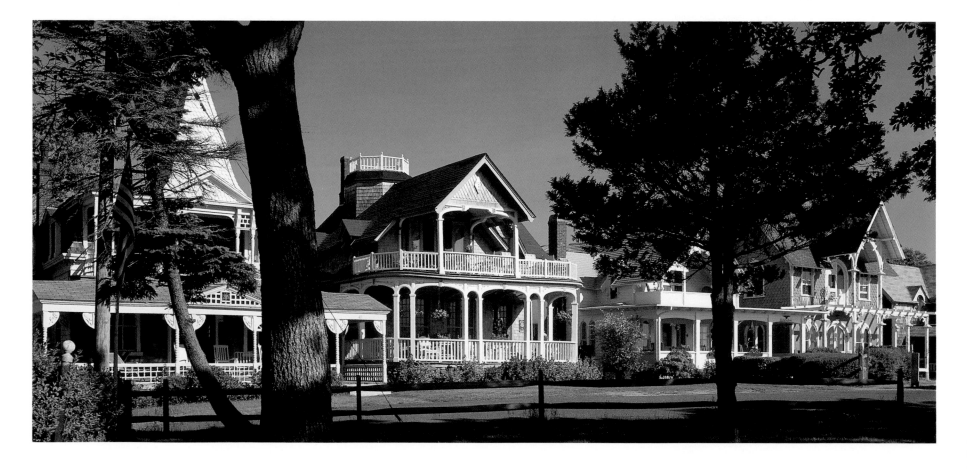

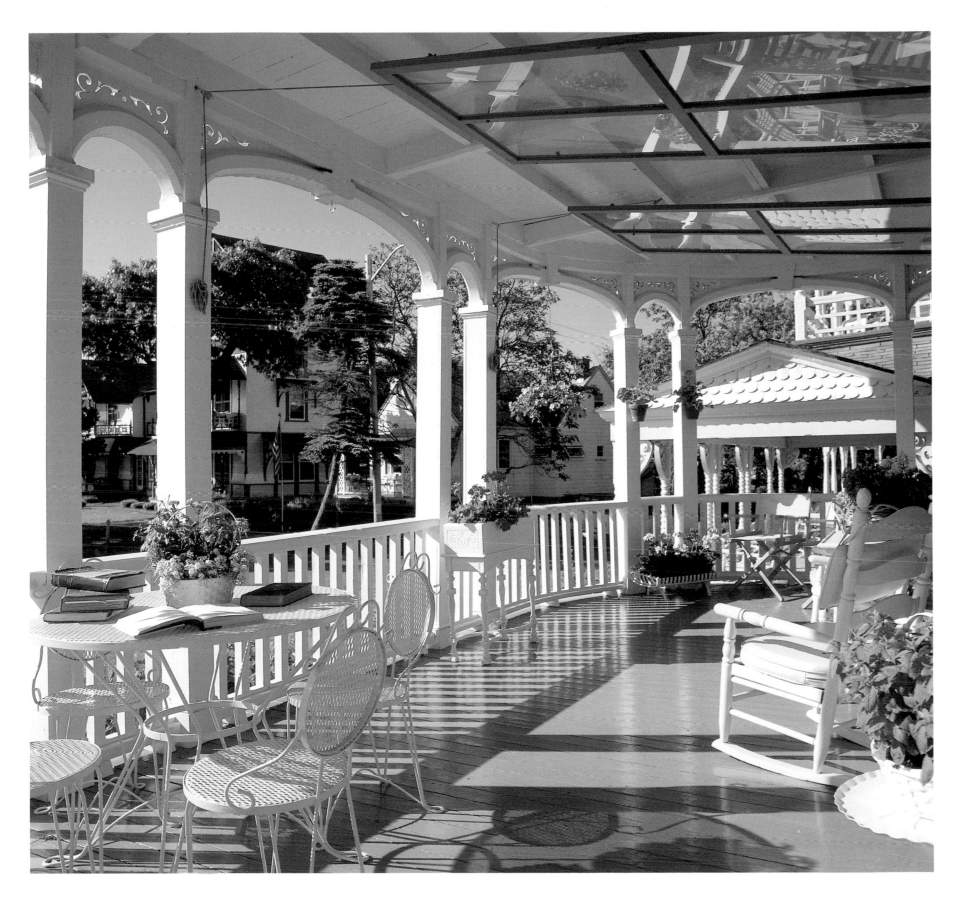

LEFT: *The dining-room table holds Henrietta's mother's china and a silver service that was a wedding present from Fleming's mother that had belonged to her mother. The china cabinet in the background holds more family heirlooms. The crystal chandelier at the top of the picture was bought for the house.*

TOP RIGHT: *In the corner of the living room is a glorious arrangement of lilies, complementing the bright colors of the fabrics used throughout the house. On the wall behind the flowers is a watercolor of the house that was found there when the Norrises moved in.*

RIGHT: *The tiny breakfast nook in the kitchen is especially cheerful when it is flooded with morning light. This is one of the features that sold the owner on the house when she first saw it.*

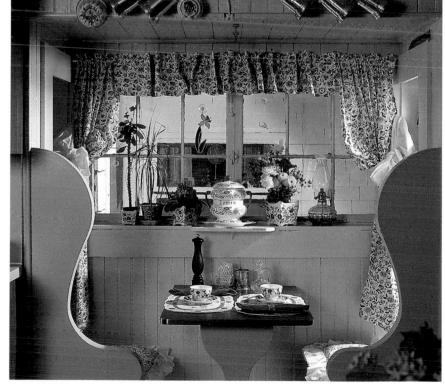

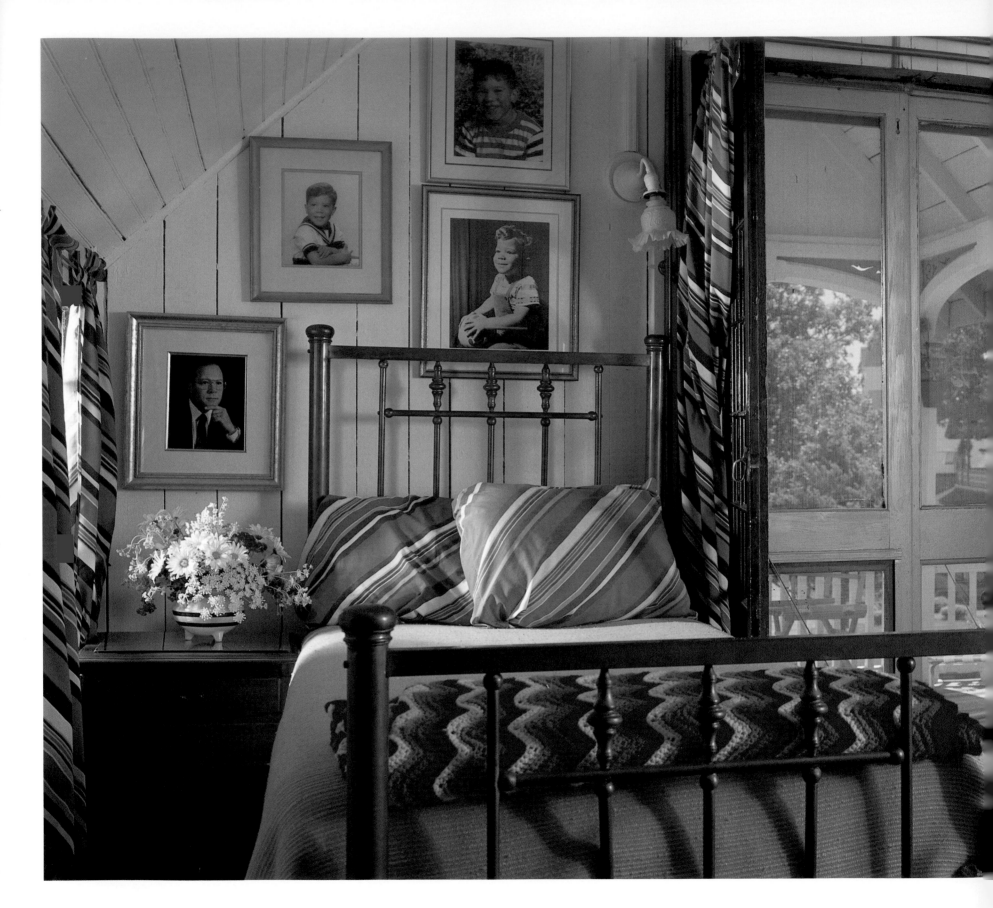

LEFT: *The upstairs guest bedroom with its sunny fabrics and white walls has photos of the couple's son and his family. This inviting room opens out onto the shady upstairs porch, which stretches across the whole front of the second floor.*

BELOW: *The upstairs bedroom and dressing room have been redone into a luxurious masterpiece of color, complete with Jacuzzi, TV, and an intercom.*

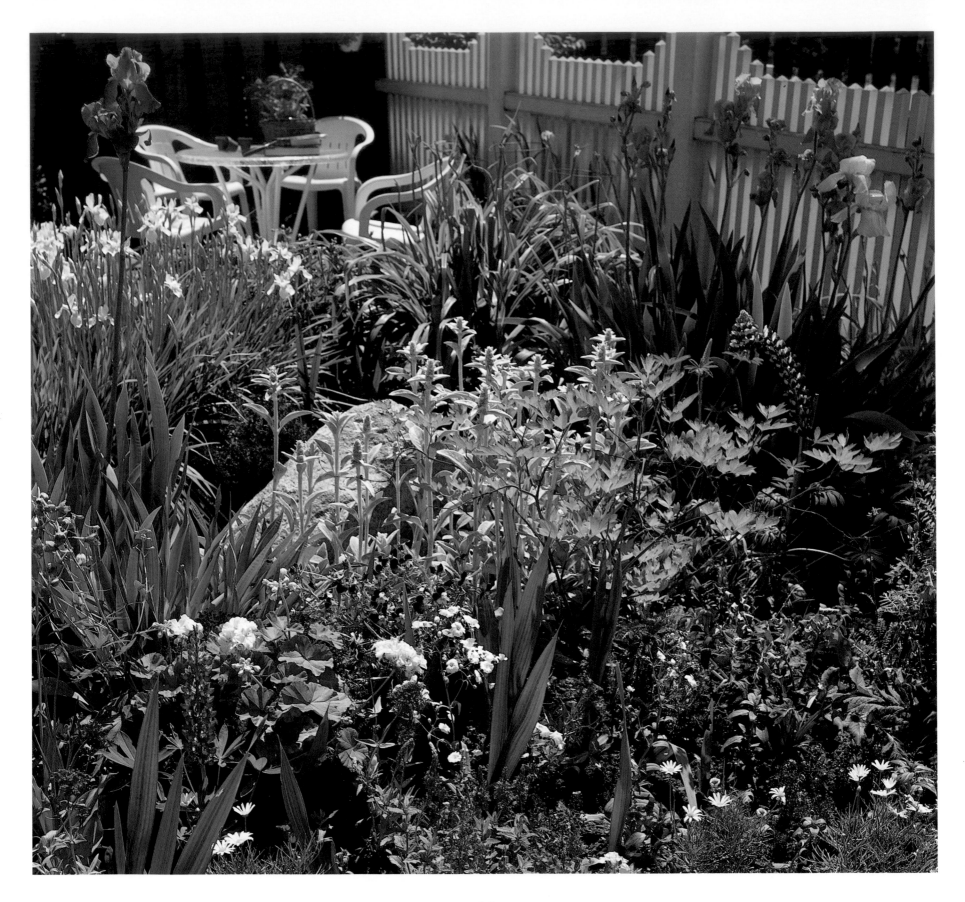

LEFT: *The pocket garden at the back of the house is filled with early summer blooms of bearded and Siberian iris, peonies, delphiniums, columbines* (Aquilegia *hybrids*), *lamb's ears* (Stachys byzantina), Veronica latifolia *'Crater Lake Blue', and* Centranthus ruber, *and all kinds of other perennials not quite ready to flower. This is a truly wonderful garden with something in bloom all season long. Henrietta loves flowers and planned this garden for successive seasonal blooms and color—everything but reds.*

ABOVE RIGHT: *In 1987 the Norrises expanded the house, adding a new room and enlarging the downstairs into office and storage spaces. Careful attention was paid to the pre-existing Victorian details of the original house. The fanlight under the gable peak of the new addition repeats the design of the one above the roof of the back porch. Yellow flag iris* (Iris pseudacorus) *bloom in front of the picket fence that frames the back entrance to the garden and the house.*

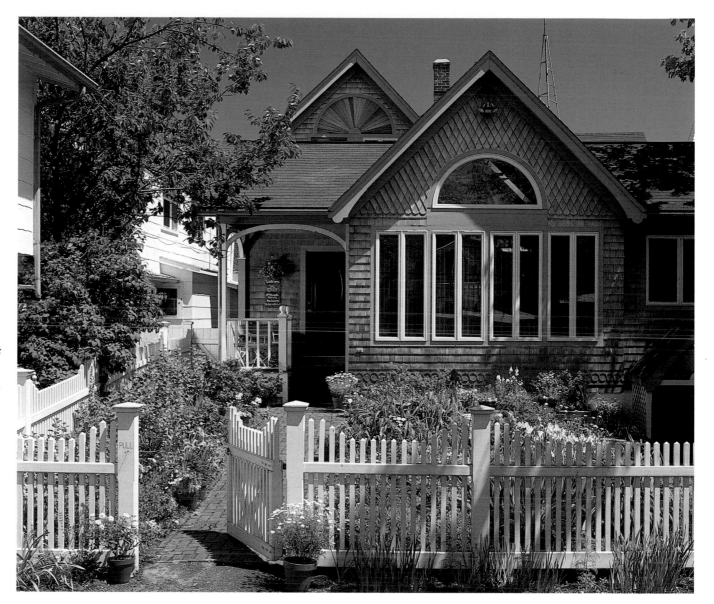

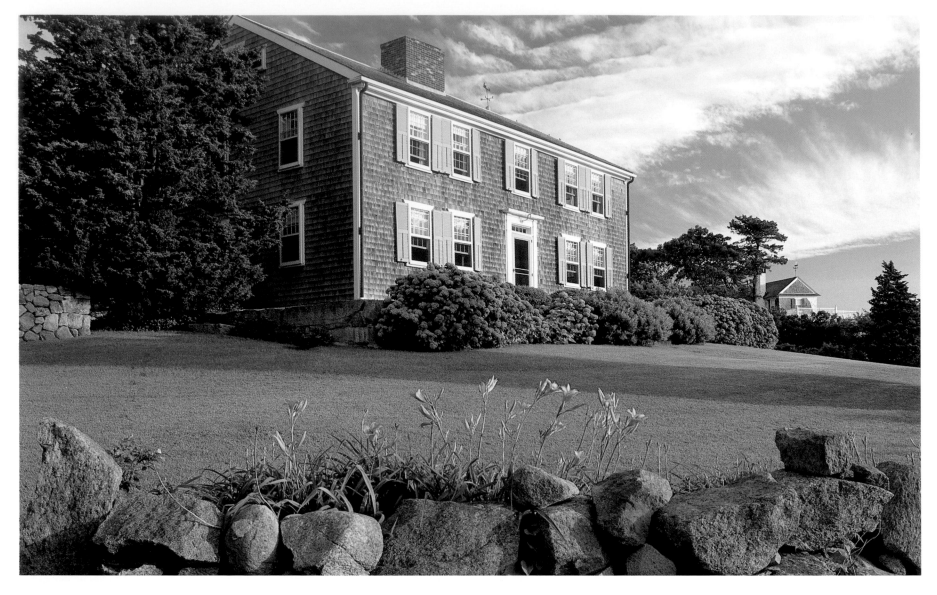

TIDE BELLS

On a rise above Nantucket Sound is this beautiful old Georgian house. Built in 1752, it was moved from Tea Lane in Chilmark around 1923. The house was dismantled, and all its pieces numbered, moved by truck, and then reassembled. Much of the original interior, with its wide-plank pine floors and wood paneling, is still intact. Most of the windows are original, some with the original panes. The house is furnished with an interesting mixture of old and new, combining antiques with contemporary art, predominantly by living Vineyard artists whose works express their views of the Island. The works are either oil on canvas or oil on board because these materials are most resistant to the local climatic conditions.

RIGHT: *The graceful entry hall has been restored to as close to its original blue color as possible. An eighteenth-century fan-back Windsor chair completes the space. The little painting on the right is a still life by Island artist Stanley Murphy. The swan is from London.*

Called the blue room or summer den, this was originally the parlor. Filled with morning light, the room is light and airy. The art in this room, as in the rest of the house, is by contemporary New England artists. On the left wall is a painting by Nell Blaine, of Gloucester, Massachusetts, called Flowers in Mexican Glass. To the right, Striper is by Kib Bramhall, a Vineyard artist. A pair of New England lolling chairs, ca. 1760, are on either side of an American Queen Anne tea table.

RIGHT: *Two Vineyard artists' paintings hang in this corner of the winter den. On the left is* Sheep at Rest *by Allen Whiting, who is a farmer as well as an artist. On the right is a portrait of Allen Whiting, painted by Stanley Murphy.*

In the winter den, referred to as the hall when the house was built, is a combination of old and new. The chairs were in the house when the owners bought it twenty years ago; the wood paneling in this room is original to the house. An old ship weather vane carved by Frank Adams decorates the mantel.

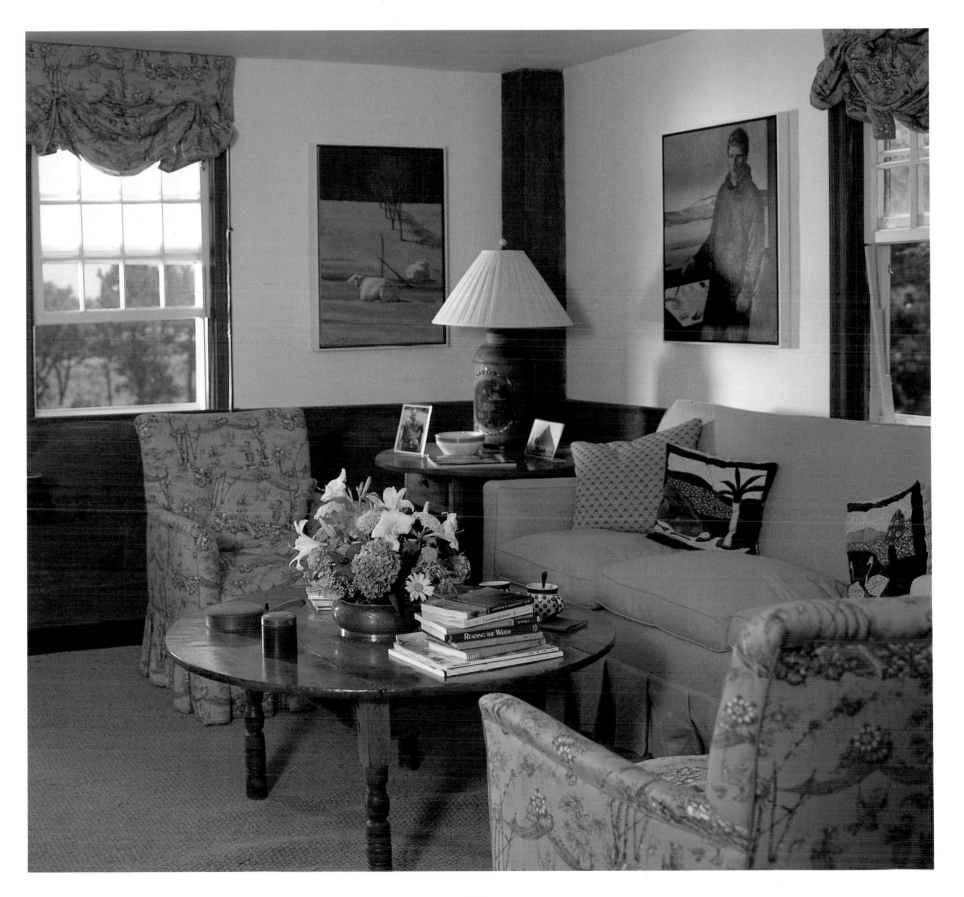

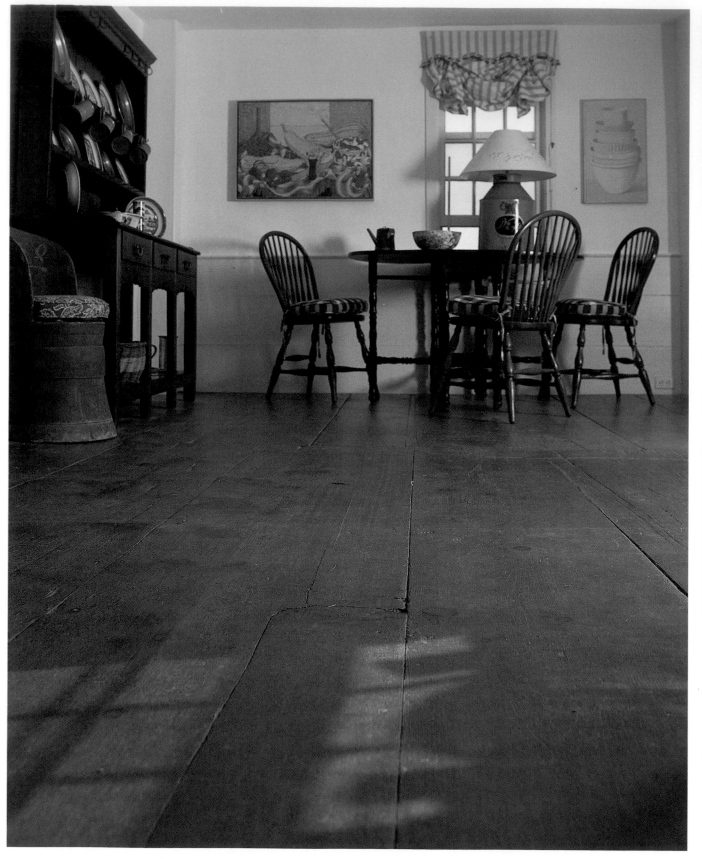

LEFT: *Painted red when the owners bought the house, the wide pine floors were stripped back to the natural wood. The widest board is 21 inches. The painting on the left of the far wall is by Michael O'Shaughnessy. To the right of the window is* Bowls *by Peter Plamondon.* CENTER: *A Welsh dresser holds collections of*

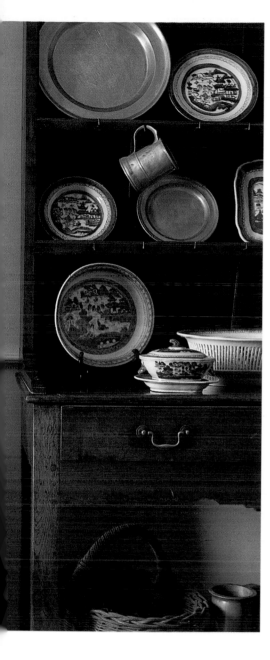

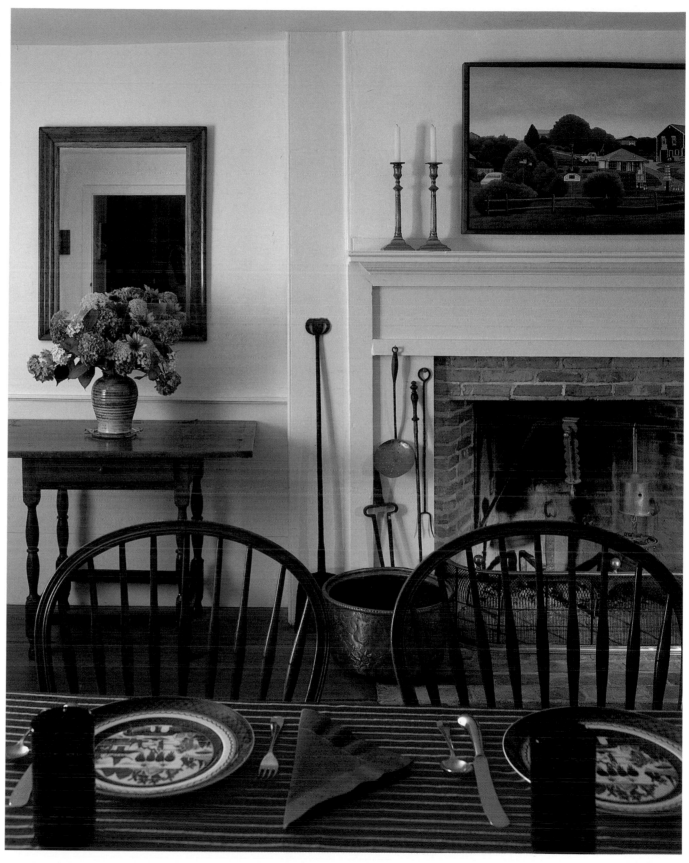

pewter and eighteenth-century blue-and-white Canton. The tiny painting is Self Portrait by Stanley Murphy. RIGHT: *The dining room has a deep fireplace that is original to the house. Arrow-back Windsor chairs surround the table. The painting over the fireplace is* Truro Landscape with Boat *by Randall Deihl.*

LEFT: *The long perennial border extends the length of the property. Blooming here in late summer are white* Echinaecea purpurea, *white phlox* (Phlox paniculata), *and* Rudbeckia, *backed by crimson and white rose of sharon and interspersed with annuals, for color. A garden rich in color, there is something in bloom from spring until fall.*

RIGHT: *The West Chop lighthouse.*

ENCHANTED GARDEN

Dorothy Jampel is the owner of this magical garden that reflects her love of Oriental philosophy and design. When she first began the garden she planted to attract birds, so she put in birdbaths and, later, the water garden. From early spring until late fall, something is blooming or adding splashes of color with foliage or berries.

ABOVE: *In early May, a crab apple (Malus 'Red Jade') in glorious bloom announces the entrance to the property. Mounds of white candytuft (Iberis sempervirens) are in the raised bed beneath it. A flowering pink dogwood (Cornus florida rubra) has just begun to bloom, surrounded by white pines and a larch.*

RIGHT: *Close-up of crab apple blossom.*

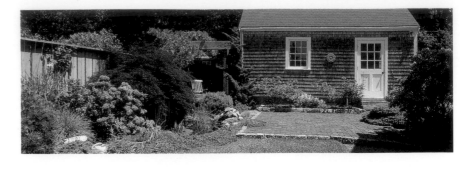

LEFT: *Mountain laurel* (Kalmia latifolia *'Ostbo Red')* *blossoms.* ABOVE: *When the garage was added, its location led to the brick circle garden and the "little secret garden" next to the garage with its wisteria-covered entrance. 'Betty Prior' roses grow along the garage wall.* BELOW LEFT: *A Chinese dogwood* (Cornus kousa) *is in full bloom to the right of* Kalmia latifolia *'Ostbo Red' with a low bird's nest spruce in front of it.* BELOW AND RIGHT: *The red of a cut-leaf Japanese maple* (Acer palmatum *'Everred dissectum')* *dominates the lily pond. In addition to the water lilies in the water garden itself are tall horsetail grass* (Equisetum hyemale) *and Umbrella palm* (Cyperus alternifolius). *To left of the maple is a bright white climbing clematis. Cotoneaster* (Cotoneaster horizontalis) *and flowering thyme* (Thymus vulgaris) *provide interest as ground covers between the rocks and the bricks.*

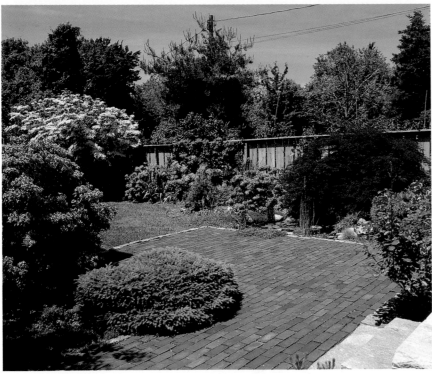

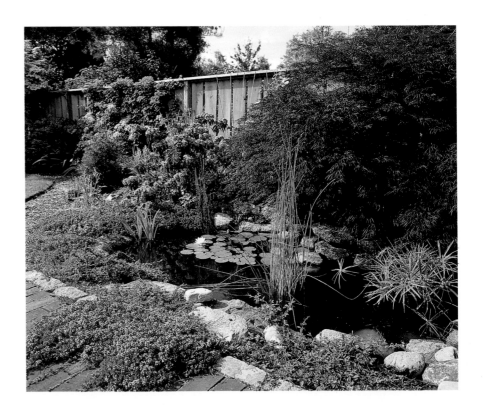

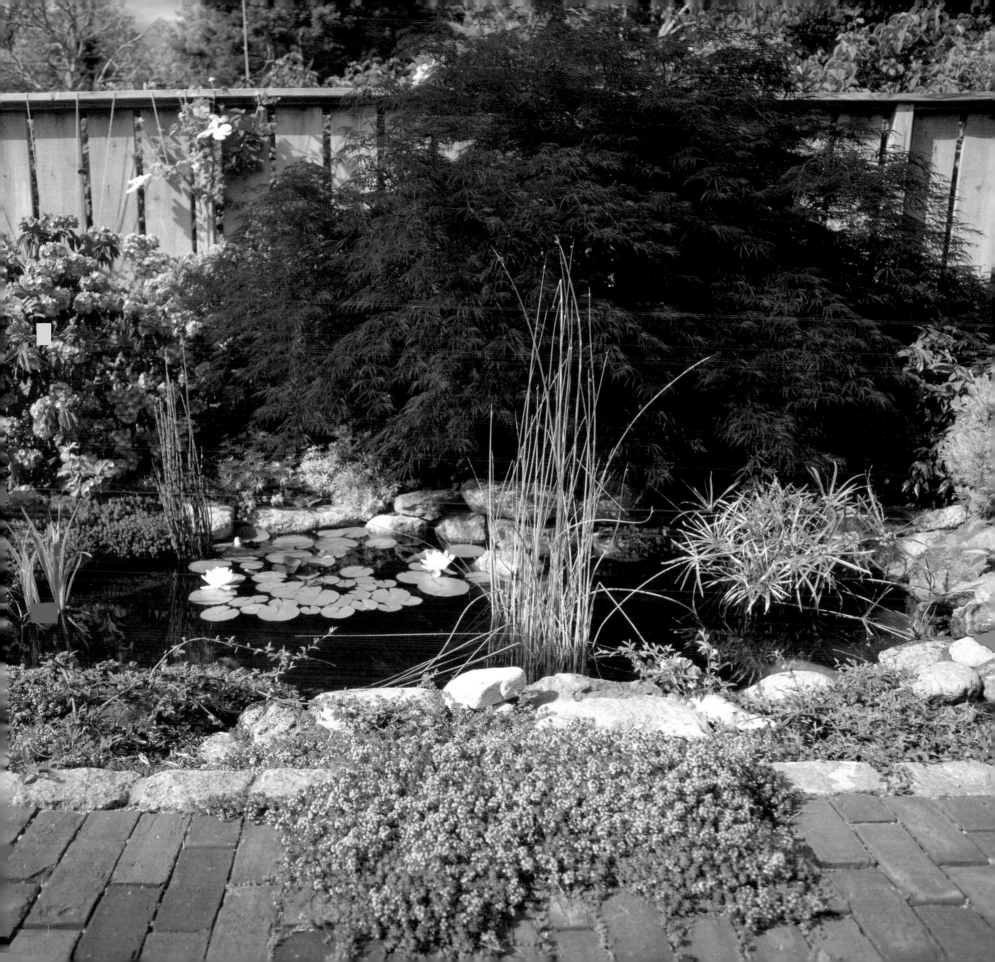

Shortly after Bronislaw and Anne Lesnikowski moved here in 1951, Broni acquired the old wooden water tower from the airport, dismantled it, and moved its pieces to this bucolic setting on Hine's Point, where he used it as a core structure for this unique house. The height of the water tower was shortened by 3 feet and the diameter decreased by 2 feet. The windows are from buildings that were being renovated in Vineyard Haven, and all the other materials used were either found or recycled. The main part of the house is round and has three floors. The ground floor is the living area, the middle floor is the master bedroom, and the third floor is Annie's studio. The stairway to the upper floors curves around the circular outer wall and was very tricky to build since each stair tread had to be individually shaped and fitted. The house has an octagonal mansard roof, another challenge to design and build. Two el-shaped wings were added to the round structure for the kitchen and the guest bedroom and bath.

RIGHT: *The terra-cotta tiled entry and kitchen are open to the living room. The paintings on the curved wall on the left are by Wolf Kahn (top); Selina Trieff (middle), a Vineyard summer resident; and Lucy Mitchell, a year-round Island artist.*

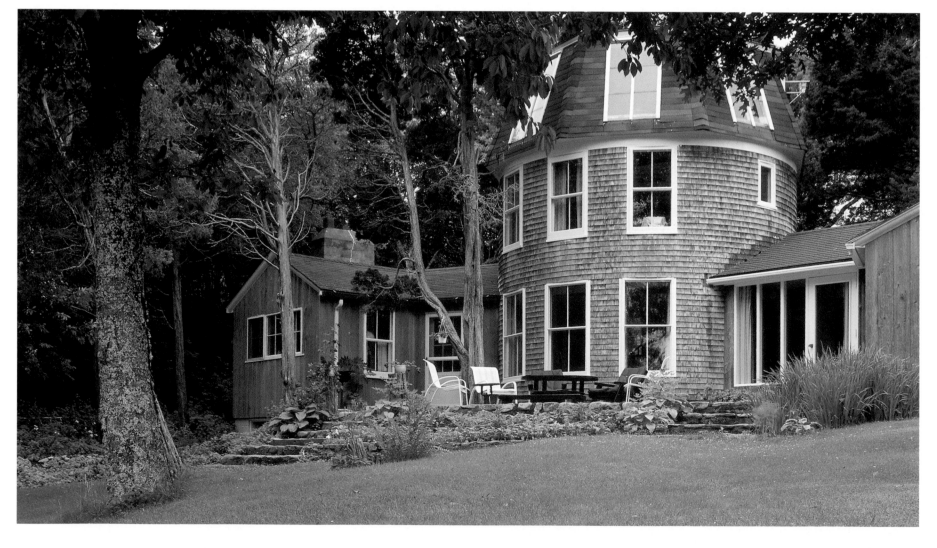

LEFT: *The outside of the old water tower is now the wall between the kitchen and living room. The original structure was painted in a red and white checked pattern. When Broni began to plane down the old boards, he decided he liked the effect of the old paint and kept the look. A fireplace has been set into the wall behind the stairs.*

BELOW AND RIGHT: *Broni's studio. Outside the door is a dark pink rambling rose the Lesnikowskis named Grandmother Berry's rose because it was started from a slip taken from Annie's grandmother's rose in Kentucky. It originally came with her family from England in the 1600's, first to North Carolina and then Kentucky.*

The first studio was reconstructed from an old horse barn that Broni bought for $80 and moved to this site from Gay Head. It burned down and had to be built again. He designed the interior without cross ties so that large work can be moved around. Extremely complicated to frame, the central truss stabilizes the building and eliminates the need for collar ties. The rafters support the structure. He built the studio to give him both height and light. The large bay window at the end overlooks the Lagoon.

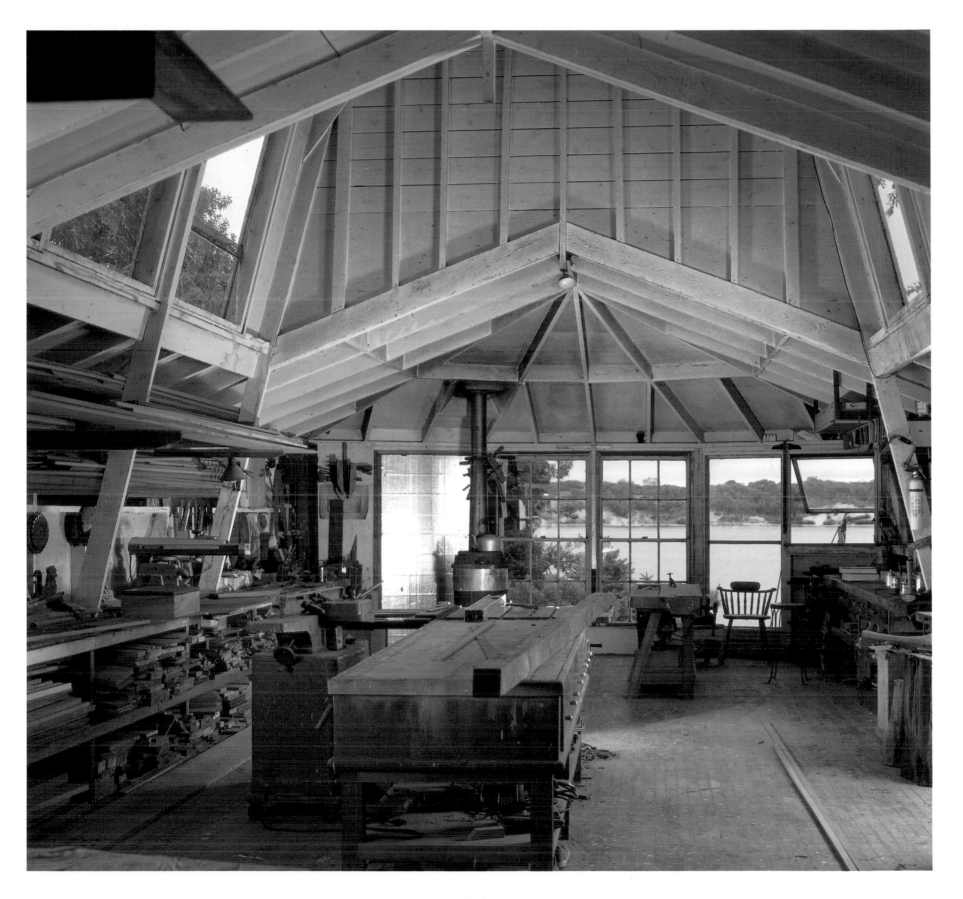

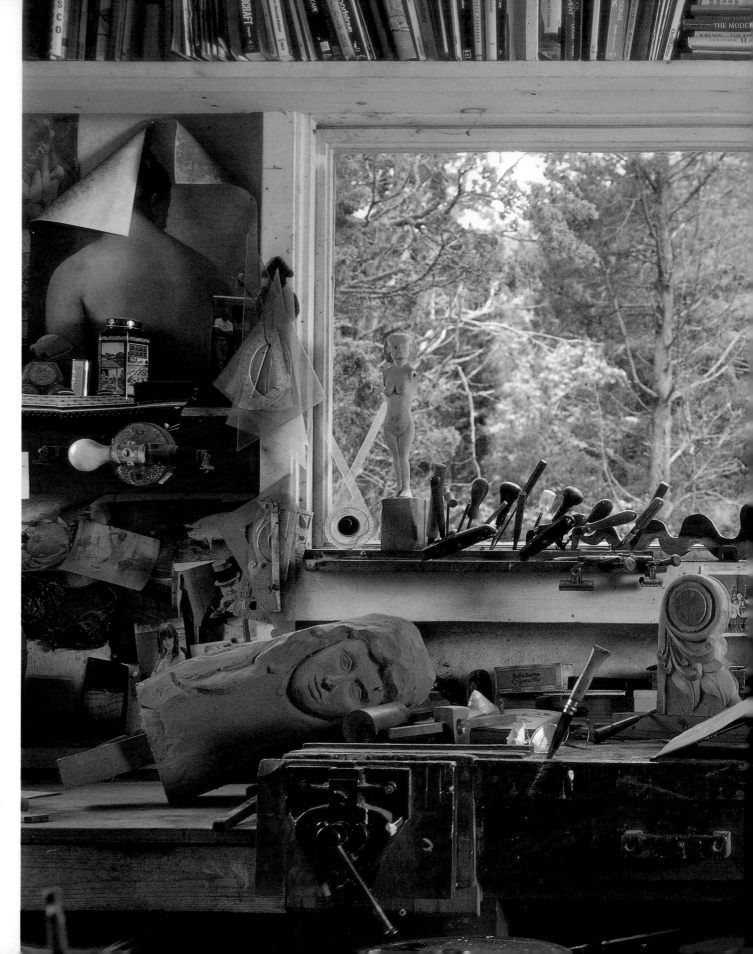

Broni's workbench in his studio, showing some of his wood carving in progress and "an accumulation of things that interest me."

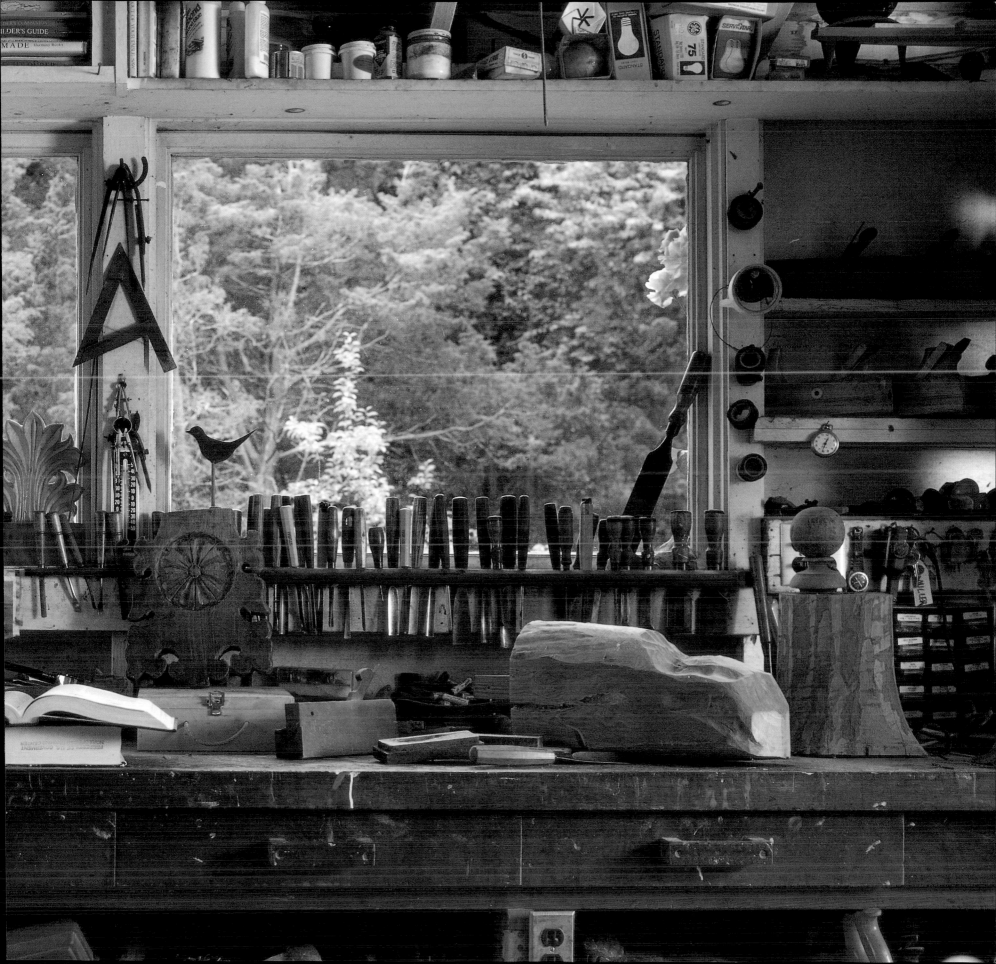

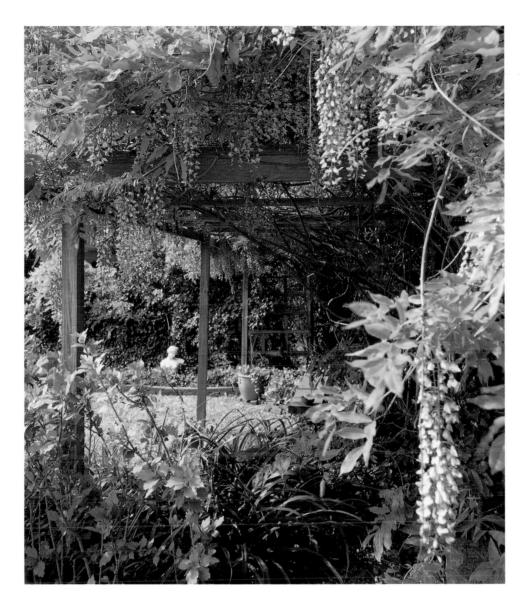

ARTISTS' ENCLAVE

 In the heart of the historic district of Vineyard Haven is this lovely Greek Revival house built about 1850 and now owned by Edward (Ted) and Jeanne Hewett, who bought it in 1978. The Hewetts bought the house from William Colby, who in the early 1950's put in the extensive garden of successively-blooming rhododendrons in every shade from the palest pinks to the deepest reds. Tall Siberian elms probably seventy-five years old, large mature maples, and tall evergreens provide the perfect backdrop for the vibrant colors of the huge rhododendrons. Other beautiful trees that complement one another with their delicately different colors of foliage and blooms are golden rain, golden chain, mimosa, weeping cherry, and pear trees. Ted and Jeanne built the grape arbor and planted the wisteria that blooms profusely in May in delicate colors.

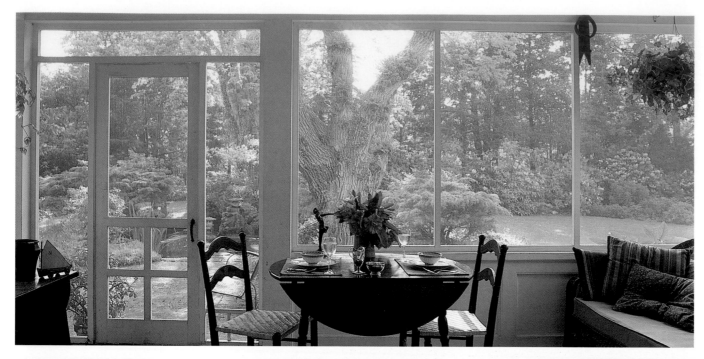

LEFT: *In spring, when all the rhododendrons and azaleas are in bloom, the garden looks like a fairyland.*

BELOW: *Brilliant yellow and red azaleas accent the little rock garden and pool.*

RIGHT: *Down the side of the garden toward the pool and the street are yellow iris, lilies-of-the-valley (Convallaria majalis), violets (Viola hybrids), azaleas, and rhododendrons.*

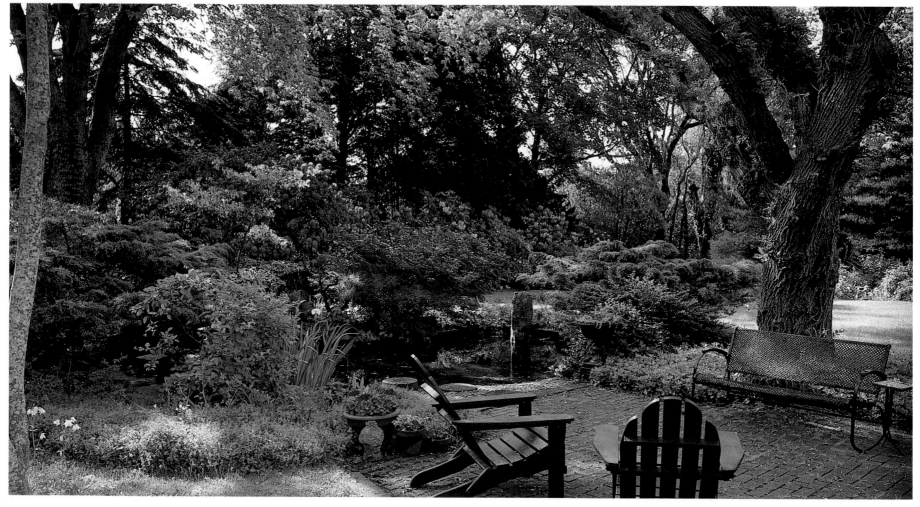

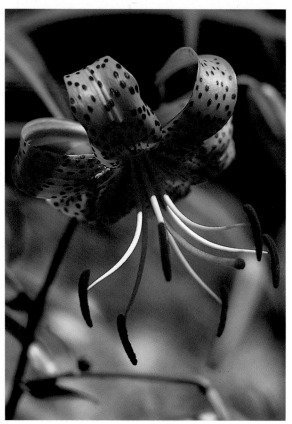

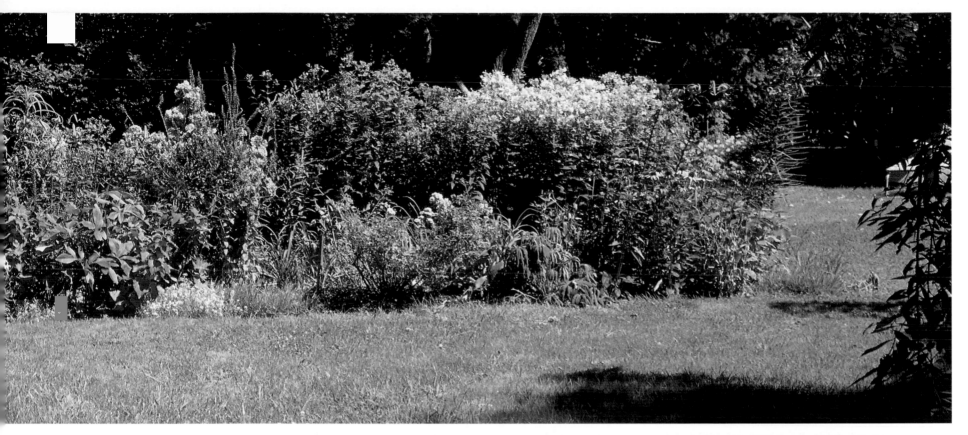

The large border is planted with tall perennials such as hydrangeas, 'Fairy' roses, phlox, lythrum, and daylilies. In the middle height range are daisies, coreopsis, coneflowers, peonies, liatris, lupines, globe thistles, chrysanthemums, and poppies. Lower-growing plants are a combination of annuals (alyssum, petunias, candytuft, snapdragons, and zinnias) and perennials (leadwort, coral bells, dianthus, and primroses) to complete the color palette of seasonal blooms.

Seen in detail from left to right are: bee balm, phlox, lily, daylily, and hydrangea.

Built on a grand scale with ceilings over 10 feet high in the early 1900's for C. C. Hine, the house has been added on to over the years. When Thomas and Anne Hale bought it in 1961, they undertook long-overdue repairs and remodeling, doing much of the work themselves. In the renovation process, they discovered that most of the structure had been built with scrap and second-hand lumber. Walls and ceilings sagged, floors sloped, and nothing was level. They propped, painted, and opened the house up to take advantage of the prevailing southwest breezes and, to the northwest, beautiful views of the Lagoon, beyond it Vineyard Haven Harbor, and beyond that Vineyard Sound. Now the views form a backdrop to the lovely gardens Anne has planted. Their five children are now grown, and the Hales share this delightful spot on Hine's Point with their two labradors, a cat, and several birds.

BELOW LEFT: *In May, a flowering dogwood* (Cornus florida) *and daffodils are already in bloom, while the creamy white flowers of a* Pterostyrax hispida *down toward the water are just beginning to open. The circular bed at the base of the tree contains hostas, epimediums, snowflakes* (Leucojum vernum), *and species tulips* (Tulipa sylvestris). *Late-blooming daffodils are in the background on the way to the water. The Hales' 42-foot motor sailer* Alpheratz *is waiting at the pier.*

BELOW: *The wonderful gnarly trunk of a red cedar* (Juniperus virginiana).

RIGHT: *Next to the dogwood* (Cornus florida) *is a large Japanese maple* (Acer palmatum). *In the circular bed in the foreground are assorted daffodils, Virginia bluebells* (Mertensia virginica), *Scilla hispanica, and iperion, with its dainty, white fragrant flowers.*

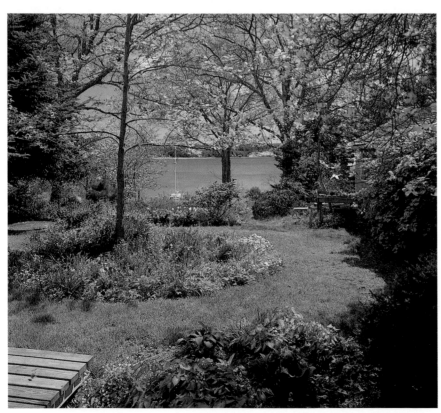

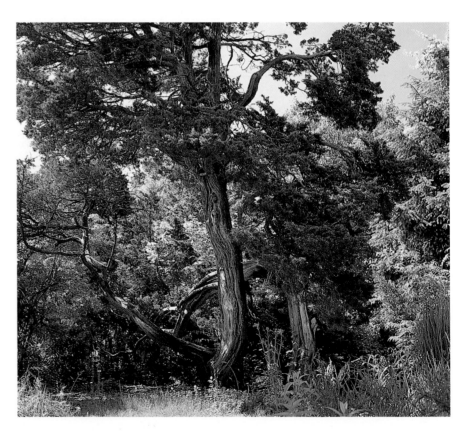

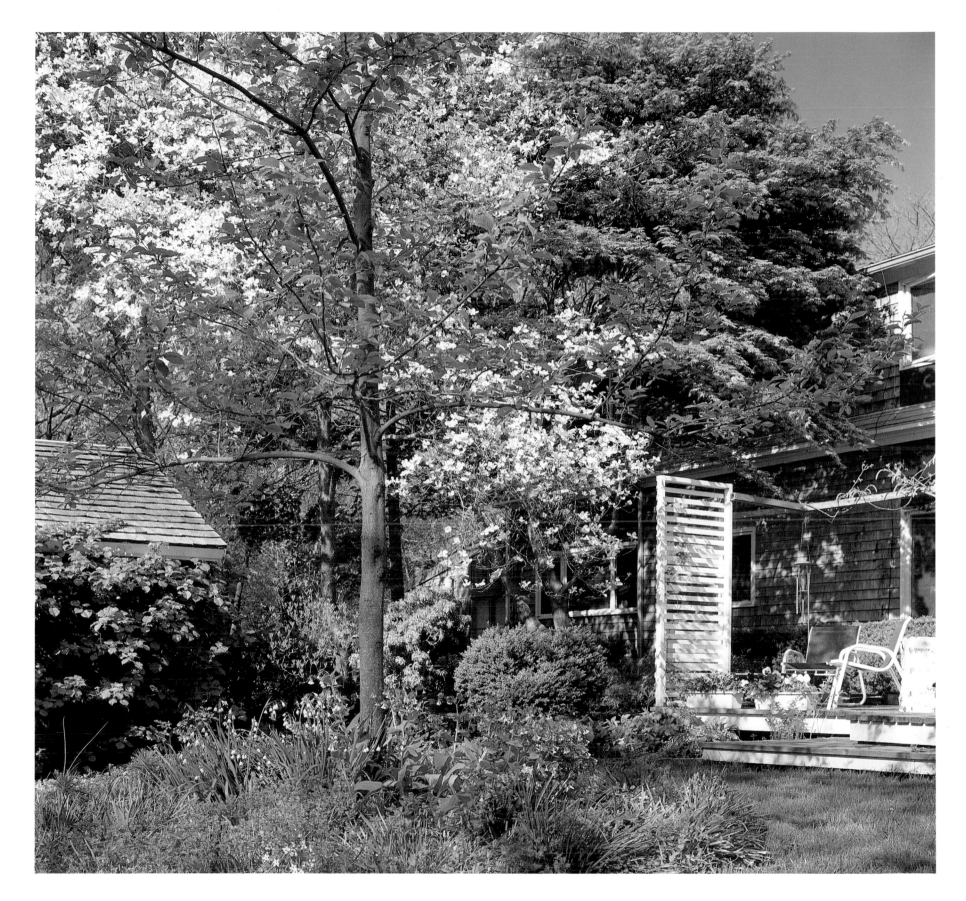

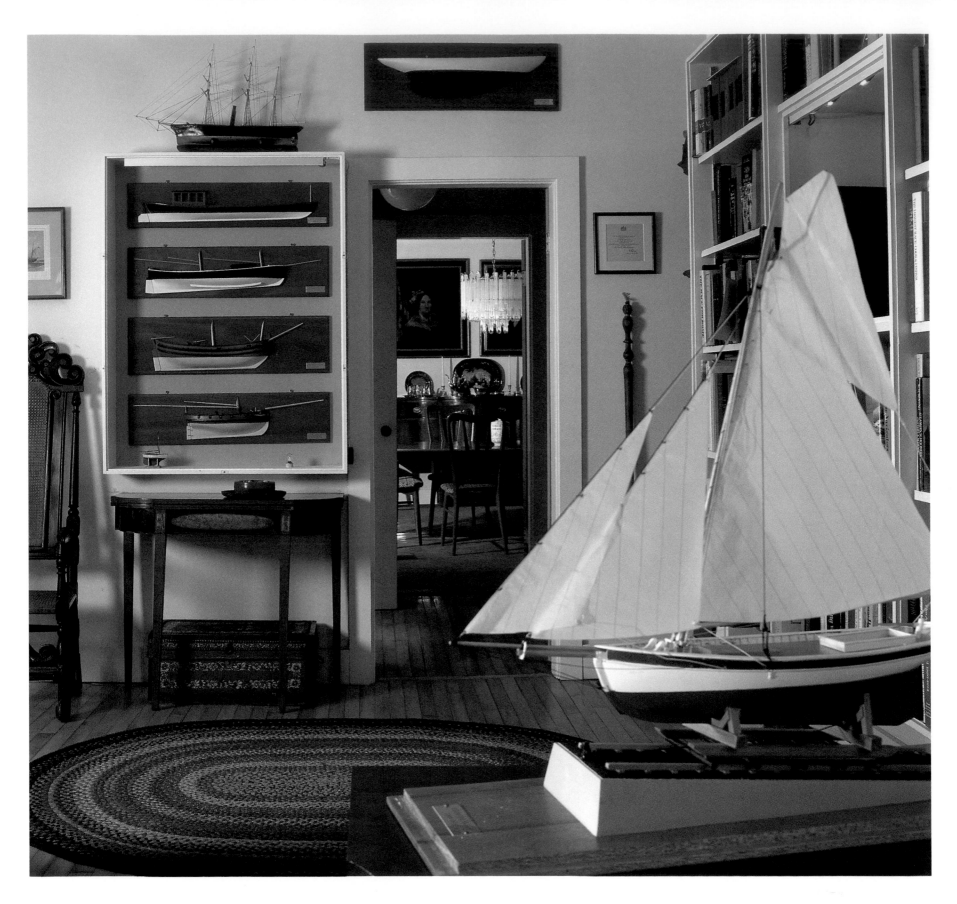

is a half-model of the 38-foot yawl Carronade. A portrait of *Elizabeth Wood, a nineteenth-century ancestor from Newburyport, Massachusetts, hangs in the dining room.*

LEFT: *Tom Hale builds ship models as a hobby. In the foreground is a Bermuda sloop, ca. 1870. Originally built as trading vessels, they were eventually raced competitively by British officers stationed on the island. On the far wall is a case of half-models (from the top): a Royal Barge, Thames River, ca. 1768; a U. S. Navy gunboat, 1804; a Colonial trading bark, ca. 1640; and an English revenue cutter, ca. 1765. The black-hulled model on top of the case is a Newburyport bark, ca. 1855. Above the door*

ABOVE LEFT: *A troupe of Indian nineteenth-century ebony elephants lines the top of a cabinet that holds a collection of Chinese and Japanese ivory carvings. The model in the foreground is of the Guide, one of the first steam pilot boats for the Port of London's Trinity House pilots.*

ABOVE: *A Simon Willard grandfather clock, ca. 1810, from the Hale family home in Newburyport has its original handmade works, and the clock still keeps time to within one minute a week. The sword was worn by an ancestor, Lt. C. E. Steadman. The flintlock was carried by another ancestor, who fought under General Wolfe in the Battle of Quebec in 1869.*

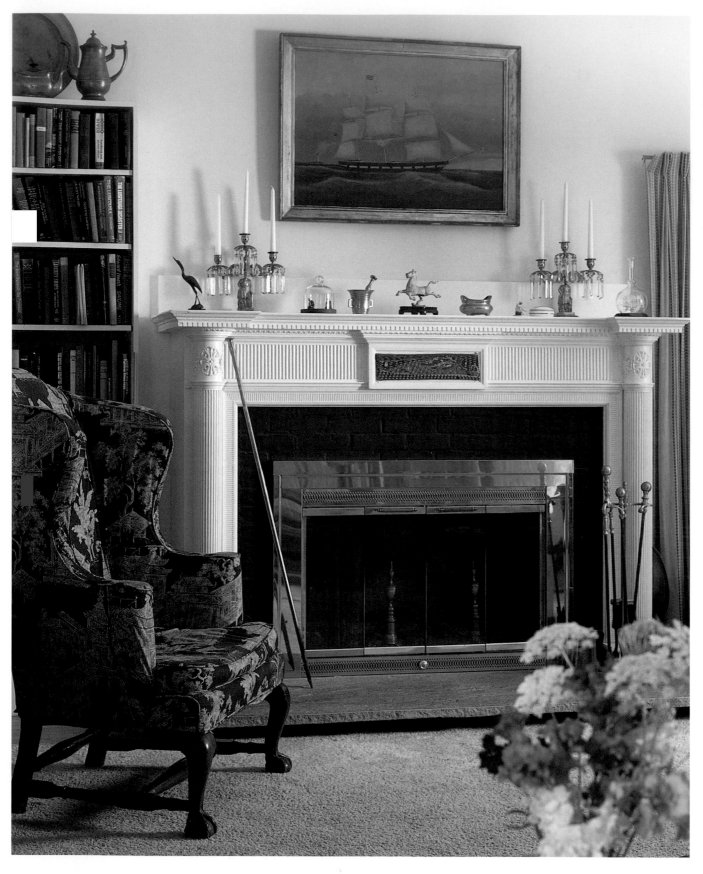

LEFT: *The armchair dates from 1808, when it was made for the daughter of William Ellery, a signer of the Declaration of Independence, upon her marriage. The oil portrait over the mantel is of the ship Dolphin, ca. 1800.*

ABOVE: *On the intricately carved mantelpiece is a tapestry, woven by one of the Hales' daughters, depicting a bird's-eye view of the Vineyard with the family's favorite spots, boats, and horses carefully included.*

RIGHT: *The Hales' cat, Spice, sits in front of a border of foxglove (Digitalis purpurea), English daisies (Bellis perennis), and striped grass (Miscanthus sinensis 'Zebrinus') backed by a golden rain tree (Koelreuteria paniculata), a Chinese dogwood (Cornus kousa 'Seven Stars'), and a Colorado blue spruce (Picea pungens glauca).*

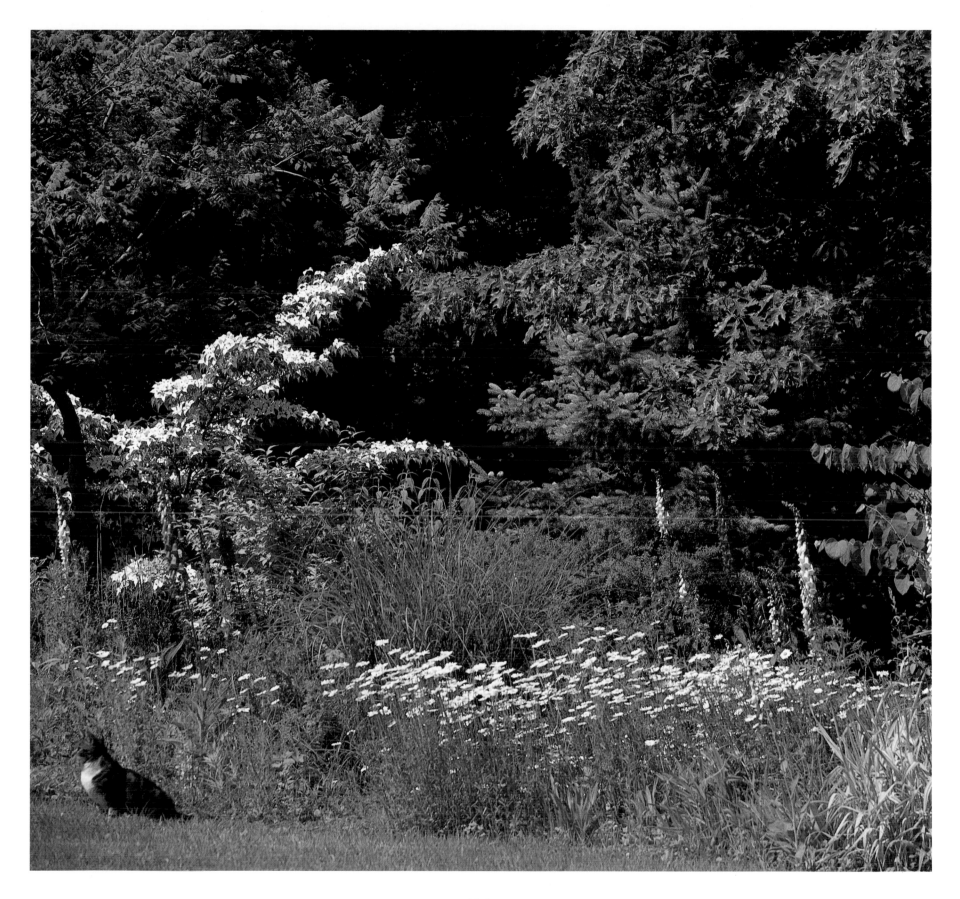

RIGHT: *Japanese snowbell tree*
(Styrax japonica) *blossoms.*

BELOW: *Some of Anne's*
hybrid daylilies (Hemerocallis)
and a sunflower grace this
border with the porch behind
them. One of Anne's hobbies is
breeding daylilies, and this bed
has many different varieties,
planned for early, mid, and late
season blooms.

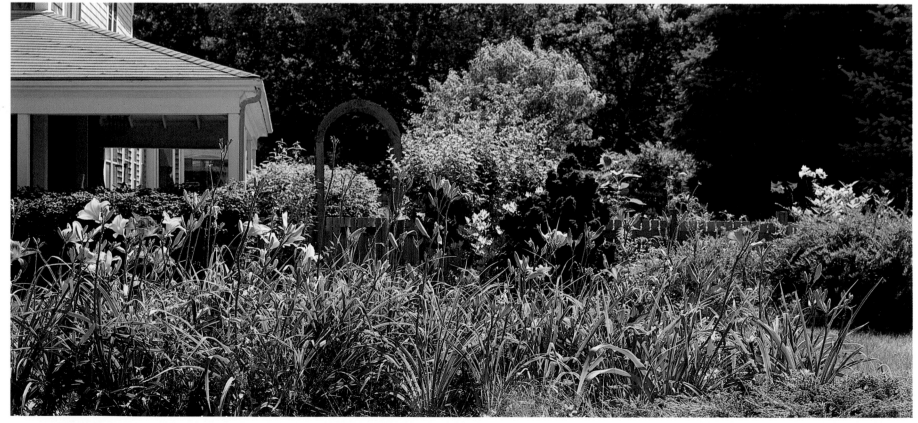

BELOW: Wisteria floribunda *envelops the trellis over the deck in* May. *Beneath its delicately fragrant blossoms are pots of pansies and dwarf geraniums. Dwarf hostas and epimedium nestle in the bed below the steps.*

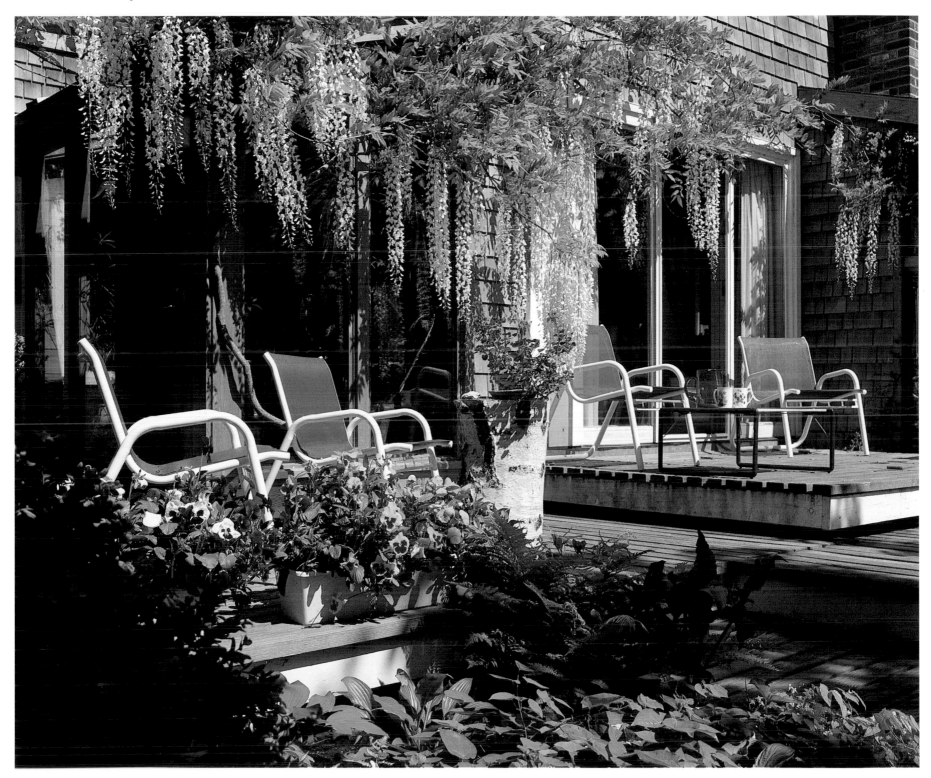

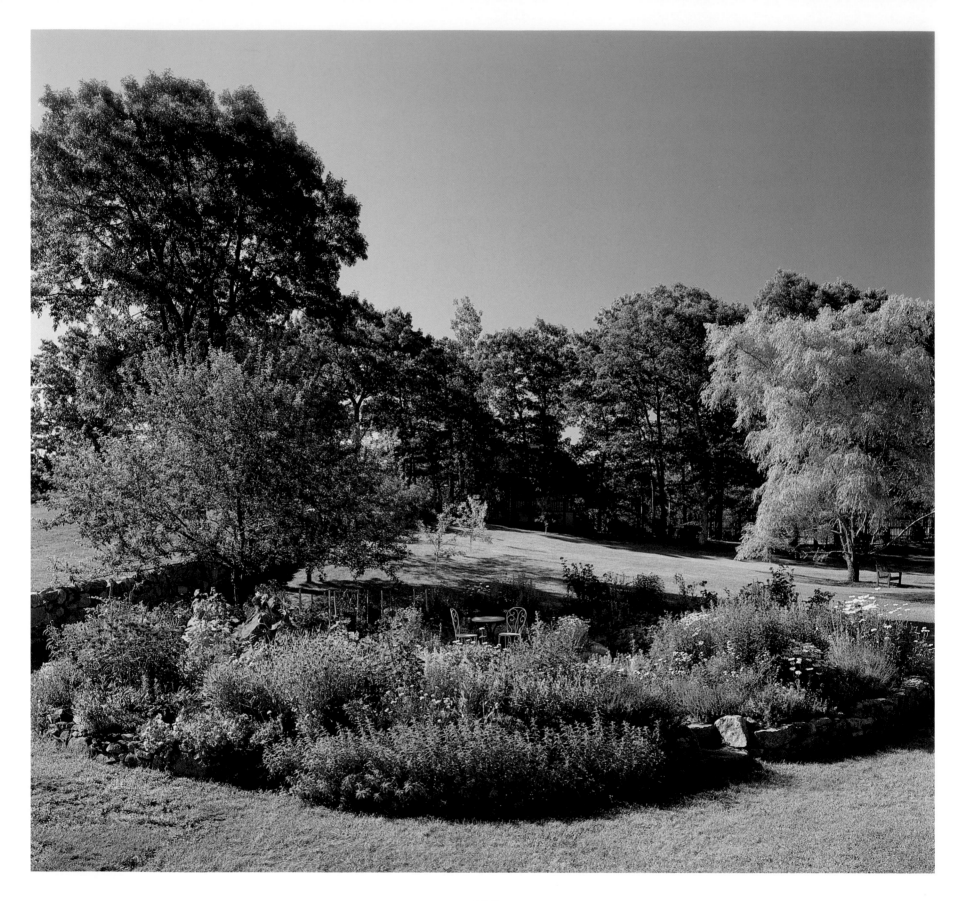

Some 60 feet in diameter, this stone-walled garden has four concentric circles around a flagstone terrace, 7 feet in diameter. Perennials fill the outer ring and provide interest year-round with textures and foliage colors. The two inner circles are planted with annuals, arranged by color; the center ring with culinary and decorative herbs is edged with a santolina border. A curving brick walk leads to the center. Located some distance from the house on a lower lawn, the garden is planted so that, when viewed from the house, the soft pastels of roses and other perennials evolve into bolder colors of annuals and perennials chosen for the inner circles and the far side of the perennial border.

LEFT: *In late June, bold colors are predominant on this side of the garden as seen from the stables. Blooming in the perennial ring are* Monarda didyma *'Cambridge Scarlet',* Lychnis coronaria, Gaillardia aristata *'Dazzler', and* Coreopsis grandiflora *'Early Sunrise'. Masses of peppermint* (Mentha pererita) *hug the low stone wall and 'Cherry Rose' nasturtiums tumble over it.*

BELOW: *On either side of the steps that lead into the garden are lavender* (Lavandula angustifolia), Teucrium chamaedrys, *and catmint* (Nepeta faassenii *'Blue Wonder'). Their gray and silver foliage balances the pale pink 'Fairy' roses behind. To the right of the steps are ox-eye daisies* (Chrysanthemum leucanthemum), *part of the plantings that are repeated throughout the border and span the season with blooms.*

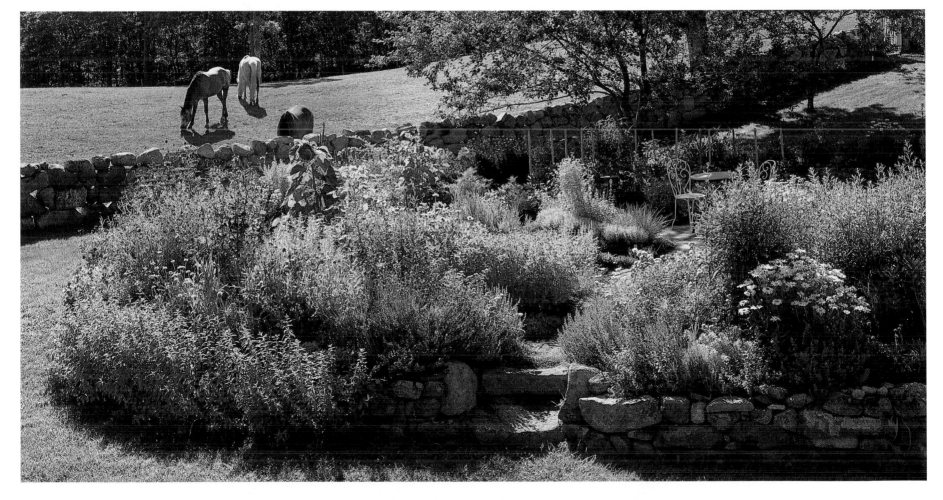

BELOW: *In early August, the garden is seen with the stables in the background. After the early-summer perennials have gone by, later-blooming perennials and annuals fill the garden with their bursts of colorful blooms. Masses of perennials such as* Echinacea purpurea *'Magnus'; sea holly (*Eryngium alpinum *'Amethyst');* Dianthus plumaria *'Doris', 'Snowbank', 'Aqua', and 'Sweet Memory';* Monarda didyma *'Stone's Throw Pink';* Rudbeckia fulgida; *and blue and white stokesias (*Stokesia laevis*) are repeated around the circle. Creeping over the wall are rock plants such as aubretia (*Aubretia deltoidea *'Royal Blue'), arabis (*Arabis caucasia *'Variegata'), and creeping phlox (*Phlox stolonifera*). On the far side of the garden are early-blooming Asiatic and later-blooming fragrant Oriental lilies along with several varieties of campanulas. The inner circles are filled with annuals in their peak of bloom, which will last into fall. Among the annuals planted here are cosmos, lavatera, nigella, scabiosa, zinnias, Italian white sunflowers, tomatoes, white marigolds, nasturtiums,* Salvia horminum, *bachelor buttons, dahlias, and asters.*

RIGHT: *Another angle and close-up view of the garden in August shows mounds of gray and silver foliage in later season maturity. Their color and texture will remain after the flowers of spring and summer have gone by. In addition to those varieties already listed are several artemesias, Russian sage (*Perovskia atriplifolia*), and rue (*Ruta graveolens*). Paths made of flagstone separate the circular beds.*

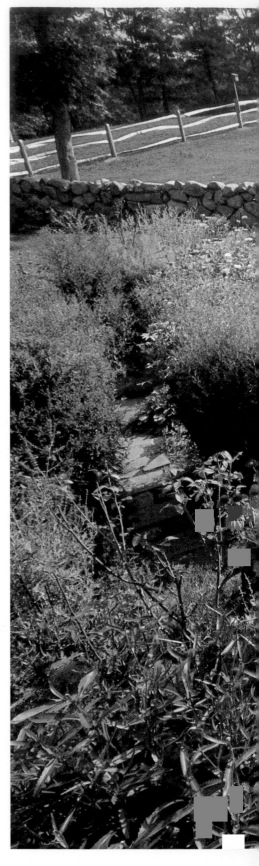

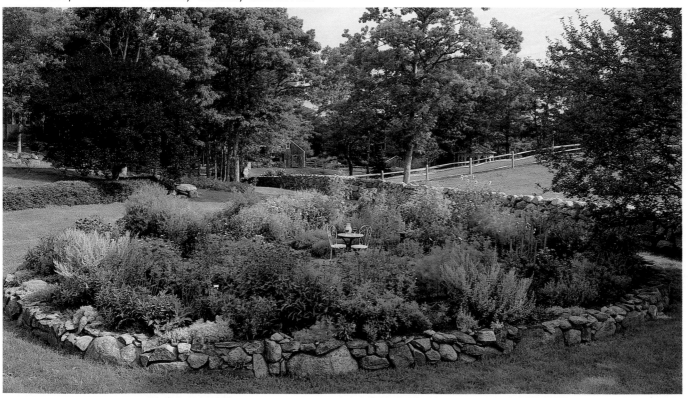

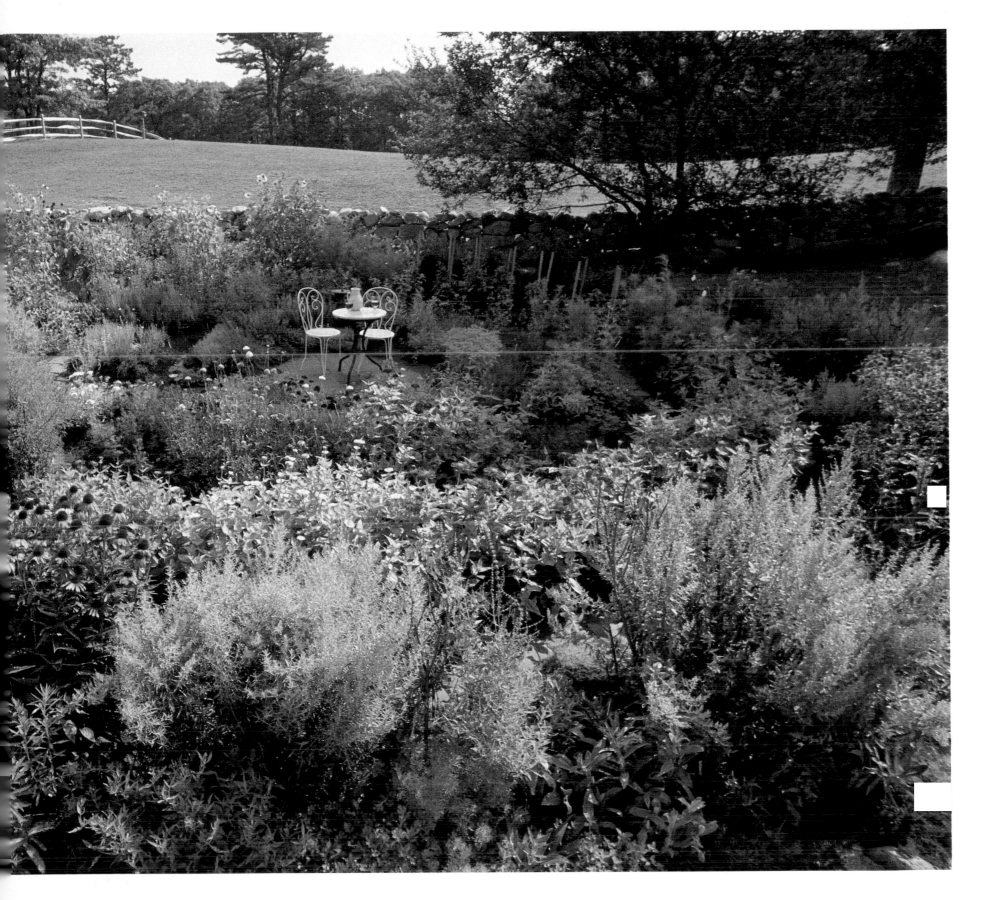

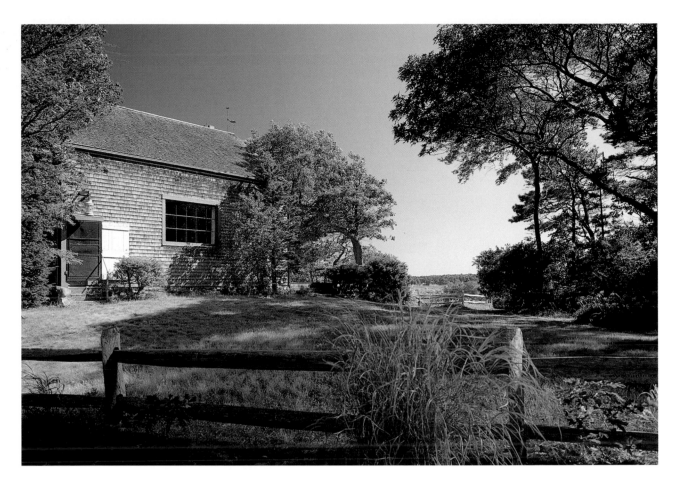

THE MEADOWS

The Meadows is an old farmstead, bounded on one side by Lake Tashmoo and on the other by Vineyard Sound. It includes an old farmhouse belonging to Sydna White and a renovated barn belonging to Francis (Pat) and Isabel West. Sydna and Isabel are the daughters of Ruth Eldridge White and the granddaughters of George W. Eldridge, who settled on the Vineyard in 1875 and is known as founder and publisher of the indispensable *Eldridge Tide and Pilot Book*. Their father, Wilfred O. White, emigrated from Australia, went to work for George Eldridge, and became a designer and inventor of compasses and other marine instruments. Pat West, also a compass expert, is from an old Island family that dates back to ancestor Thomas West, who was King's Attorney in the early 1600's.

The West family, along with the Chases and the Cottles, settled Vineyard Haven in the 1600's. Pat's great-uncle was keeper of the West Chop lighthouse, and his father was an artist in Menemsha. When Pat and Isabel moved back to Martha's Vineyard in 1970, they took the old barn and renovated it into a wonderful home, maintaining much of the original interior walls and spaces.

LEFT: *The exterior of the original house, which belonged to Ruth and Wilfred White, is set back behind a field of butterfly weed, which blooms profusely in July and was planted more than fifty years ago by Ruth White.* ABOVE: *The renovated barn is ideally sited on the shore of Lake Tashmoo. It is surrounded with carefully planted gardens in bloom from spring well into fall.*

ABOVE: *Isabel calls this garden her swamp garden. In spring it is filled with yellow and purple iris and bounded by flowering* Rosa rugosa.

RIGHT: *Pat is a master mariner, an inventor of marine instruments and compasses, and collector of boats, models, and all things nautical. In early spring, some of Pat's boats, not yet in the water, provide a frame for Lake Tashmoo, just outside the door.*

Inside the former barn is a beautiful home filled with collections of ship models, ship paintings, and other Island art. Outside the deck doors is Lake Tashmoo. The living room is filled with light from the large windows and two pairs of glass doors. A model of Pat's Friendship sloop Erda, named for their daughter's first operatic role, was built by Pat and his son, Nathaniel. On the wall above the fireplace is an oil painting of the schooner America as rerigged by owner F. L. Barnum. Between the fireplace and the door to the deck is an oil painting of the herring fleet and smokehouses in Bourneholme, Denmark, painted by Matthew Geddes, a Danish artist who painted in Menemsha. RIGHT: The view looking toward the front hall and stairs shows the level of the old hayloft in the house's former incarnation as a barn. On the wall above and between the two white doors hangs a portrait of Pat's father, Francis West, painted by his good friend Jim Gilbert, an artist and naturalist from Chilmark.

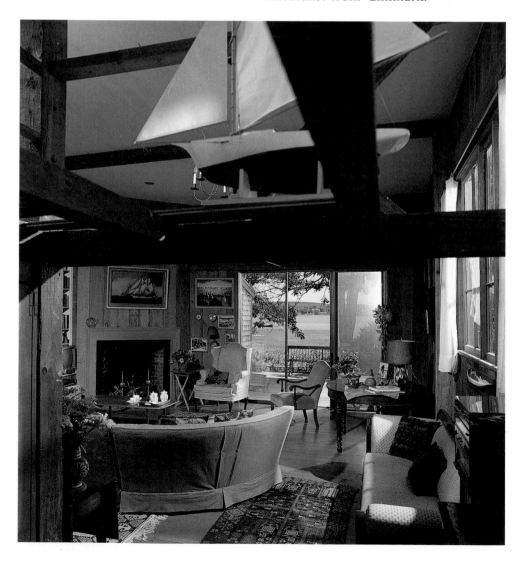

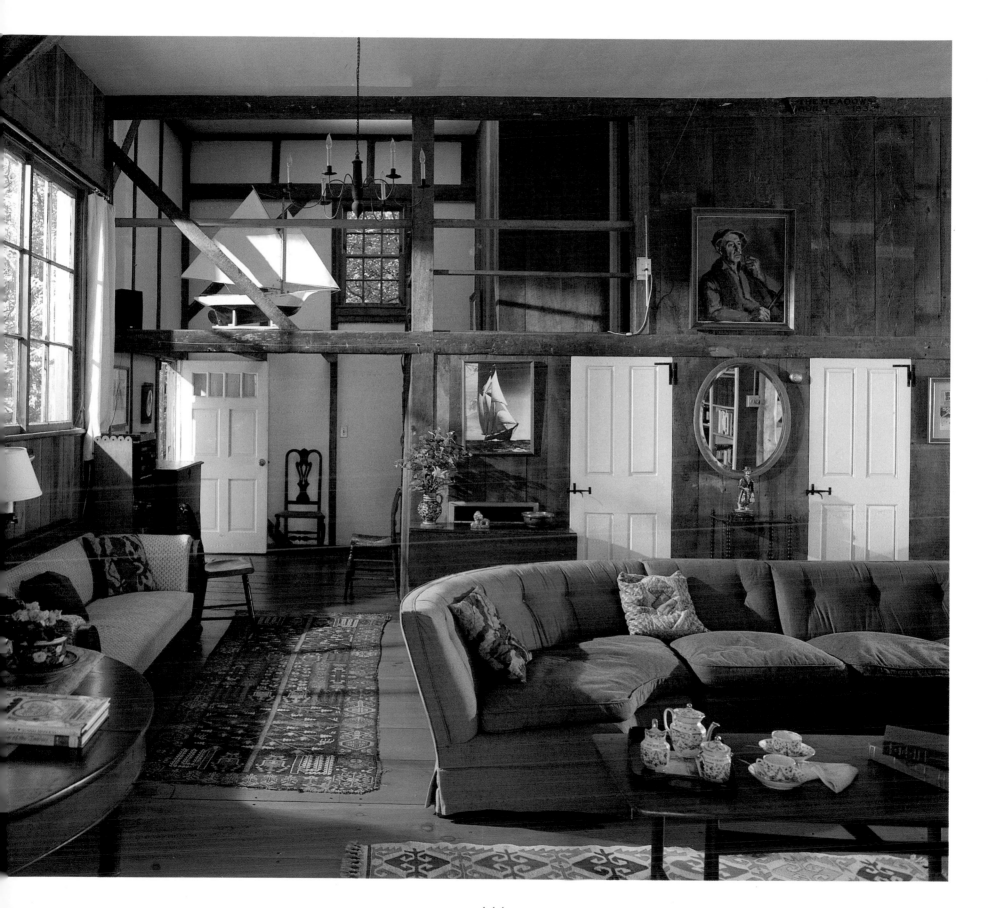

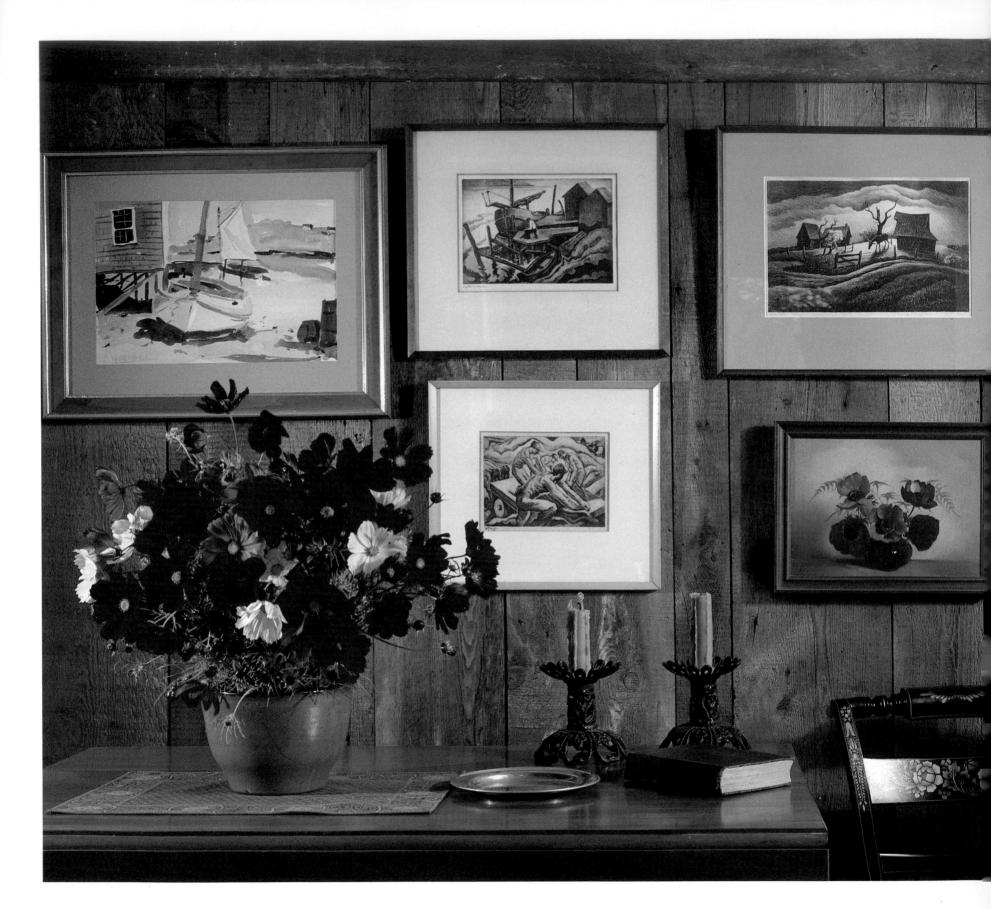

This wall holds paintings: The watercolor on the left is by Harry Curtis, the Wests' friend from Long Island; the two lithographs next to it are by William Scott, an artist who lived in Menemsha and was a good friend of Pat's. To their right is a lithograph by Thomas Hart Benton, a wedding present to Isabel and Pat from the artist. Below it is a still life bought in France off the street. The half-model is of the Venture, the 38-foot gaff-rigged Lawley sloop Pat owned and sailed for many years. The cross-section below it came from England.

BELOW: A view of the living room from the east entrance to the house. The glass doors open onto a deck with an enticing view of Lake Tashmoo.

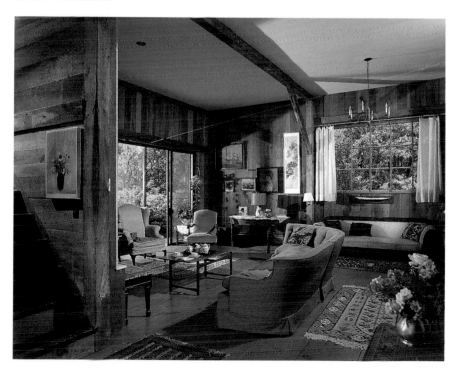

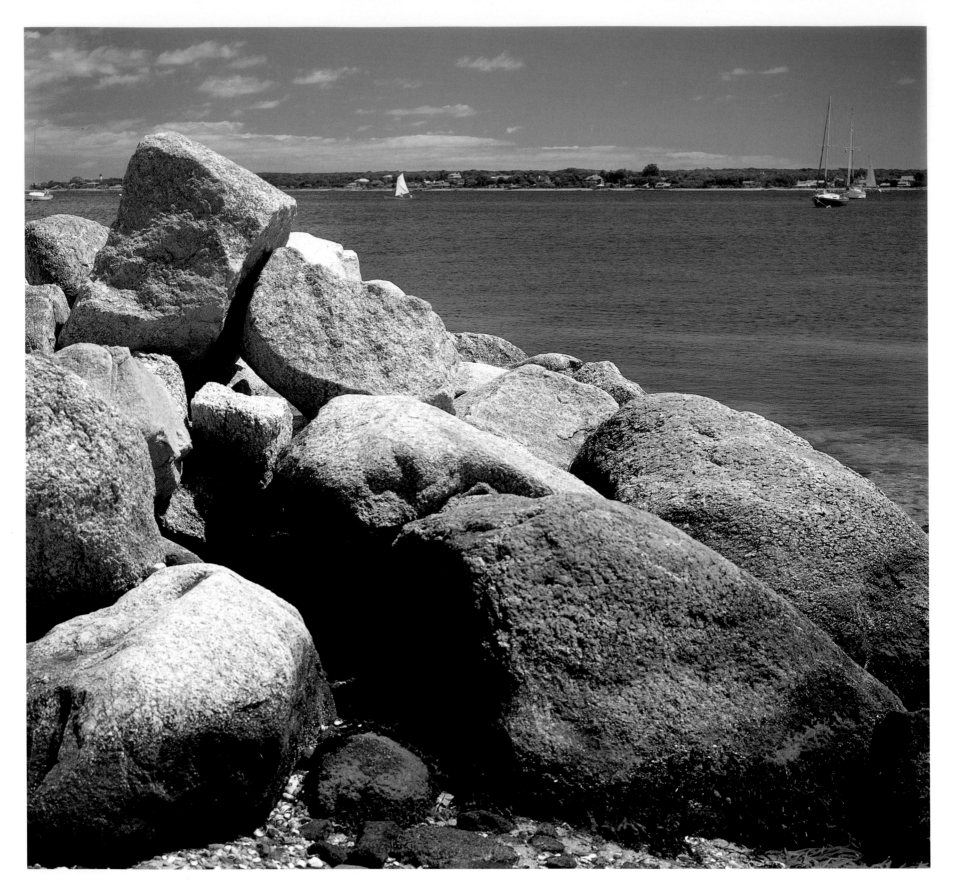

SHORE GARDEN

Almost on the beach, this seaside garden thrives on the Vineyard Haven harbor front. Old-fashioned rambling roses, tumbling down the hill to the beach, protect the bank from erosion and cover it with blooms in June and early July.

BELOW LEFT: *Looking up to the house from Vineyard Haven Harbor.*

BELOW RIGHT: *Predominantly a lily garden with successively blooming varieties, in early August the garden features Oriental lilies 'Stargazer' and 'Casa Blanca'. Perennials planted to*

complement the lilies include Veronica spicata, liatris (Liatris spicata), burgundy gaillardias (Gaillardia grandiflora), asters (Aster amellus), Coreopsis verticillata 'Moonbeam', Coreopsis rosea, and Alchemilla mollis. In the foreground raspberry pink snapdragons have been added as accents.

OVERLEAF LEFT: *The front steps in late June are surrounded with pink old-fashioned rambling roses, Shasta daisies (Chrysanthemum x superbum), hybrid lilies, delphinium, scabiosa (Scabiosa caucasica 'Kompliment'), white stokesia (Stokesia laevis), and Artemisia schmidtiana 'Silver Mound' with white Nicotiana alata.*

OVERLEAF RIGHT: *The lily garden as seen from the water side.*

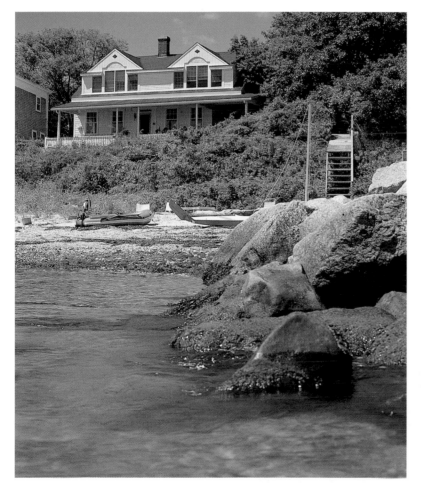

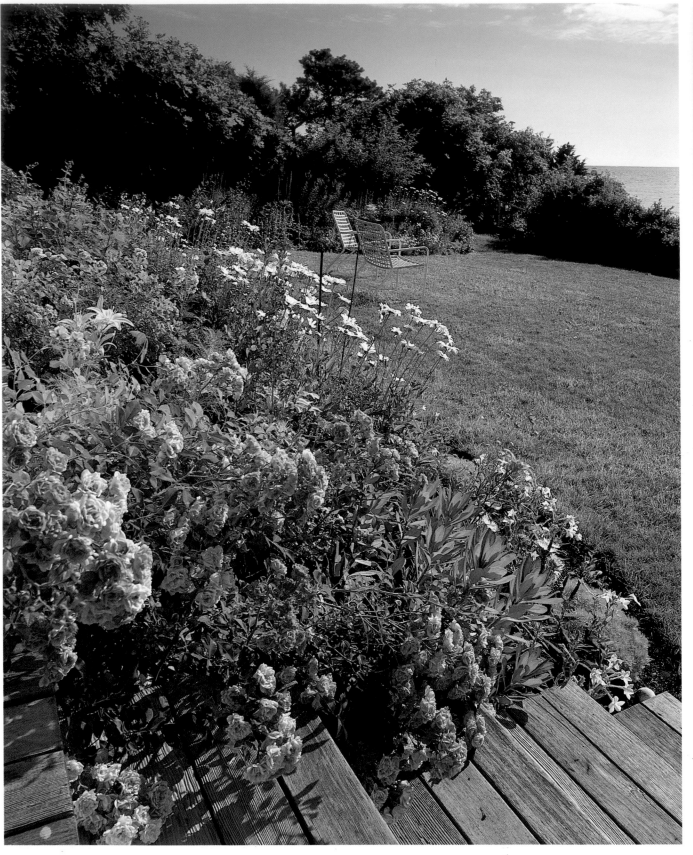

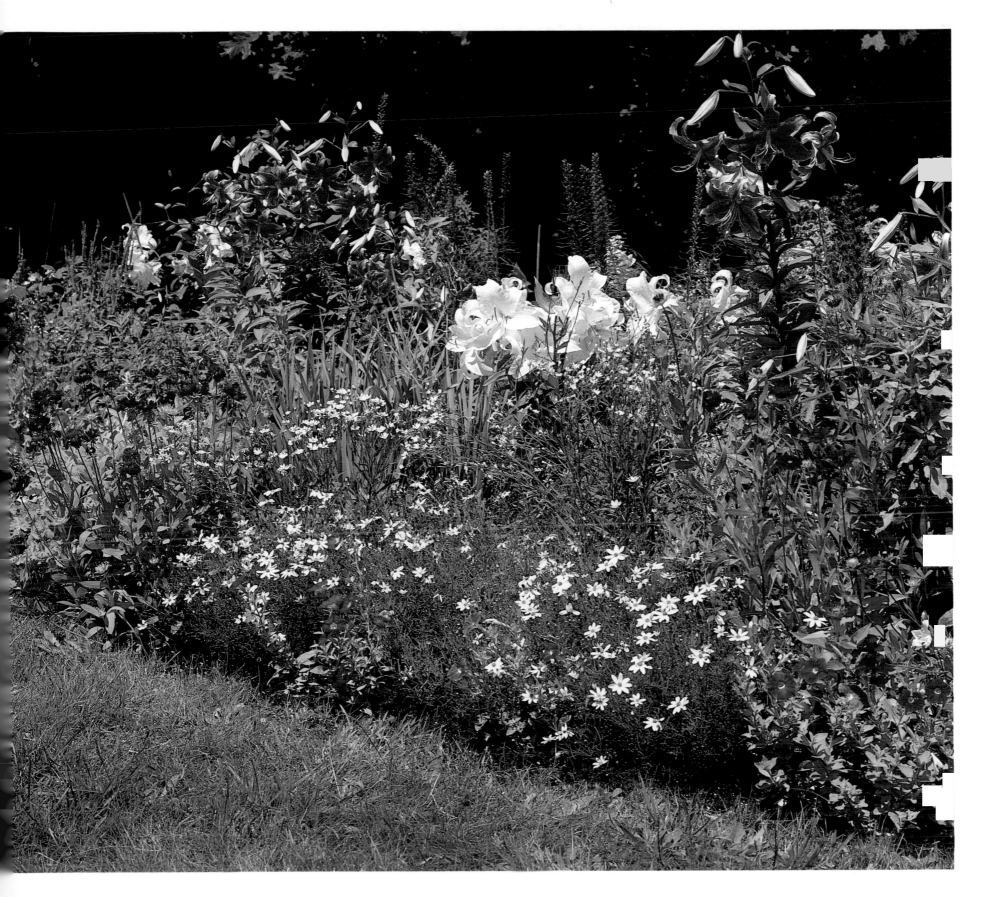

147

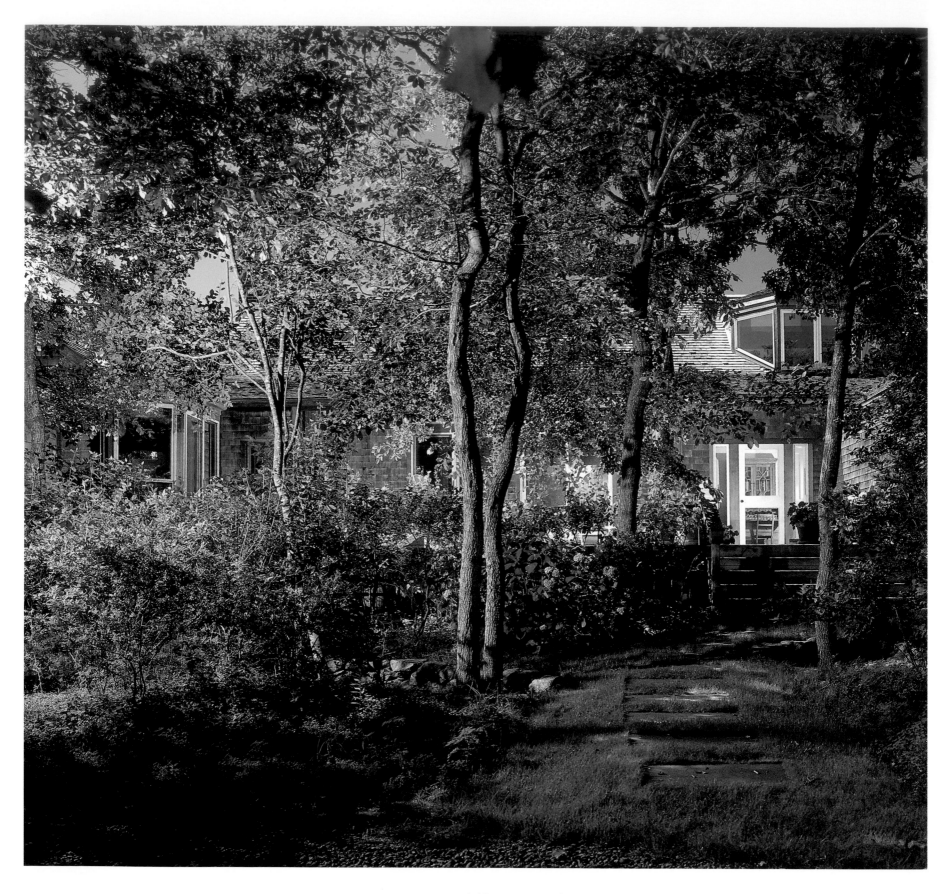

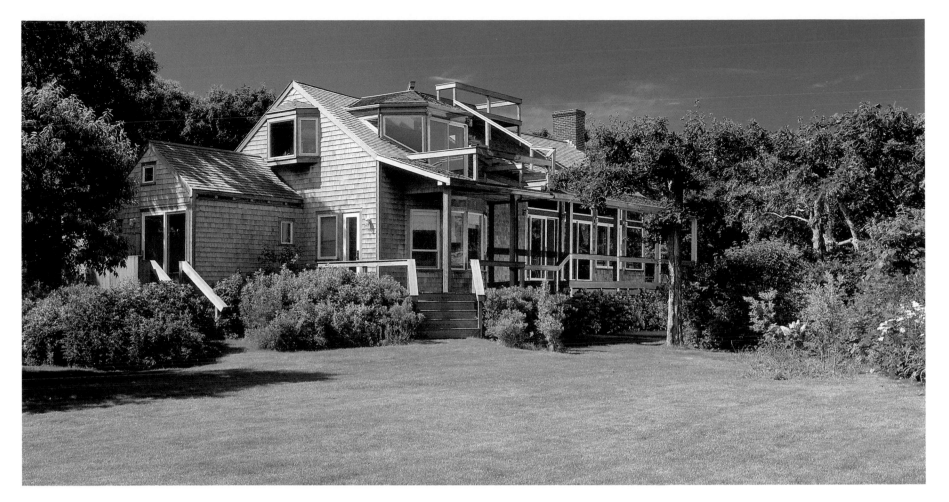

STORY HOUSE

Tucked into a grove of scrub oak at the end of a long sandy lane is this secluded seaside house. It consists of a main structure, nestled under low sheltering eaves, with step-down wings that wrap around a deck courtyard entrance. Built with careful attention to the zoning by-laws for Island shore properties, the house respects both height restrictions and distance requirements from the water. Framed by wind-sculpted oak trees and hydrangeas, a lawn separates the house from the beach. Though built at one time, the house was designed to look as though it had grown piecemeal over the years. The outside walls and roof are shingled in white cedar, while the interiors are crafted from a variety of woods. The floors are ash, the decks fir, and the ceilings cypress over cedar framing.

LEFT: *Behind a canopy of scrub oak leaves is a sunny deck protected from colder sea breezes. A large country kitchen has a generous bay, warmed by the morning sun and opening onto the protected court. The entrance to the house is on the right side of the deck at the top of the steps. The guest rooms are in their own wing on the right.*

ABOVE: *This side of the house faces the sea. Each of the interior spaces has its own individually designed deck and views. On the left is the master bedroom suite connected to the main room, which has generous bay windows and sliding glass doors. The loft study also has a large bay and its own deck—and also the only access to the tiny rooftop deck.*

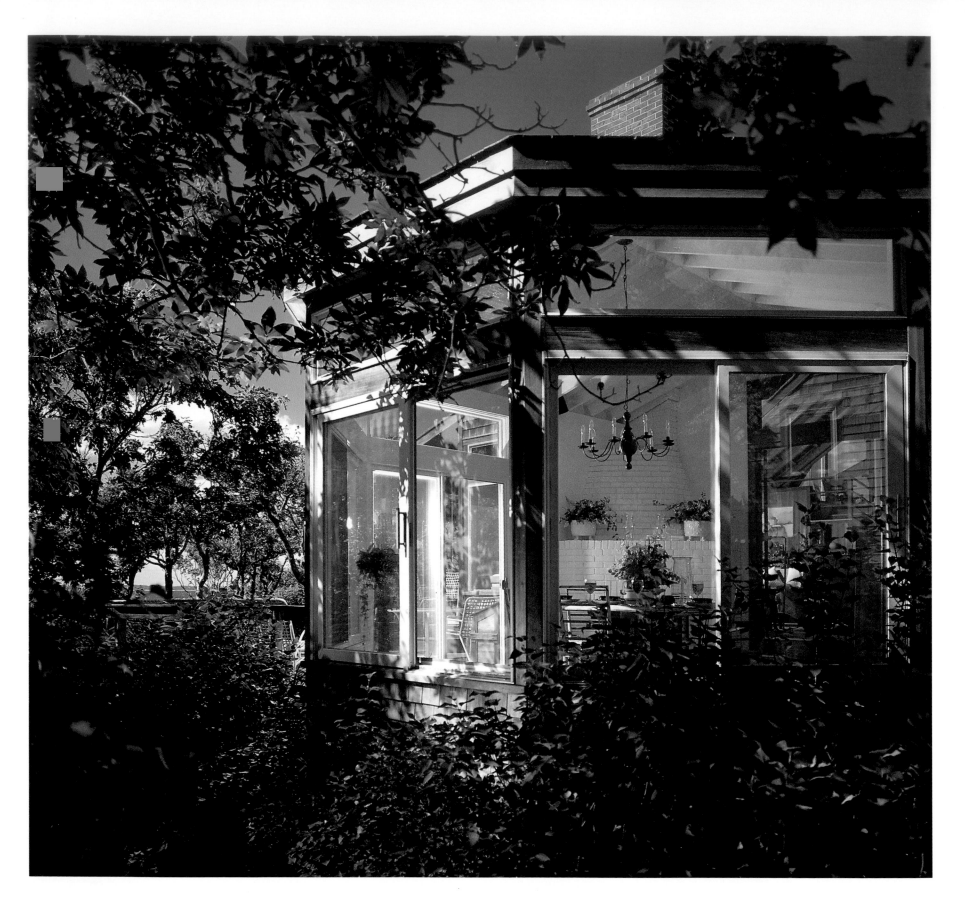

The octagonal dining room on the west end of the house takes advantage of beautiful sunsets and discrete views of the water through the trees. Its fireplace shares a chimney with the fireplace in the main living area, a few steps up on the right.

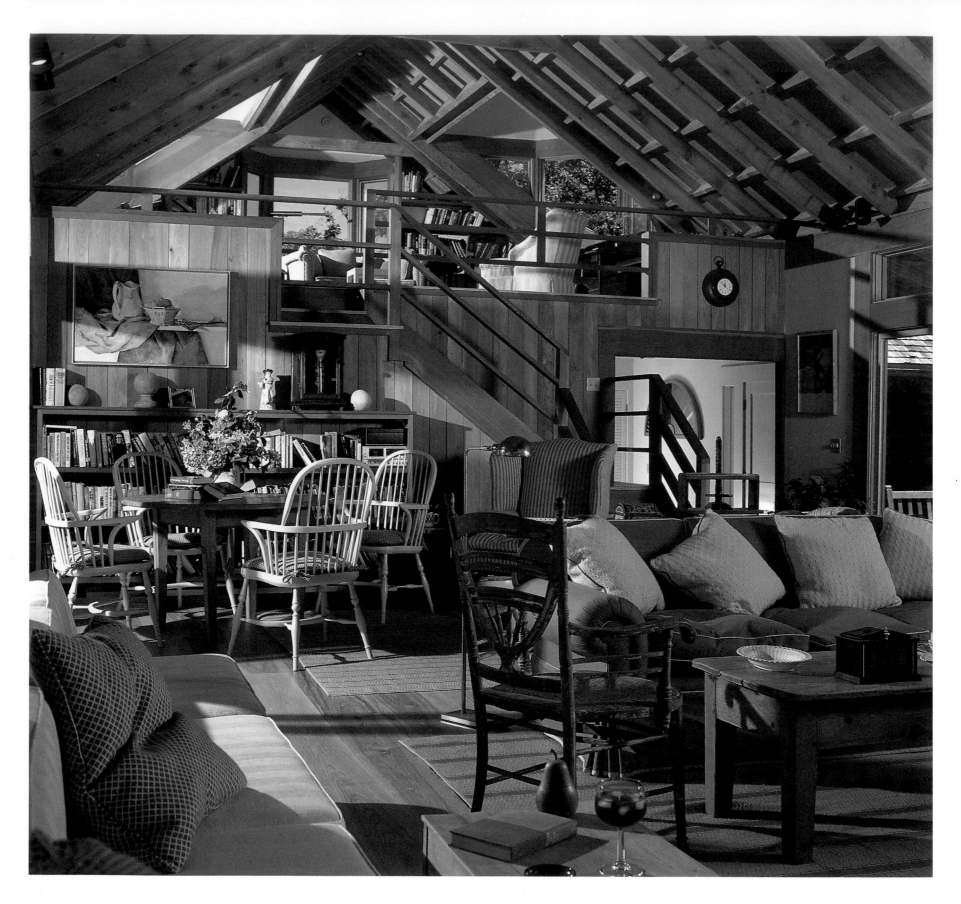

LEFT: *Carefully conforming to height restrictions, the large main room still has space for a loft study on an upper level, tucked beneath the open-beamed ceilings.*

BELOW: *The loft study is open to the living area at the top of the stairs. With bay window dormers on three sides, it is a room with sweeping views of the water and the surrounding countryside beyond the treetops. On the water side the glass door leads to a deck and, via more stairs, even more dramatic rooftop views from a "widow's walk." Comfortably furnished with books, telescope, and antique toys, the study is a wonderful retreat.*

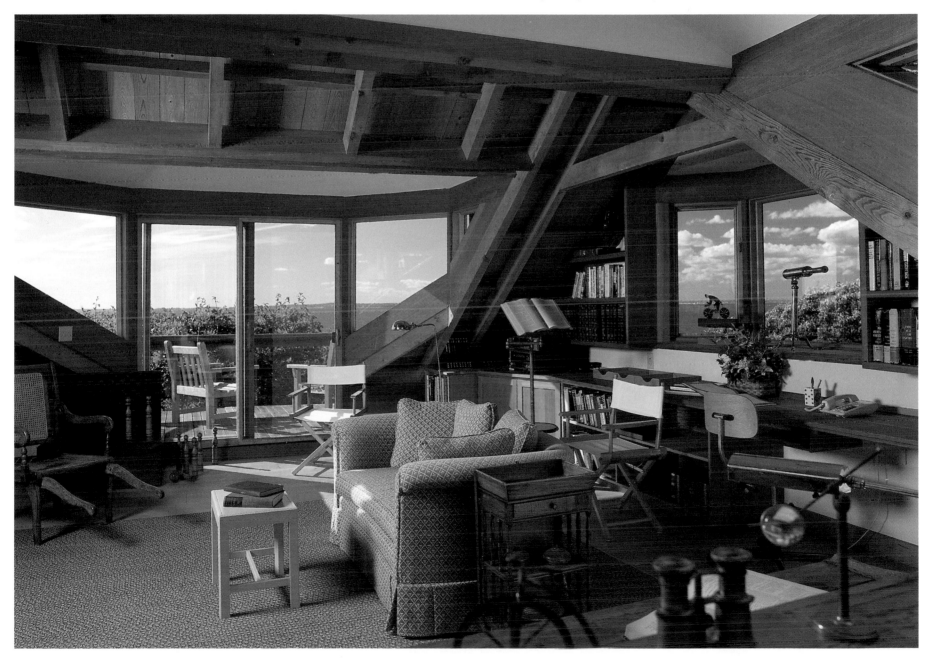

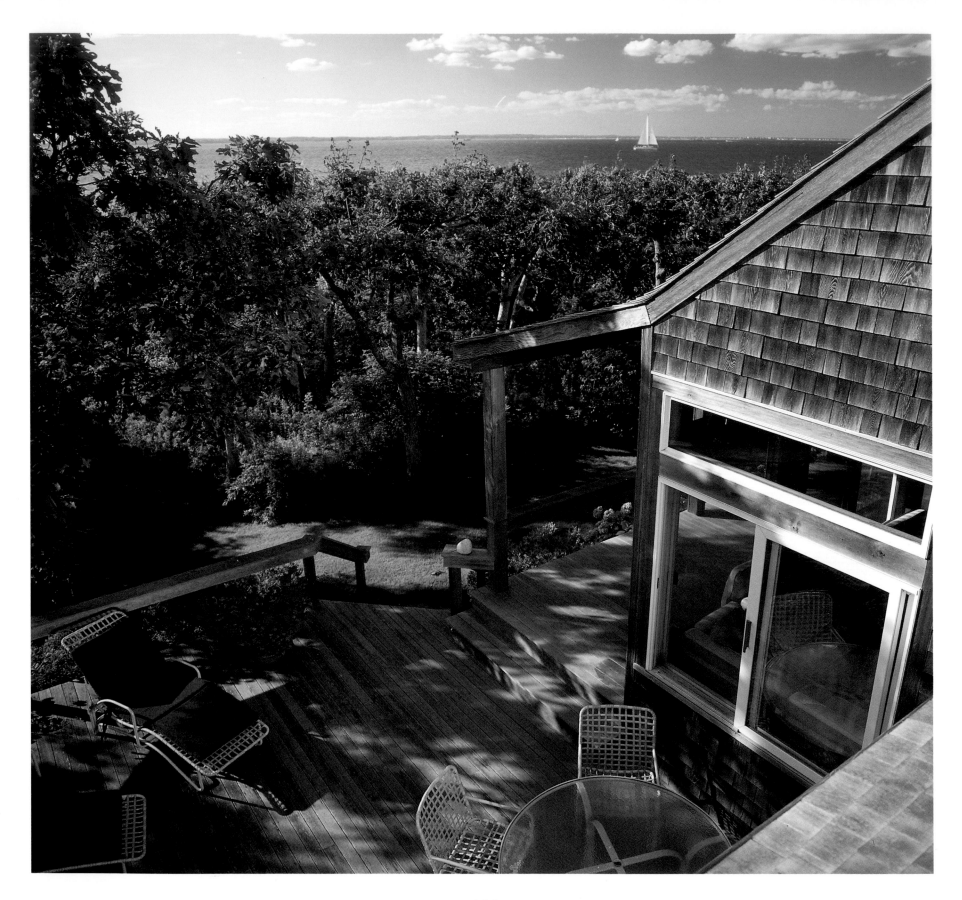

LEFT: *The deck outside the dining room.*

RIGHT: *Reflections.*

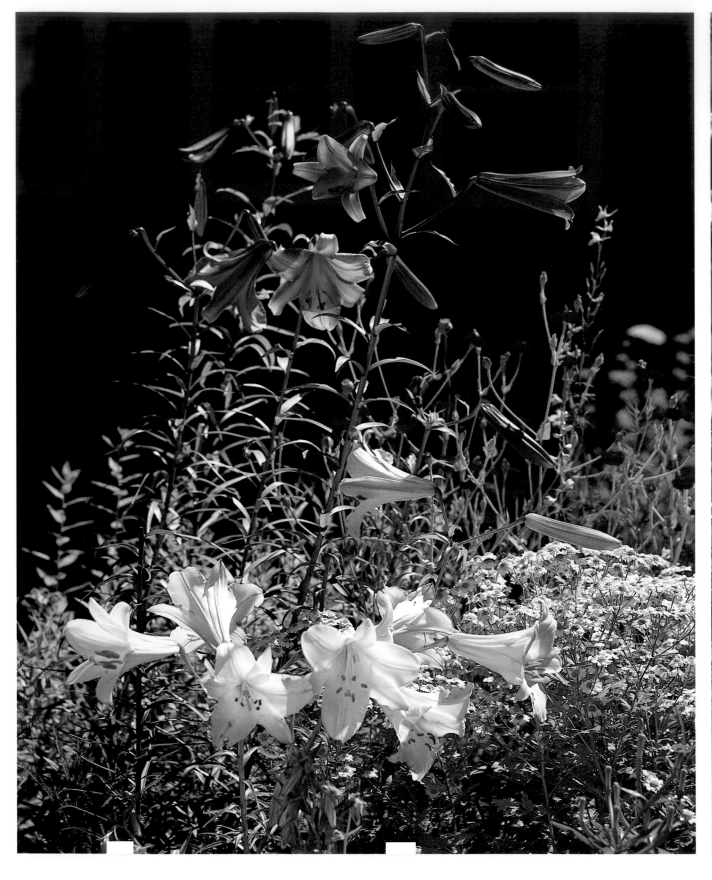

GARDEN QUILT

A working garden with an artist's touch, this tiered garden overlooks Lagoon Pond. Started in 1989, the beds are filled with a wide variety of plants propagated from seeds and cuttings, and some of the varieties are surprises when they bloom. Many of the seeds come from a seed exchange program, and they often come labeled simply "larkspur, mixed" or some other very general description. The owner also exchanges with other gardeners on the Vineyard, always on the lookout for the unusual or interesting.

FAR LEFT: *Two varieties of lilies, the beautiful 'Pink Perfection' and a white 'Regale', flanked on the right by white feverfew* (Chrysanthemum parthenium) *and brilliant* Lychnis coronaria *with its soft gray-green foliage.* LEFT: *Tall larkspur, raised from seed, with a wild sweet pea that adds an interesting color contrast.* BELOW: *The stepped beds overlook the deck of the house, with its tranquil view of Lagoon Pond. From left along the house are montbretia* (Crocosmia x crocosmiiflora), *with foliage that turns bright red in fall, and red and yellow lilies. A little to the right, pots of heath* (Erica carnea) *and heather* (Calluna vulgaris) *grown from cuttings are in front of a bed of larkspur and rudbeckia.* RIGHT: *Teasel* (Dipsacus sylvestris) *dominates this corner of the garden with golden Marguerites* (Anthemis tinctoria 'Kelwayii') *in the background.*

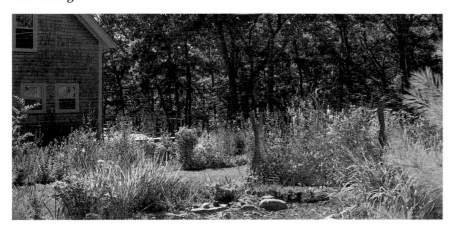

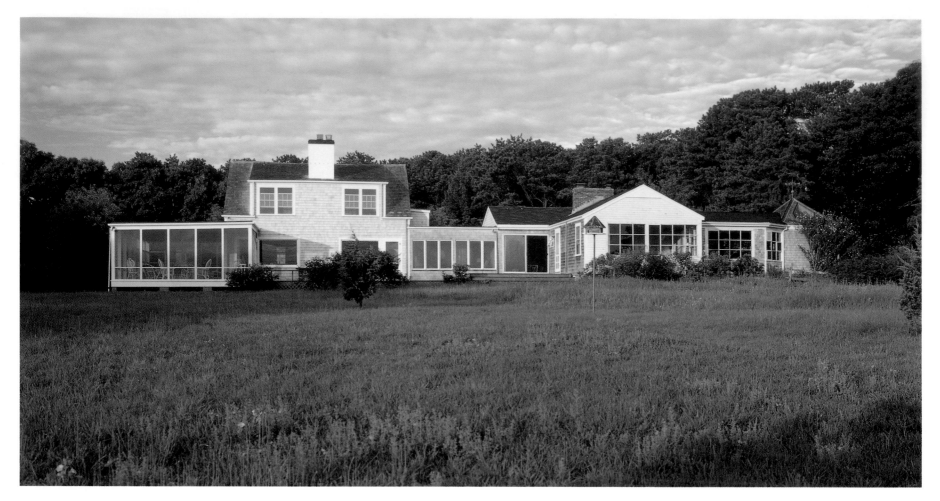

THE BARN

 Katharine Cornell acquired this old Vineyard barn because she wanted to keep her own cow and needed a place for it. Nancy Hamilton, who was Katharine Cornell's secretary as well as a composer and scriptwriter, acquired the barn and renovated it into a house in 1959. Many additions have been made to the structure, which is on the wooded western shore of Lake Tashmoo, a tidal pond that opens into Vineyard Sound.

After Katharine Cornell's husband died, the actress sold her large house nearby and moved here, where she spent the rest of her days. The house is filled with an amazing collection of furnishings and memorabilia. Margaret Lindsay purchased The Barn in 1989 and has carefully preserved its spaces with as many of Katharine Cornell's furnishings as possible.

ABOVE: *The rambling house as seen from the marsh on the water side of the property. The two-story section adjoining the large screened porch is the original barn and comprises the living and dining rooms and the upstairs bedroom. Several bedroom suites on the right are joined to the barn by a modern kitchen–breakfast room area.*

RIGHT: *The multipaned windows with objects from a glass collection displayed on the partitions are part of the kitchen wing. The front door opens into a little entrance hall and then the dining room.*

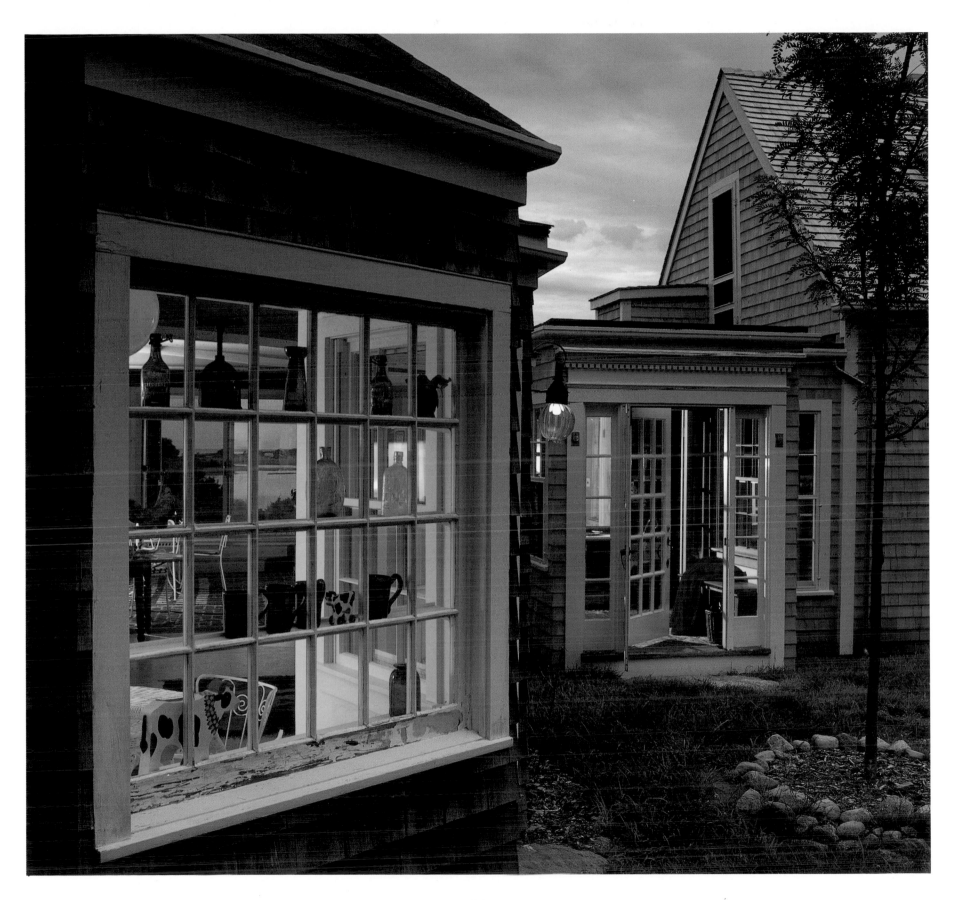

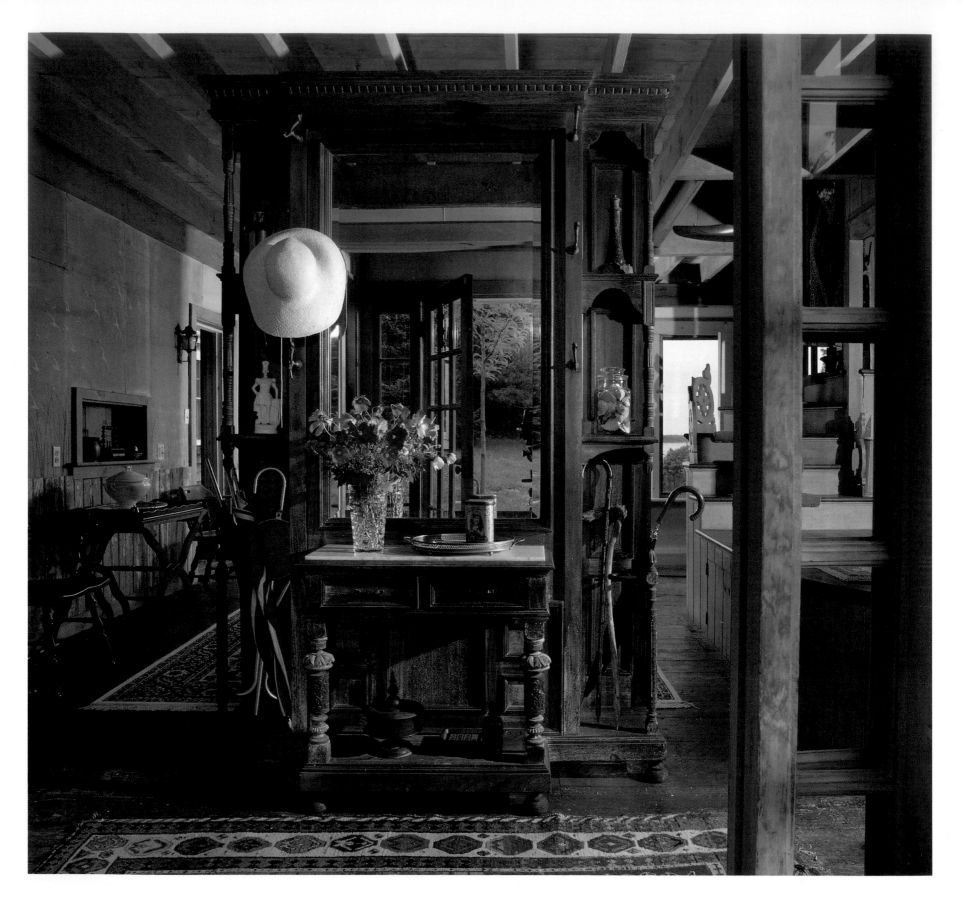

LEFT: *On the left is the side wall of the dining room with a seaside mural painted by Stanley Murphy, a Vineyard artist who also painted the murals in the Katharine Cornell Theatre in Tisbury's town hall. The old Victorian hall bench serves as a divider between the entryway and the dining room.*

RIGHT: *The long living room was formerly part of the old Gay Head lighthouse.* BELOW: *The dining room is separated from the living room by the curved staircase.*

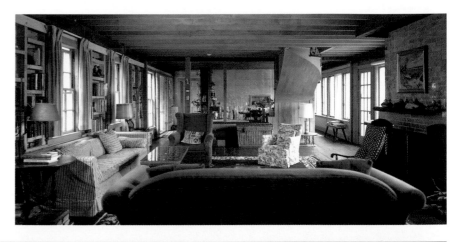

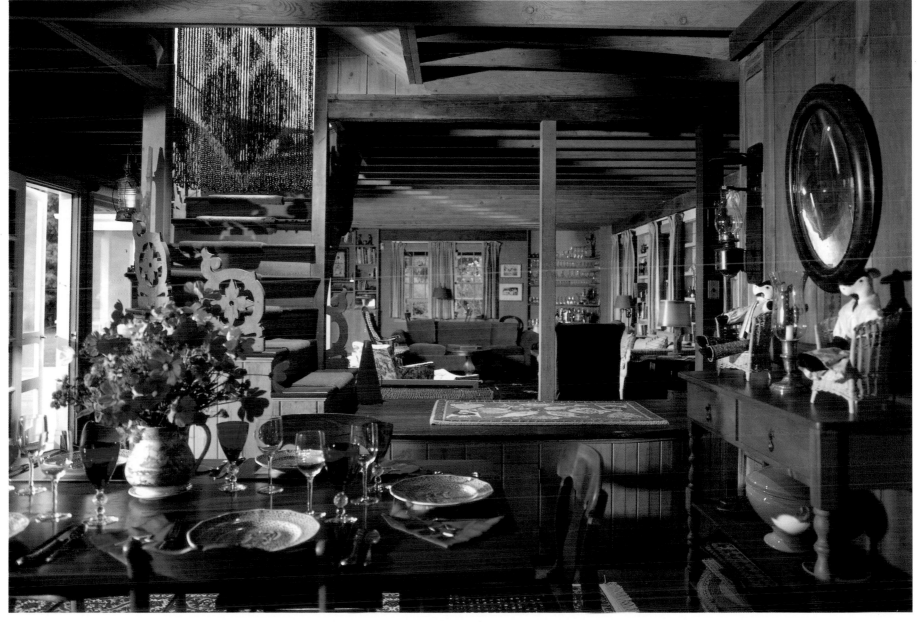

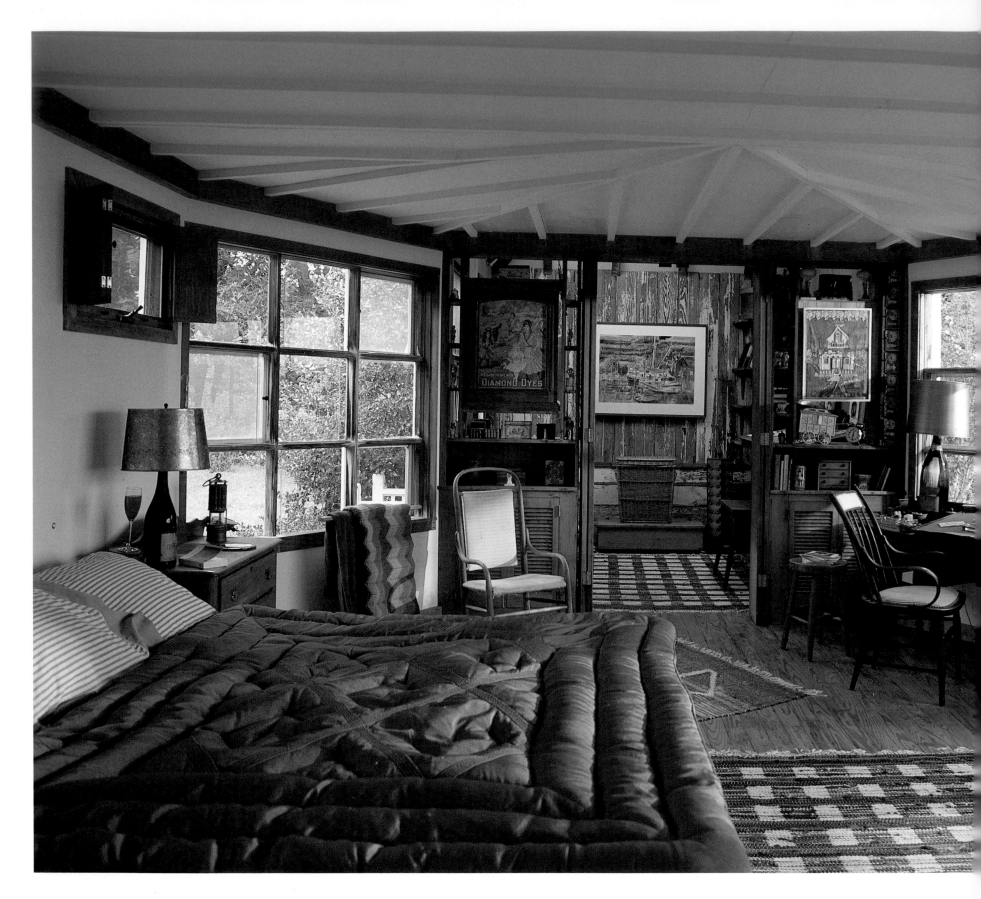

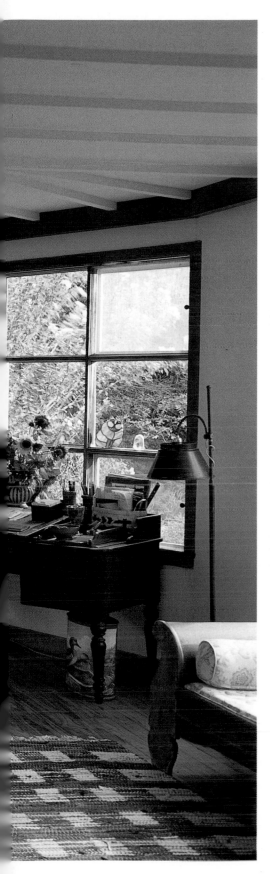

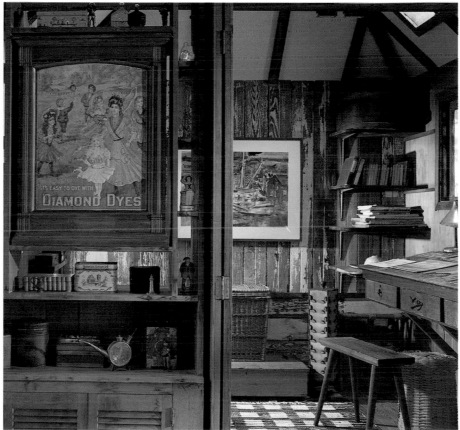

Katharine Cornell's bedroom with her little office beyond. The bay window on the right looks out over Lake Tashmoo. The office was created by the addition of an old shed and is separated from the bedroom by an open cabinet with little shelves that hold more of her memorabilia.

RIGHT: *The living-room coffee table.*

BELOW, LEFT TO RIGHT: *A painted iron doorstop; behind a carved wooden sign made for the original owner is a section of wall containing an inscription and the signatures of all the workmen who renovated the structure, and those of their wives; a ship's model in a niche on the side of the fireplace in the Cole Porter bedroom upstairs; a painted cast-iron fisherman.*

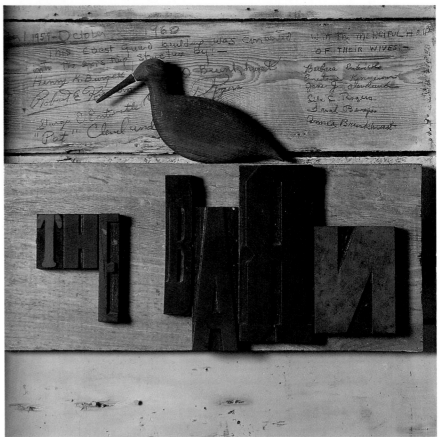

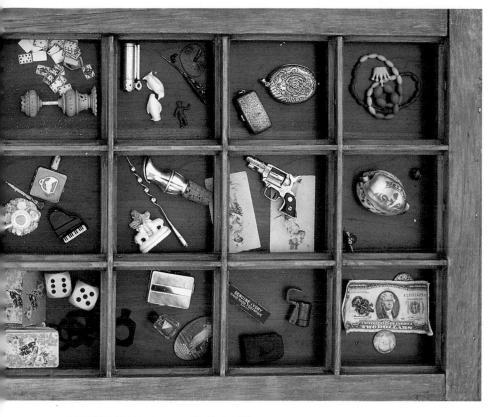

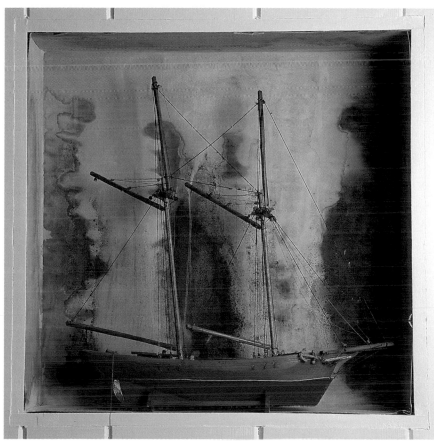

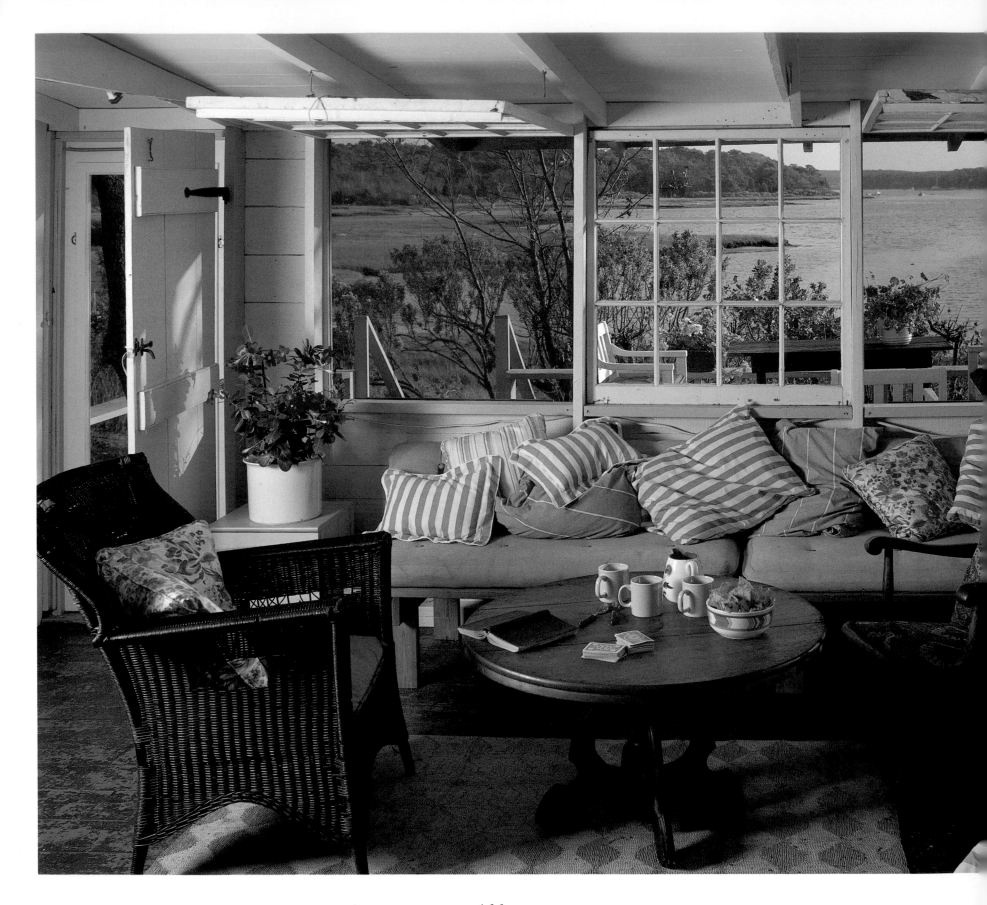

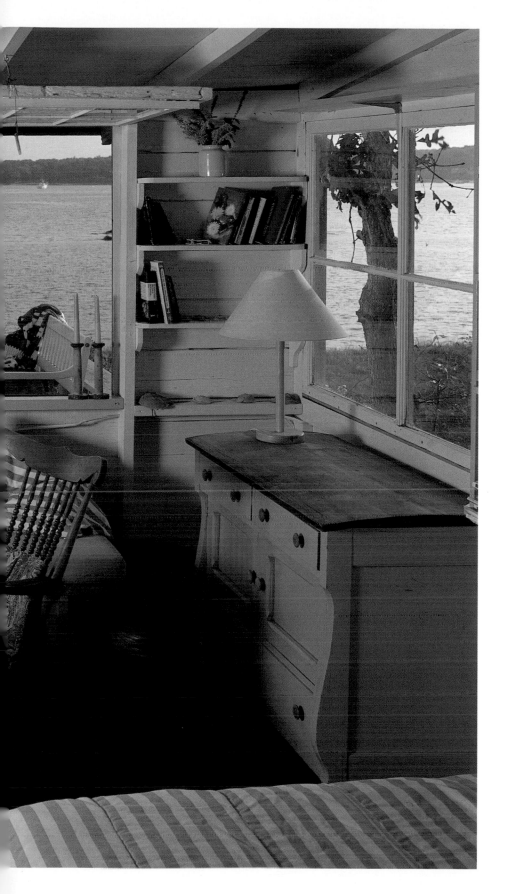

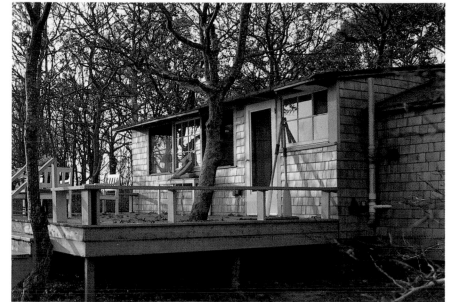

TASHMOO RETREAT

 This tiny camp belongs to Eleanor Hubbard and Geoffrey White. A much-loved little summer cottage, where Eleanor loves to come and paint, it consists of three rooms. Sydna White, an Island artist, built a one-room camp many years ago as her place on the shore, and it grew from there. The cottage is on property that has belonged to her family for over fifty years. Due to the particular curve of the shoreline at this spot, it has a special view of Lake Tashmoo from the north. Set slightly back from the shore under carefully trimmed trees and in typical beach grass and swale, the cottage enjoys all the summer activities of Lake Tashmoo, which is a noted haven for sailors and home to some beautiful boats.

Eleanor and Geoff have carefully preserved the simplicity of the camp with its window-seat couches and unpretentious deck that overlooks Lake Tashmoo by painting it in delicate shades of blue and furnishing it with light colorful fabrics and a rush mat on the floor. It was designed to be a basic little retreat on the shore for summer enjoyment—and it still is.

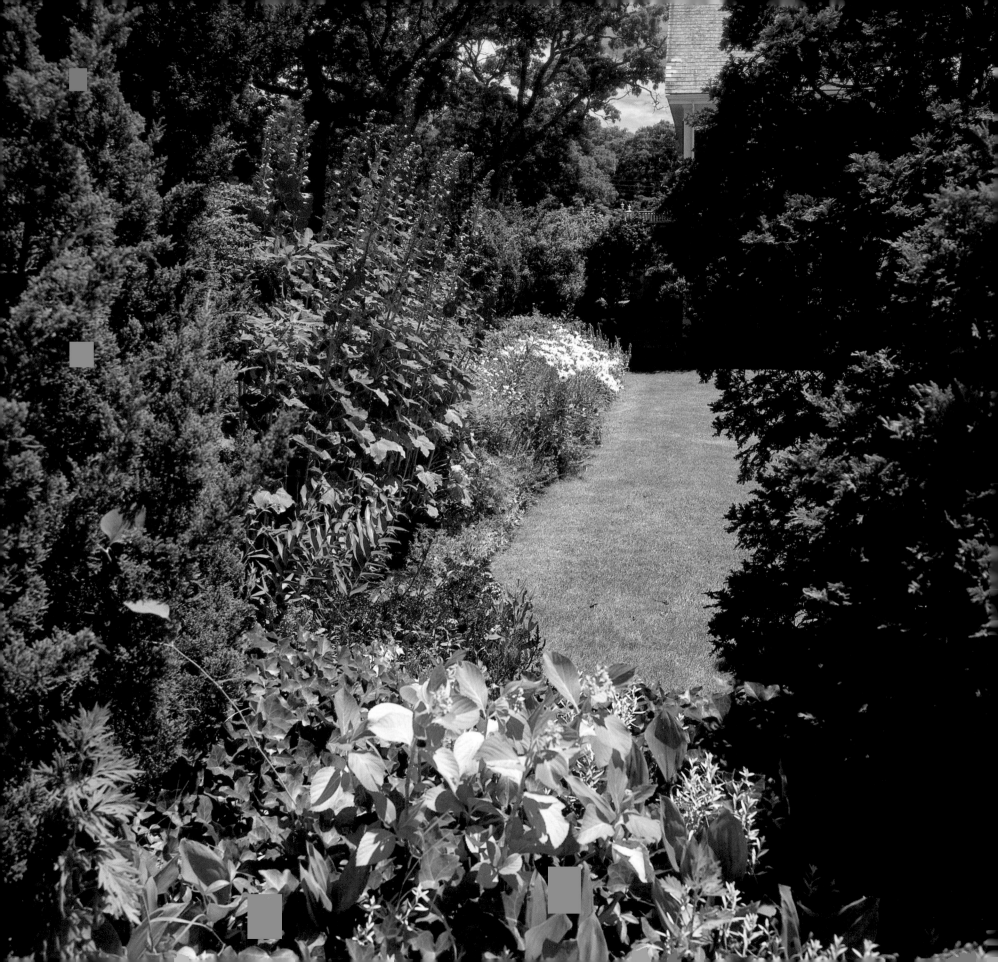

VICTORIAN GARDEN

A garden restoration began when this 1890's house was bought by Dale and Frank Loy in 1979. Remnants of a once grand garden were present in an inner garden that had been a croquet lawn with a formal border. It had become little more than a tangle of weeds. In an upper garden, utilitarian beds for berries, vegetables, and flowers have been redone into cutting gardens for herbs, salad greens, and flowers for the house.

Recovering the garden area meant pulling out all the ivy, myrtle, and sweet peas that had taken over. Then any surviving perennials were lifted and the soil was replaced with new topsoil, seaweed, and manure. A wooden barrier to keep the vines from intruding from the soil level, or at least slow them down, was installed. The surviving perennials, such as *Physostegia virginiana*, lupines, and wild sweet peas (*Lathyrus odoratus*), were then regrouped and replanted with additional old-fashioned flowers such as single hollyhocks (*Althaea rosea*), astilbe, Shasta daisies (*Chrysanthemum* x *superbum*), *Phlox paniculata*, daylilies (*Hemerocallis* hybrids), perennial geranium (*Geranium endressi*), lamb's ears (*Stachys byzantina*), columbine (*Aquilegia* hybrids), Oriental lilies, *Lobelia siphilitica*, *Lychnis coronaria*, liatris (*Liatris spicata*), *Salvia* x *superba* 'East Friesland', and stokesia (*Stokesia laevis*). Black-eyed Susans (*Rudbeckia hirta*) and sweet Williams reseed themselves from year to year.

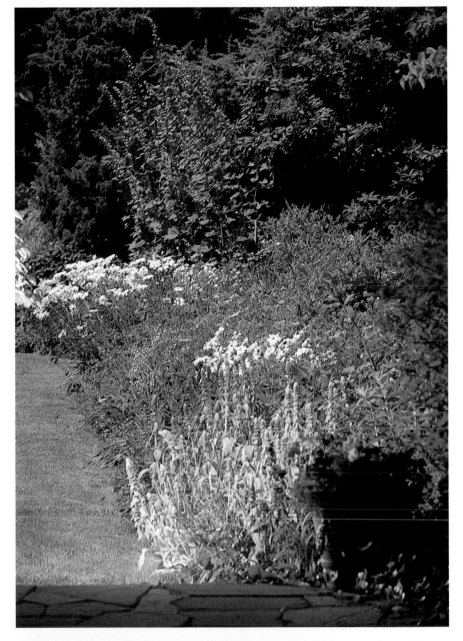

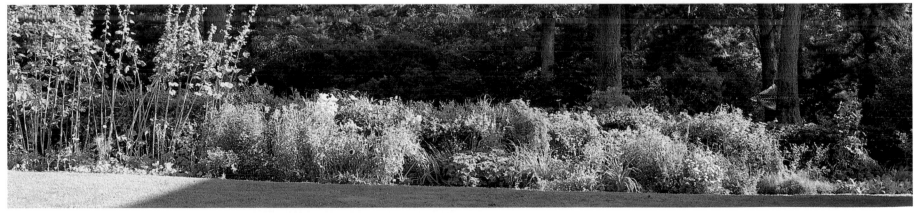

LILY HILL

On the shore of Lagoon Pond sits this lovely rambling house, which was built in the early 1950's. Sara Jane Sylvia bought it in 1978 and has furnished it with antiques, soft mahogany woods, and beautifully patterned prints. It is both rich and warm as well as light and airy. The grounds are wonderfully landscaped with a number of perennial borders. On the water side of the property is a broad expanse of lawn with an extensive border along the side that features globe thistles, lilies in innumerable varieties grown for color and scent, daylilies also in many varieties, and yarrow. The driveway is bordered by rose-covered fences as well as bright perennials, with some-

thing in bloom in every season. Sara Jane began gardening when she bought the property and has planned all the gardens, choosing her plants for color, especially the lilies, which are generally in melon tones, for cutting and bringing indoors to complement her interior color schemes.

RIGHT, CLOCKWISE FROM TOP LEFT: *'Aloha' roses climb the split-rail fence with bright coreopsis* (Coreopsis lanceolata) *and white hybrid daisies in front; daylilies* (Hemerocallis *hybrids*), *mixed with phlox* (Phlox paniculata) *and lythrum* (Lythrum virgatum); *red and white climbing roses; dogwood* (Cornus kousa) *flourishes beside the circular drive.*

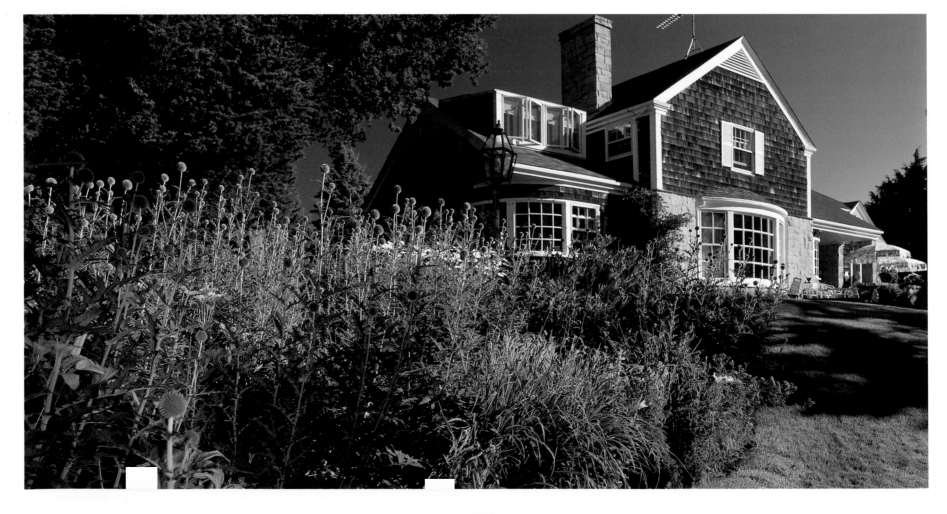

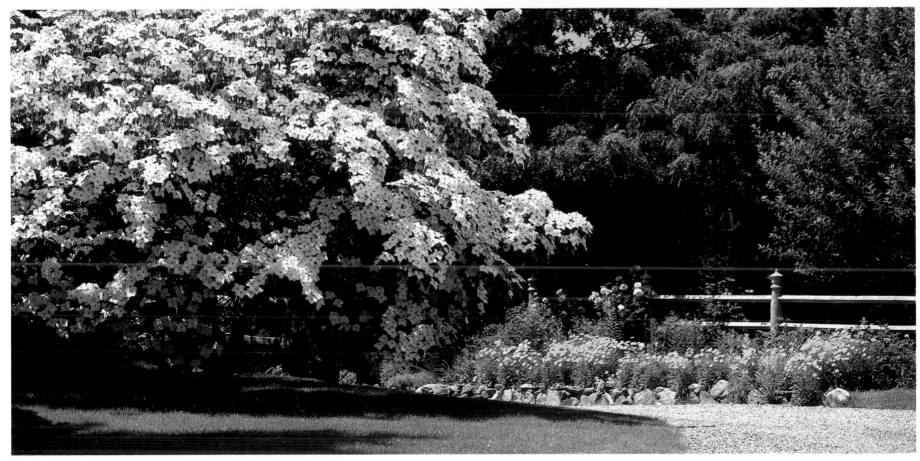

LEFT: *The large windows offer a grand view of the Lagoon from the dining-room table. The Chippendale chairs are covered with needlepoint upholstery seats. The tall-case clock, ca. 1760, to the right of the windows was bought at auction on the Vineyard and is signed by Eaton Sanford, Plymouth, Massachusetts. The china cabinet to the right of the clock holds Sara Jane's collection of Crown Derby china.*

TOP RIGHT: *Above the bombé chest with its whimsical marquetry design hangs a Chippendale mirror, which comes from an Island family. The picture on the wall to the right was originally from Katharine Cornell's townhouse in New York. A collection of antique and family silver is displayed on top of the chest.*

BOTTOM RIGHT: *A Victorian loveseat and chair furnish this corner of the living room. The little drop-leaf table with claw feet holds a collection of Rose Medallion china and an overlay lamp with a glass front.*

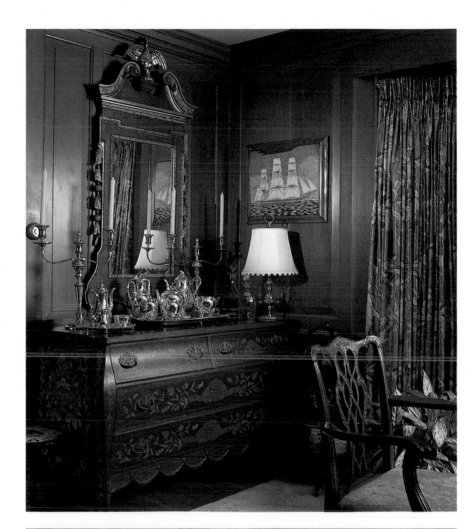

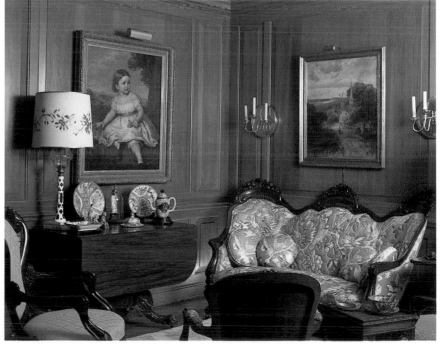

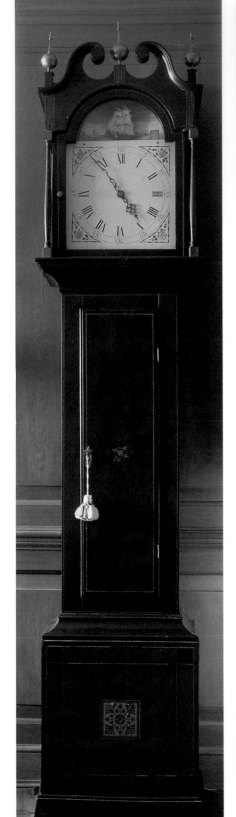

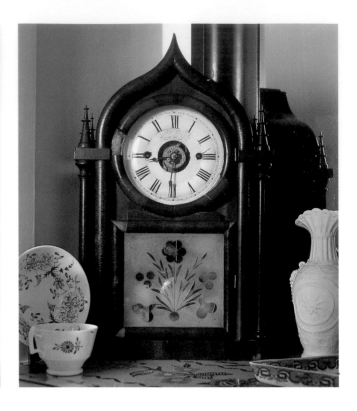

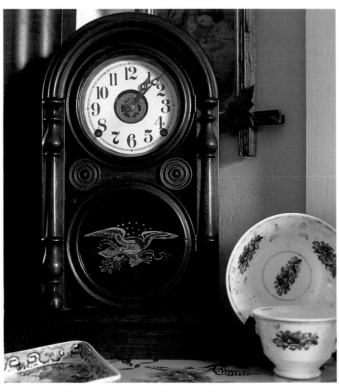

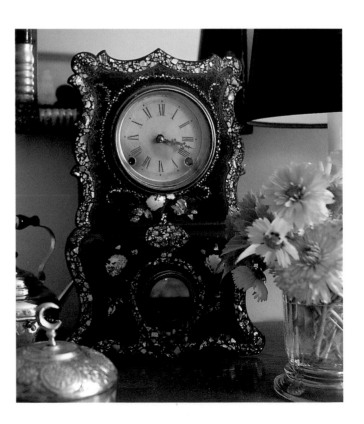

CLOCKWISE FROM LEFT: *The tall-case clock, ca. 1850, has a rocking ship above the face; a Seth Thomas clock, date unknown; a twelve-day double-steeple clock with etched glass, signed "J. C. Brown, Bristol, Connecticut," from the first half of the nineteenth century; clock of papier-mâché and mother-of-pearl inlay, ca. 1830; clock in a gothic case with eagle emblem, date unknown.*

RIGHT: *A collection of Staffordshire figurines is grouped beneath a sconce with an old blue glass shade and a gilt mirror.*

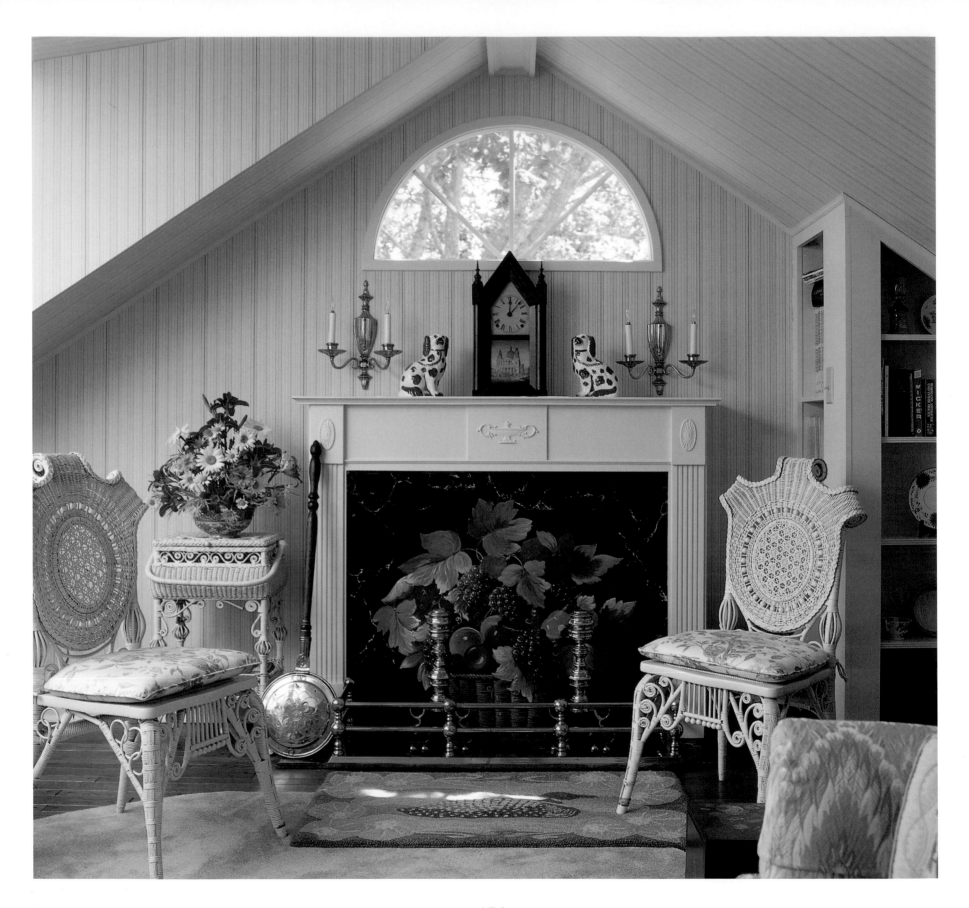

LEFT: *Antique wicker furniture gives the upstairs sitting room a light summer look. On the mantel is a steeple clock, part of the collection of antique clocks Sara Jane inherited from her mother.*

BELOW: *The little gazebo on the lawn is decorated with baskets of hanging geraniums. The long border is backed by arborvitae* (Thuja occidentalis) *and rose of Sharon* (Hibiscus syriacus). *Beach plums* (Prunus maritima) *alongside the Lagoon frame the shoreline.*

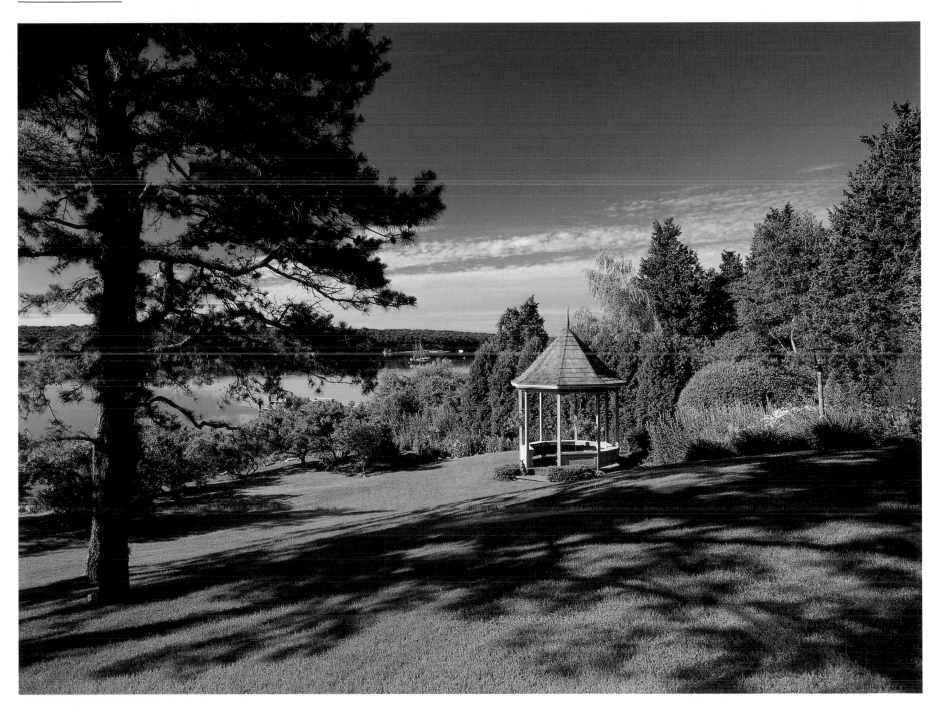

ABOVE: *Several varieties of daylilies, globe thistles* (Echinops ritro), *lilies* (Lilium *hybrids*), *and Montauk daisies are prominent in this bed overlooking the Lagoon.*

BELOW: *Another border backed by a grape arbor holds more hybrid lilies and* Lythrum virgatum, *mixed with daisies for contrast.*

RIGHT: *A hardy Asiatic lily* (Lilium *'Fox Trot'*).

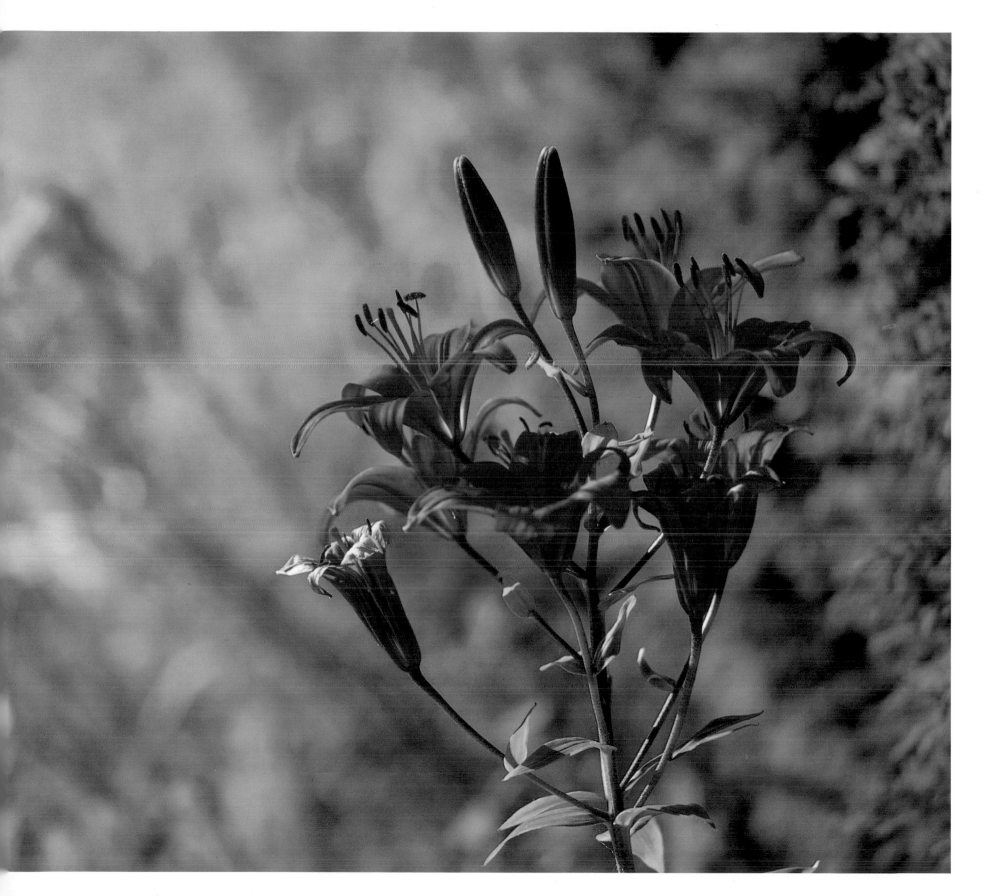

UP-ISLAND

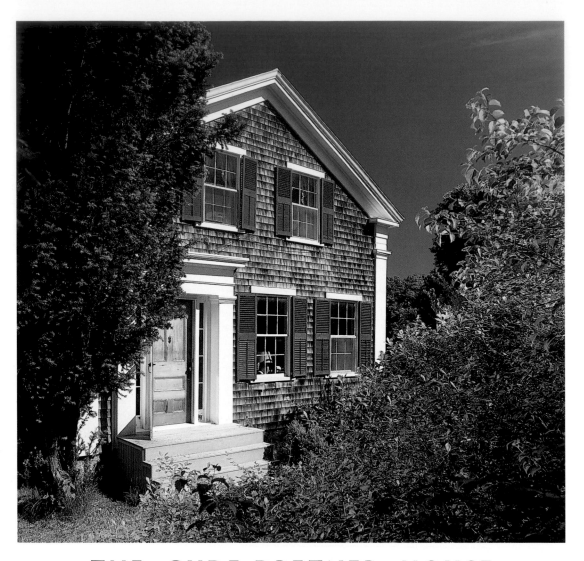

THE GUDE-DREZNER HOUSE

Sometime in the mid-1800's, Captain Austin Smith retired from the sea and took up farming. In 1847 he built this half-Cape in Chilmark. In 1941, John and Helen Gude bought the farm and spent summers here until they moved to the Vineyard year-round. The Captain's house has been carefully restored to its present state. The original barn was struck by lightning in 1931, and the Gudes rebuilt it as a working barn soon after they bought the property. The Gudes' daughter, Liz, and Michael Drezner moved to the Vineyard in 1980, and since then they have renovated the barn, making it a passive solar home. On the property are colossal stone walls, which were part of the old farm enclosures. Beautiful old trees, including several varieties of fruit trees, along with gardens backed by stone walls, wildflower fields, and newly planted fruit trees make the farm an especially appealing site.

The main house is set back from the road behind stone walls in a stand of ailanthus trees. The front door has been stripped down to its natural pine and the shutters have been painted dark red. Liz and Michael have restored the interior room by room, carefully retaining as much of the original house as possible.

RIGHT: *The backdoor to the captain's house leads to the kitchen.*

BELOW: *Flowering crab apple shelters the farm gate that leads to the yard of the captain's house. The granite gatepost was set in the 1800's and is typical of many on the Island.*

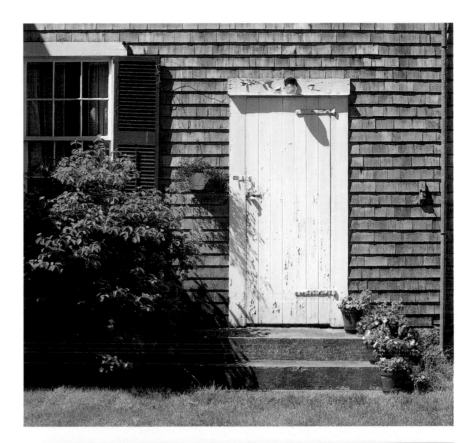

RIGHT: *This substantial stone wall is more than 6 feet high and encloses what is known as the bull lot. It is particularly interesting not only because of its intricate pattern of large boulders interlaced with small stones but also because the outside of the wall, seen here, has finished surfaces while the inside is rough-cut.*

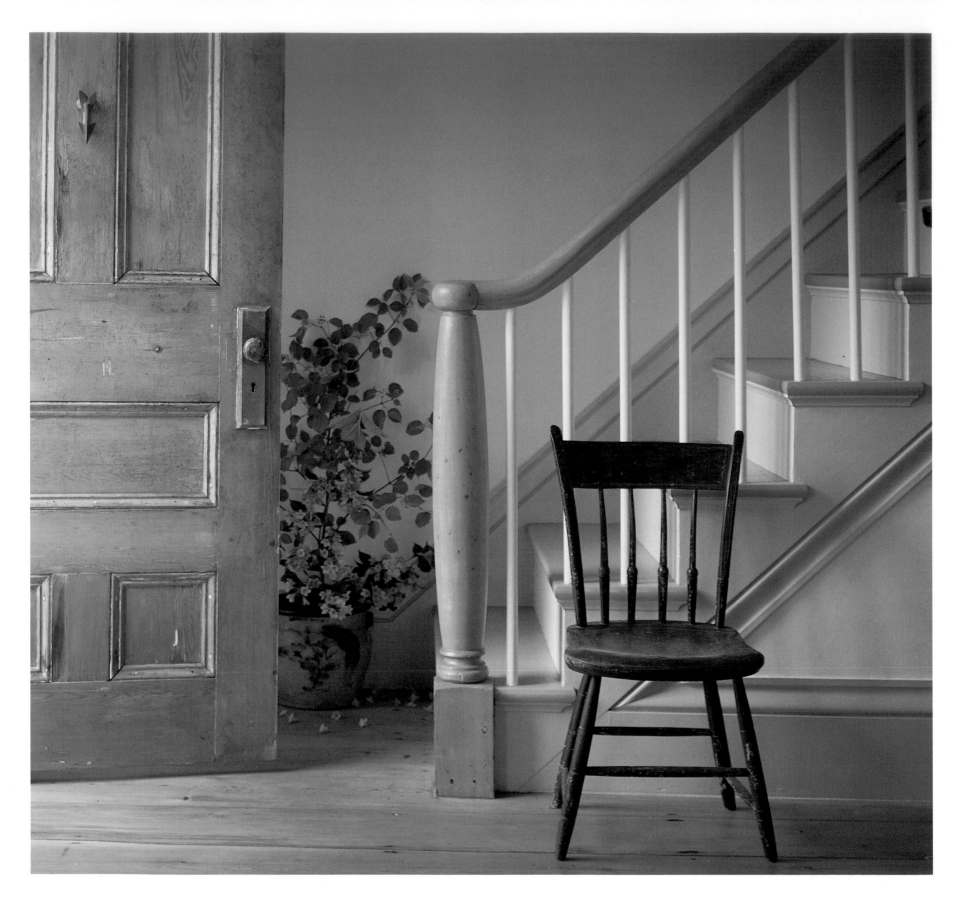

LEFT: *Immediately inside the front door is the stairway. The banister, which had been painted with many layers of brown paint and darkened with soot to imitate walnut, has been stripped to reveal the original pine. The walls, stair rails, and stair treads have been painted in subtle shades for an interesting effect. The wide pine floorboards are original.*

RIGHT: *The captain's house at dusk as seen through two sets of old farm gates.*

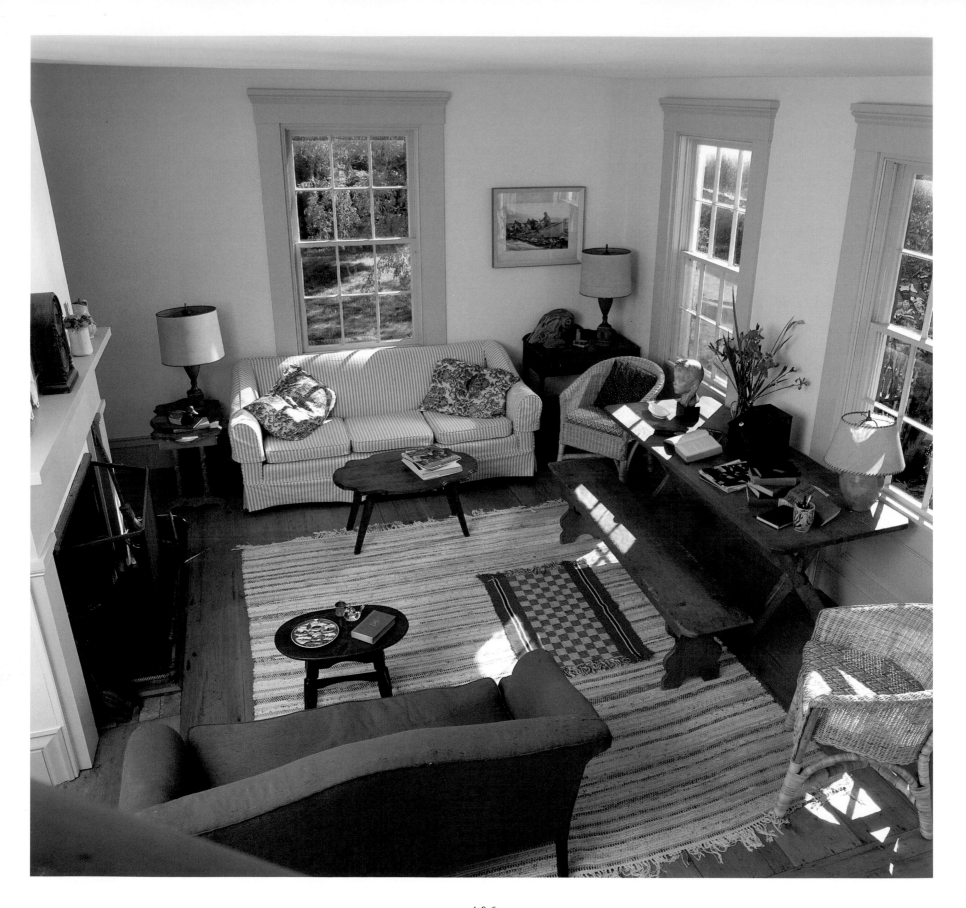

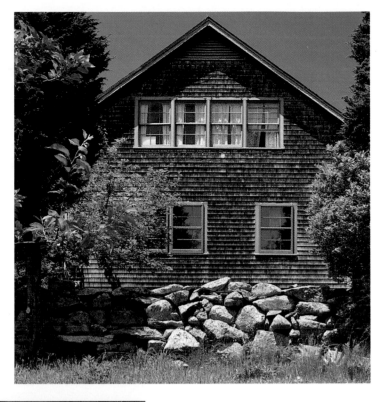

LEFT: *The living room has been furnished simply and comfortably. The only major alteration was to take out a wall that had divided this into two rooms.*

RIGHT: *The exterior of the barn behind its low stone wall.*

BELOW: *Behind the barn is an enormous field of wildflowers. In early June, it is a sea of daisies accented by an occasional lupine.*

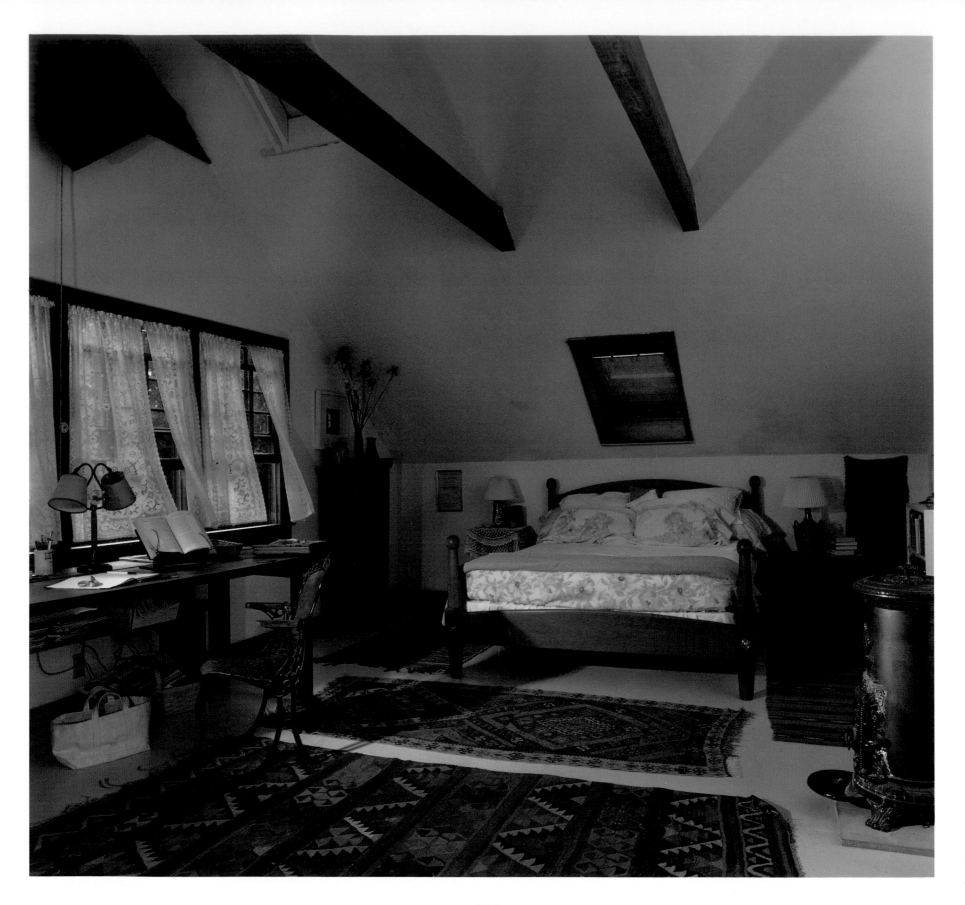

LEFT: *Upstairs in the barn is this bright and spacious bedroom, which doubles as a workspace. The abundant windows and skylight furnish lots of light and air in the summer months, while the little Godin stove, which burns both wood and coal, keeps it toasty warm in the colder seasons.*

RIGHT: *This little upstairs bedroom was part of an original apartment in the barn. It too gets plenty of light, through the window over the door.*

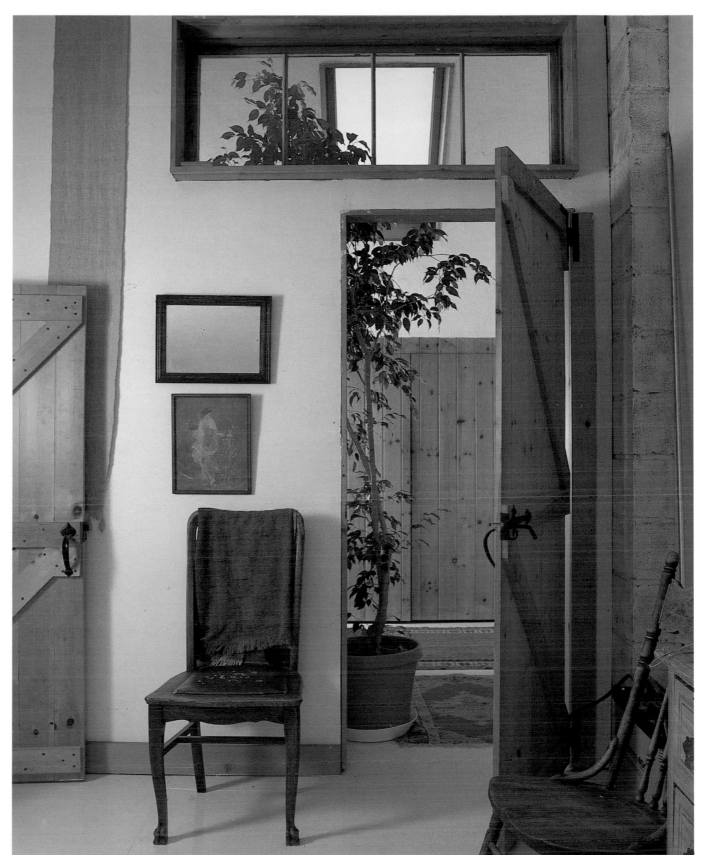

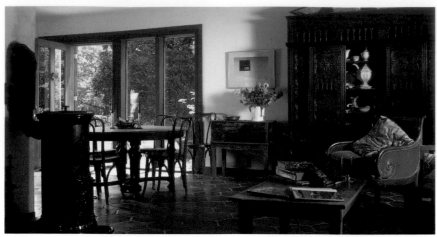

ABOVE: *Mexican terra-cotta tiles add warmth to the living area of the barn, furnished with an interesting mix of antiques such as a Brittany bed that functions as a hutch.* RIGHT: *The kitchen window overlooks a wildflower meadow, stone walls, and fields beyond.* BELOW: *A photograph by Raymond Kellman, taken in Yugoslavia, on the wall above an old painted chest from Durango, Mexico.*

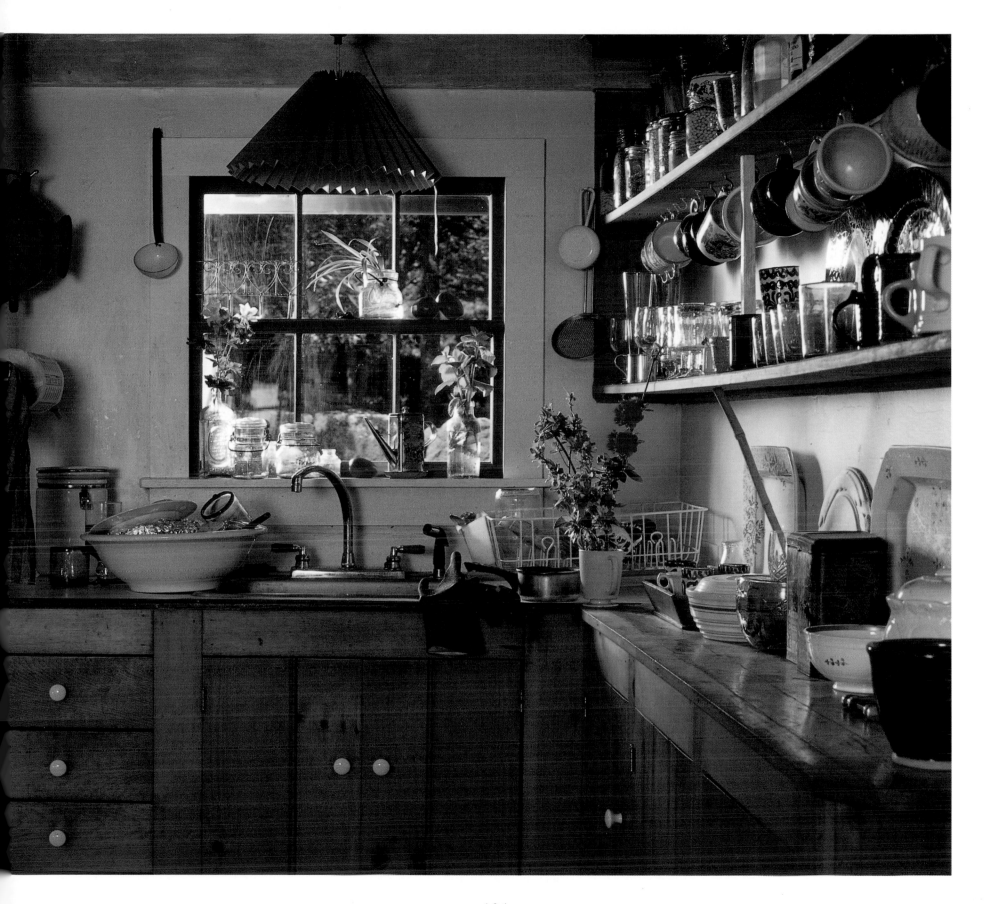

Ten years ago when Nina and Herman Schneider bought this property, it was an unassuming rectangular lot with not much growing on it but locusts, briars, and poison ivy. It did have a lovely south-facing view of the Tiasquam River, the only "river" on Martha's Vineyard. First they cleared the lot for airiness and space to emphasize the water vista. Heavy evergreens were used to create curves in the angular lot. Clumps of colors, hedges, and circular and elliptical beds with repetitions of large evergreens, such as junipers, mugo pines, hollies, and boxwood, establish the strong basic shape and give the garden year-round interest with texture and eight months of continuous bloom. Near the house is a narrow English-style garden with rich colors and quite a formal arrangement of brick paths, terraces, and evergreens.

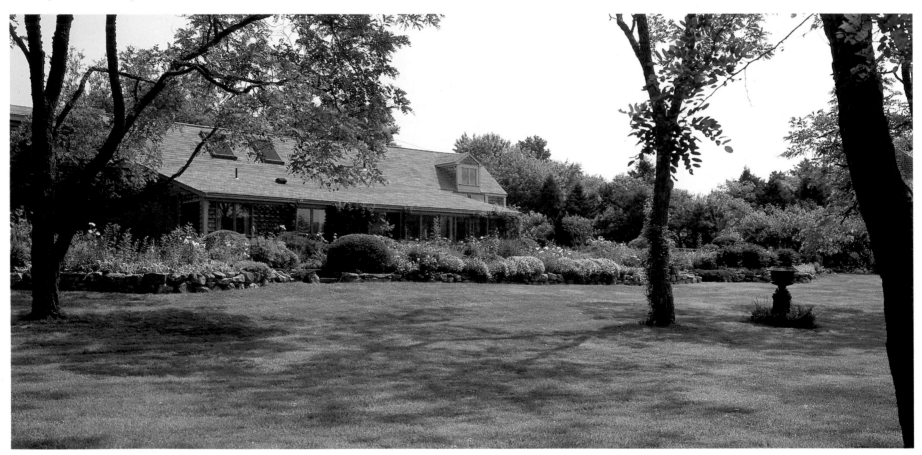

RIGHT: *Only the tops of the willows were visible above the tangle of poison ivy and debris when the Schneiders first acquired the land. Now the property is planted for an ongoing color display to be seen from the dining-room windows. In June the evergreen walk is lined with yellow willows and lilies overarched with swamp maples. The island is reached by a small footbridge.*

OVERLEAF: *A stepped-down terrace of mixed materials—irregular bluestone, local bricks, and fieldstone—allows for functional social spaces within the formal garden. Strictly defined brick paths within the flower garden and among the massive mugo pines and boxwood give the winter garden both color and shape. Masses of 'Fairy' roses are planted near the house for fragrance and color and because they bloom until frost.*

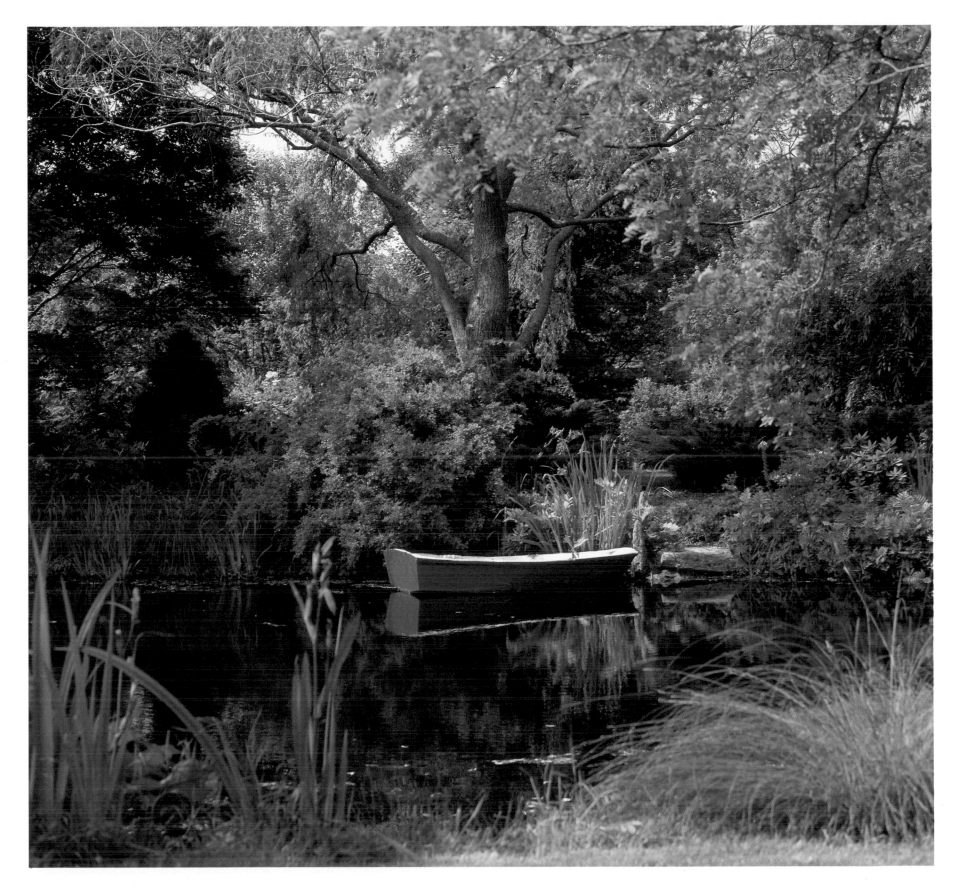

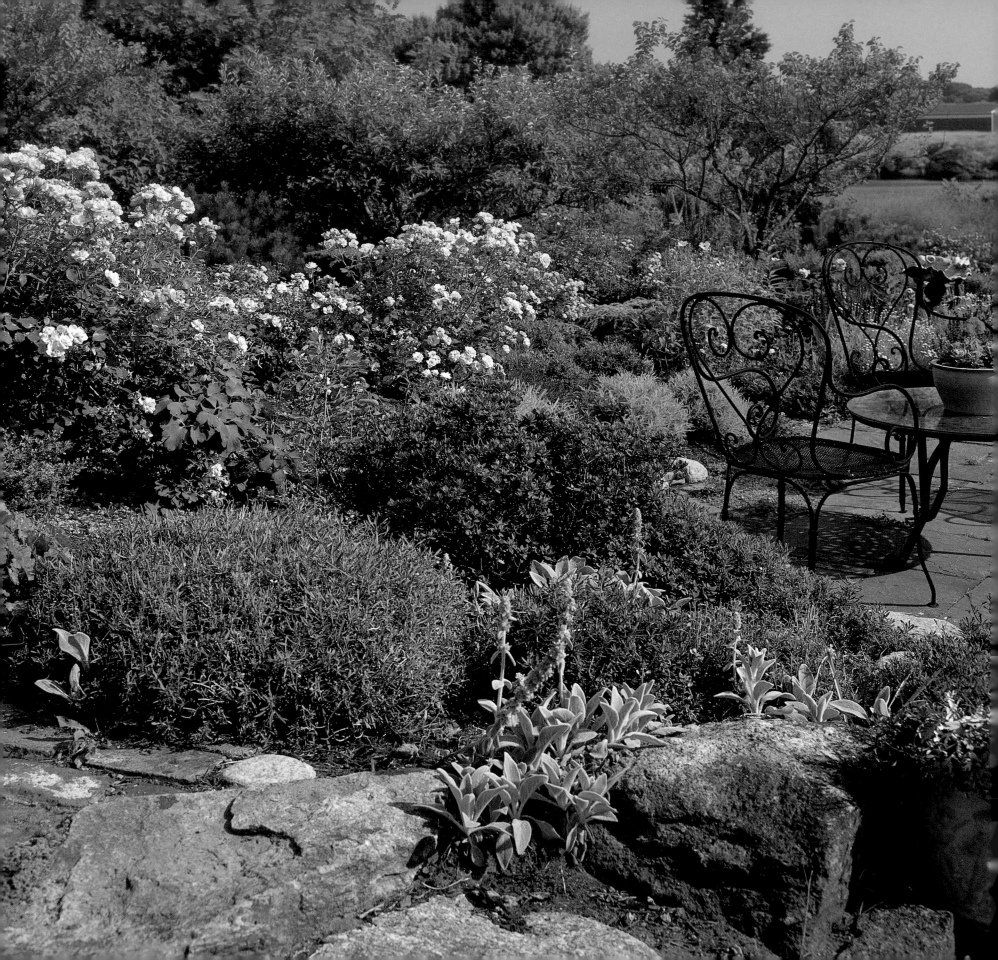

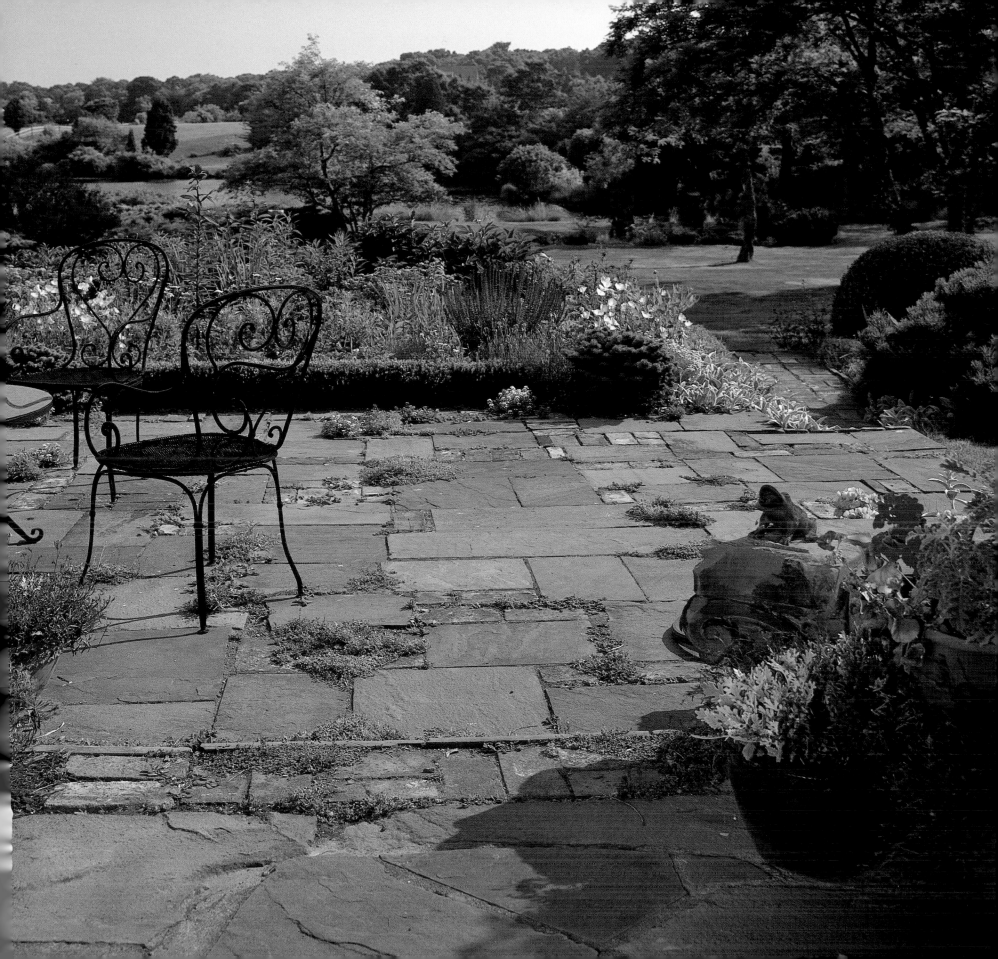

LEFT: *Part of the raised rear border uses gray lamb's ears* (Stachys byzantina) *to create an underlying holding color. Lilies predominate in July and early August, are interspersed with blue balloon flower* (Platycodon grandiflora), *and are accented by a splash of pink annuals.*

RIGHT: *Dwarf boxwood frames this border featuring the blues and purples of ageratums, bellflowers* (Campanula persicifolia), *and* Centaurea montana, *accented with pink foxglove* (Digitalis purpurea) *and pale yellow zinnias. In the background are pink 'Fairy' roses.*

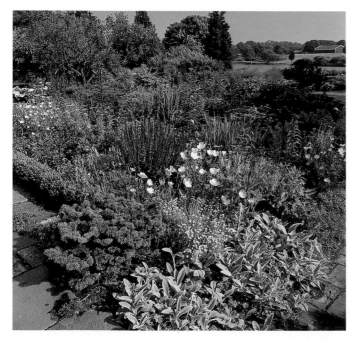

BELOW LEFT: *A view of the front border with the Tiasquam in the background. Dwarf arabis angles into the walk in front of the dwarf boxwood, offset by gray lamb's ears* (Stachys byzantina), *pink primrose* (Oenothera speciosa), *pink Marguerites, blue scabiosa* (Scabiosa caucasica), *and lavender. Pink and red roses are scattered with pink bee balm* (Monarda didyma).

RIGHT: *Astilbe.*

FAR RIGHT: *'Fairy' roses and* Santolina ericoides, *which stays green all winter.*

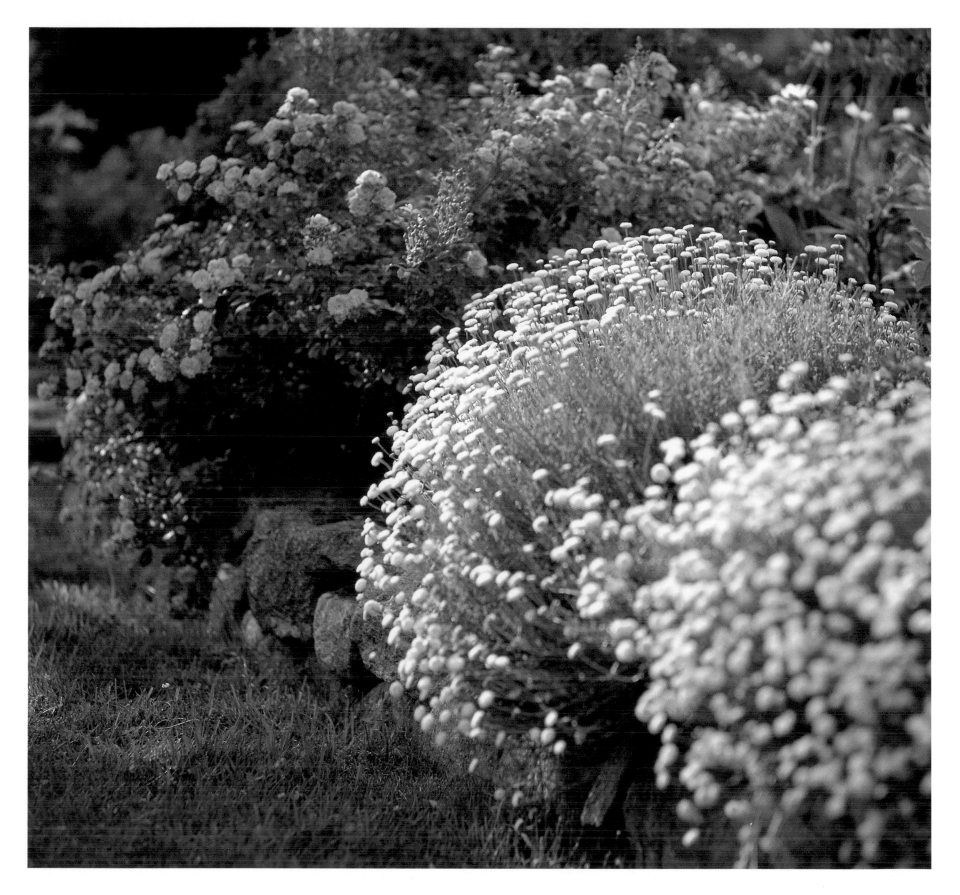

SUNSET VISTAS

High on a hill on the North Shore, overlooking Vineyard Sound, this contemporary house, built in 1983 for Richard and Sally LaRhette, combines an openness to magnificent views of the sea with snugness and comfort inside. Two of the priorities in the design of the house were light and lots of air. Open to the outside with sliding glass doors, windows, and skylights, the house is filled with light even on the grayest of winter days. Inside, cozy fireplaces and protected spaces provide a feeling of intimacy. Each bedroom is actually a suite in itself, private and completely separate from the others with its own bathroom and deck. The grounds are landscaped with the textures of soft shades of whites, grays, and greens. In spring, cascades of white wisteria cover the deck on the living-room end. On the driveway side of the dining room is a sheltered deck that makes a lovely breakfast space. Around the main entrance is another partially enclosed deck—with an outdoor shower.

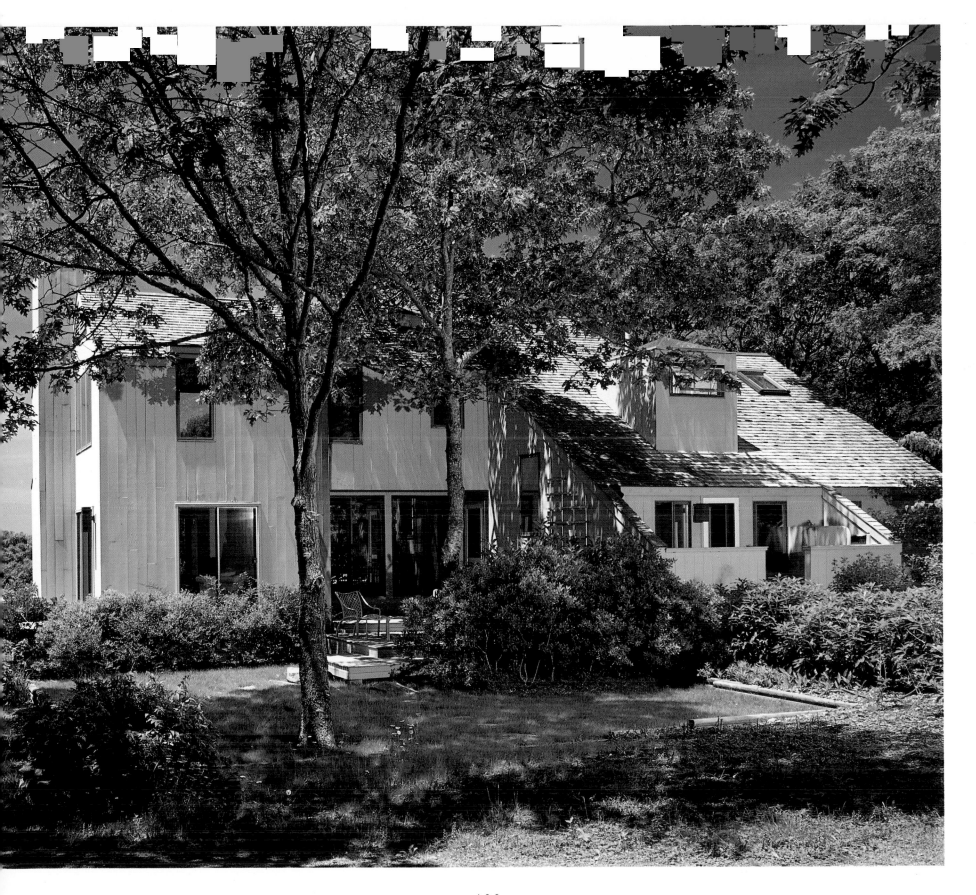

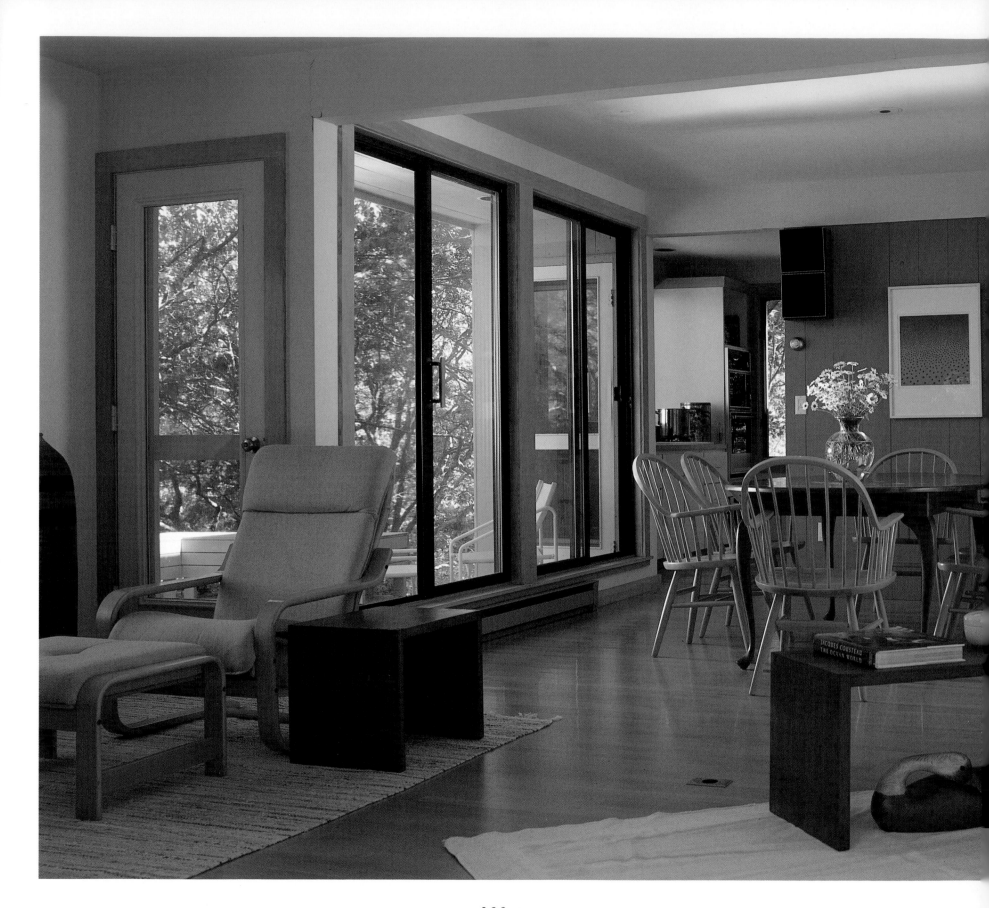

LEFT: *The living and dining rooms are simply and comfortably furnished. The dining room, open on two sides with sliding glass doors, can feel like a screened porch, suspended between a morning deck on the sheltered side of the house and a large deck on the sea side with superb sunset panoramas. On the far wall is one of a series of silk screens by Umberto Faini. Another one of the series is in the hall behind.*

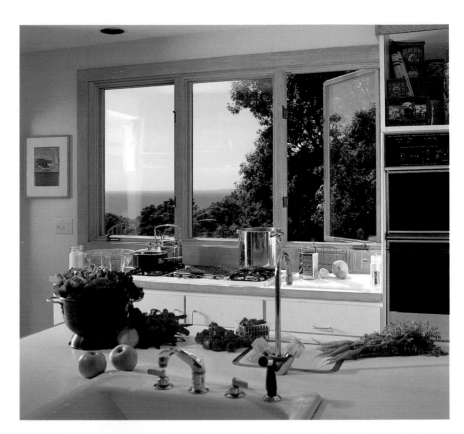

RIGHT, TOP: *Sally's kitchen overlooks both her herb garden and the tapestry of gardens sloping down the hillside toward the sea with glistening Vineyard Sound in the distance. Sally not only loves to cook but also teaches cooking. Her kitchen is designed to combine cooking and entertaining while enjoying views of the sea from the windows over the stove. The center island provides work and clean-up space for any assistants. It also opens into the living spaces of dining and living rooms.*

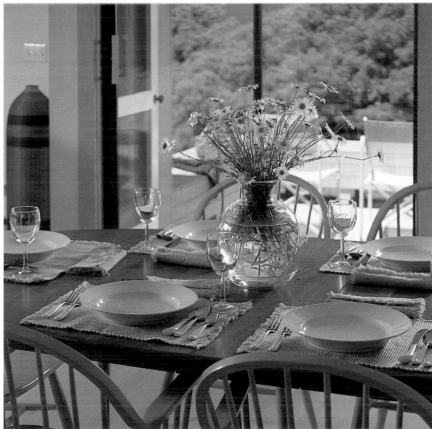

RIGHT: *On a late June afternoon the cherry dining-room table by Jos. VanBenton, of Brookline, Massachusetts, is set for dinner in anticipation of a sunset meal.*

LEFT: *An upstairs shower is brightly lit by its pyramidal skylight.*

BELOW LEFT: *The coziness of this small bedroom is enhanced by the deck on the far end of the room and the light from skylights overhead, which also allow a view of the stars at night.*

RIGHT: *Sunny and cheery, the master bedroom with its large sun deck is beautiful at sunrise, when the Elizabeth Islands across the Sound glow pink in the early-morning light. The fireplace was designed and built by the LaRhettes' architect.*

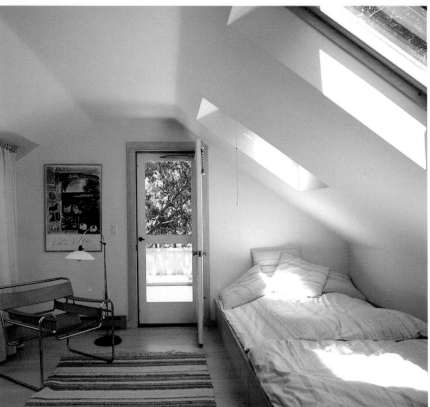

LEFT: *A view of the house as approached from the drive shows the living room and dining room above the garage with the morning deck outside the dining room. The tall, narrow window above the deck lights the stairway leading to the upper floor.*

RIGHT: *The large dining-room deck overlooking the herb garden, the tapestry of the planted hillside, and the vegetable garden in the distance.*

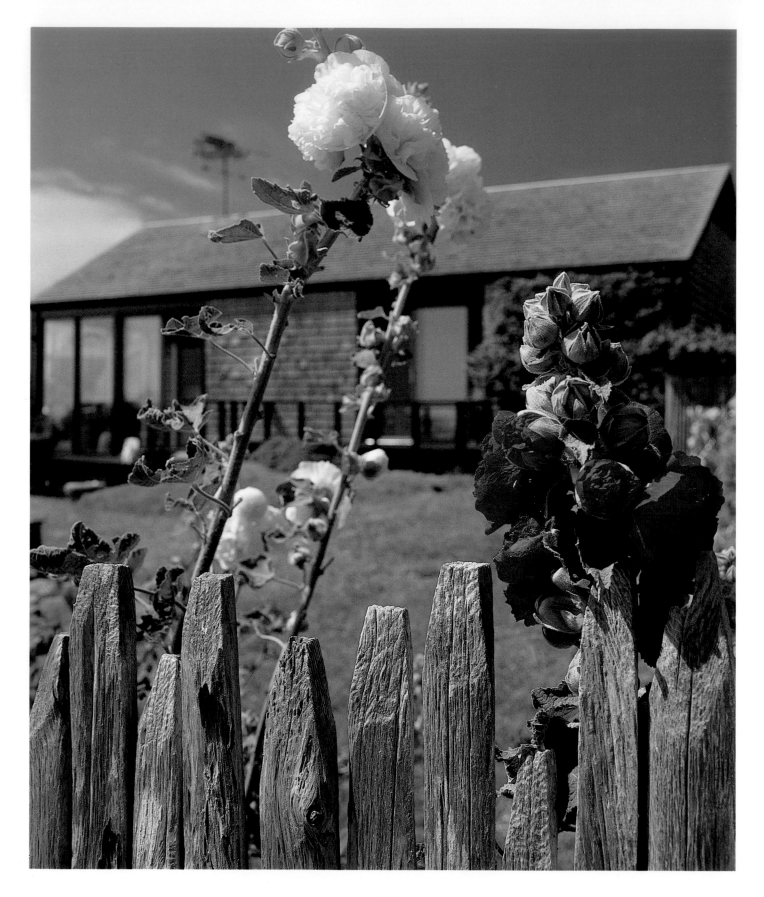

In Chilmark there is a lovely little house perched on a rise overlooking tranquil Stonewall Pond and, on the other side, dramatic Stonewall Beach that bounds this stretch of the Atlantic Ocean. The home of Trudy Taylor, the house is indeed a cocoon—warm and secure, filled with books, music, birdsong, and flowers year-round. It is also open to the outside from all sides with views of the pond or the ocean at every turn. A passive solar house, it is kept cozy with its wood stove in the kitchen-dining area and large fireplace in the living room.

Trudy's house is surrounded by gardens with every color and kind of bloom, ranging from the naturally old-fashioned hollyhocks that line the rough-cut picket fence and welcoming gate to the more formally planted border on the side of the house with its lily-lined pathways and little chairs and ceramic bird baths tucked among the flowers and trees. Trudy has been gardening since she was ten years old, and loves to design new gardens as well as restore old ones.

BELOW: *Stonewall Pond in the distance is a tidal pond that empties into Quitsa Pond, which in turn empties into Menemsha Pond, which empties into Menemsha Bight, a wide bay of Vineyard Sound. The large garden on the left is filled with daylilies* (Hemerocallis *hybrids*) *of many hues, cosmos, phlox* (Phlox paniculata), *mallow* (Malva *spp.*) *almost ready to bloom, hydrangeas, and fruit trees, among other things. The ceramic tables on the lawn are from New Hampshire and were made by Eric O'Leary.*

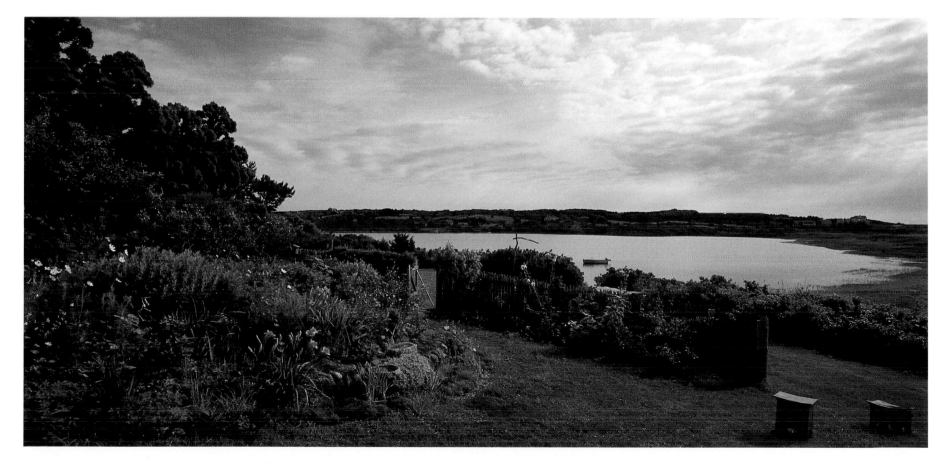

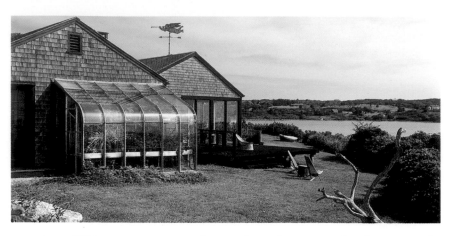

ABOVE: *This exterior view shows the solarium in the foreground and the deck that wraps around the living room to the right. The angel wind vane on top of the house has a real brass horn that sounds when the wind is just right. It was made by Max Kahn of West Tisbury.*

BELOW: *Queen Anne's lace.*

TOP RIGHT: *Driftwood hauled up from Stonewall Beach decorates this side of the property, backed by an old stone wall that probably dates to the seventeenth century.*

BOTTOM RIGHT: *The toolshed.*

RIGHT: *The herb and vegetable garden has rows of brightly colored nasturtiums and graceful fennel* (Foeniculum vulgaris).

BELOW: *Hydrangeas in the garden. Trudy does not treat the soil with chemicals because she likes to see what colors their flowers will take on naturally.*

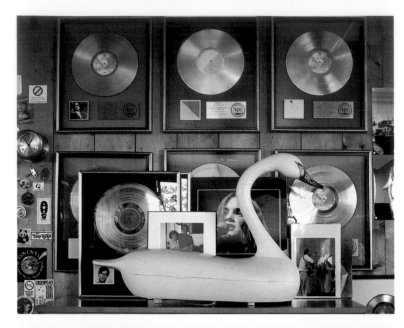

LEFT: *Trudy's ego wall displays the gold records and pictures of her children. The decoy is an eighteenth-century piece from the Chesapeake area.*

BELOW: *The living room was added to the original house, a summer vacation retreat with no electricity where the family used to come and camp out. The later addition carefully preserved the simplicity of the original structure. In the corner are Trudy's skis and oars. The sculpture on top of the chest is by Nagare, a Japanese sculptor.*

RIGHT: *Flowers from the garden decorate the dining table in front of the solarium with its fig tree and birds—a Brazilian finch and a canary.*

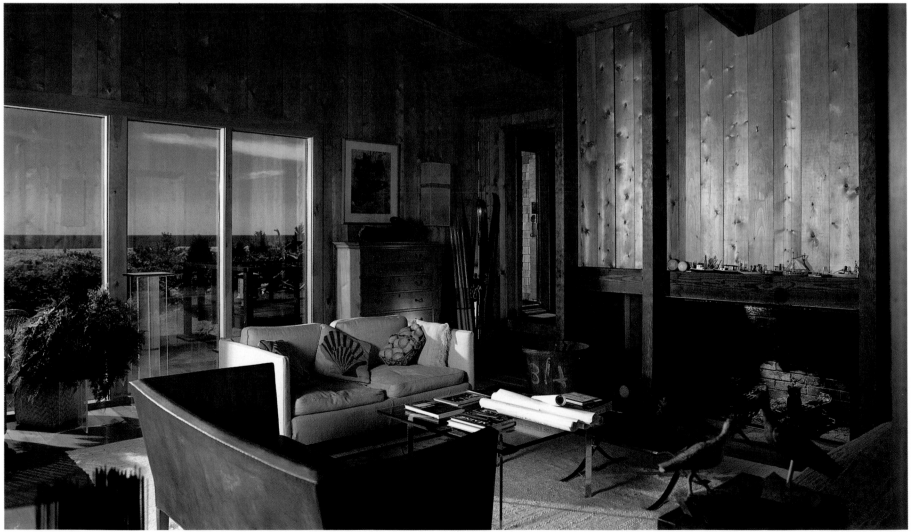

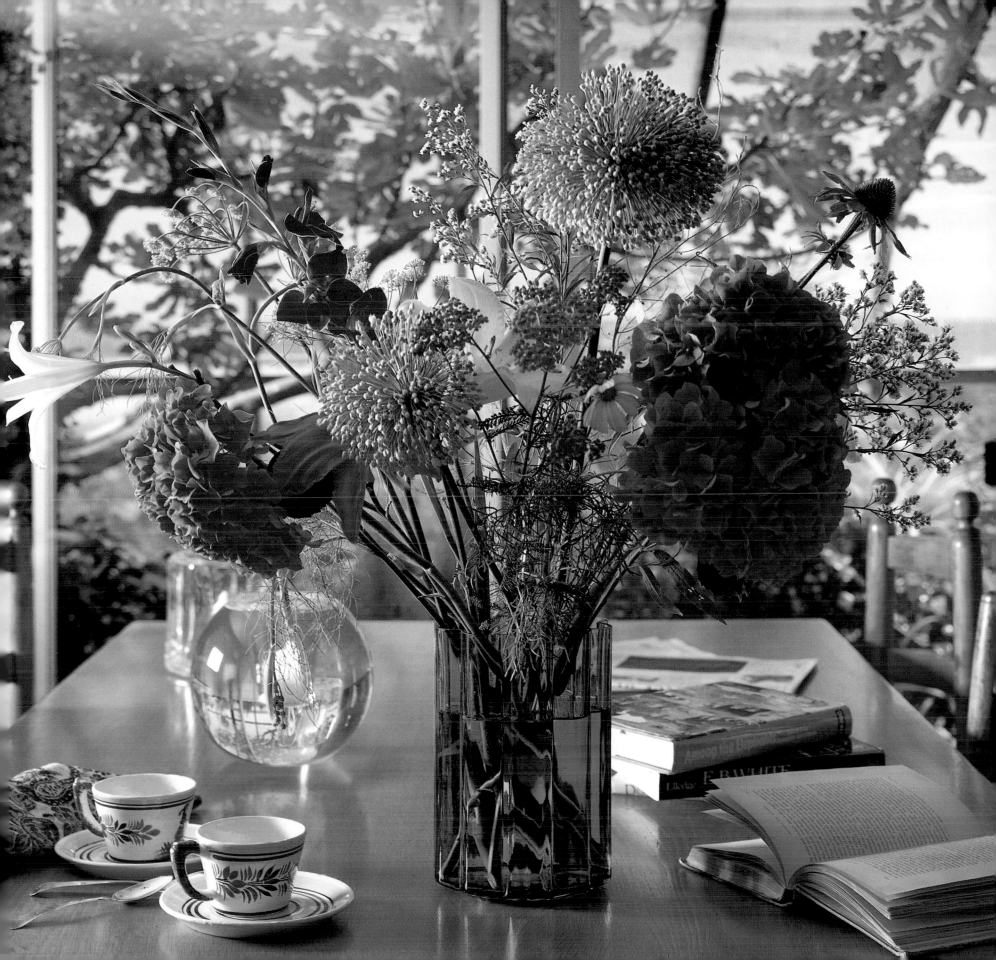

Laughing Water is the home of Eleanor Hubbard and Geoffrey White. It began in 1981 as a cozy little year-round house of 300 square feet and grew in stages to its present incarnation. First they added the large studio in 1982 to provide work space—Eleanor is an artist and Geoffrey is an architect. In 1983 they increased the house by 3100 square feet, adding more rooms in preparation for the birth of their son and to provide more family space. The walls for the basic rooms— dining room, kitchen, and extra bedrooms—were put up quickly, with the couple taking more time to finish the interior spaces. To increase light, doors and windows were added or moved. Colors were chosen to establish the mood for each room. The couple travels frequently to Scandinavia, and their selections of colors and accessories are personal adaptations of the simplicity of line and the purity of color they admire in Scandinavia.

The color schemes and design patterns carry over to the outside terrace, reflecting pool, and gardens. Made up mostly of perennials, the gardens were planted to provide a long blooming season and cut flowers to accent the inside.

BELOW: *The studio on the left was designed for maximum space and light to work in. The original house can be seen in the center with the new additions to the right.*

RIGHT: *The garden path leading from the front door to the drive is made of paving stones, set in a diamond pattern, and lined with pachysandra on one side; and on the other, dwarf Alberta spruce (Picea glauca 'Conica'), and impatiens for color. A triangle of lemon thyme (Thymus x citridorus) is set into the path where it gives off a delicate scent as it is stepped on.*

FAR RIGHT: *At the end of the front hallway is a painting of Eleanor's called* Letter to a Cat. *Covering the table, which holds flowers from the garden, is one of a collection of antique Swedish rugs. This rug was the first thing Eleanor chose for the house, and she has used its colors as the palette for the rest of the house because they are "both gentle and complex."*

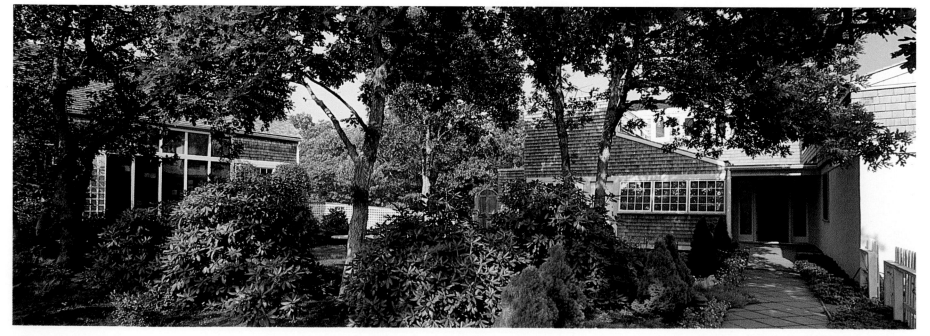

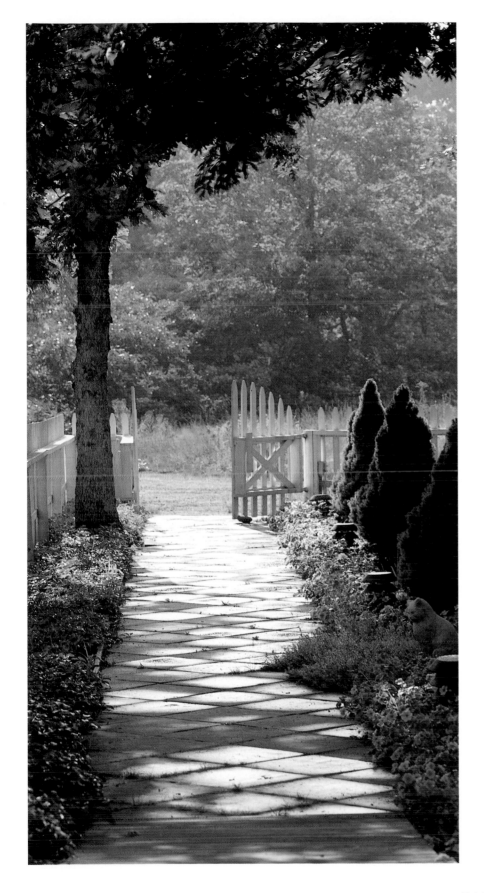

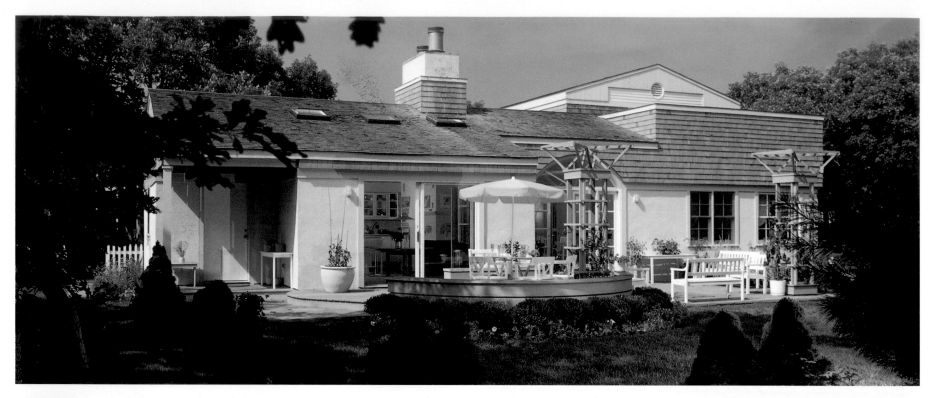

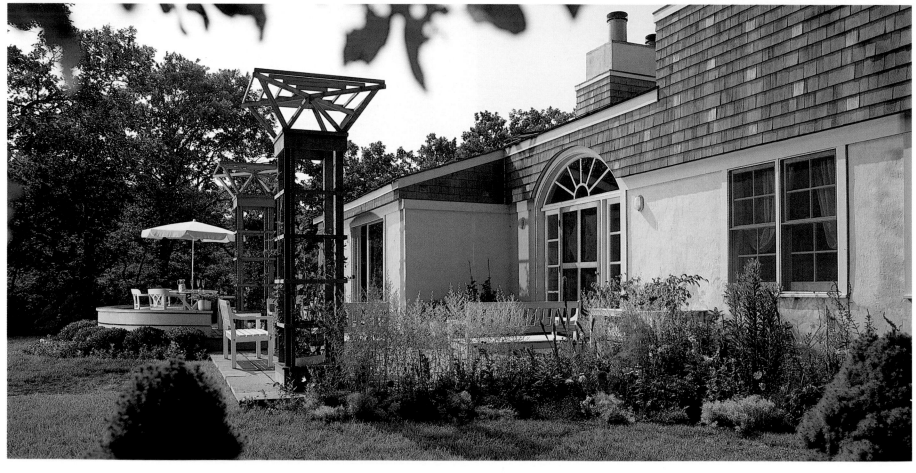

LEFT: *Pale pink stucco on the exterior walls gives an ordinary surface texture as well as color. Interspersed in a grid pattern within the otherwise plain shingled areas are copper-sheathed shingles that contribute both color and texture with their soft verdigris patina.*

RIGHT: *This angle of the garden reveals the flagstone terrace and upper-deck levels with their mixture of shapes. The garden is planted primarily with perennials and some annuals for color accents. The trellis towers hold bright pink climbing* Dipladenia splendens, *a tropical plant that needs to be brought inside over the winter. Dahlias,* Penstemon barbatus, *balloon flowers (*Platycodon grandiflorus*), lilies (*Lilium hybrids*),* Phlox paniculata, *Artemisia ludoviciana 'Powis Castle',* Liatris spicata, *cleome, Gerbera daisies, and cosmos complete the garden plantings. The whole garden seems to glow in the late afternoon light.*

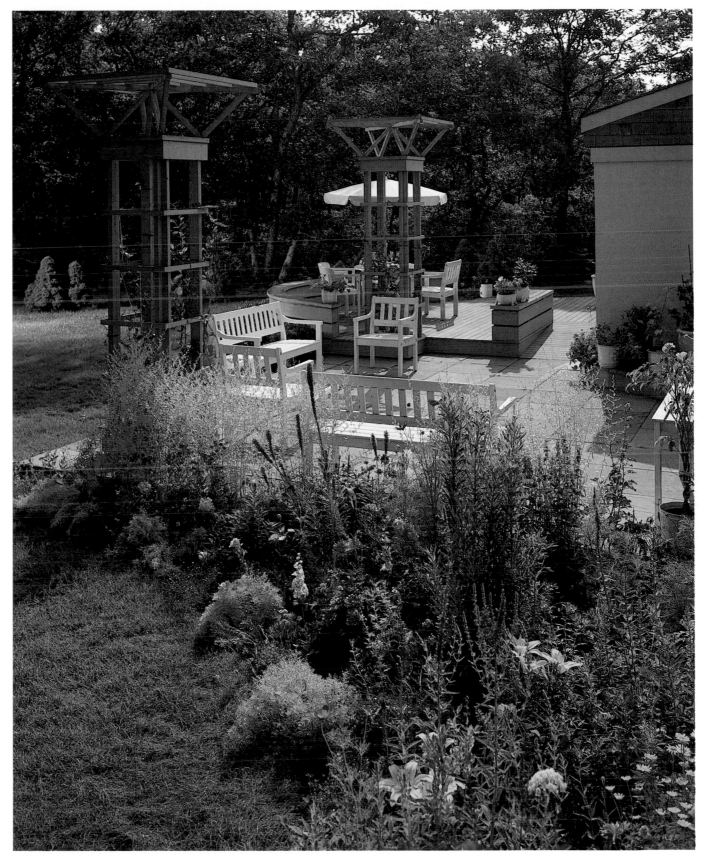

The bright dining room is filled with light from the outside. French doors provide vistas of the garden and the forest beyond, bringing the outdoors inside. The surprising gold wall was part of a joint outdoor exhibition Eleanor and Geoffrey participated in in Philadelphia. Their work was a fantasy remnant of a facade from a time when all Philadelphia houses were made of gold. The gold wall was the entrance to the exhibit's house. The already high ceiling was adjusted to make room for the wall, and the black marble that surrounds the fireplace was added to represent the doorway. The fish on the pair of Swedish tables were designed and painted by Eleanor to represent fossilized fish and were also part of the exhibit. On the shelf on the left is a papier-mâché sculpture called The Big Gold Sofa by Laura Garrison, a blind sculptor from Philadelphia. The brightly painted chair is one of Eleanor's designs.

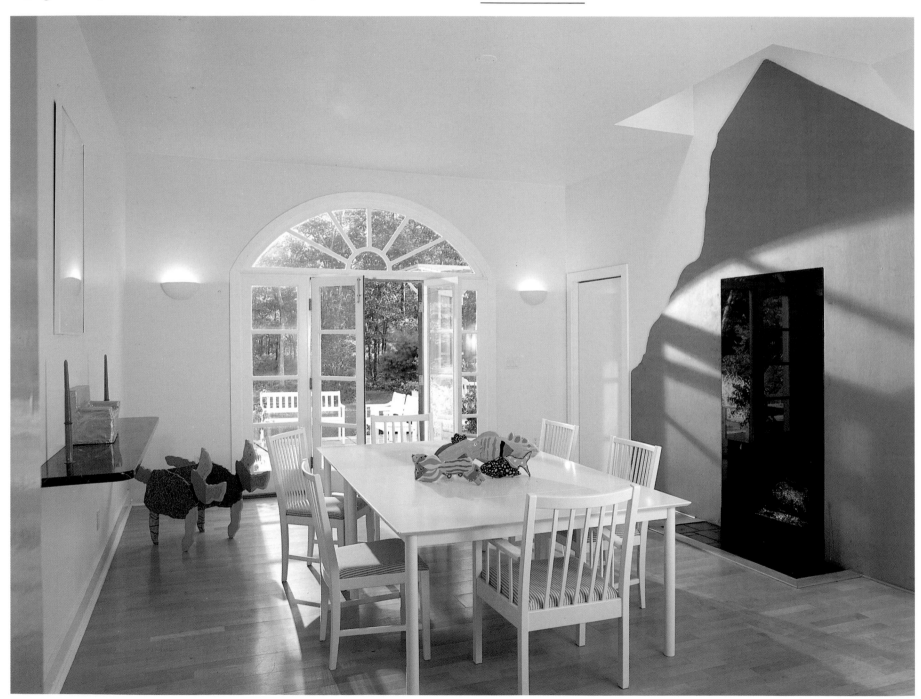

Einar, one of the family cats, guards the kitchen. The colorful sheep set among the kitchen tiles, individually glazed and fired, were made from Eleanor's sketches of local Vineyard sheep. The diptych landscape over the oven is by Emily Brown; the face above the fireplace by Janis Salik; the abstract oil next to it by Lillian Concordia; to the right a map by Perry Steindel. Around the corner is one of Eleanor's still lifes, France. On the dining room wall is a lace apron that belonged to Eleanor's grandmother.

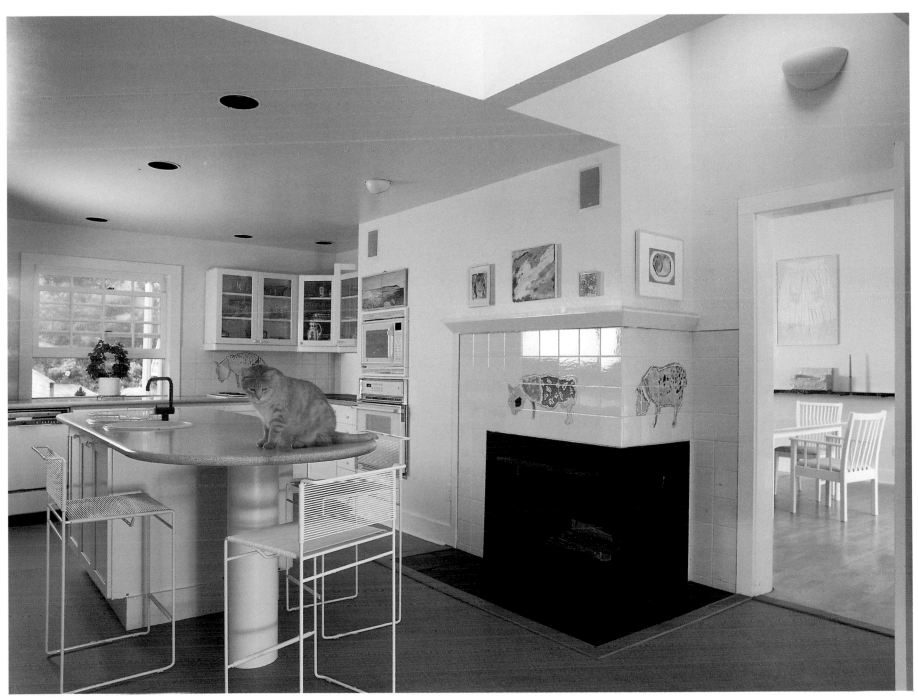

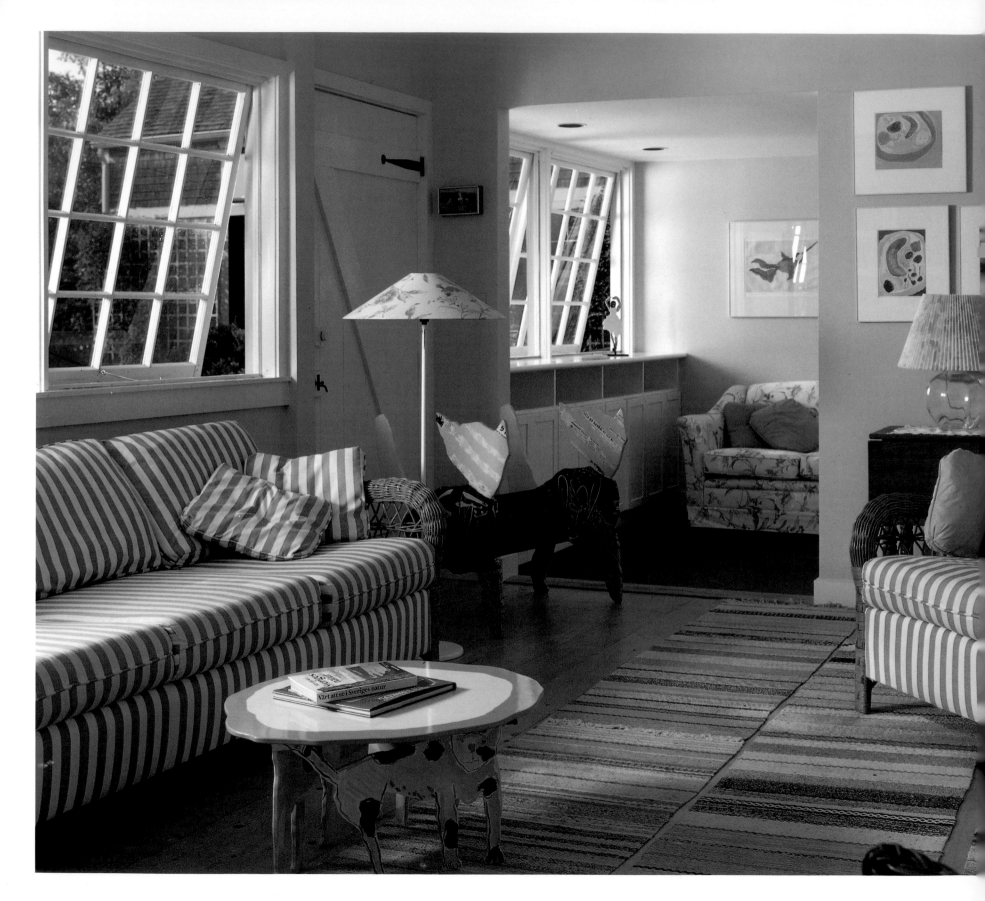

The living room and music room beyond are part of the original house. The large multipaned windows were custom-made after the style of the windows of a well-loved little cottage on Lake Tashmoo, where Eleanor and Geoff spent summers and where Eleanor loves to paint. On the floor are antique Swedish rugs. On the living-room wall are part of an ongoing series of Eleanor's oil paintings called "A History of the World in Still Life" of fruits and vegetables that remind her of every country she visits. The cat table and chair are more of Eleanor's works.

Eleanor's studio with works in progress.

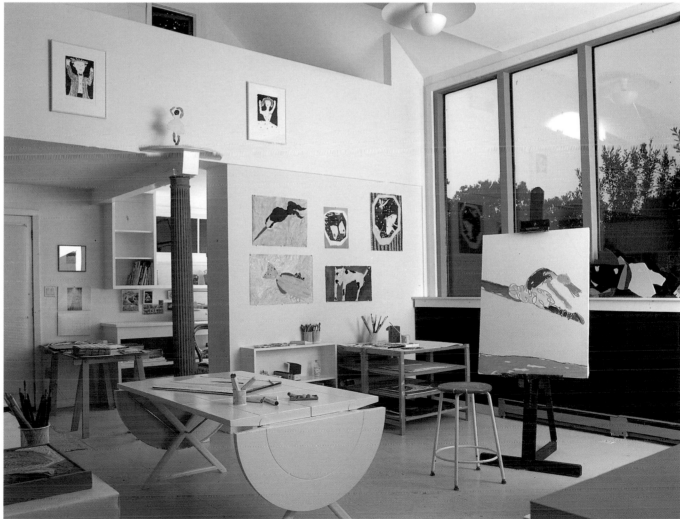

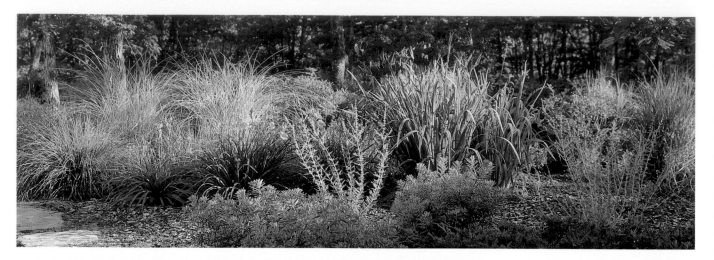

LEFT TOP: *A section of the garden in June when the dark purple iris* (Iris Kaempferi) *and daylilies* (Hemerocallis 'Stella de Oro') *are in bloom. In front are Russian sage* (Perovskia atriplicifolia), *with its silvery aromatic wood stem, and gray foliage and blue flowers, and daphne 'Carol Mackie', a fragrant variegated variety. Ornamental grasses, variegated maiden grass* (Miscanthus sinensis 'Variegatus'), *and fountain grass* (Pennisetum alopecuroides), *add a backdrop of green textures and softness.*

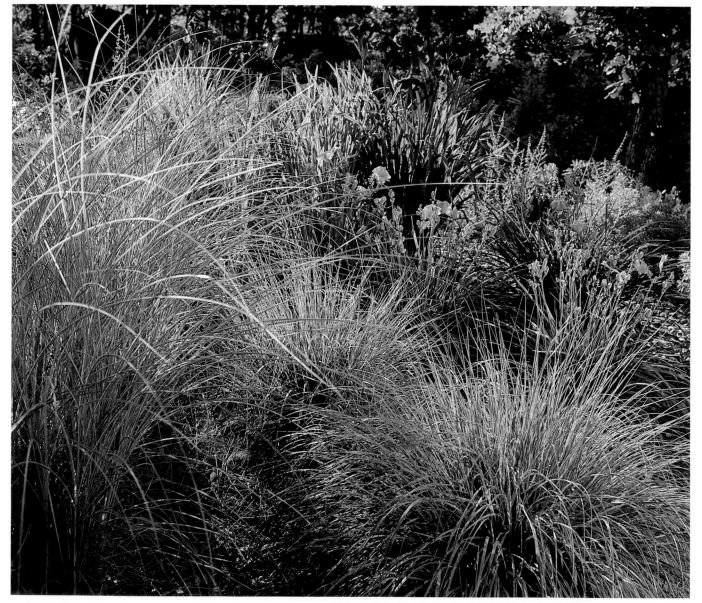

LEFT BOTTOM: *The same section of the garden with* Miscanthus sinensis *on the left in the foreground and* Pennisetum alopecuroides *in front. Purple Japanese iris and yellow 'Stella de Oro' daylilies in bloom create a foil for the soft background colors and textures of the grasses and shrubs. Leaves of a post oak, which is rare, if not actually endangered, are highlighted in the woods in the background.*

RIGHT CENTER: *Two varieties of heather* (Calluna) *in late fall. The one on the left is greenish gold in warm weather, turning to this red rust color as the cold weather sets in. The one on the right is still this deep green color in late October.*

POINT COUNTERPOINT

Carlos Montoya, Jr., created his garden to feature species native to an authentic woodland community. The garden is planted with a combination of ground covers, grasses, and shrubs with a few perennials to add color before the fall color changes of the native plantings. Grasses have been planted for their ornamental charm, their subtle greens that change to tans, purples, and reds in autumn, and for their whispery sounds in the breeze. Ground covers of bearberry, sweet fern, and sheep's laurel add texture. Shrubs such as inkberry, high bush blueberry, bayberry, winterberry, leatherleaf, clethra, and swamp azalea are grown both for their textures and varying heights. Some are evergreen and others turn to red, maroon, or deep burgundy in autumn. Other shrubs and perennials have been added for naturalizing.

CLOCKWISE FROM TOP LEFT: *Seed heads of a non-native ornamental grass,* Miscanthus sinensis 'Variegatus'; *the whole plant in late autumn. Switchgrass* (Panicum virgatum), *a native warm-season beach grass on the Vineyard, typical along shorelines in dense drifts or scattered through meadows, creates part of the structure of a Vineyard grassland wildlife habitat. Stalks and leaves of Little Bluestem* (Andropogon scoparius) *in late fall—the Vineyard's premier meadow grass. Leaves and seeds of mountain andromeda* (Pieris floribunda). *Seed heads of* Pennisetum alopecuroides *in late autumn.*

MIDDEN MOOR

When the owners bought the property some thirty years ago, it was moorland, broken up with eighteenth-century stone walls, overlooking Menemsha Pond. They built the house to take advantage of the magnificent views. English-style dooryard gardens have been meticulously planted and maintained near the house, and the wild beauty of the surrounding moors encloses the property on all sides.

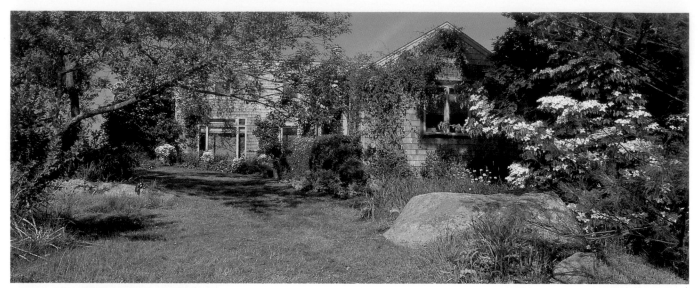

LEFT: *A Chinese dogwood* (Cornus kousa) *on the right marks the entrance to the little dooryard garden.*

BELOW LEFT: *'New Dawn' roses surround the windows behind English box. In the foreground, mounds of white feverfew* (Chrysanthemum parthenium) *flourish in June.*

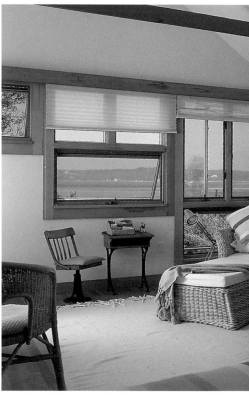

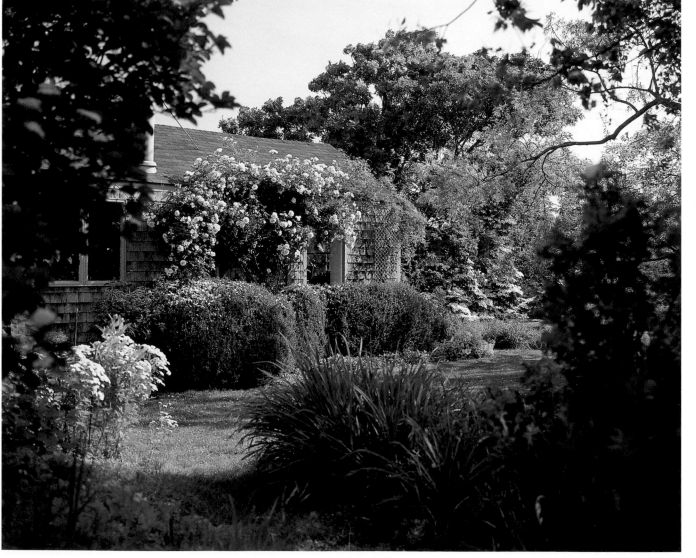

ABOVE: *The windows of the master bedroom are perfectly arranged to capture the extraordinary views. The room is furnished with handwoven fabrics and a wool rug from Mexico, and a mix of Vineyard things, including an eighteenth-century child's school desk from Edgartown and a nineteenth-century driftwood table.*

RIGHT, TOP, AND BOTTOM: *In midsummer the dooryard garden has a border of daylilies (Hemerocallis hybrids) along the side and clusters of Monarda didyma, black-eyed Susans (Rudbeckia fulgida), plume poppy (Macleaya cordata), rue (Ruta graveolens), and wild viburnum beneath the windows. A large potted lantana sits beside the kitchen door.*

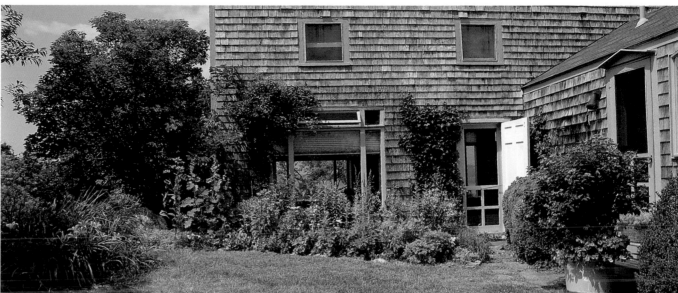

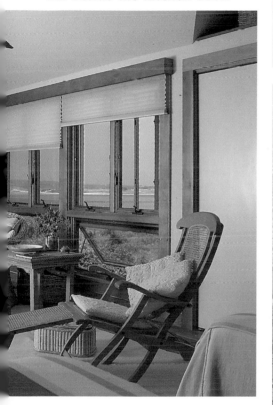

OVERLEAF: *At sunset, the climbing 'Blaze' rose virtually glows in the last rays of the summer sun.*

MCMAK

This intricately designed contemporary house was built in 1970. Designed to take full advantage of its magnificent site facing Vineyard Sound with the Elizabeth Islands in the distance, the two long, low slopes of the roofline shut out views of neighboring houses and shelter the structure from winter storms. The house is built on a long and very narrow lot, and the entire house is contained in a 24-foot square, with a small extension on the lowest level. Inside the little house feels large; it is arranged on six levels, each one a separate space with a different function. In descending order are master bedroom and bath, living area, dining area, kitchen, and two guest rooms with a second bathroom. Each level is 2 feet above the next one, so that the interior spaces wind around a central stair and support. Because the windows follow the roof inclines, their shapes are irregular and resemble various triangular and four-sided sails. As much of the furniture as possible has been built in, to maximize space and minimize cleaning chores. The built-in units are of the same cypress that covers the walls and ceilings.

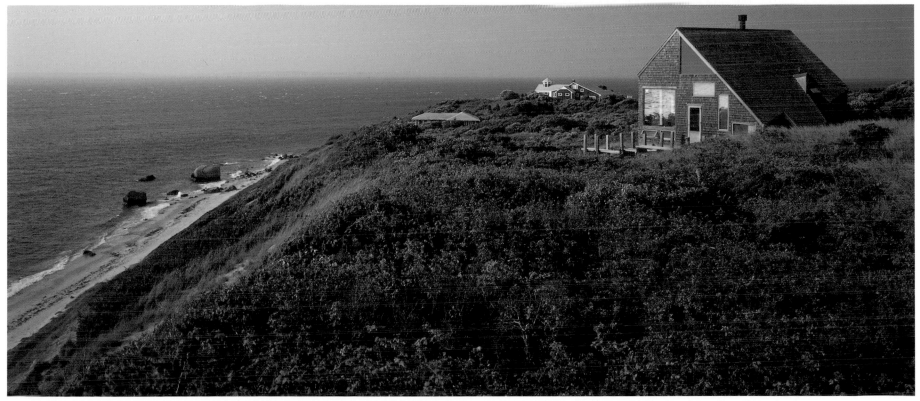

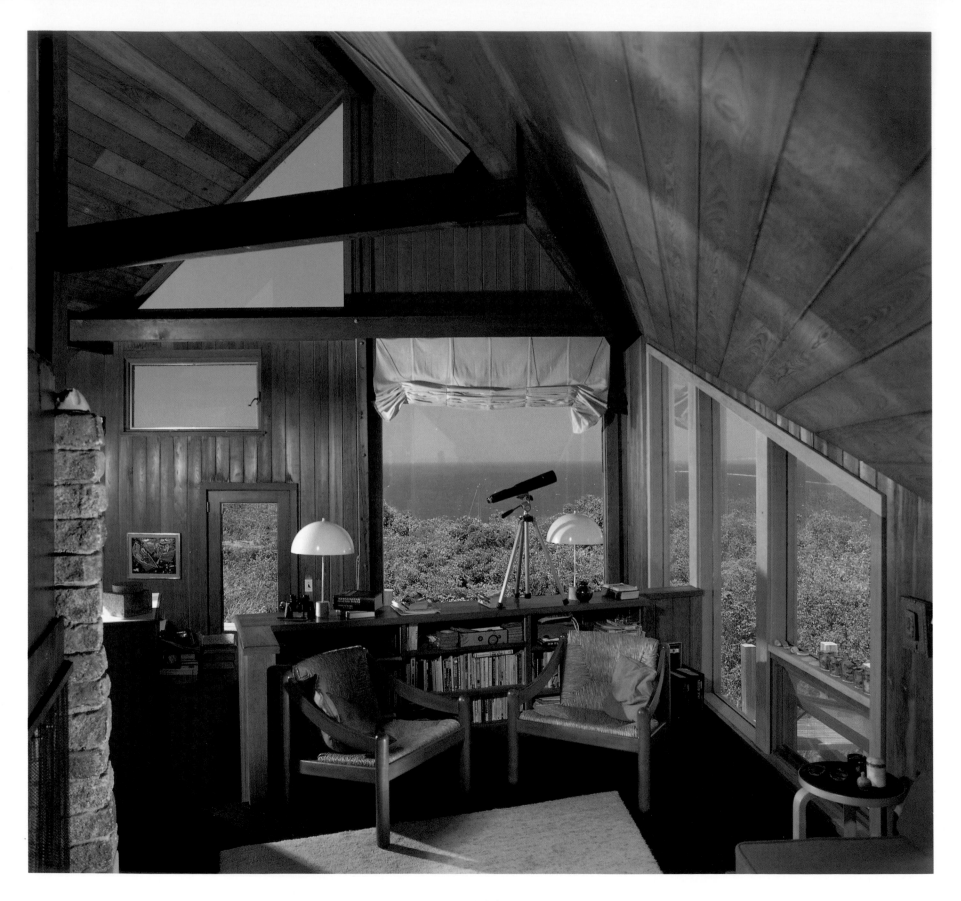

LEFT: *The living-room level has a fireplace enclosed in a U-shaped wall constructed from cobblestones that were saved when one of Boston's old streets was repaved. This level affords wonderful views of the coast toward Gay Head. The dining-room level is just beyond the low bookcase, which functions as a divider between these two levels. The kitchen is down three more steps to the left. Directly beneath this level is the lowest deck, a combination bedroom—sitting room for guests, with its own entrance.*

BELOW: *The cozy living room is warmed by the afternoon sun and the fireplace, whose free-standing chimney radiates heat to warm the level above. A few steps up and to the right is the master bedroom, its bed built into a bay that extends outward under the roof.*

RIGHT: *The shower in the master bathroom has a skylight top, designed to avoid running too high a wall to the soaring ceiling. The living room is to the right and the dining room is directly forward. Beneath this room is the second guest room, with high bunks above built-in storage closets.*

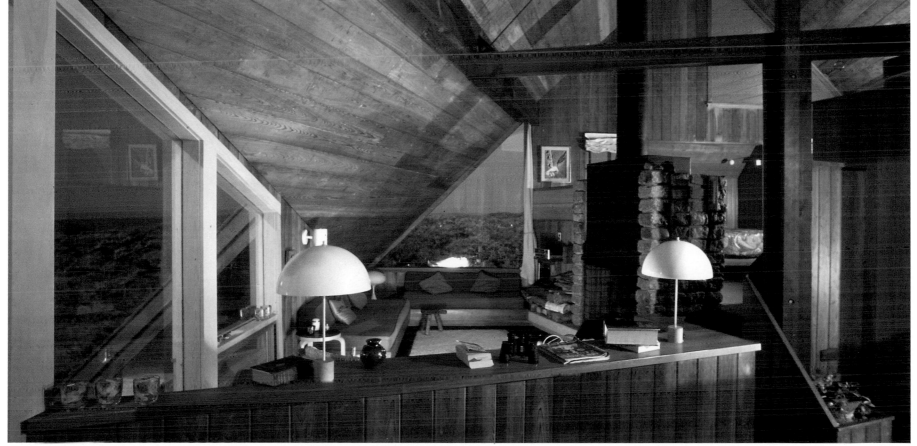

THE HERITAGE

On a hilltop with a commanding view of the Coast Guard station and Menemsha Bight on one side and Menemsha Pond on the other stands an old farmhouse, built in the early 1830's by the Skiff family. The farm and farmhouse were purchased by Edy Coffin Flanders when he retired from whaling. His wife, Mary Athearn Flanders, and his two sons, Allen and Ernest, moved out here with their father from Scrubby Neck in West Tisbury, where they had lived with Mary's family while Edy was at sea. Edy and his sons went into trap fishing. In later years, after living in California for a time, Ernest came back to the farm to care for his widowed mother and, in the early 1920's, added a large addition to the barn for a dairy. The barn has been renovated into two living spaces with the newer addition currently used as a rental property. Following Ernest's death, the property went to his nephew Leslie Mayhew Flanders, who saw it through extensive renovations, carefully and lovingly preserving the feeling and integrity of the old homestead.

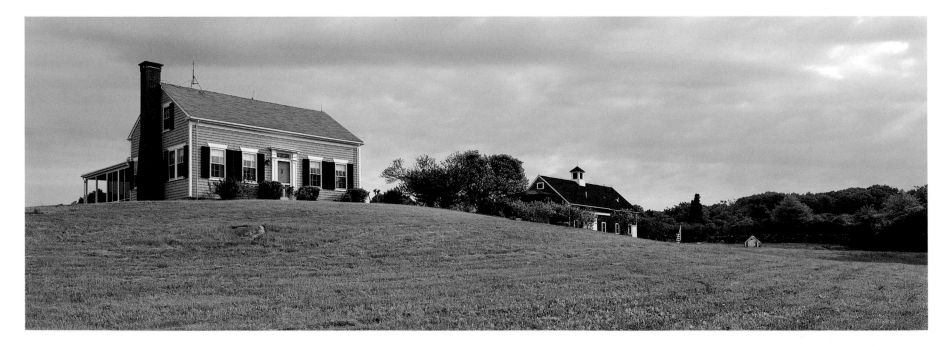

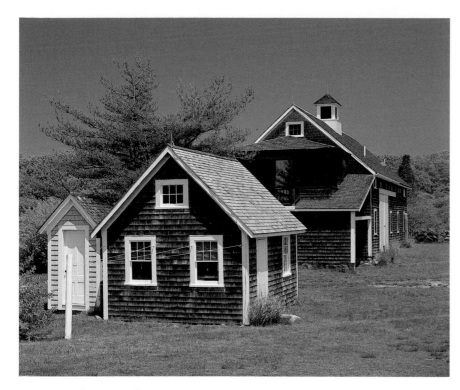

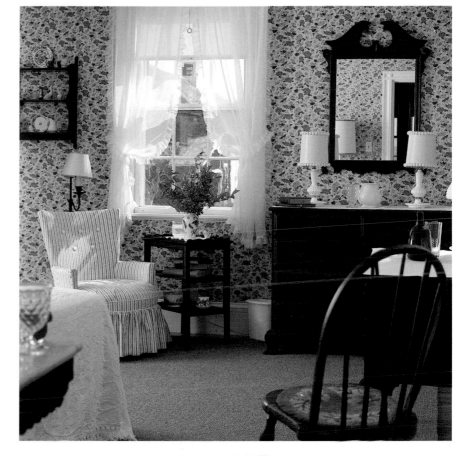

ABOVE: *Among the outbuildings on the property are a carefully renovated cow barn that can be seen behind a milk house and the old outhouse.*

RIGHT, TOP: *The downstairs bedroom in the farmhouse is especially cheerful, filled with morning light.*

RIGHT: *The living room is comfortably furnished in a traditional style with braided rugs, pineapple-motif wallpaper, and antique toys that have been in the family for generations.*

OVERLEAF: *The attic bedroom is an ideal place for children to play and keep an eye on the activities of the Coast Guard Station and Menemsha far below.*

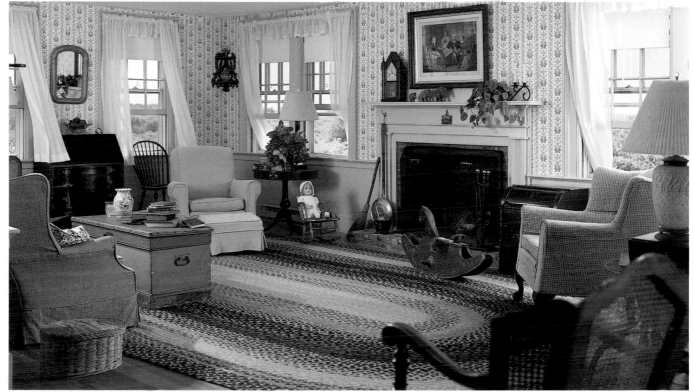

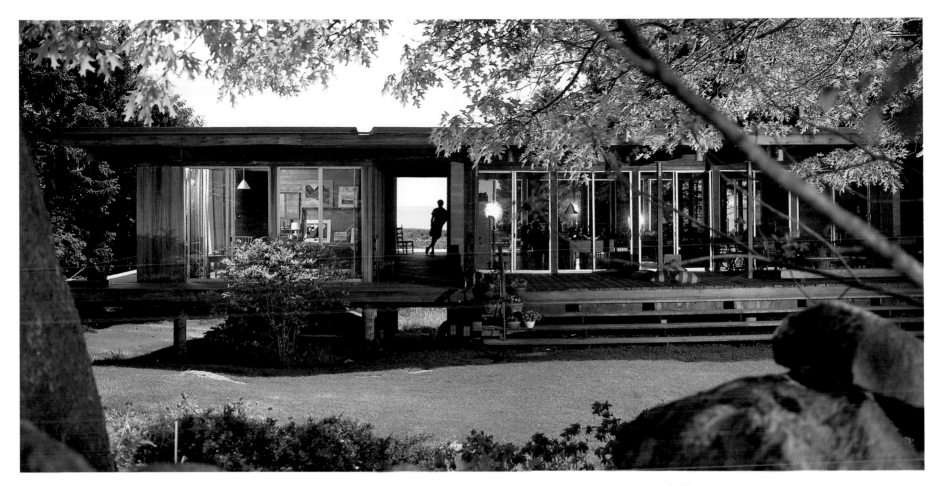

THE TALBOT RANTOUL HOUSE

Composed of three sections, with full glass walls on two sides of the central living area, the house seems to float in space. The structure actually rests on cylindrical cement pillars, and is solidly grounded. Its hillside location affords grand ocean views, with woodlands all around. Built primarily as a summer home in 1961, it nonetheless has a full basement underneath and is fully heated. Seen from behind a stone wall on the edge of the property with a wildflower garden in front, the guest-room wing is on the left, separated from the living area by an open passageway. The center pavilion has a solid wall at each end, with a fireplace on one end and kitchen on the other. The other two walls are all glass with sliding doors along each side that open up to allow the maximum benefit of summer breezes. The two bedrooms in the guest wing each have an all-glass wall on one side. There is a bathroom between the two rooms. On the other end of the house is a similarly designed master bedroom suite. The deck along one side of the house is in full sun in the morning, while the other deck is sunlit in the afternoon. The Rantouls removed no trees when they built the house; they sited it in an open clearing.

The house was designed for people and ease of entertaining both family and friends. The one large room allows for the cook to be with the guests and makes cleaning up as simple as possible. The house is furnished with a delightful combination of early American antiques mixed with contemporary furnishings and accessories.

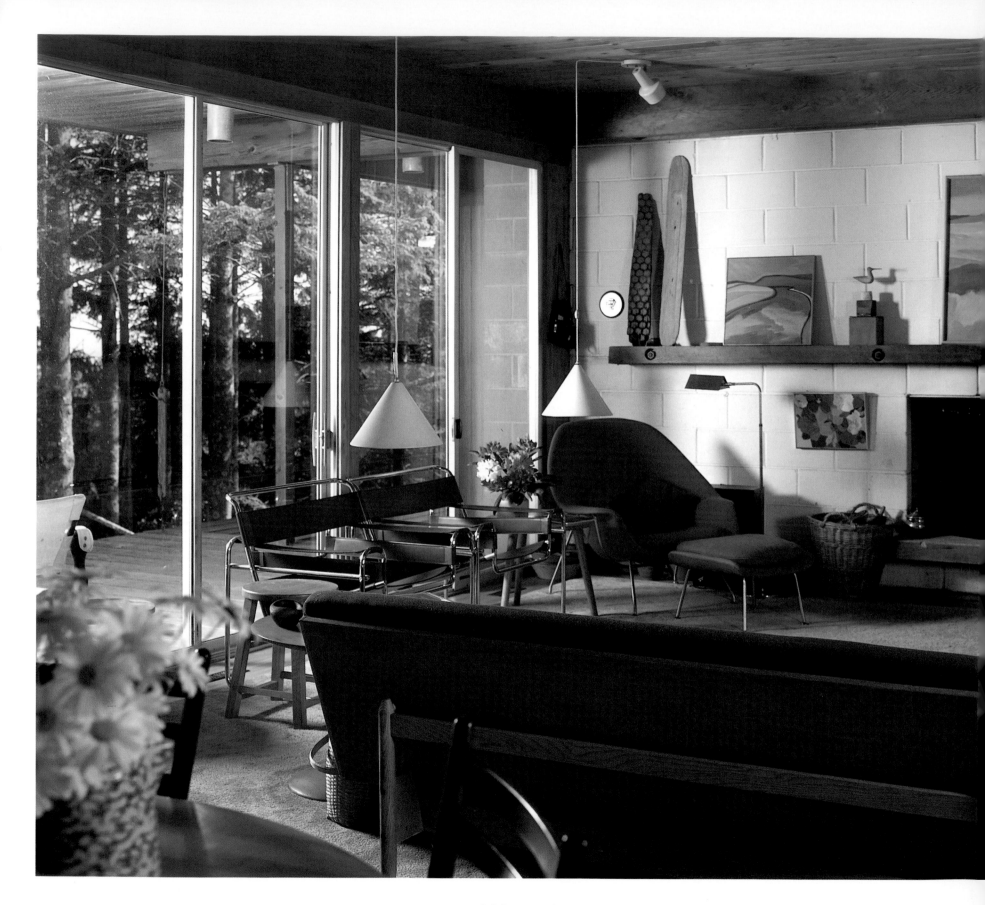

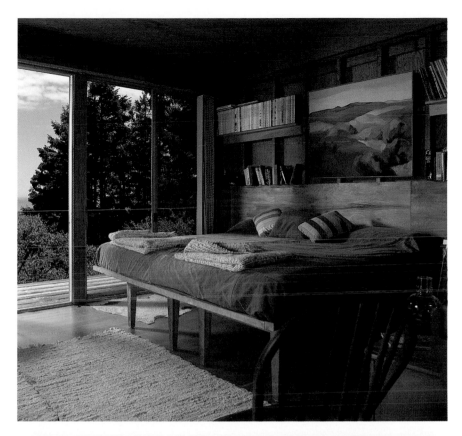

LEFT: *The fireplace end of the living room with several of Claire Rantoul's paintings on the mantelpiece. Always filled with light during the day, this room, as do all the others on this side of the house, overlooks the wooded hillside that leads to the ocean a mile away.*

RIGHT, TOP: *This guest room has a built-in king-size bed. The house was built to require as little maintenance as possible, and the beds are somewhat higher than normal for ease in making them up.*

RIGHT, BOTTOM: *The master bedroom is especially peaceful with its view of the ocean through the trees. The colors in all the rooms were chosen to reflect the colors of Martha's Vineyard in the fall, as does Claire's painting above the bed. Most of her paintings reflect the Vineyard's seasonal colors.*

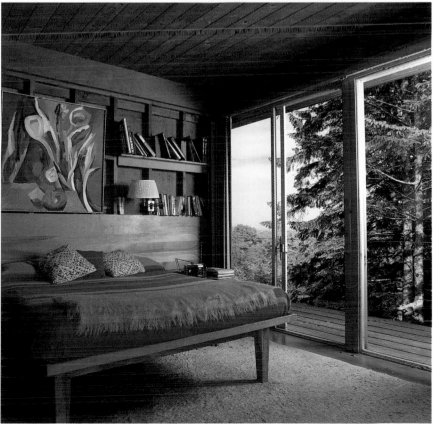

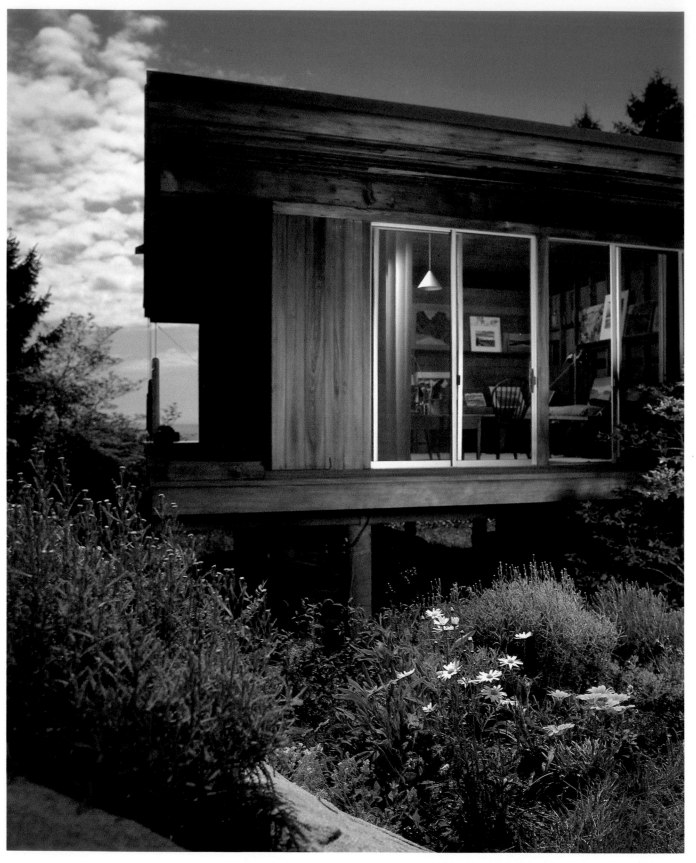

LEFT: *The guest wing as seen from behind one of the rock gardens on the property. Blooming here in late May are dark blue* Lithodora diffusa, *two kinds of santolina, Shasta daisy* (Chrysanthemum x superbum), *dwarf coreopsis, and gazania.*

RIGHT: *An old stone wall edges the property and forms a backdrop for the lovely wildflower garden alongside it. Across the lawn is another rock garden, which marks the entrance to the house from the drive. The deck along this side of the house is furnished with bright pillows and outdoor wooden furniture, providing a comfortable place to sit and enjoy the gardens.*

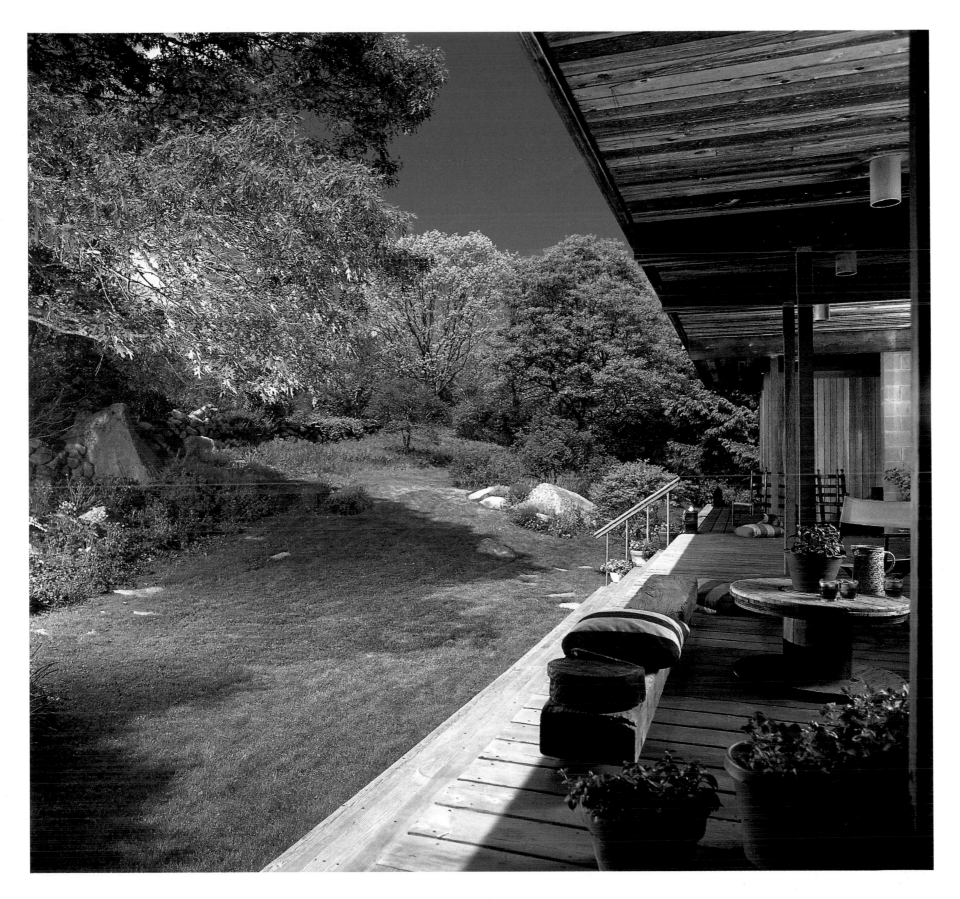

CLOCKWISE FROM TOP RIGHT: *Yellow-and-pale-lavender columbine* (Aquilegia); *Iris gracilus*; *Solomon's seal* (Polygonatum biflorum); *Bishop's weed* (Aegopodium podagraria *'Variegatum'*) *mixed with ferns; wild columbine* (Aquilegia canadensis); *lady slipper* (Cypripedium calceolus *'Pupescum'*); *lily-of-the-valley* (Convallaria majalis) *and sweet woodruff* (Asperula odorata); *crane's-bill* (Geranium endressii).

BELOW: *The wildflower garden in glorious May bloom.*

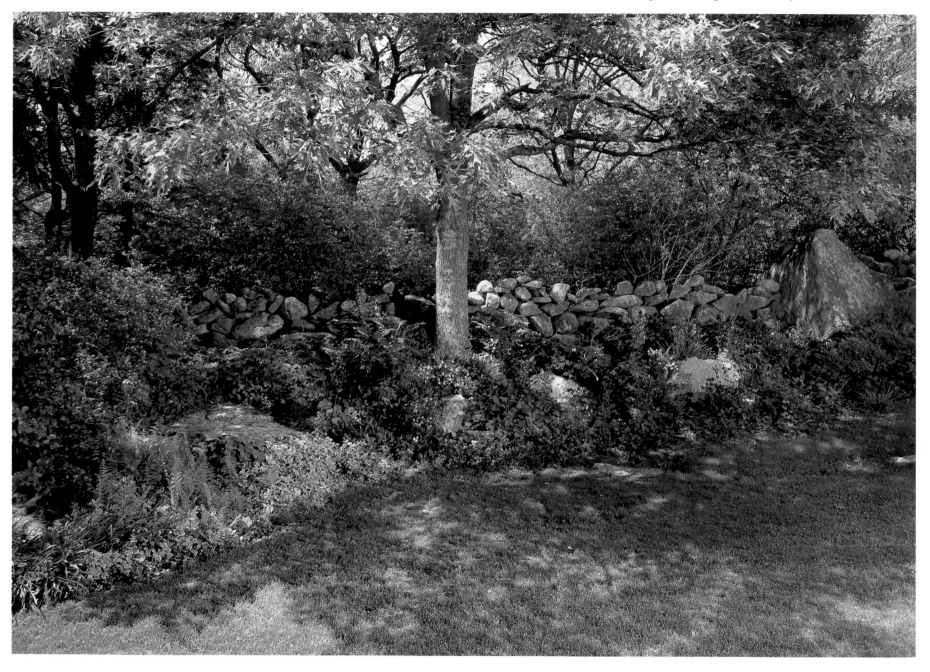

SEA-AND-SKYSCAPE

Nestled into the hillside, this large contemporary house built from 1981 to 1984 has sweeping views of Squibnocket Pond, Noman's, and the ocean beyond, rolling meadows, and lush vegetation. The landscaping of the vast property is magnificent in scope as well as in detail. Natural woodland walks wind through bogs with wild high-bush blueberries, summer sweet, and swamp azaleas arching over the pathways. Innumerable varieties of native black oaks, swamp maples, beetlebung, and enormous wild cherry trees of some vintage have been carefully preserved. The house has been built to complement its setting as well as to take advantage of every one of its grand vistas. Thoughtfully planned not to intrude on its site, no ridge line was broken and no variances were necessary to build. Long and lean as it melts into the hillside, it is

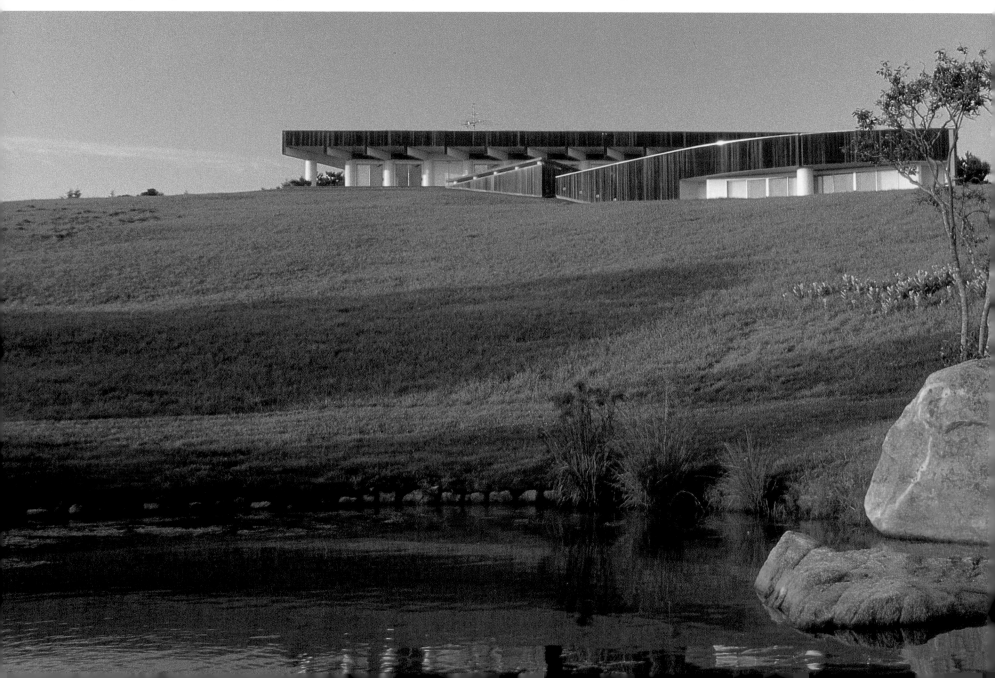

surrounded by decks that open into the vast panorama around it. The house is arranged on levels that disappear into its landscape. The guest house is below the main house and actually underground, with a lush lawn on its top so that it isn't visible from the house itself. The pool is up a long outside stair and sits on top of the hillside overlooking the sea from every direction. The geometry of straight lines intersecting at nontraditional angles play against circular shapes both outside and in. Inside, the house is arranged with open spaces to take advantage of the views, and the rooms flow one into the other. The furnishings were carefully chosen to add warmth to the light-filled spaces. The owners' interest in the sea, contemporary art, and antiques is reflected in their collections of contemporary ceramics, antique maps, and ship's models and paintings.

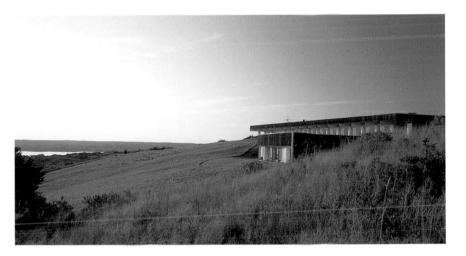

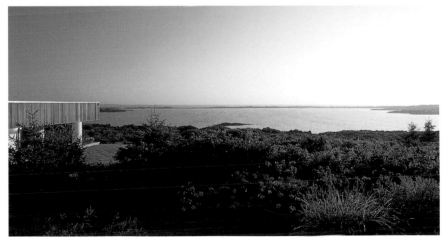

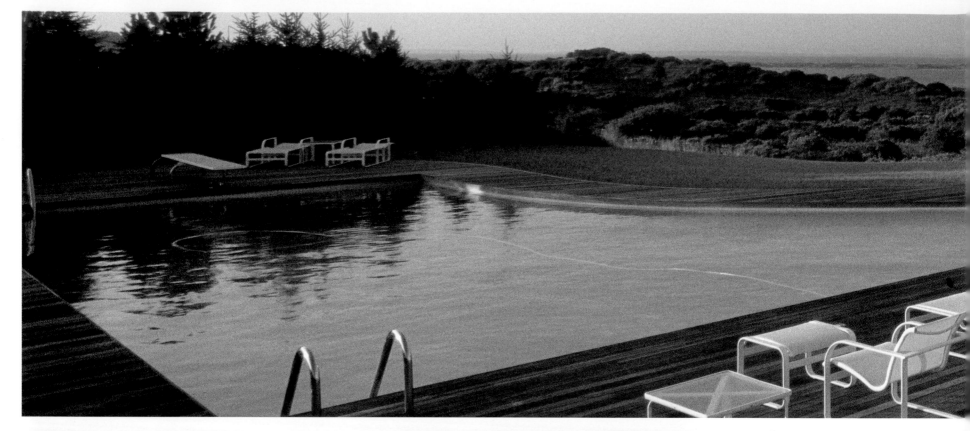

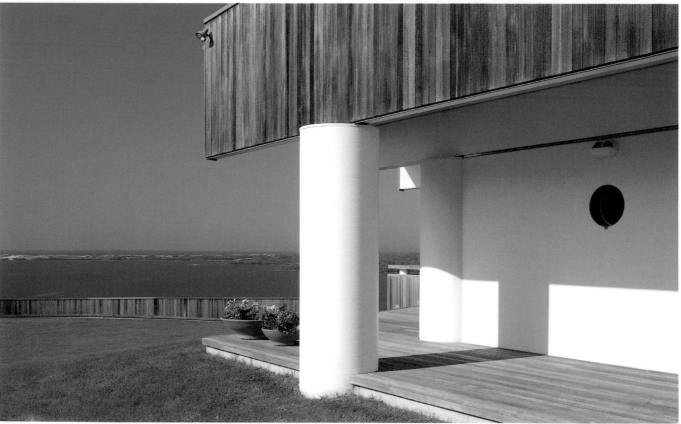

LEFT: *The house has a definite Mediterranean feeling about it with its white walls, natural wood decks, geranium-filled terra-cotta pots, and the glistening blue sea beyond.*

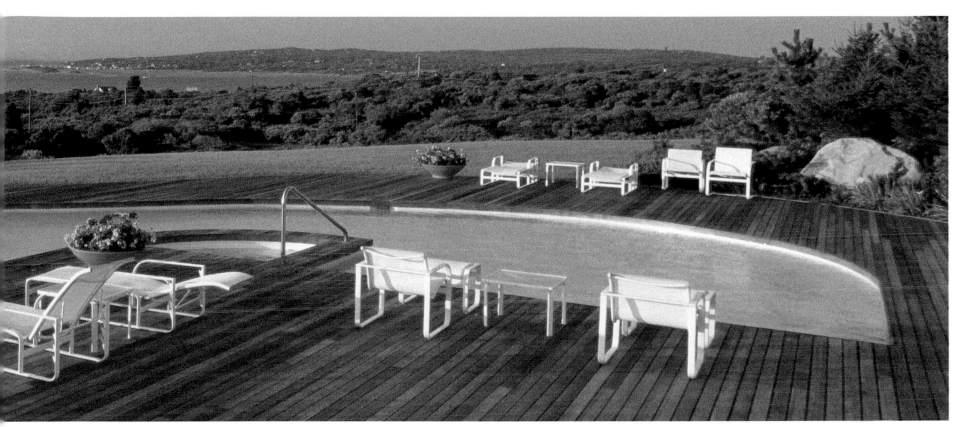

ABOVE: *The pool that looks like it is on top of the world is situated above and to the side of the main house. It is not visible from the house, nor is any part of the interior of the house or its decks visible from the pool.*

RIGHT: *Bedrooms open off this long hallway that leads to the playroom at the end. The walls are lined with an extensive collection of antique maps of New England, most of which feature Cape Cod and Martha's Vineyard from the earliest maps and charts of the region, dating from the mid-sixteenth century up to the nineteenth century. The antique clock at the end of the hallway is Swedish, from the nineteenth century. It was chosen for this particular spot because its round top and angled straight sides continue the geometric patterns of the structure of the house.*

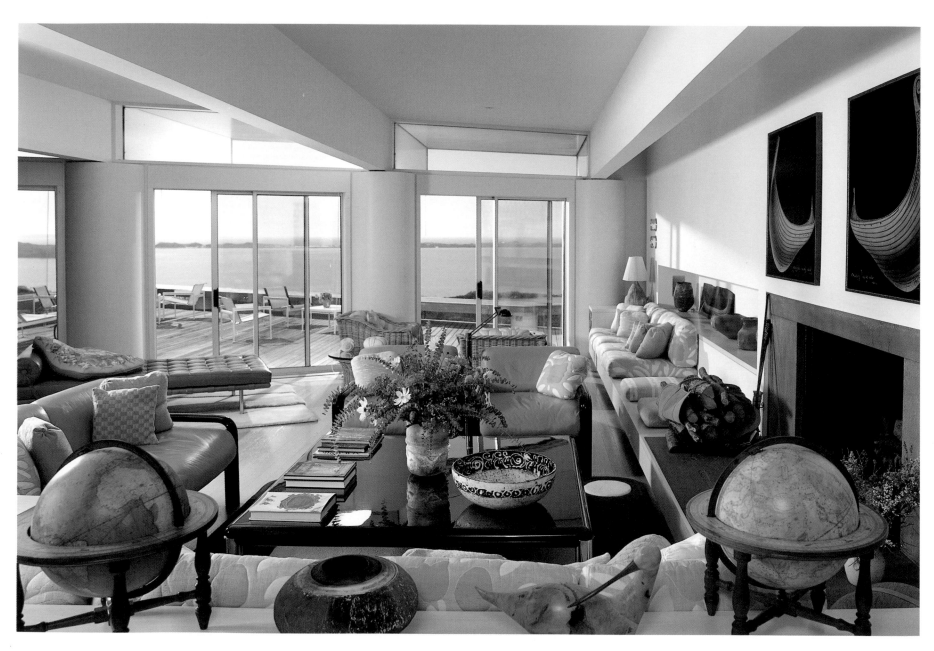

The living room with its interesting arrangement of windows for light and views of the sea has a deep marble fireplace and recessed shelves that provide ample space for the owners to display some of their collection of contemporary American ceramics. The globes in the foreground are antique American pieces. Two Danish oil-on-wood paintings of Viking ships hang over the fireplace.

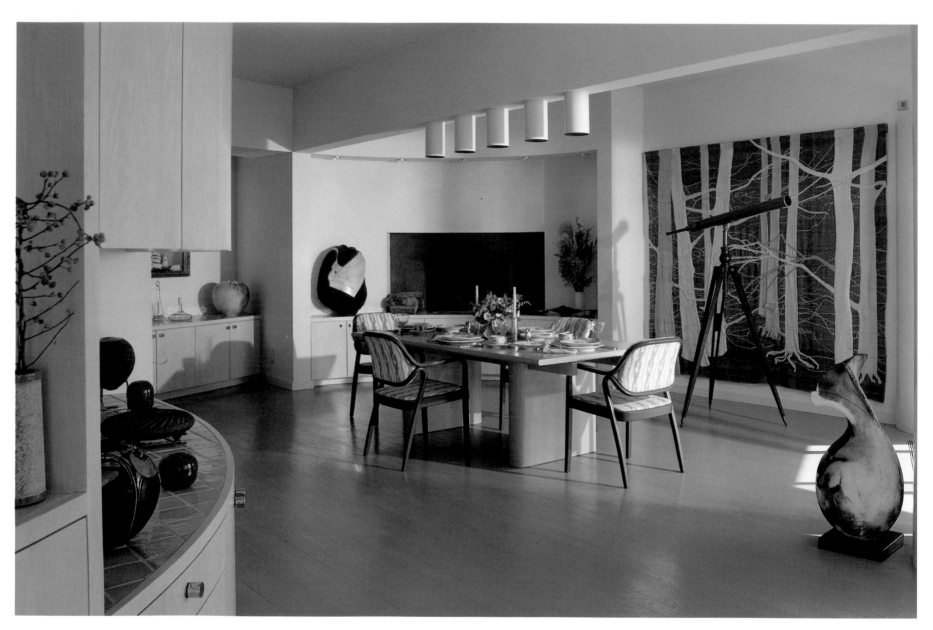

The dining room on the other side of the main living space of the house has a raised fireplace on its angled rear wall. The sculpture in front of the doors on the right is by Tom Neugebauer. The large tapestry on the far wall was made by Nancy Heminway. The curved wall on the left is the outside wall of the kitchen.

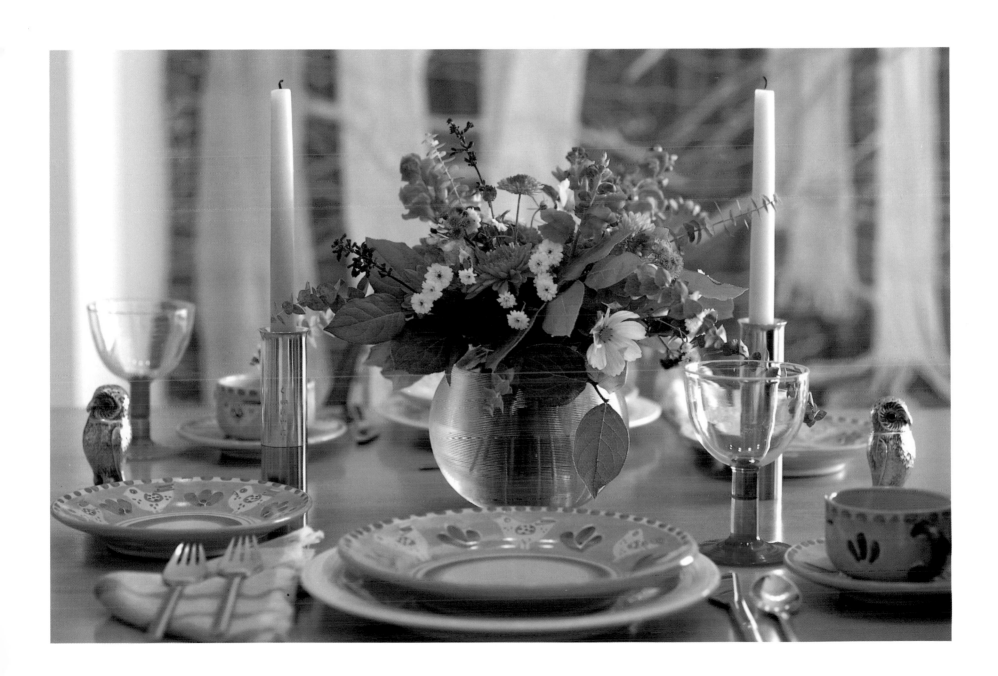

The kitchen is located in the center of the living space and is cleverly encircled in symmetrical curved walls that have copious storage space in cabinets and drawers as well as open spaces for display. Seen through the kitchen on the far wall of the dining room are nineteenth-century half models of ships that were made for ships' officers of the time. They are displayed in glass cases cut into the wall as they would have been in the nineteenth century.

Nestled in the dunes and separated from the sea by sweeping stretches of sand, scrub vegetation, and beach grass, this stark contemporary structure deliberately blends in with its surroundings. Unlike most water-view houses, its narrow end faces the sea. The plain weathered gray board siding and simple windows are combined with stark lines to allow the elongated boxlike shape to harmonize with its setting. Large glass sliding doors open out onto its decks with their glorious views of Vineyard Sound and the Elizabeth Islands. The house was built in 1987 for Janet Odgis and Steven Berkowitz and won an Honor Award from the American Institute of Architects. This is one Island site where adopting a traditional architectural style would have been an unwelcome intrusion.

TOP RIGHT: *Though not visible from the road, the tall end of the house faces the road. Upstairs, a penthouse master bedroom suite has commanding views of the sea as well as complete privacy from the rest of the house. The long covered walkway leads from the back of the house and the driveway, down along the guest rooms to the entrance between the kitchen and dining room. A high rooftop deck is enclosed by a railing.*

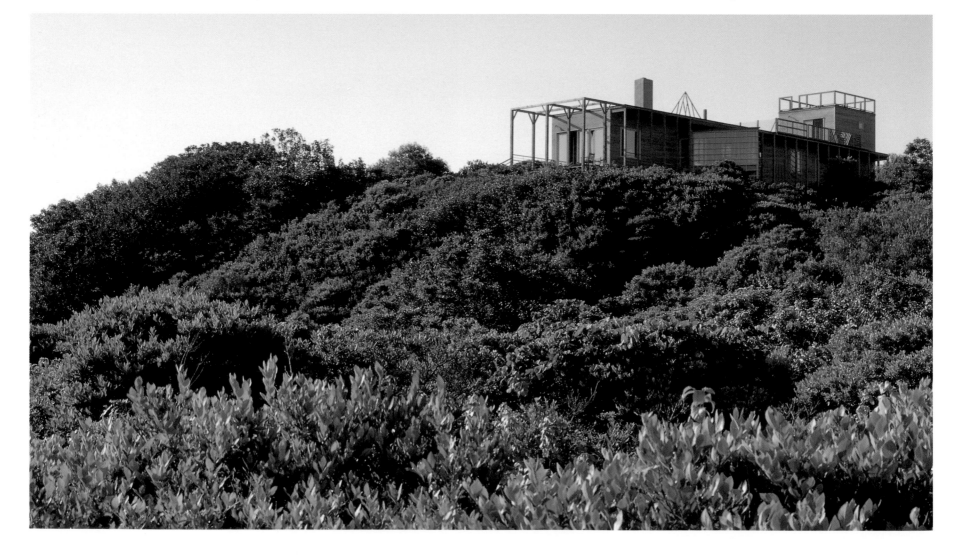

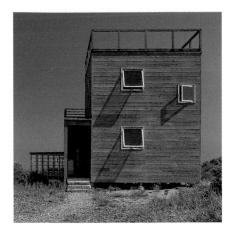

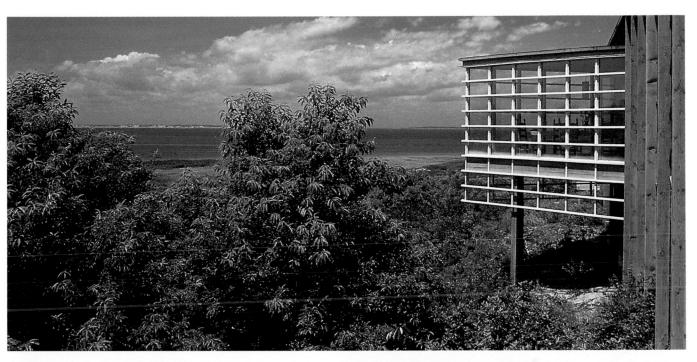

RIGHT: *A glass-walled triangle-shaped dining area appears to float out over the landscape and is the only interruption in the simple shape of the rest of the house.*

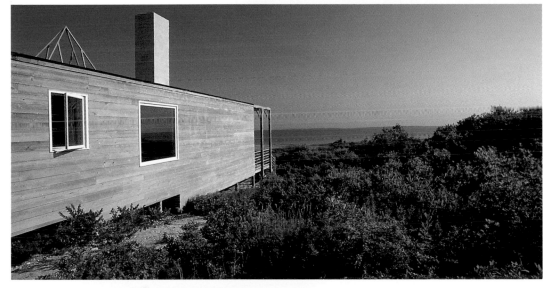

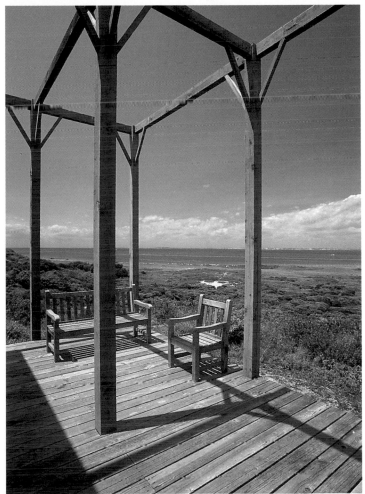

ABOVE: *This side of the house is completely plain except for windows. The large square glass window, like others strategically placed around the house, offers a dramatic coastline vista.* LEFT AND RIGHT: *The tall living-room windows on the seaward side are protected by a timbered trellis that frames the space.*

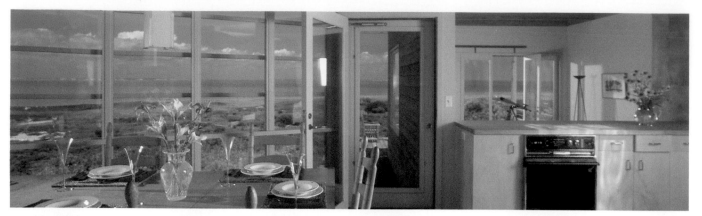

LEFT: *The kitchen and dining level is several steps above the living area, sharing the magnificent views while still being separate.*

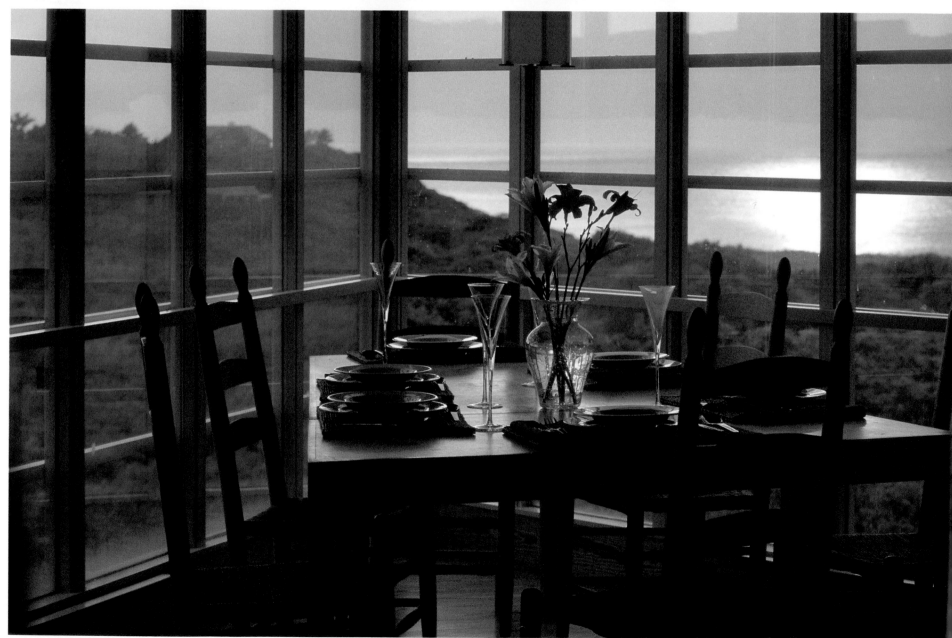

BELOW AND RIGHT: *Simplicity in furnishings with a minimalist approach is the key to contemporary comfort in this dining room, floating in space and light.*

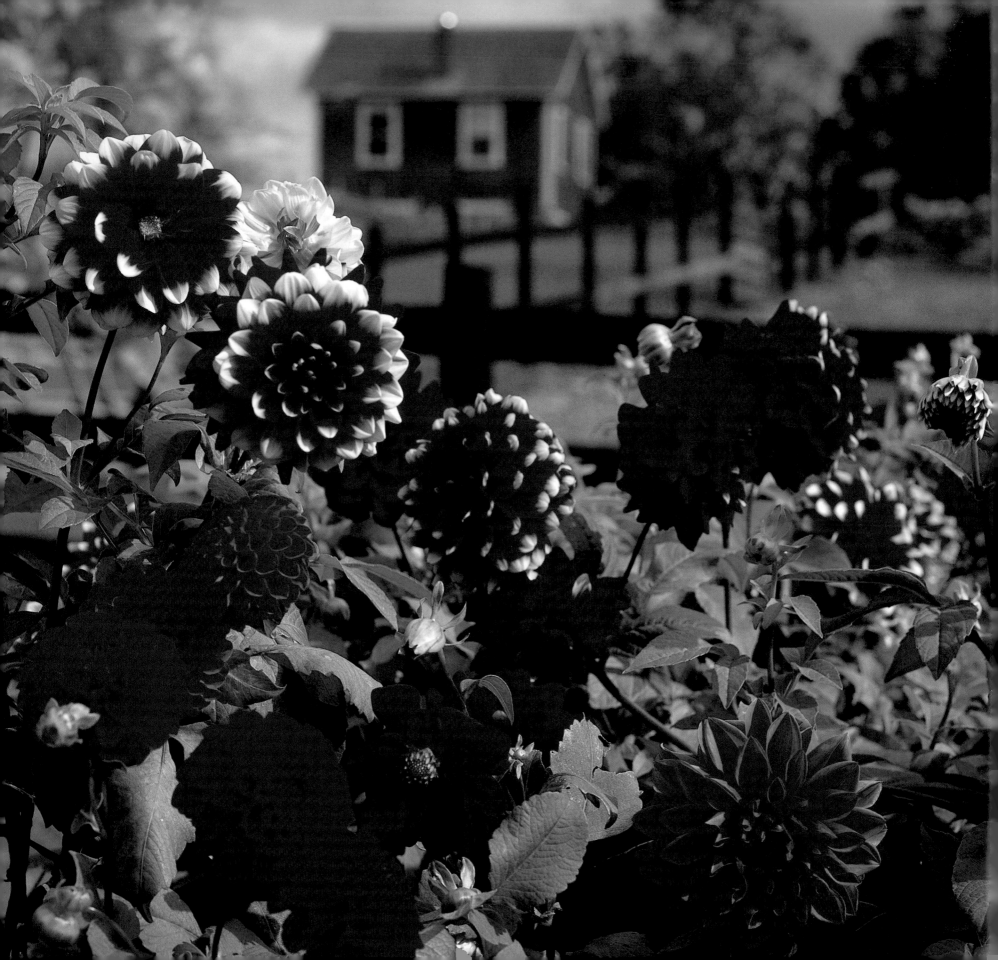

Built in 1983, this three-quarter Cape is the home of Peggy and Bob Schwier. The house and its surrounding property reflect its owners' combined interests—Peggy's love of gardening and all its elements and Bob's careful attention to traditional detail. Tucked into woods in West Tisbury, the house is surrounded by gardens filled with fragrant, colorful, and purely ornamental blooms from early spring through until frost.

LEFT PAGE: *In October, one corner of Peg's picking garden is lush with dahlias in a mixture of varieties collected over the years. Some have been given to Peg by friends and other gardeners and some have evolved from hybrids planted and dug and replanted year after year. Over time, this garden has increased and is both a source for satisfying the floral needs of Peg's clients as well as trying new varieties and colors for floral arrangements and for her own gardens.*

LEFT: *The house in the fall with the little fenced garden on the side. It is planted with hollyhocks along the house wall, phlox and oriental poppies for early bloom, followed by lilies in mid-summer for fragrance and color, and dahlias and nicotiana for late summer and fall blooms and scent.*
RIGHT: *Dahlia 'Red Envy'.*
BELOW: *Favorite pink dahlias in luxuriant autumn glory.*

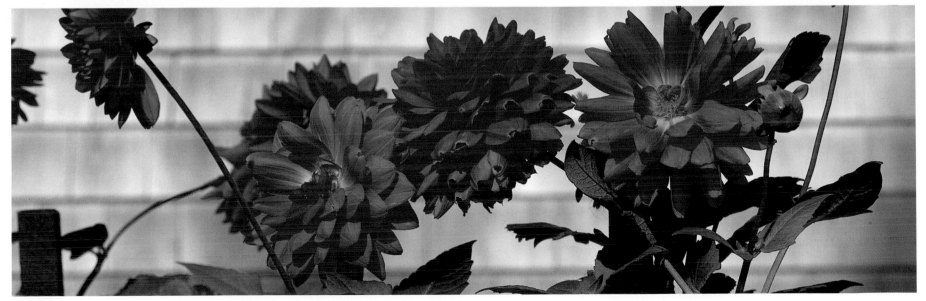

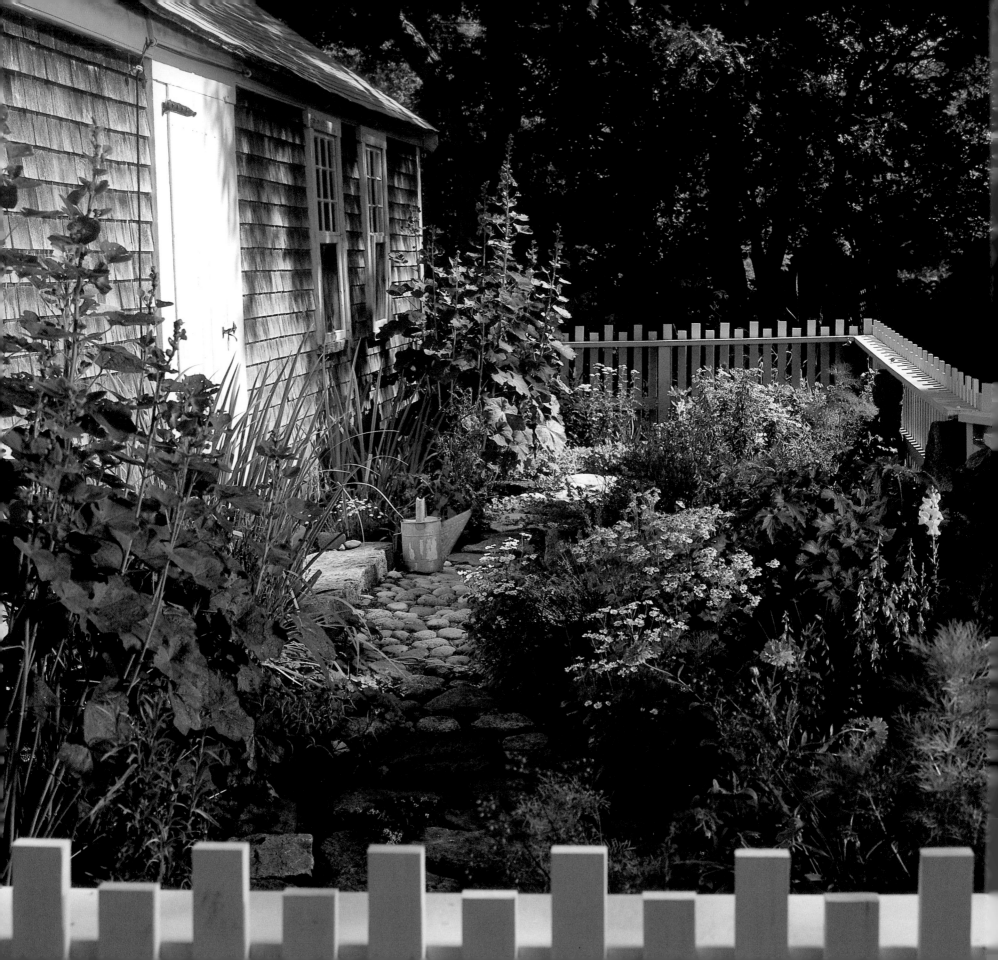

THE HILL HOUSE

 At the end of a winding lane in Indian Hill is this old farmhouse. It was built about 1720 for the parents of Mayhew Norton, a ship's pilot and father of some twenty-seven children; now it is the home of Julia Mitchell and John Christensen. They have carefully preserved as much of the original house as possible and have long-range plans to restore it further. The house was owned by members of the Norton family until 1921, when Julia's grandfather James Sanborn bought the house from Henry Norton, a stonecutter. Originally a full Cape cottage, at some point in its history, it was owned by two brothers who split it and moved half the house to another location up the hill. The brother who owned this house then added on to it with scrap timber to return it to a full Cape. When John and Julia began restoration, part of that half had to be torn down and rebuilt because so much of the wood had rotted.

The garden at the front of the house is enclosed with a white picket fence that has stone posts along the front, at the corners, and for the gate. The large stone at the front door was there when Julia and John moved here, but it was buried under layers of dirt that had washed down the hill and completely covered what is now the garden. They created the path from stones found on the property. The garden is planted with old-fashioned varieties: hollyhocks (Althaea rosea) along the house wall and feverfew (Chrysanthemum parthenium), snapdragons, creeping bellflower (Campanula rapunculoides), coral bells (Heuchera sanguinea), hollyhock mallows (Malva fastigiata), calendula, lavender, and yarrow.

RIGHT: *The dining room with its original wide pine floors and heavy beams personifies the simplicity of the old house.*

BELOW: *Bingo, the family dog, guards the back door that opens into the dining room.*

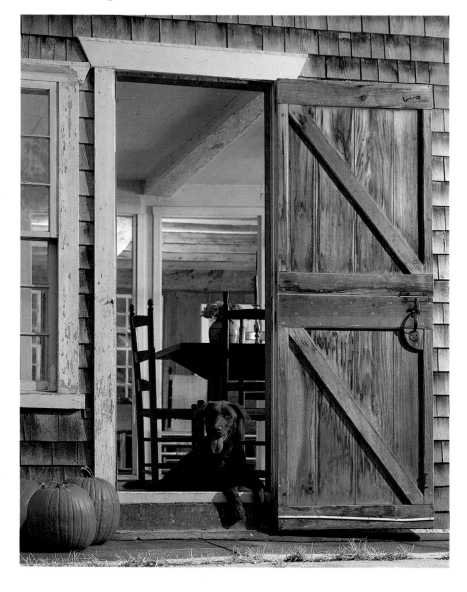

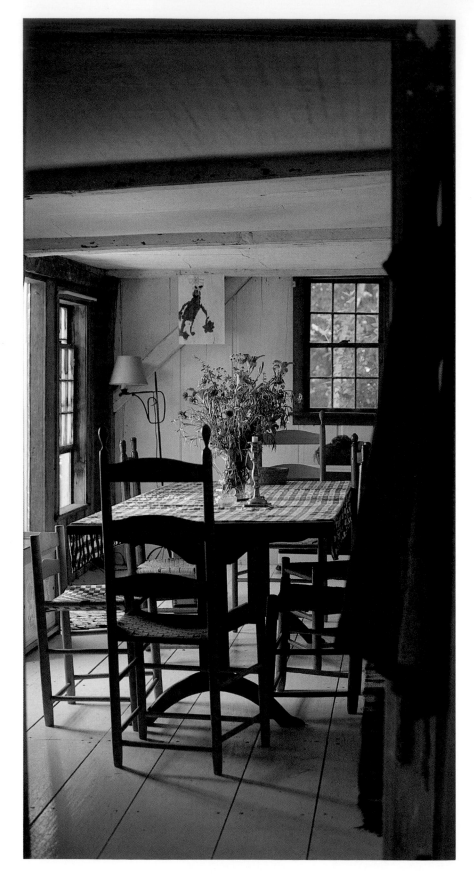

*A first-floor bedroom is filled
with morning sunlight.*

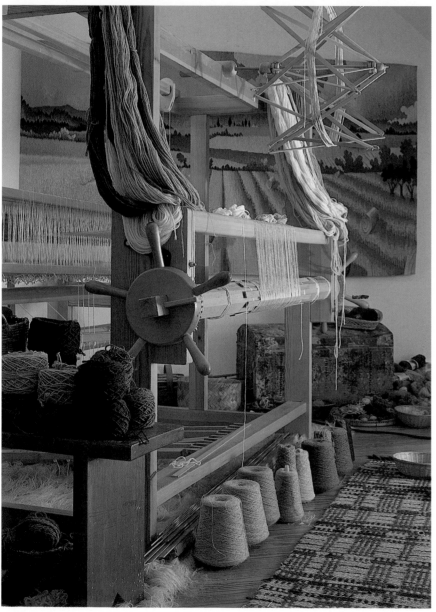

When Julia and John moved here there was an old barn on this site, but it was beyond restoration and was torn down and a bigger one built to house Julia's studio on the top floor and a workshop and storage on the lower level. Julia is a tapestry designer and weaver. Some of her works line the walls and cover the floor of her studio. The large loom on the right was made for large rugs and tapestries; the smaller loom on the left is used primarily for smaller works.

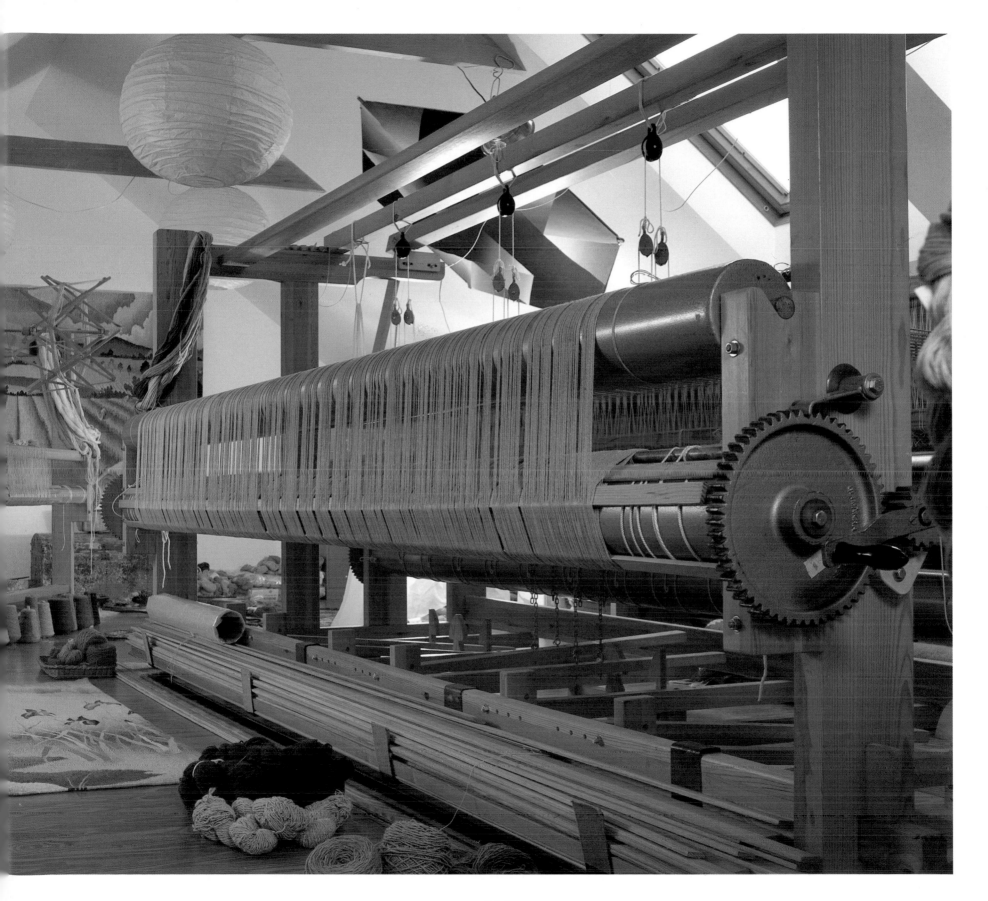

Barnard's Inn Farm belonged to the Luce family for two hundred years. Some time after the last of the family, Barnard Luce, died, Polly and Julian Hill bought the farm. When Polly began gardening on the Vineyard, she found the soil to be a good mix of sandy loam and clay with good drainage. Thinking there was a scarcity of interesting plants on the island, she decided to try new species. Starting with the plowing of one field, she has developed and grown from seed many varieties of rhododendrons, azaleas, magnolias, stewardias, and clematis. Her goal is to develop species of plants that will thrive here on the Vineyard and to select cultivars that benefit Vineyard horticulture.

BELOW: *In spring, the arboretum has the bright green of new leaves. The stone walls and old oaks were here when Polly added native azaleas and rows of conifers among the deciduous trees.*

RIGHT: *The bower was made from dead locust boughs. It is covered with three varieties of clematis: 'Lazursterne' with monstrous blooms in early June on the left; 'Betty Corning' on the right; and across the back is the July- and August-blooming 'Gabrielle', a Viticella hybrid of Polly's own raising that began from a seed in 1958 and was selected after twenty years.*

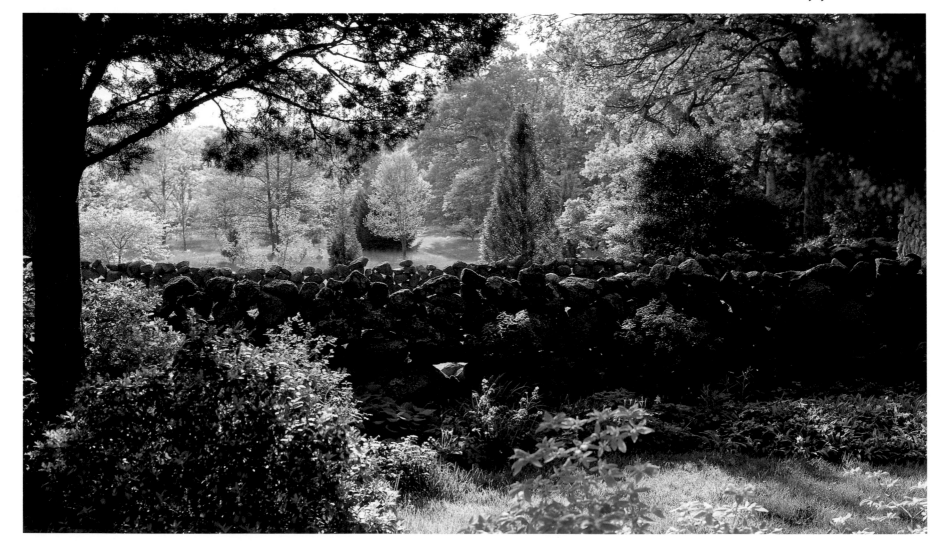

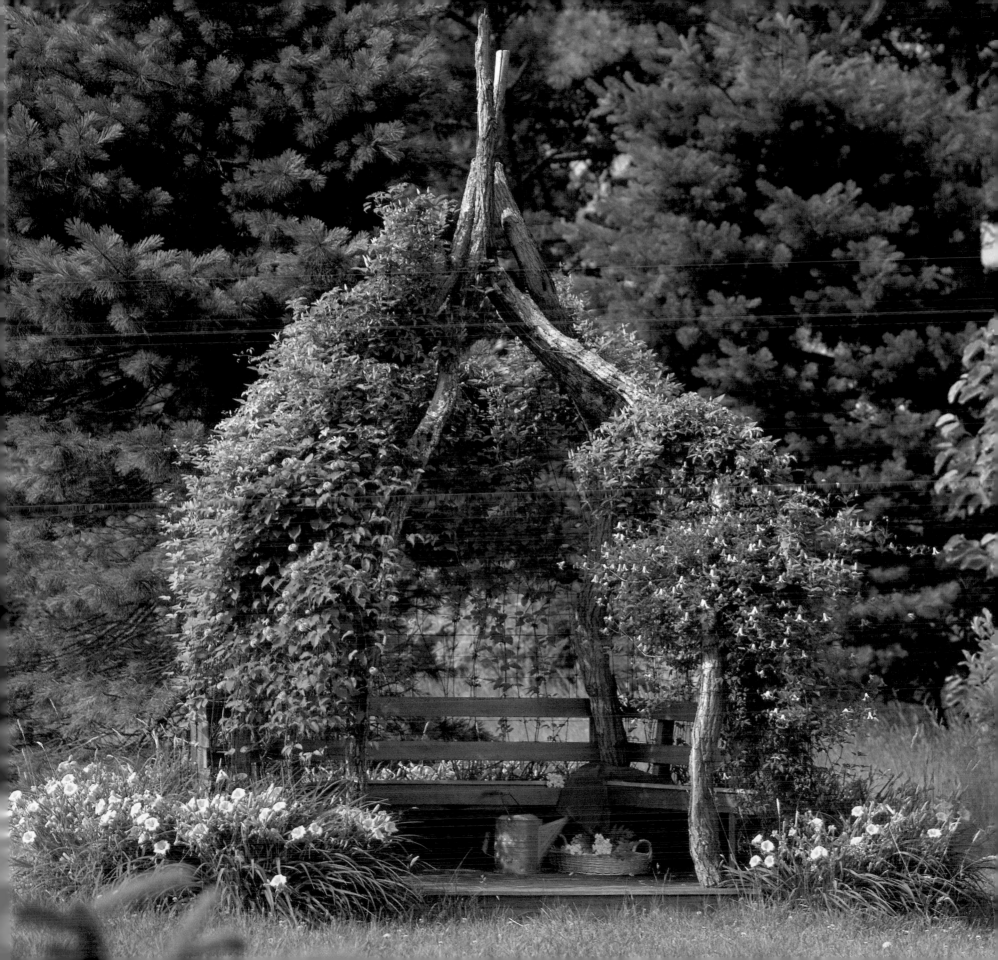

The Play Pen is surrounded with 10-foot-high wire fencing to protect the foliage inside from deer and other nibblers, and is filled with innumerable varieties of azaleas and rhododendrons as well as box, yews, junipers, and magnolias. On the left is a tall yew (Taxus baccata 'fastigiata') in the midst of three 'Late Love' azaleas, which are the last to bloom of her Nakaharae group. They are relatively new—a species from Taiwan that had not been used in hybridizing until Dr. Tsuneshige Rokujo used it as a parent—and are grown from the seeds of those plants. Also here are ground cover azaleas of which there are about twenty different cultivars. In the foreground on the left is a weeping hemlock (Tsuga canadensis 'Cole's Prostrate') that was given to Polly by Elizabeth McFadden, who has been working with her since 1983.

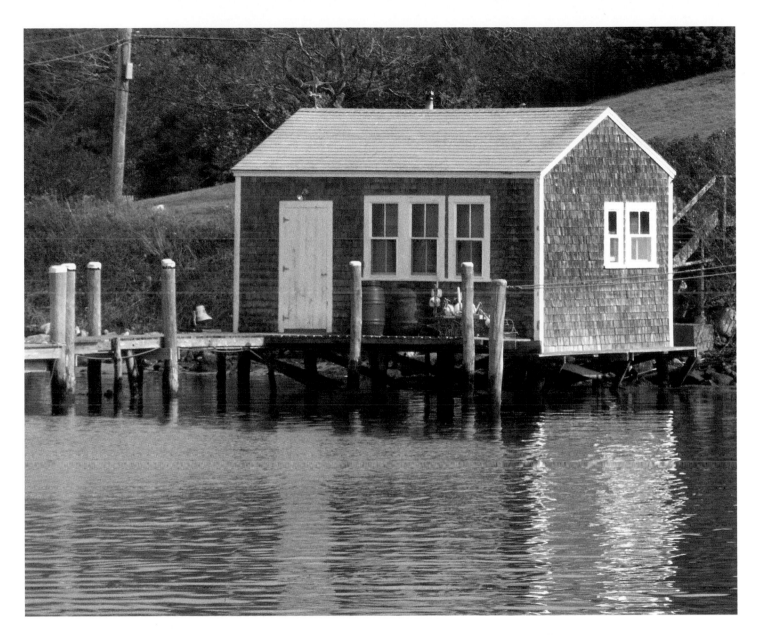

MENEMSHA FISHING SHACK

The little fishing village of Menemsha has physically changed since the early 1900's, when Menemsha Creek was dredged and the jetties were constructed to protect the channel. The 1938 hurricane destroyed many fishing vessels and ruined many buildings. Hurricane Carol rearranged others in 1954, but the life of the fishing village has continued unchanged.

This little shack was built by an off-Island commercial fisherman in the late 1940's. For thirty years he occupied it from mid-April until late October, respecting and becoming part of the traditions of the community. Built right over the water, it is reached by an elevated wooden walkway from the bank on the shore. The tides rise and fall beneath the floor. Its own dock extends out into the water on the other side.

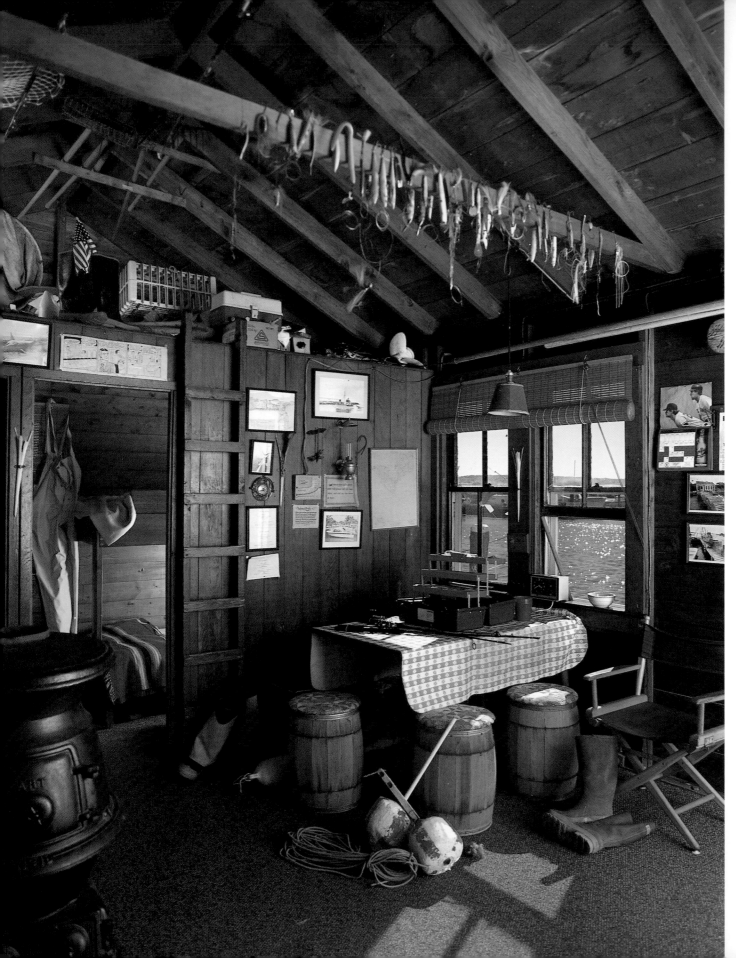

Both compact and functional, the interior is one room, with a little bunk area for sleeping and a loft above it for storage. Furnished with the bare necessities, the cozy shack reflects its owner's love of the sea. Fishing lures line the rafters, lobster pot buoys crowd the floor, and a swordfish harpoon hangs over the windows.

BELOW: *The wall is lined with swordfish bills from fish the owner harpooned. Outside the door that leads to the dock is the activity of Menemsha and its harbor.*

OVERLEAF: *The outside wall is decorated with swordfish tails. The swordfish weather vane on the rooftop glows in the waning sunlight at the end of a long summer day.*

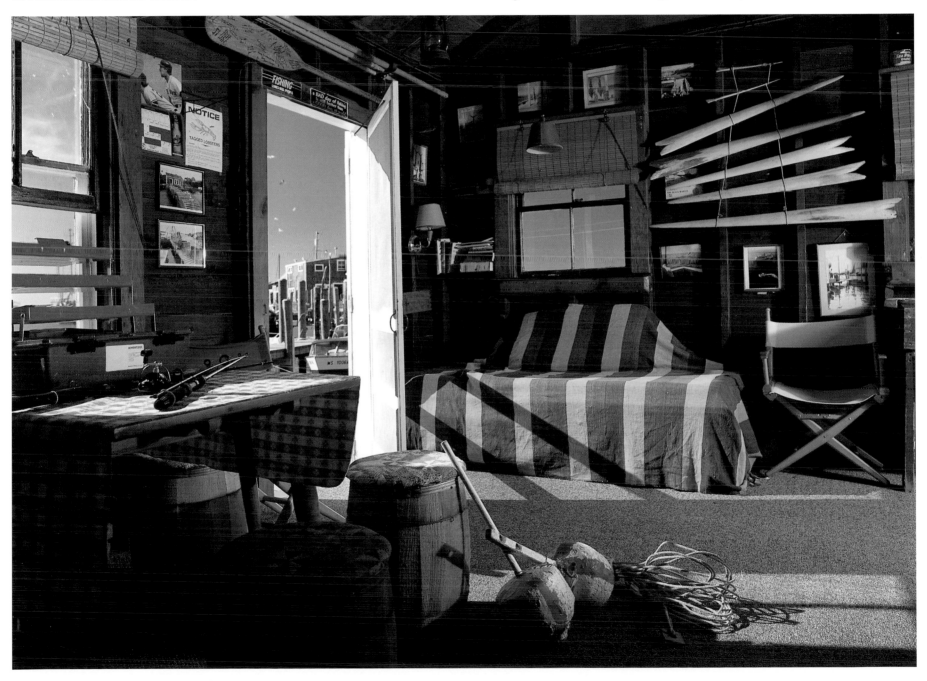

SOURCES

ARCHITECTS

Robert Avakian, page 97
Arthur Cogswell, pages 206–211
Joseph L. Eldredge, pages 18–23, 44–50, 66–
 67, 198–205, 228–231, 232–236, 276
Steven Holl, pages 254–257
Eliot Noyes, pages 237–241
Frederick Noyes, pages 223–225
Benjamin Thompson, pages 148–154
Geoffrey White, pages 213–219

DECORATIVE PAINTING

Margot Datz, pages 4, 6
Mary Mayhew, page 9
Stanley Murphy, pages 160, 161

FLOWER ARRANGEMENTS

Anne Bacon, pages 43, 248, 250, 251
Alison Cannon, pages 44–51
Teddie Ellis, pages 60–69
Catherine Fallin, pages 60–63, 80, 83–89,
 160–163, 256–257
Liz Gude, pages 182–191
Anne Hale, pages 124–131
Nancy Highet, pages 30–39
Mariko Kawaguchi, pages 90–97
Eleanor Hubbard, pages 212–219
Julia Mitchell, pages 260–265
Eleanor Olsen, pages 52–59
Jacqueline Ronan, pages 2–13
Sara Jane Sylvia, pages 170–179
Margaret Koski Schwier, pages 11, 19–23,
 150–153
Elizabeth Talbot, pages 76, 233
Trudy Taylor, page 211
Isabel West, pages 140–143

GARDEN CONSULTANTS

Anne Bacon
Marion Baker
Margaret Koski Schwier

HORTICULTURALIST

Polly Hill, pages 266–269

INTERIOR DESIGNER

Leta A. Foster, pages 98–107

HORTICULTURAL STYLING

Donorama Nurseries, pages 90–97
Mariko Kawaguchi, pages 96–97

LANDSCAPE ARCHITECTS/DESIGNERS

Anne Hale, pages 124–131, 198–205
Rebecca Potter, pages 108–111
Maurice Wrangell, pages 244–253

LANDSCAPE GARDENERS

Michael Faracca, pages 24–27
John Gadowski, pages 108–111
Virginia Iverson, pages 108–111
Carlos Montoya, pages 220–221
Margaret Koski Schwier, pages 18–23, 132–
 135, 144–147, 168–169, 258–259
Nina Schneider, pages 192–197
Chuck Wiley, pages 96–97

**SELECTED GARDEN AND HISTORICAL
REFERENCES**

Bloom, Alan. *Alpines for Your Garden*. Chicago:
 Floraprint, U.S.A., 1981.
Damrosch, Barbara. *The Garden Primer*. New
 York: Workman Publishing Company,
 Inc., 1988.
Foley, Daniel J. *Gardening by the Sea, from Coast
 to Coast*. Orleans, Mass.: Parnassus, 1982.
Hale, Anne. *Moraine to Marsh, a Field Guide to
 Martha's Vineyard*. Vineyard Haven, Mass.:
 Watership Gardens, 1988.
Hough, Henry Beetle and Alfred Eisenstaedt.
 Martha's Vineyard. New York: The Viking
 Press, 1970.
Huntington, Gale. *Introduction to Martha's Vine-
 yard*. Edgartown, Mass.: Dukes County
 Historical Society, 1969.
McAlester, A. Lee and Virginia McAlester. *A
 Field Guide to American Houses*. New York:
 Alfred A. Knopf, 1984.

Macy, Eliot Eldridge. *The Captain's Daughters of
 Martha's Vineyard*. The Chatham Press,
 1978.
Nerney, Ruth S. *Reflections in Crystal Lake, East
 Chop, Martha's Vineyard*. 1985.
Niering, William A. and Nancy C. Olmstead.
 *The Audubon Society Field Guide to North Amer-
 ican Wildflowers, Eastern Region*. New York:
 Alfred A. Knopf, 1979.
Norton, James. *A Walking Tour of William Street*.
 Edgartown, Mass.: Dukes County Histori-
 cal Society, 1985.
Railton, Arthur R. *Walking Tour of Historic Edgar-
 town*. Edgartown, Mass.: Dukes County
 Historical Society, 1988.
Stoddard, Chris. *A Centennial History of Cottage
 City*. Oak Bluffs, Mass.: Oak Bluffs Histor-
 ical Commission.
Taylor, Norman. *Taylor's Guide to Annuals*. Bos-
 ton: Houghton Mifflin Company, 1961.
———. *Taylor's Guide to Shrubs*. Boston: Hough-
 ton Mifflin Company, 1987.
Weiss, Ellen. *City in the Woods: The Life and De-
 sign of an American Camp Meeting on Martha's
 Vineyard*. New York: Oxford University
 Press, 1987.
West, Isabel White. *Wilfred O. White, 1878–
 1955, a Family Journal*. Vineyard Haven,
 Mass.: 1990.
White Flower Farms. *The Garden Book Catalog*.
 Spring 1991. Litchfield, Conn.

PRODUCTION CREDITS

Design concept and photo layouts by Taylor
 Lewis
Type design and mechanicals by Abby Kagan
Photography assistance by Greg Hadley and
 Greg Goebel
Editorial production by Pamela Stinson and
 Susan Groarke
Copy edited by Marion Baker and Kate Scott
Proofread by Susan Groarke and Pauline
 Piekarz
Composition by N.K. Graphics
Production coordination by Joanne Barracca
Printed and bound by Tien Wah Press